THE PRINCETON SERIES IN
NINETEENTH-CENTURY ART,
CULTURE, AND SOCIETY

The Popularization of Images

The Popularization of Images

Visual Culture under the July Monarchy

Edited by Petra ten-Doesschate Chu
and Gabriel P. Weisberg

Princeton University Press

Library of Congress Cataloging-in-Publication Data
The Popularization of images : visual culture under the July Monarchy
/ edited by Petra ten-Doesschate Chu and Gabriel P. Weisberg.
p. cm. — (The Princeton series in nineteenth-century art,
culture, and society)
Includes bibliographical references and index.
ISBN 0-691-03210-6
1. Arts, French. 2. Arts, Modern—19th century—France. 3. Mass
media and the arts—France—History—19th century. 4. Art and
history—France. 5. France—History—Louis Philippe, 1830–1848.
I. Chu, Petra ten-Doesschate. II. Weisberg, Gabriel P.
III. Series.
NX549.A1P66 1994
709'.44'09034—dc20 93-47332

Contents

Contents

List of Illustrations

Preface

THE PRESENT BOOK is the outgrowth of a symposium on the art and culture of the July Monarchy that was held in Minneapolis in 1991. Sponsored by the Department of Art History and the Center for Western European Studies at the University of Minnesota, the symposium brought together a group of historians and art historians embracing a variety of viewpoints and methodologies. To many in attendance it came as a surprise that the culture of the July Monarchy—generally considered one of the less exciting periods in nineteenth-century history—could arouse so much discussion. Terms often applied to the July Monarchy, such as *juste milieu* and proto-Realism, became lightning rods for heated debates that centered around the relation between art and politics, Romanticism and Realism, subject matter and facture, paintings and prints.

To perpetuate the debate, the editors of this volume decided to publish several of the papers presented at the symposium and others newly solicited in an attempt to show that, rather than a transitional, hence character-less, period, the July Monarchy was a pivotal phase in the history of French nineteenth-century culture when visual culture flourished and the old boundaries between "high" and "low" art were rapidly fading away.

The editors thank all contributors for their participation in this volume. They also are indebted to Elizabeth Powers, Fine Arts Editor at Princeton University Press, for her interest in the project and her efforts to see it through the arduous process from manuscript to book. In addition, special thanks are due Yvonne Weisberg who prepared the bibliography and index, and to Tim Wardell, copy editor of the manuscript.

The Popularization of Images

Introduction

TOGETHER with the Second Empire, which it equalled in duration, the July Monarchy was the longest-lasting regime of the nineteenth century. Born of three "glorious" revolutionary days in July 1830 and terminated by a shabby insurrection in February 1848, it was a time of contradiction. It was also a time, unlike the Second Empire, that is not easily characterized. While the Second Empire immediately evokes such cultural and social phenomena as supreme confidence in science and technology, Realism in art, international exhibitions, a flourishing though dirty iron and coal industry, a glittering imperial court, and a Haussmannized Paris with gaudy theatres, opulent department stores, and burgeoning markets à la Zola (who was, of course, the ultimate chronicler of the era), the July Monarchy lacks such obvious traits. The age of Louis-Philippe is often thought of as transitional, even "shifty," devoid of a set political course or a clearly defined cultural identity. Belated Romanticism, Romantic Classicism, Romantic Realism, and "proto-Realism" are among the terms used for the art and literature of this period. Even in sociological terms, the July Monarchy, commonly qualified as a bourgeois society, is more ambiguous and complex than that simplistic label implies. For one thing, the bourgeoisie itself was not a solid social body, as it ranged from a wealthy, hence powerful, upper middle class to a petty bourgeoisie of small shopkeepers and traders whose status was not too different from the upper crust of the working class. For another, this bourgeoisie, even in its full range, was demographically speaking a minority when compared to the numerically predominant class of rural and urban proletarians.

The mental picture that most immediately comes to mind at a mention of the July Monarchy is "la poire," the pear, an image that originated as a shorthand caricature of the heavy-jowled face of the monarch Louis-Philippe, but that ultimately became the emblem of the period, acquiring such dubious connotations as conservatism, mediocrity, narrow-mindedness, and lack of backbone and principle. Considered negatively, the July Monarchy was indeed a period of broken promises and missed opportunities. Founded on the revived ideals of liberty, equality, and fraternity, the regime of Louis-Philippe, in the face of political challenge and social disorder, increasingly backed away from those ideals, though without ever renouncing them altogether.

Seen in a more positive light, it must be conceded that an effort was made, especially during the early part of the period, to go at least half-way (a policy called *juste milieu*) to forge a nation founded on the principles of 1789. It was soon realized, however, that liberty led to anarchy, that equality was a pipe dream in a nation where differences

in property and education formed an unbridgeable rift between a privileged minority and a disenfranchised majority, and that fraternity was impossible to achieve in a polarized world where nations willy-nilly were forced to take sides. The regime made serious efforts to overcome some of these obstacles, particularly those that stood in the way of social equality. In 1833, an education law was passed that stipulated that each commune (alone or in cooperation with one or more others in the immediate vicinity) had to provide a school for primary instruction and all communes with a population over 6,000 had to have a secondary school. By elevating the literacy level through increased availability of education, the July Monarchy government caused a larger segment of the population to have access to the written word, most importantly to the media: newspapers and weekly or monthly magazines. Yet, though improved literacy enhanced political awareness among the lower classes, it did not necessarily enfranchise them since voting rights under the July Monarchy continued to be linked to the payment of a stipulated minimum in taxes. Literacy did, however, have an impact on the cultural scene of the 1830s and 1840s as access of at least part of the lower classes to the media, as well as contemporary literature (through serial novels and books sold in cheap editions or lent by lending libraries), eliminated the dividing line between high and folk culture, creating instead a popular culture that encompassed a social continuum ranging from the privileged class of landlords and urban capitalists to the petty bourgeoisie and upper crust of the laboring class (artisans, prosperous farmers, etc.).

It would be wrong to credit this popularization of culture solely to increased literacy since many other historic factors were at play as well. The use of powered equipment for manufacturing processes led to a large-scale production of commodities (particularly in fashions and home furnishings), which could be sold at much lower prices than earlier hand-made goods, and thus could be brought within reach of a considerable segment of the population. Urbanization and increased geographic mobility further broadened the distribution of machine-made (i.e., identical) commodities, gradually forging a growing sameness in taste and consumption patterns.

In addition, improved picture printing techniques (lithography, wood engraving) facilitated the production of images, which quickly found their way into the rapidly expanding publishing industry of the July Monarchy. This created a popular visual culture that was not confined to newspaper caricatures and cartoons but included illustrations in books and magazines, published in huge editions for a popular readership. Such illustrations were often done by (or after the works of) well-known artists of the period, the very same ones whose large-scale works could be seen at the annual Salons in Paris and in permanent settings such as the Musée historique in Versailles. Partly as a result, Salons and museums became increasingly popular, turning from meeting grounds of the cultivated elite into places of popular entertainment. Thus in the visual as in the verbal realm, a popular culture developed that embraced a range of social strata unprecedented in European cultural history.

The essays in the present volume are devoted to the popularization of visual culture under the July Monarchy. Visual culture is defined rather broadly, to include all aspects of culture that have a visual component: paintings, drawings, prints, book illustrations, as well as architecture and the performing arts. Numerous connections are also made with non-visual cultural forms, to emphasize that the popularization of culture was an all-encompassing phenomenon that affected the arts as well as literature and even music.

The interest in the rise of a popular visual culture during the Romantic period, i.e., the later part of the Restoration and the July Monarchy, is not altogether new. As the bibliographical essay at the end of this book indicates, during the past two decades much attention has been paid to one aspect of this phenomenon, namely media art—the caricatures, cartoons, and other types of illustrations that are found in the numerous newspapers and magazines that appeared in the course of the 1830s and 40s. Little has been written, however, about other aspects of the popularization of visual culture, in such areas as book illustration, history painting, architecture, or the performing arts. The present volume aims at correcting this situation and furthermore suggests that there was a good deal of contemporary awareness of the popularization of visual culture. Both the regime and its opposition realized the growing potential of images and the visual in general as a means of propaganda. Indeed, it may be argued that Louis-Philippe's Musée historique at Versailles and Charles Philipon's illustrated papers were directed at essentially the same public, though obviously the medium and the message were different.

Four essays in the present volume are devoted to media art and illustration under Louis-Philippe and all four, in their own way, are an attempt to move the subject in new directions. James Cuno, in his "Violence, Satire, and Social Types in the Graphic Art of the July Monarchy," focuses on caricatures of social types drawn from the various *quartiers* in the city of Paris. Cuno relates the appearance of specific types to the commercial strategies of Philipon and demonstrates that earlier popular prints, the so-called *Cris de Paris* (which go back as far as the seventeenth century and which are likewise linked to social class), as well as turn-of-the-century physiognomic caricatures, functioned as models for Philipon's "typical caricatures." In stressing that the July Monarchy types were rooted in these earlier models, Cuno suggests that there was a functional tie between typical caricatures and the science of phrenology which aimed at reading character in faces and associating behavior with appearance. He convincingly demonstrates that the coarse, vulgar, and violent types that are prominent among the typical caricatures of the July Monarchy betray middle-class anxieties during a period of dramatic change in the demography of Paris and its social structure.

Elizabeth Menon's "The Image that Speaks: The Significance of M. Mayeux in the Art and Literature of the July Monarchy" reveals the many complex ties that connected the graphic arts with the popular literature and theatre of the time. Menon demonstrates that Mayeux, visualized by artists as a hunchback dwarf, was not merely a grotesque

figure but functioned as a "voice" (in the theatre, the media, and in prints) to effectively ridicule almost every aspect of contemporary society. A kind of nineteenth-century "everyman," Mayeux used humor to find truths and he spoke, almost subliminally, against pretension. As a destroyer of illusions, Mayeux attacked everything that was sacred and sacrosanct.

Michael Driskel's essay on "The Proletarian's Body: Charlet's Representations of Social Class during the July Monarchy" elaborates on earlier discussions of "class representation" (by Judith Wechsler and others) and the way graphic images reveal contemporary concerns with the presence of the troubling *classes dangereuses*. Charlet's preoccupation with proletarian types, who are effectively contrasted with the "bourgeois other," shows that he was grappling with new ways of visualizing class identity. Convinced that prints played a viable role in documenting the members of various classes, Charlet created a broad range of types in a way akin to Honoré Balzac's attempts to cover the broad spectrum of humankind in his *Comédie humaine*. As in Menon's essay, important parallels are drawn between different cultural forms.

Gabriel Weisberg's "Proto-Realism in the July Monarchy: The Strategies of Philippe-Auguste Jeanron and Charles-Joseph Traviès" establishes the direct and intimate relation that existed, during the July Monarchy, between media graphics and "fine" art. Weisberg shows that the popular graphic images of the July Monarchy were a crucial element in the formation of an early realist aesthetic in drawing and painting. As an example of his thesis he discusses the work of Jeanron and Traviès, two artists who long have been considered unimportant figures, though they were seen as radical innovators in their time. Focusing on the representation of the daily life of lower classes, these artists developed a direct, vigorous, often brutal style of presentation that was at odds with the "high" artistic tradition of the period. As such they may be seen as pioneers of the Realist movement that would triumph during the Second Empire.

A second group of essays in this volume deals with the representation of history, a crucial aspect of the visual culture of the July Monarchy. Michael Marrinan in "Historical Vision and the Writing of History at Louis-Philippe's Versailles" is concerned with the way historical images in Louis-Philippe's Musée historique at Versailles were constructed, presented, and, finally, interpreted by contemporary audiences. Referring to the guidebooks that were to lead visitors through the museum, Marrinan demonstrates various ways in which the composition and display of paintings were intended to control the way history was read by contemporary viewers. Marrinan further draws attention to the growing importance of explanatory texts, which often were read more attentively than the images they were meant to elucidate; he carefully analyzes the disparities that existed between these verbal aids and the painted representations of history in the context in which they were originally presented.

Kim Munholland, in his "Michaud's History of the Crusades and the French Crusade in Algeria under Louis-Philippe," examines similar issues from a historian's

perspective. He demonstrates that by bolstering the historical investigation of the crusades, the official propaganda machine of the July Monarchy attempted to legitimize France's imperialist agenda in Algeria. Munholland goes a long way to proving that Louis-Philippe had Empire ambitions, that he wanted to bring France's culture to the African shores as well as forcefully enhance its supply of raw materials and expand its markets. Extending his argument to include the "crusades" room in the Musée historique in Versailles, Munholland demonstrates the subtle ways in which history was slanted to accomodate, justify, and gain public approval for contemporary policies.

Petra Chu's "Pop Culture in the Making: The Romantic Craze for History" is less concerned with official history painting and its political agenda than with the popular aspects of historicism. Using a variety of indicators, she demonstrates that a fascination with history powerfully marked all cultural forms (painting, graphic arts, literature, theatre, opera, fashions, etc.) of the July Monarchy and reached an unprecedentedly large segment of the population. She argues that this overarching interest in history was symptomatic of the emergence in France of a popular culture, different from traditional folklore and anticipating in several (though not all) important ways the mass culture of the twentieth century. In doing so, Chu explodes the myth that the culture of the July Monarchy only satisfied the well-to-do middle class or was primarily a construct of merchants and industrialists working closely with the "Citizen King." What emerges is a more complex vision of a modern society filled with individuals interested in improving their education and quality of life.

The next essay carries some of the earlier arguments into the realm of architecture. David van Zanten's "The Power of Axes and the Axes of Power: L.-T.-J. Visconti, the New Louvre and the Shape of Paris" presents further evidence of Louis-Philippe's all-encompassing efforts to legitimize and aggrandize his rule by closely linking it to past tradition. Using newly found documents, Van Zanten proves that the project to complete the Louvre, generally attributed to Napoleon III, was in fact conceived during the July Monarchy in an attempt to forge a concrete, visible connection between the reign of Louis-Philippe and that of Louis XIV. Van Zanten demonstrates that the Louvre project, unexecuted at the time of the 1848 Revolution, was one of a series of projects, including the transformation of the Palais Bourbon, the Luxembourg Palace, the Place du Panthéon, the Hôtel de Ville, and the projected Palais de Justice, that were intended to continue the great tradition of French Baroque classicism into the nineteenth century.

Concluding the volume, Albert Boime's "Going to Extremes over the Construction of the *Juste Milieu*" outlines the broader philosophical context within which the culture and politics of the July Monarchy must be understood. Boime reaffirms the link between the much-maligned term *juste milieu*—first used by Louis-Philippe in 1831 to define his domestic and foreign policies—with the eclectic philosophy of Victor Cousin, which pervaded the educational institutions and practices of the July Monarchy. He defends the usage (by Léon Rosenthal and later authors, including Boime himself) of

juste milieu as a cultural-historical term against the recent criticisms of Marie-Claude Chaudonneret (1991) and Michael Marrinan (1991). In doing so, Boime defines *juste milieu* as a "strategizing principle for appealing to a weary and confused body of middle-class and aristocratic types who longed for a unity and healing of the divisions of social impulses, interests, and enterprises."

The essays in this book lead to several interrelated conclusions. To begin with, the popularization of visual culture under the July Monarchy, formerly seen as a symptom largely restricted to media graphics, was in fact a much broader phenomenon, affecting, to a greater or lesser degree, all forms of culture with a visual component.

Related to this expanded notion of popular visual culture is the manifestation of a new fluidity of the boundaries between cultural forms (painting, graphic arts, literature, drama, music). Mayeux was a cartoon character, as well as a pseudonym of numerous satirical writers and a figure on the Parisian stage. Walter Scott's novels were read, performed on stage, sung in the opera, and depicted in Salon paintings. The same social types that are described in the novels by Balzac are depicted in Charlet's prints. July Monarchy painters write (Delacroix) and writers paint (Victor Hugo). In essence, there is a growing tendency, in the 1830s and 1840s, to relate the visual and the verbal. The vogue for illustrated books and magazines, the demand for descriptive guidebooks in museums and exhibitions, the symbiotic relationship between image and caption in July Monarchy cartoons, the introduction of (visual) tableaux as a reprieve from the (verbal) mono- and dialogues of melodrama and opera, all point to a new urgency to link word and image.

Another conclusion to be drawn from the essays in this volume is that there was a close connection between the emergence of a popular culture (visual as well as literary) under the July Monarchy and Romanticism's powerful sense of history. That connection was not coincidental. The events of the revolutionary and Napoleonic periods had greatly affected all classes—though obviously not in the same manner. As a result, national history was redefined as the combined experience of the nation's people at large. Romantic historiographers increasingly stressed that history was a shared patrimony in which all classes had a stake. Historic images, ranging from large-scale paintings to book illustrations, became an important part of the visual culture of the July Monarchy and had a broad appeal ranging from the king to the man in the street, who found in history relevance, even justification for their own existence.

Finally, this book raises—and answers as well as the paucity of documentation allows—an important social-historical question: How far "down" did the popular visual culture of the July Monarchy reach? Obviously, in order for the lower classes to be visually acculturated in a period when the visual was so closely related to the verbal, functional literacy was a must. Acculturation also required a minimum amount of disposable income, if only to buy a newspaper, a ticket for an omnibus ride to the museum or the theatre, or the lending fee of a *cabinet de lecture*. If, as Aline Daumard

(1975) has pointed out, from 50 percent (rural areas) to 70 percent (urban centers) of the population were indigent and, if, according to James Allen (1991), even in 1841, 39 percent of all men and 54 percent of all women in France remained functionally illiterate, in spite of growing efforts to educate the masses, it is clear that there was a huge social "underbelly" that did not partake in the material, social, and cultural gains of the uppercrust of the working class. Indeed, it was in large part the failure to reach out to this underbelly that ultimately brought the July Monarchy to an untimely end.

I

Violence, Satire, and Social Types in the Graphic Art of the July Monarchy

JAMES CUNO

THE JULY MONARCHY witnessed the development in Paris of a broad commercial interest in the printed graphic arts.[1] This was due to a number of factors: the commercial development of the city's Right Bank along the Rue de Rivoli and the Palais Royal, the rise of popular journalism and increasing rates of literacy among the burgeoning middle class, the rapid increase in the number of aspiring artists and writers who were immigrating to the city from provincial towns, perhaps even an "excess of educated men," who, when crowded out of the market place for conventional careers in public administration and the liberal professions, turned their skills to the demands of the French Grub Street, as described in Balzac's *Illusions perdues*.[2] It was due equally to the introduction of lithography into Paris: a new printing process that, compared to the complex and labor-intensive intaglio processes of the recent past, was easily learned and offered inexpensive prints in large print runs for a variety of purposes.[3]

On the eve of the July Monarchy, in December 1829, Charles Philipon opened a print shop in the fashionable Passage Véro-Dodat, just to the east of the Palais Royal.[4] Having arrived in Paris in 1819 as a young, aspiring artist from Lyon, he was attracted to lithography and worked designing vignettes and caricatures for print and book illustrators throughout the 1820s. (He claims even to have invented a way to apply lithography to the decoration of *devants de cheminée*, a discovery quickly exploited by his publisher for which Philipon was paid only 200 francs.)[5] In October 1829, he joined others in founding and publishing *La Silhouette*, a satirical journal that included original lithographs in each issue. Insufficiently funded and riddled with fines imposed by the

censors of Charles X, *La Silhouette* lasted only a few months, and in November 1830 it was replaced by *La Caricature*, a weekly journal of similar purpose started and published by Philipon alone. Two years later, Philipon added a daily journal, *Le Charivari*, as well as a monthly, *L'Association Mensuelle*, each of which included original lithographs. Subscribers to the latter received each month a large-format, lithographic caricature suitable for framing.[6] By 1840, Philipon and his print shop and publishing company, the Maison Aubert, dominated the Parisian trade in lithographs, publishing one-fifth of all prints registered in the *dépôt légal* that year and over three-quarters of the small, wood-cut illustrated satirical books known as *Physiologies*.[7] Indeed, in 1841, Balzac addressed a letter to Philipon with the words, "Mon cher Ponpon, Duc de Lithographie, Marquis de dessin, comte de Bois gravé, Baron de Charge et chevalier des caricatures"— words that place Philipon at the front of the pack of print publishers who, together with book and newspaper publishers, were working frantically to meet the Parisian demand for printed materials and whose businesses were central to the thriving commercial culture of Paris during the July Monarchy.[8]

THIS, THEN, IS THE CONTEXT within which to consider two prints published by Philipon in the December 30, 1830, issue of *La Caricature* (figs. 1, 2), prints that introduce the theme of this essay—violence, satire, and social types in the graphic art of the July Monarchy—and which, in light of the images by which Philipon and his artists are better known, might seem a little odd. It is the purpose of this essay to argue that far from odd they were part of the commercial strategy on which Philipon depended, especially in the first years of his business, when Paris was experiencing a demographic crisis of unprecedented proportions.

The first print, Achille Devéria's *That Which is the Most Beautiful on Earth* ("Ce qu'il y a de plus beau sur la terre"), depicts three coquettish young women in formal dress— ribbons, bows, flowers, long gloves, fans, and necklaces (on one, a small cross)— pausing in their conversation. They appear to be at a ball, having gathered to recount the evening's doings: the seated one is lost in innocent reflection, while the others—not so innocent, rather more knowing and experienced, more confident in their erotic appeal—look up and acknowledge the viewer with alluring glances. The second print, Traviès' *That Which is the Ugliest in the Universe* ("Ce qu'il y a de plus affreux dans l'univers"), depicts a violent argument: three older women dressed in filthy, tattered garments patched together from various pieces of old cloth; one screeching and pulling at another's hair; a third restraining the first, clutching at her throat with gnarled hands. Unlike in the first image, the women here ignore the viewer. We take stock of their brutish behavior, hideous appearance, and animal-like physiognomies unacknowledged, as if we are not of their world.

It is not my intention to overburden these small, seemingly incidental images, but this point is crucial: the first invites our imaginative participation in its subject, while

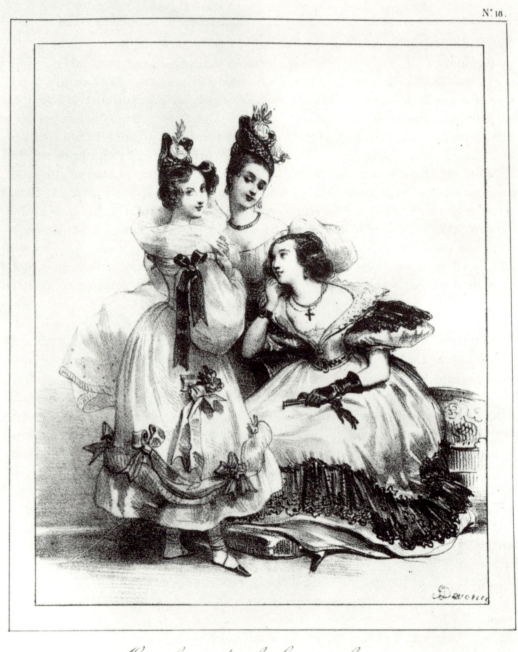

Ce qu'il y a de plus beau sur la terre.....

1. Achille Devéria, *That Which is the Most Beautiful on Earth,* 1830, lithograph. Paris, Bibliothèque Nationale

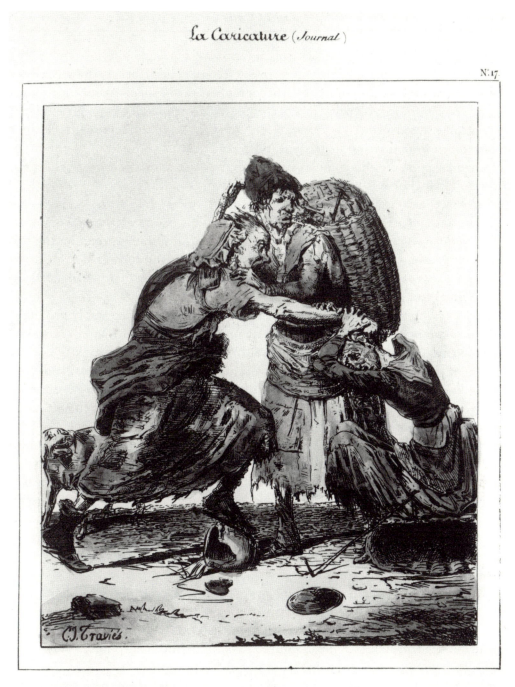

Ce qu'il y a de plus affreux dans l'univers.

2. Charles-Joseph Traviès, *That Which is the Ugliest in the Universe,* 1830, lithograph. Paris, Bibliothèque Nationale

the second does not. We—in the place of *La Caricature*'s original public—are meant to feel intimate with the first and distant from the second. The prints are drawn that way. In Devéria's print, soft grey tones of a lithographic crayon shape round, open forms, while in Traviès', quick, incisive lines of a lithographic pen mark out rough and jagged edges on dark, closed forms. The question, then, is this: What did it mean that Philipon contrasted Devéria's inviting image with the repellent one by Traviès? Or, put another way: What meaning did this comparison take on in the particular culture of the center of Paris within which it was produced and distributed?

First, we need to recognize that these are "typical" caricatures; that is, they exaggerate and make fun of certain social "types": on the one hand, young, aristocratic Parisian women—love-struck and tarted up in the latest fashions—and on the other hand, older, lower-class women of the *barrières*, with their propensity to drink and violence. The two caricatures are quite similar to those drawn by Pierre-Numa Bassaget (called Numa) and published by Philipon in 1832 as part of a four-print series entitled *Les douze arrondissemens de Paris* (figs. 3, 4). In the first of these later prints, Numa depicts three young women dressed in the best contemporary fashions with hour-glass figures and, in one instance, a neat butterfly coiffure. In the second, he portrays three heavy-set women, one dressed in rags, another in a working-class apron and bonnet, and a third dressed like a *grisette*, with her skirt hiked up in back just far enough to reveal her leg above her stocking. In addition, Numa identified each woman with a particular Parisian district, or arrondissement—the Faubourg St.-Honoré, Palais Royal, and Boulevard Montmartre in the first, and Les Invalides, Luxembourg, and the rue Mouffetard in the second. The women "typified" the character of contrasting geographic districts within the capital: the fashionable and respectable Right Bank contrasted with the brutish and working-class Left Bank. As we shall see, such images were popular in early nineteenth-century French caricature, and undoubtedly Philipon was referring to this tradition when he published Devéria and Traviès' caricatures, with the former "typifying" the quartier Chaussée-d'Antin, perhaps—open and inviting—and the other, the barrière d'Enfer—closed and repellent.

What is interesting about these prints is how they were meant to represent the "typical" qualities of the distinct Parisian *quartiers* and their respective cultures; how such representations were formalized and commercialized; and what they indicate about the political and cultural attitudes of Philipon and his public. This public was—as far as we can determine by the publisher's list of subscribers, the character of the prints' imagery, and the venue of their production and distribution within Paris—middle class and republican, comprising journalists, professional men, doctors and lawyers, shop keepers and *rentiers*: the established and politically liberal class, that is, that emerged in France with the Revolution of 1789 and consolidated its power through the Empire, only to be challenged during the Restoration by the restored Bourbon monarchy that reintroduced hereditary privileges.[9]

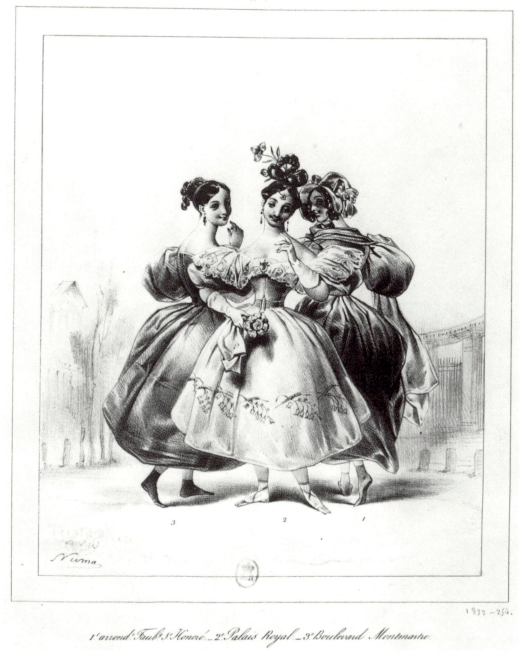

3. Pierre-Numa Bassaget, Plate 2 from *Les douze arrondissemens de Paris, statistique physique et immorale*, 1832, lithograph. Paris, Bibliothèque Nationale

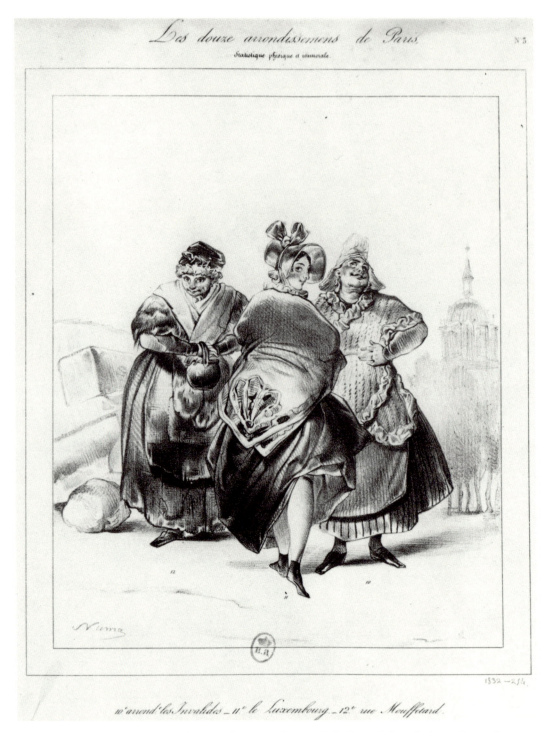

10.e arrond.t les Invalides _ 11.e le Luxembourg _ 12.e rue Mouffetard.

4. Pierre-Numa Bassaget, Plate 3 from *Les douze arrondissemens de Paris, statistique physique et immorale*, 1832, lithograph. Paris, Bibliothèque Nationale

In any case, the task of this essay is to interpret the ideological content of such "typical" caricatures published in Paris between 1825 and 1840, and to do so in light of the demographic crisis of Paris during that time, as it was perceived by Philipon's middle-class public. It is also to reflect on the meaning of violence in these images, violence most often against or between women. I will argue that these caricatures betray the anxieties of Philipon's public during a period of dramatic change in the population of Paris and its social structure.

To begin, we need to know that between December 1829 and September 1841, when Philipon moved his print shop north to the Place de la Bourse, the Maison Aubert occupied three storefronts within the Passage Véro-Dodat. The first, in which Philipon opened the shop on December 15, 1829, was at no. 31, in the center of the *passage* amidst various haberdashery, novelty, and confectionery shops. Ten months later, in September 1830, Philipon moved the shop to no. 12 at the east end of the *passage*, the windows of which were depicted in Traviès' caricature of December 1831, *Got to Admit the Government Has Quite a Funny Head* ("Faut avouer que l'gouvernement a une bien drôle de tête!"; fig. 5). There, the Maison Aubert was opposite the entrance to the Messageries Générales and its daily coaches bringing tourists, foreign and provincial, into the city in search of entertainment and accommodations near the Palais Royal. But again, nineteen months later, in March 1832, Philipon moved his shop, this time to no. 38, at the opposite end of the *passage* on the corner of the rue de Bouloi. Here—as depicted in an anonymous caricature published in 1832 with an affiche calling for subscriptions to *Le Charivari* (fig. 6) and also in an anonymous lithograph of the 1830s (fig. 7)—the Maison Aubert enjoyed a broad corner location, with windows running down the *passage* and along the street, looking out toward the Palais Royal, three minutes walk to the west.

It was from this final location, within the Palais Royal area, that the Maison Aubert shared in the general boom in trade taking place between the various *galeries* of the Palais Royal to the west, the *passages* and *grands boulevards* to the north, the Rue St.-Honoré to the south, and the Halle au Blé to the east, and from which it came to dominate the Parisian trade in popular prints. It was an area whose commercial culture was characterized by the presence within it of the Louvre, the Palais Royal, the Bibliothèque Royale, the Stock Exchange, numerous royal and popular theaters, as well as such public spectacles as the Panorama de Rome, the Néorama, and the Cosmorama. In addition, its restaurants and cafés were among the city's most fashionable and its commerce among the city's most luxurious: 68 percent of the city's tailors were there, 59 percent of its *marchands de mode*, 51 percent of its *parfumeurs*, 75 percent of its furriers, and, if one includes those just the other side of the *grands boulevards*, 63 percent of its banks.[10] It was, as one journalist described it in 1828, the area in which "everything imagined in art and culture, every luxury commodity, every refinement of taste and fashion could be had without leaving this area; elsewhere, everything is imitation, here everything is original."[11]

5. Charles-Joseph Traviès, *Got to Admit the Government Has Quite a Funny Head,* 1831, lithograph. Cambridge, M.A., Fogg Art Museum, Harvard University Art Museums

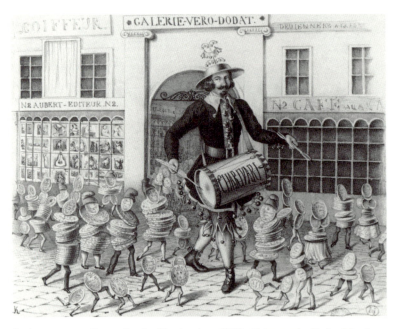

6. Anonymous, Poster for *Le Charivari,* c. 1832, lithograph. Paris, Musée Carnavalet

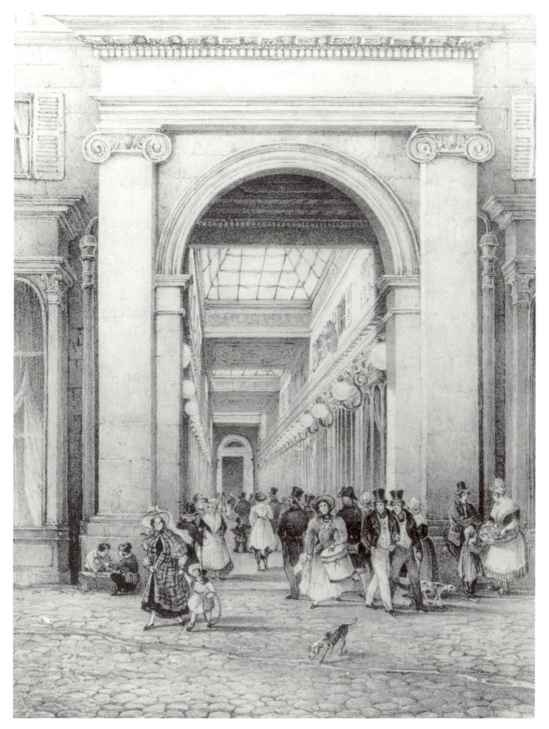

7. Anonymous, *Passage Véro-Dodat, Entrance, Rue du Bouloi*, c. 1828, lithograph. Paris, Musée Carnavalet

Architecturally, the area was marked by the Palais Royal on the one hand and the new Stock Exchange on the other. The Palais Royal was the result of a project begun in 1780 by Louis-Philippe's father to enclose the gardens of the original palace with a structure of shops and apartments. By 1786, three galleries were completed running the length of the garden's east, north, and west sides. Due to financial problems, only the foundation was laid for the southern gallery and a set of wooden barracks was improvised to complete the enclosure and create a continuous arcade of shops. It was the southern wooden gallery, the so-called Galerie de Bois, that gave the Palais Royal and neighboring streets their reputation in the early years of the nineteenth century.[12] This was a reputation based on the gallery's trade in books and journals; on its cafés and popular entertainments, such as rope dancing, pantomimes, an orchestra composed entirely of blind men, a physiognomic clown famous for his impersonation of a grinning savage beating a drum "like a madman," it was said; and above all, on its great numbers of prostitutes.[13] Contemporary descriptions of the Galerie de Bois, most famously that made by Balzac in his *Illusions perdues*, described the place as a kind of public "masked ball" in which prostitutes dressed as "birds of paradise" and sang their promises of pleasure from scented shadows.[14] In these accounts, as in Boilly's well-known painting of the Palais Royal galleries in 1809, prostitution was seen as an embellishment, adding character to the cold and indifferent stoniness of its galleries—a dash of color and *patois* amidst the bland anonymity of its endless colonnades.[15]

These descriptions were part of a growing discourse on the charm and intimacy of the city's center, the site of *le vieux Paris*. But these descriptions are only partly true. There is something obviously missing in their portraying the Palais Royal as picturesque and their giving the whores and grotesque performers a gloss of charm. What is missing are the statistics gathered by Parent-Duchâtelet in his study of Parisian prostitution published in 1836 and the fears of epidemic disease and destitution that prompted the study.[16] There it was determined that between 1812 and 1832 the number of registered prostitutes in Paris more than doubled, increasing from 15,523 to 42,699, and that between 1827 and 1832 alone, the number increased by about 40 percent. Further, it was figured that of the 148 *maisons de tolérance* in 1824, slightly more than half were located in the Palais Royal area, and of those prostitutes working out of *boutiques*, most were concentrated in the Palais Royal area, the majority in the Palais Royal itself. Indeed, Parent-Duchâtelet placed the Palais Royal at the center of the city's trade in prostitution and warned of the consequences of its dramatic increase: more and more young girls would be tempted to the streets by the promise of release from their mundane shop jobs, only to end up as vagrants or wards of the city's increasingly large and burdensome public health system.

WHEN LOUIS-PHILIPPE (then the duc d'Orléans) had the Galerie de Bois taken down, it was the first step in a campaign to clean up the Palais Royal area and to make the city's

center safer and more attractive for commercial speculation. An elegant arcade of stone decorated with mirrors and marble replaced the old wooden barracks and completed the enclosure of the gardens in stone galleries with continuous colonnades. In this respect, it was part and parcel of the commercial architectural style that was transforming the area, represented by the arcades of the Rue de Rivoli and the imposing new Stock Exchange on the widened Place de la Bourse. To many contemporary writers, this development promised destruction of the old and familiar Paris: the city of intimate and private spaces, "narrow, unhealthy, insufficient, but picturesque, varied, charming, full of memories," as a character in a play of 1866 recalled it. [17] It was a development intent on keeping the city's center from drifting to the rapidly developing bourgeois *quartiers* west and northwest of the Palais Royal.

It is here, then, in this cultural and social cross-over zone, where the picturesque Paris of the recent past and the more imposing and impersonal city of the projected future lived uncomfortably cheek by jowl, and where the classes still mingled in a certain confusion as the city was segregating itself into a bourgeois west/northwest and working class east/southeast, that Philipon founded his shop in 1829 and developed the commercial and political strategies that allowed him to dominate the city's trade in prints within just ten years. Crucial to his success was Philipon's trade in "typical" caricatures, such as those by Devéria, Traviès, and Numa already described.

Philipon knew well the tradition and appeal of "typical" caricatures. He had apprenticed in the Parisian print trade during the 1820s, when Carle Vernet's popular *Cris de Paris* was published. In this series of one hundred lithographs, Vernet depicted the picturesque charm of the *petits métiers*—women selling sausages, fruits, and flowers; men selling coffee, hats, and plaster figurines—each on a separate sheet that would later be bound into an album by the middle-class collector. Gathered together, the prints offered a nostalgic view of Parisian street life in the tradition of Edmé Bouchardon's famous series of the 1730s and 40s and provided a link between contemporary Paris and that of the *ancien régime*. They suggested that, however much life may have changed since the Revolution, the city was still charming, still a center of picturesque commerce, and still a place where the classes mingled peacefully. This may be a rather abrupt way of putting it, but in light of the general suspicion with which *les marchands ambulants* were regarded in the 1820s, there is really no other way to read these images. Their insistent tone of nostalgia—evident in the way they play up the simple character of the figures, their quaint dress and sympathetic expressions—is surely a response to the anxiety over the changing character that was surfacing in the later Restoration and contributed to the illusion that such change was insignificant. [18]

Much later, in 1887, Victor Fournel would return to this theme, lamenting the changes that had occurred in Paris since the turn of the century, and especially the loss of the traditional street cries: "Old Paris, from one end of its walls to the other, was nothing less than an ongoing symphony blending all the tonalities of the aggressive voices of the

street vendors."[19] *Le vieux Paris*, Fournel imagined, awoke each morning to the sweet, discordant sounds of street cries filtering through every section of the city equally, unifying Paris into a common theater of pageantry and spectacle. But this did not last, Fournel complained. Things began to change with the Revolution of 1789, when the streets were filled not with the pleasant songs of common street criers but with the loud and aggressive shrieks of political journalists calling for the overthrow of the government or announcing and describing the latest republican victory. As a result, Fournel continued, the streets had become politicized, and the criers were now either of the lowest order—the more respectable ones having left the streets for other forms of commerce and advertisement (i.e., fixed shops with advertisements taken out in newspapers or printed on posters)—or they were not really criers at all but criminals and revolutionaries posing as such. Rigorous regulations governed the movement of *les marchands ambulants* and the picturesque charm of *le vieux Paris* had given way to capitalist speculation, police surveillance, and bureaucratic control. Public squares and street crossings, once the province of "charlatans and quacks who sold their potions, teeth-pullers, and jugglers," were now "exclusively reserved for the army." And the city, once united by the picturesque charm of *les marchands ambulants*, was now divided against itself.[20]

Of course, Fournel's recollection of Old Paris and its innocent street life was—like earlier journalistic descriptions of prostitution in the Palais Royal—largely a fiction, an attempt to gloss over a complicated and threatening reality. Between 1801 and 1851, Paris was transformed into a complex and volatile urban society. Its population almost doubled, increasing from 546,846 to 1,053,261—an increase in fifty years more than three times that of the previous two centuries, due principally to extensive immigration from the provinces and abroad.[21] This latter fact was worrisome to the middle-class residents and merchants of the Palais Royal area in 1833. Of every one thousand residents of Paris, 677 were born outside the city. Indeed, throughout the July Monarchy, immigration accounted for a full 88 percent of the total increase in the population of Paris. Police reports spoke of the immigrant population as a kind of "nation within a nation," a culture distinct from that of middle-class Paris, and one grounded in the ethics of *les campagnonnages*, or rural worker associations, which often expressed their rivalries in bloody confrontations.[22]

Such violence, it was feared, would spread through Paris, driving the middle class toward the developing *quartiers* in the north and northwest, leaving the center to the emerging proletariat. Shop keepers in the Palais Royal area complained of the proliferation of unauthorized *bouquinistes* and fraudulent *colporteurs* in the city streets, and police surveillance increased in an attempt to control the movement of thieves and violent criminals posing as *marchands ambulants*. Numerous police ordinances were written that depended on the proper identification of social types—on the ability to distinguish, that is, between picturesque and dangerous street criers. Here is where "typical" carica-

tures played an important role, not directly, of course, but as part of this impulse to identify and distinguish between different "types."

Contemporary with Vernet's *Cris de Paris* was Boilly's *Recueil de Grimaces* (fig. 8), a series of ninety-two lithographic caricatures exaggerating the facial features and expressions of various "types." In *Smokers and Snuff-Takers* (Les Fumeurs et les Priseurs), for example, Boilly played on the responses of such "types" to the inhalation of smoke or snuff. The bewigged and drink-bearing aristocrat to the left holds a small cigar gently to his lips and cocks an eye in a look of confidence; the old *rentier* to his right draws his face up tight like a fist as he cleans out the bowl of his pipe, exhibiting a certain miserliness in his manner; the old working-class woman at the bottom contorts her face into a hideous squint as she sniffs snuff from the underside of her fat thumb; the young, determined artisan at the top puffs fiercely on his pipe, turning his face into a defiant scowl; the young, working-class woman in the upper left wrenches her animal-like face into a grotesque distortion as she sneezes from having taken snuff indelicately. In other words, each response epitomizes a certain "type," and each "type" is representative of a certain social class.

Boilly's caricature is meant to be read as both funny and revealing, telling us something about the nature of each class: the self-absorbed aristocracy, the miserly bourgeoisie, the defiant, crude, and even grotesque working class. Such descriptions were common in "typical" caricatures of the time and were grounded in the contemporary interest in the physiognomic theories of Johann Caspar Lavater and the phrenological theories of J.F. Gall, which stressed that a person's moral character could be read from certain external bodily signs, particularly the structure of the head and face.[23] The effect of such physiognomic and phrenological theories was the implication that the basis for determining—or at least transmitting—behavior was thought to be, most fundamentally, biological. Just as physiognomic traits persist from generation to generation, despite environmental conditions, so does behavior. This meant that certain "types" behaved and looked as they did naturally, and that one could identify certain behavioral "types" simply by the way they looked.

The vital link, then, between physiognomic caricatures, such as Boilly's, and the science of phrenology was that each valued the observation of biological traits. In each, assumptions were made about the character of a person by reading his face and the shape of his skull. I do not mean, of course, that Boilly's caricatures were read as a kind of source book for the identification of dangerous types, or that there was some specific functional relationship between the environment of physiognomic caricatures and the practice of phrenological inquiry. The two practices did share, however, a common impulse for reading character in faces, for associating behavior with appearance, and, most important, for relying on certain formulae for describing social types and typical behavior. And, in a larger sense, each was grounded in the demographic transformation of Paris, in the effect such transformation was feared to have on the possibility of

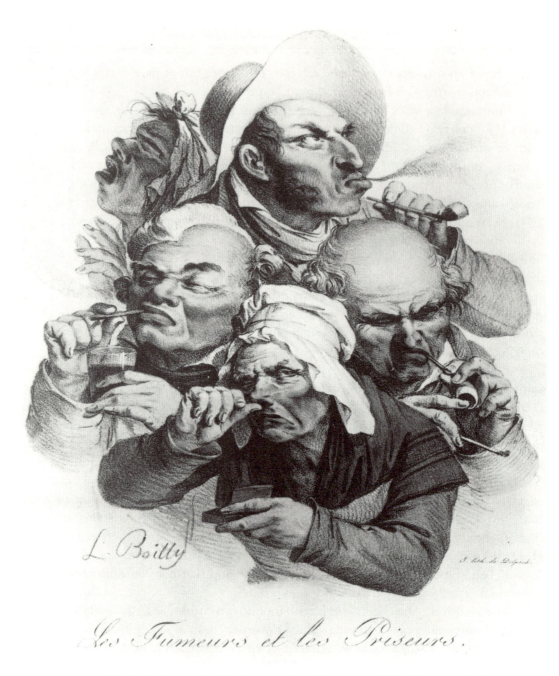

Les Fumeurs et les Priseurs.

8. Louis-Léopold Boilly, *Smokers and Snuff-takers* from *Recueil de grimaces*, 1823, lithograph. Paris, Bibliothèque Nationale

securing public identities within the shifting social and commercial ambience of the city's central *quartiers*.[24]

Philipon very much admired Boilly's work, and in the early years of the July Monarchy he published numerous physiognomic caricatures in series with such titles as *Galerie physiognomique* and *Types français*. The latter series was particularly important. Drawn by Daumier and Traviès, and comprising thirty-one lithographs published in *Le Charivari* between September 1835 and July 1836, it marked a radical departure from the more traditional "typical" caricatures by employing a new and more realistic mode of description, one that was more probing of posture, expression, and character, and more detailed and specific in the particulars of its subjects' dress and habitat. Traviès had employed this new descriptive mode in earlier images of 1832 and 1834. In the first (fig. 9), a *chiffonnier* (rag picker) is presented full-figure in extraordinary detail. The coarse textures of his worn shoes, patched trousers, torn shirt, and tattered vest and coat; the roughness of his soiled hands and unshaven face; the darkness of his features; the confrontational power of his stare: all are rendered palpable by the rich and varied markings of the lithographic crayon. In the second (fig. 10), entitled *Liard, Rag Picker Philosopher* (Liard, chiffonnier philosophe) and published by Philipon, Traviès depicts an actual *chiffonnier* at a *barrière* with walking stick in hand, sack over his shoulder, and dressed rather better than the earlier *chiffonnier*. His pants are not patched, his vest has buttons, and he wears a kind of *foulard*. But above all, he is given a distinct personality, an individual character, as he steps forward, his head tossed back, his cap to one side, a drunken smile on his face. After all, this is Liard, the *chiffonnier* who roamed about Paris entertaining the patrons of cafés and wine shops with his monologues in Greek and Latin. Indeed, he seems caught mid-sentence in one such monologue which he directs at us.[25] In other words, in contrast to the earlier, more generalized and picturesque images of *chiffonniers*, those of Traviès include a high degree of descriptive realism to give them real presence in our imagination. Why did Traviès employ a new descriptive mode here? Why did he insist on a more engaging and palpably real image of the *chiffonnier*? To answer these questions, at least in part, we need to know more about the *chiffonniers* and their place in the society of the July Monarchy.

IN HIS STUDY of *les classes dangereuses*, published in 1840 but researched four years earlier, the sociologist Frégier devoted a whole chapter to *les moeurs des chiffonniers*.[26] He described them as being among the poorest of the working classes, whose daily earnings amounted to no more than twenty-five to forty sous, for which they had to work every day in all seasons, making three rounds (two during the day and one at night) to look in discarded rubbish for anything they might be able to sell in the city's worst neighborhoods. There is nothing picturesque about Frégier's description of *chiffonniers*, and no attempt is made to sentimentalize their condition.

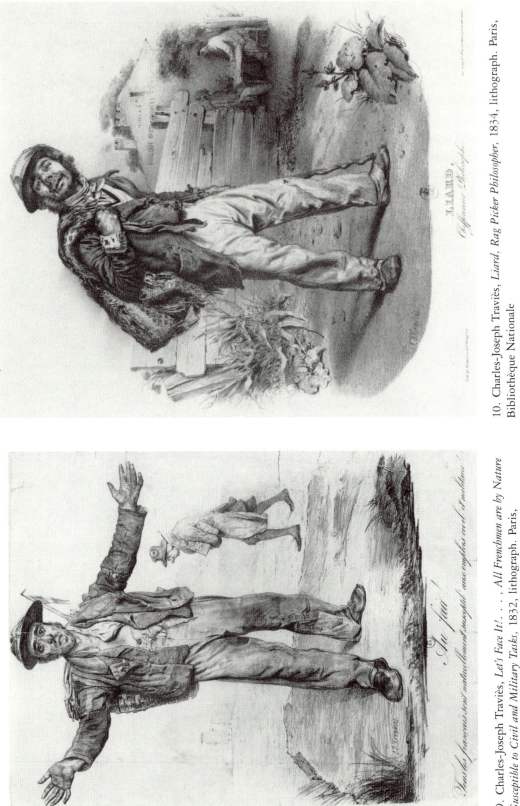

10. Charles-Joseph Traviès, *Liard, Rag Picker Philosopher*, 1834, lithograph. Paris, Bibliothèque Nationale

9. Charles-Joseph Traviès, *Let's Face It!...*, *All Frenchmen are by Nature Susceptible to Civil and Military Tasks*, 1832, lithograph. Paris, Bibliothèque Nationale

Among all categories of the poor, the rag pickers inhabit the foulest and most disgusting dwellings. . . . Those who are best off live in one or two small rooms which they rent for themselves and their families. The others have a straw mattress which serves them as a bed in the common room in which they sleep; but that article is often collectively rather than privately owned. Yet, even while shared, it is still envied by the poor devils who sleep in some kind of troughs, on rags or a few handfuls of the straw that covers the pavement. The policemen charged with the supervision of the dwellings and furnished rooms earmarked for the ragpickers paint an incredible picture of them. Each tenant closely guards his basket, sometimes filled with rubbish and what rubbish! Those savages don't flinch from including dead animals in their gatherings and passing the night next to their stinking prey.[27]

They lived on the margin, roaming the streets, gathering even the carcasses of dead animals, sleeping amidst the rotting, stinking harvest of their daily rounds. It was a life that easily called to mind an image of the savage, the uncivilized nomad, and Frégier referred to them as just that—"ces sauvages."

In the popular journalistic literature, however, *chiffonniers* were cast in a very different light. In La Bédollière's picturesque descriptions of *les industriels*, published in 1842 with illustrations by Henry Monnier, emphasis was not on the rag picker's savagery and his vile living conditions, but on his independence, his freedom from the daily worries of the more responsible and respectable working members of society.[28] If he lives a life on the margin, La Bédollière would have it, it is precisely because it preserves his freedom. "Subject to all possible privations, the rag picker is proud for he feels he is free." He represents not a violent threat to respectable society, but instead symbolizes that state of nature to which in our modern fantasies we all aspire: the savage, perhaps, but the noble savage. In this respect, his impoverished condition is not tragic, nor even particularly unfortunate; it is the hair shirt he wears, the sign of Diogenes, *le chiffonnier philosophe*.

This shift in the public perception of *chiffonniers* is significant. It suggests an attempt on the part of middle-class culture to appropriate the rag picker for its own purposes, in effect, to disarm him of his savagery and adopt him as an image of *le vieux Paris* in the midst of the modern one. Like the prostitutes in the literary accounts cited above, and like *les marchands ambulants* in the prints of Vernet, *les chiffonniers* often represented the charm of the past in the harsh reality of the present. Their appearance in popular prints was a rephrasing of the disgusting and dangerous circumstances in which the actual rag picker worked. Such images presented him as a harmless ornament to the city streets, distinct from but not threatening to the middle-class public and its view of the city. We see this in Traviès' *Liard, chiffonnier philosophe* as it emphasized the jolly and engaging nature of a particular rag picker, a popular figure known to the print's public if

only by reputation, and as it renders him appealing even to us: the tilt of the head, the drunken smile, the worn but inoffensive (one wants to call them "informal") clothes. Traviès' *Liard* is more convincingly charming, more insistently appealing precisely because he is more than picturesque. Whatever threat he may have represented to his public is removed by his believability, by the sense that we, too, can share in his wit, his humor, his perhaps slightly abrasive good nature.

What then of Traviès' earlier *chiffonnier*? I would argue that the confrontational character of this image, its total lack of sentimentality, its insistence on the coarseness of life lived on the margins of civilized society, all represent a variation on the charming view of the rag picker, a variation that sought not to include him in middle-class culture but to exclude him from it, not to bring him into the central *quartiers* but to banish him to the barren and violent landscape of *les barrières*. In other words, the threat of savagery represented by the *chiffonnier* was here dealt with not by defusing it through sheer charm, but by rendering it compelling and palpable: it forced the distinction between civilized and uncivilized, middle- and working-class cultures. We have already seen that *chiffonniers* were often described in official reports on working-class types during the 1830s as "savages." Indeed, comparisons between the poor and the savage in studies such as Eugène Buret's *La Misère des classes laborieuses en France et en Angleterre* of 1840 reveal a general confusion between the working and dangerous classes, and between poverty and crime, a confusion most often described in racial terms: "ces sauvages," "le nègre de la Côte d'Afrique," and "les races indigènes de l'Amérique du Nord."[29]

In Traviès' caricatures these racial terms had their equivalent in the bestial physiognomies that he gave to working-class "types." For example, in *When Mr. Bernard Drinks He Doesn't Like to Be Disturbed* ("Quand Mr. Bernard boit il n'aime pas qu'on l'embête"; fig. 11), a coarse and gnarled, brutish worker is depicted at a *barrière* wine shop kicking a woman, while a bemused man, arms crossed, looks on. The worker's dark, almost canine features reinforce the character of his behavior, which, as the captions tells us, becomes beast-like when he drinks. And in *Antigone of the Faubourg St. Marceau*, from the series *Aspects d'un Md. de vins hors les barrières* of 1830 (fig. 12), an old *chiffonnière* of porcine features carries her besotted mate in a basket on her back while behind her a man urinates on another figure who is passed out from drink and lies next to a fence. Emphasizing this kind of physiognomic relation between animals and human beings brings to mind Lebrun's great treatise on the subject, in which a person's moral quality was comparable to the "character" of the animal he resembled physically. It was a treatise that had currency in Paris around 1830 and for which Philipon himself executed lithographic illustrations. Caricatures like these simply exploited the implications of Lebrun's treatise in order to strengthen their metaphorical disfigurations of workers' physiognomies. In other caricatures (figs. 13–14), such as Traviès' *Barrière du Combat*, from the series *Barrières de Paris* published by Philipon in 1839, or Pigal's earlier *You Dog / You Pig* ("Ah! Chien" / "Ah! Gueuse") from the series *Scènes populaires* published in

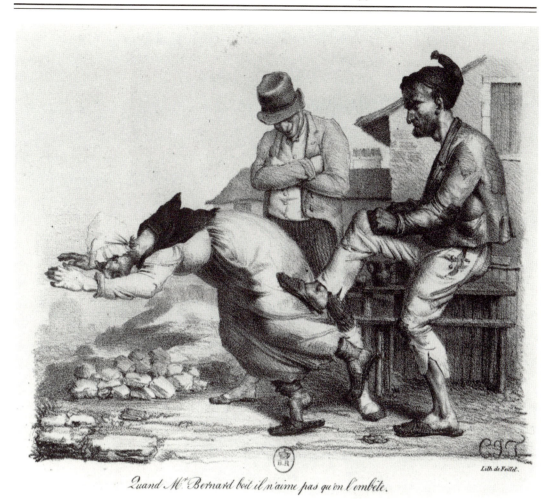

Quand M.ʳ Bernard boit il n'aime pas qu'on l'embête.

11. Charles-Joseph Traviès, *When Mr. Bernard Drinks He Doesn't Like to Be Disturbed*, c. 1830, lithograph. Paris, Bibliothèque Nationale

1825, the identification of worker with beast was made explicit. In the first, the two workers resemble their fighting dogs (particularly the one on the right, who scowls and growls and is short and stocky like his spotted mastiff), and in the second, in which women scratch and pull each other's hair as they shout animal epithets at each other— "You dog!" / "You pig!"

There is nothing charming about these images, no sympathy in their rendering of working-class "types" as coarse, crude figures given to bestial behavior. On the contrary, there is a kind of positive delight in the grotesque, in the exaggeration of the traits— behavioral and physiognomic—of a particular social class: a delight that played to the suggestion that the conditions of poverty and the moral character of the poor were not

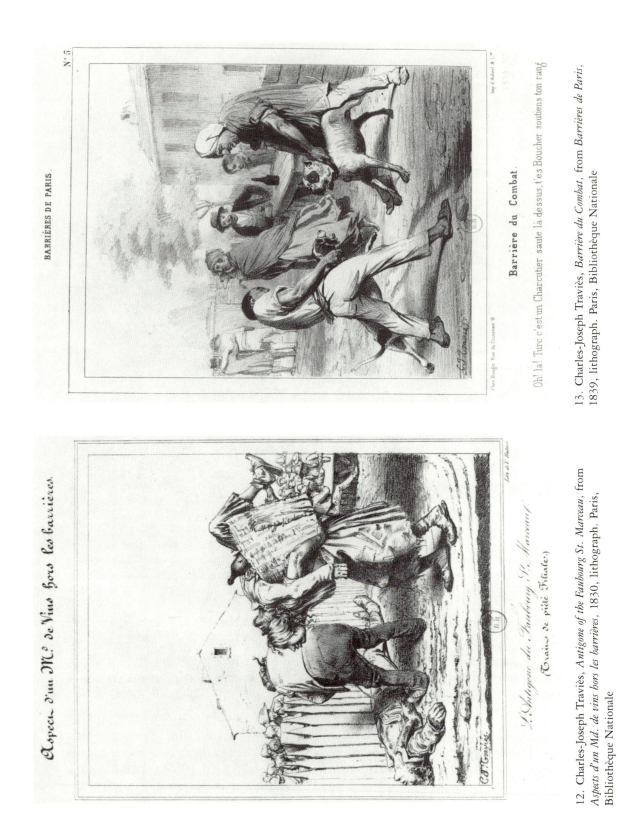

12. Charles-Joseph Traviès, *Antigone of the Faubourg St. Marceau*, from *Aspects d'un Md. de vins hors les barrières*, 1830, lithograph. Paris, Bibliothèque Nationale

13. Charles-Joseph Traviès, *Barrière du Combat*, from *Barrières de Paris*, 1839, lithograph. Paris, Bibliothèque Nationale

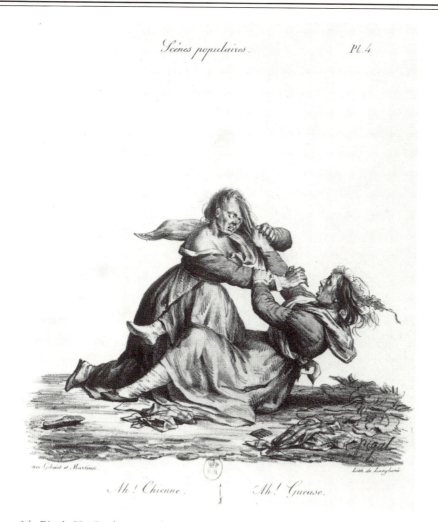

Scènes populaires. *Pl. 4*

Ah! Chienne. *Ah! Gueuse.*

14. Pigal, *You Dog/ You Pig,* from *Scènes populaires,* 1825, lithograph. Paris, Bibliothèque Nationale

socially but biologically determined, and that since the poor could not therefore be easily rehabilitated (domesticated might be a better metaphor), they should be excluded, banished altogether from the daily life of the city's center.[30] This, then, is an answer to the question posed earlier. Traviès employed a new, more realistic mode of description in his caricatures of working-class "types" because it made the threat of the savage more real, more convincing to his and Philipon's public, and it justified their anxieties about losing the heart of the city that had been theirs since the turn of the century, won over by their commercial speculation, to this new, nomadic "nation within a nation."

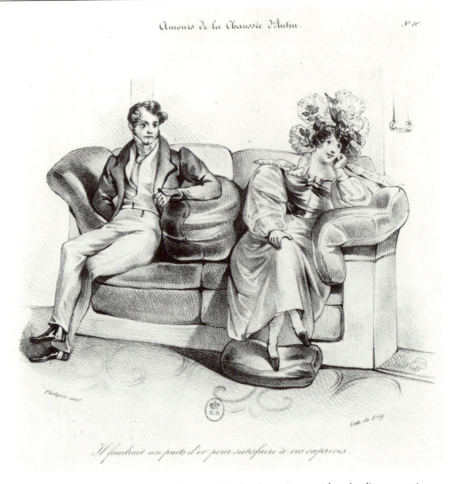

15. Charles Philipon, *Love on the Chaussée d'Antin,* from *Amours (dans les divers quartiers de Paris),* 1829, lithograph. Paris, Bibliothèque Nationale

This brings me back to the images with which I began this essay: Devéria's *That which is the Most Beautiful on Earth* and Traviès' *That Which is the Ugliest in the Universe.* In describing them I suggested that the different styles in which they were drawn were intended to have us feel intimate with Devéria's subject and distant from that of Traviès, as if we belonged to the first and not the second. I also suggested that they referred to the tradition in caricature—evident in Numa's *Les douze arrondissemens de Paris*—of representing the "typical" character of contrasting geographic districts within Paris. I want now to suggest that Philipon's strategy of locating social distinctions in geographical terms was presented as an image of the peaceful coexistence of the classes in Paris, a coexistence dependent upon their mutual isolation. In other words, I am arguing that "typical" caricatures had the effect of giving an image of a clear and coherent structure to

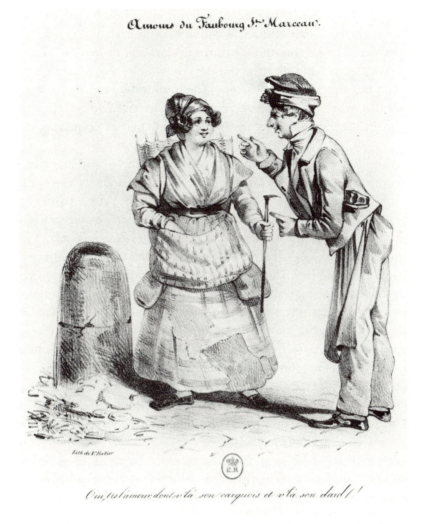

16. Charles Philipon, *Love on the Faubourg St. Marceau,* from *Amours (dans les divers quartiers de Paris),* 1829, lithograph. Paris, Bibliothèque Nationale

class relations in Paris at a time when such relations were unstructured and incoherent, and when such incoherence was particularly threatening to Philipon's middle-class public and its connection with the central *quartiers.*

This is evident from two caricatures of Philipon's own design: *Love on the Chaussée d'Antin* (Amours de la Chaussée d'Antin) and *Love on the Faubourg St. Marceau* (Amours du Faubourg St. Marceau), from his series *Amours (dans les divers quartiers de Paris)* of 1829 (figs. 15, 16). Here the contrast is between a western *quartier* and an eastern one, and between the *haute bourgeoisie* and *la classe laborieuse* (specifically a *chiffonnière* and a cobbler). In the first image, a young gentleman is frustrated by the capricious character

of the young lady as they sit in an elegant interior on opposite ends of a couch with a cushion between them. In the second, a cobbler confronts a young *chiffonnière* on the street and fumbles his way through a bizarre declaration of love—"Yes, you're a cupidon, here is your quiver and there is your dart"—which she, in her simple way, seems to find a bit odd but touching nonetheless. The humor between these two prints relies on stereotypes that work when a certain cultural coherence and isolation is presumed, when each remains unthreatened by the other, when there is no mixing or diluting of stereotypes.

To put it another way, the joke in "typical" caricatures—whether they stand alone or refer to a comparable image within the same or in a related series—works precisely because it is a joke on someone else, on one's social "other." And it works because it is rooted in one's perception of and attitudes about that "other"; a perception and attitude informed by what he—or more often she—represents to one's self, to one's social identity, formed by one's sense of belonging to a particular class and culture. In "typical" caricatures, such as those I have shown here, the social "other" of Philipon's middle-class public was described as being either picturesque or savage. If picturesque, he would be unarmed, non-threatening, even clownish perhaps. If savage, as in Traviès' or Pigal's images of life at the *barrières*, he would be depicted as violent and grotesque, at play within his own dark and mysterious *quartier* at a safe distance from the middle class in the Palais Royal area. The threat to middle-class hegemony over the city's center, represented by the ever-increasing number of working poor moving through the area, required this recasting of reality, a polarized depiction of the truth. It diverted the viewer's attention, if only for a moment, from the confused tensions that comprised the reality of class relations in Paris at the time.

Philipon and his public negotiated their place in these class relations from a position, as it were, within "two worlds": on the one hand, the world of entrepreneurship and republicanism promised first by the Revolution of 1789 and then again by the Revolution of 1830, and on the other hand, by the world of increasing political authority in the hands of the compromised monarch Louis-Philippe. The former offered the freedom to practice and develop one's business as one liked and as the market would bear, while the latter put constraints on one's business in the form of increasing censorship, police control, and economic distress. The two worlds required savvy businessmen to seek multiple alliances. In Philipon's case, this meant alliances with the working class when it was necessary to create a united front against the actions of the king (as when Paris was put under martial law in 1832) and then alliances with his own middle class, when his and its businesses were thought to be threatened by bands of roving and often violent workers moving in the center of the city.

And the latter were occurring with increasing regularity during the early years of the July Monarchy. A police report of August 22, 1830, described an event that took place near the Palais Royal on a warm summer night.

A mob of about six hundred young people carrying torches and for the most part armed with sabers marched through several neighborhoods; after passing through the Passage des Panoramas and the Passages Vivienne and Colbert, they moved in the direction of the Palais Royal and ended up in the Galerie Colbert, where they stopped to sing patriotic songs. They did not disperse until half past eleven in the Rue Lenoir, after having been asked to do so by a station commander of the National Guard.[31]

But it was not only this kind of violence that worried the middle class in the center of the city, not just "political" violence, as it were, with mobs focusing their discontent on certain areas or shops that were seen to represent the succesful bourgeois character of the monarchy, the "haves" and those catering to them. It was wanton violence: violence that occurred "naturally" among the working classes, violence they wrought upon each other in the Faubourg St. Antoine and the *barrière* wine shops, violence that was akin to the rural *campagnonnages*: the *savate*, which Gautier described in 1846 as

a kind of vulgar combat in which only the "pale street loafer with puny body and old-penny-yellow complexion" would engage. Indeed, one did not see anything but awful bandits in workman's blouses full of holes, in torn caps and down-at-heel shoes, who made mysterious and sinister hand gestures that frightened the peaceful citizen, and moved their feet in a way that caused the surprised patrol to sit down in the middle of the gutter.[32]

This was the violence of "savages," of a "nation within a nation," more and more often playing itself out on the streets and in the *passages* of the middle-class city center. And this is the context within which "typical" caricatures took on meaning during the July Monarchy.

I have tried in this essay to articulate the ideological character of those images published by Philipon, to describe how they gave form to certain attitudes of their middle-class public in the context of the dramatic demographic transformation of Paris. In short, I have tried to account for the provocative description of Daumier and Traviès published in *Le Rivarol de 1842*:

Daumier and Traviès are two caricaturists who have had much fun drawing the poor human nature of Paris their way. Old portières, drunks, rag pickers and that whole race whose prerogative to see humor not only in all ridiculous beings but also in all ugliness and social misery entitles it to be illustrated in the windows of Aubert and Martinet.[33]

It is a description that, I believe, gets closer to the meaning of the typical caricatures drawn by Daumier and Traviès than the descriptions one often reads in art historical literature. In the latter, Philipon and his artists are generally described as

being sympathetic to the working class—"democratic" or "republican" are the terms most often applied, always without further qualification—and their depictions of working-class "types" are interpreted as commentaries on the conditions under which those "types" lived, for the purpose of improving their lot.

I have argued to the contrary: Philipon's typical caricatures served not to erase differences between the social classes, but to reinforce them in an effort to confirm an ideological position of entitlement on behalf of the middle class. They offered simple solutions to very complex problems. It is in the nature of satire to do so.

The Image that Speaks: The Significance of M. Mayeux in the Art and Literature of the July Monarchy

ELIZABETH K. MENON

M. MAYEUX (fig. 17), an ugly, deformed dwarf suggestive of the Hunchback of Notre Dame,[1] was one of a trio of emblematic figures "invented" during the reign of Louis-Philippe. In addition to Mayeux, they included Robert Macaire and Joseph Prudhomme. Articles and stories that described Mayeux appeared in the pages of Charles Philipon's famous *La Silhouette* while Charles X was still in power, and were published side by side with Honoré Balzac's "Physiologies."[2] The identification of these three satirical figures as the primary caricatures created during the July Monarchy was made by Champfleury in his *Histoire de la caricature moderne* (1865), in which he established the July Monarchy as one of the key periods in the advancement of caricature per se.[3] Study of the caricatures of this period has led some scholars to draw parallels with the science of phrenology; others, such as Chevalier and Cuno have suggested that they functioned as responses to tensions between different, often opposing classes of society.[4]

Mayeux, Robert Macaire, and Joseph Prudhomme are special cases of the new status of caricature, however, for they were each fictional yet named actual representatives of different aspects of society. (This is in contrast to the "anonymous" figures produced in the written "physiologies" of Balzac and the representations of bankers, lawyers, and people of diverse professions that became staples in Philipon's third publication, *Le Charivari*.) Mayeux, Robert Macaire, and Joseph Prudhomme became very popular characters during the July Monarchy, as they were all related, in some

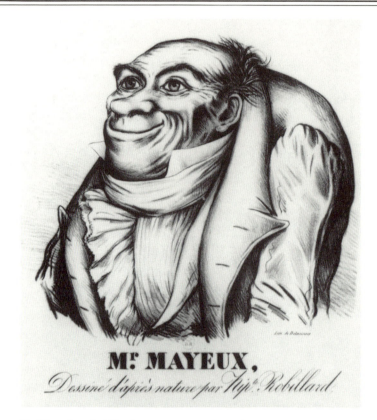

17. Hippolyte Robillard, *Mr. Mayeux*, 1831, lithograph. Paris, Bibliothèque Nationale

way, to the reign of the "Citizen King." Indeed, Mayeux has proven to be a multi-dimensional character—an intentionally ambiguous individual who operates on several levels of interpretation simultaneously. Robert Macaire began as and remained a "swindler" and the personification of Guizot's famous phrase "enrichissez-vous."[5] Henri Monnier's Prudhomme, meanwhile, was the ultimate fat, boring member of the middle classes—and the prints that depict him emphasize that he is trapped in this one-dimensional existence. Mayeux, the earliest of these caricatures to appear, cannot be pigeonholed so easily. He exhibits good and bad qualities; he changes his political orientation and his social attitudes seemingly at will. For this very reason, he was a better representative of the ambiguity inherent at the beginning of the July Monarchy.[6]

While Macaire, Prudhomme, and Mayeux each found a role in popular theatre, thus becoming living, breathing personas, Mayeux is a frequent character in popular literature as well.[7] A number of documents were written by different authors who used the pseudonym of Mayeux. The account of his life history (probably written by Phil-

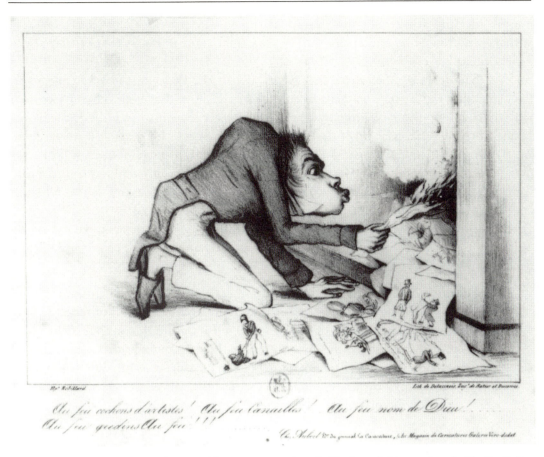

18. Hippolyte Robillard, *Into the Fire Filthy Artists! . . . Into the Fire Scoundrels! . . . Into the Fire for God's Sake! . . . Into the Fire Rascals Into the Fire!!!.* Paris, Bibliothèque Nationale

ipon) begins with an interview of sorts between Mayeux and the author who transcribes the dwarf's biography: "Laugh, laugh to your heart's content Mr. Author, you will not be the first who has pursued me with an insolent sneer, since the day when two or three boorish artists made me the laughing-stock of the public."[8] Consistent with this quote, in the artistic representations of Mayeux, the dwarf eventually became deeply critical of the very artists that drew him—he burns images of himself (fig. 18), with a caption that reads: "Into the fire filthy Artists! Into the Fire Scoundrels! . . . Into the Fire for God's Sake. . . . Into the Fire Rascals Into the Fire!" Like so many of the images and the texts, the caption contains a double entendre—for "feu" means fire, but placed before a noun such as *cochons*, *canailles* and *gredins* (which all mean rascal or scoundrel) it means "late" as in deceased. This suggests that the image can also be interpreted as a comment upon censorship of the printed word and artistic image—a censorship that was for all practical

purposes killing the artists and literati of the July Monarchy (another reason why authors used the name of Mayeux, rather than their own, in books that criticized the government).

In many prints, Mayeux as the "petit bossu" (the little hunchback) engages in dialogues with the artists who malign him. One work shows Mayeux attacking two men who are hawking prints—prints that happen to depict Mayeux.[9] In some of the works Mayeux becomes the artist. In *Mayeux peintre classique*, he tells his model that he received his training at *l'école de la bosse*.[10] These obvious attempts to give Mayeux a life of his own—often with humorous overtones—made him more than just another caricature from one of Philipon's journals. By doing this, artists were able to create a "real" critic of the July Monarchy, one who could, despite strict censorship laws, be brutally honest. Furthermore, it is possible that Mayeux was developed as a "hero" or a popular champion of the "majority" of society.[11] This was suggested in an article that appeared in *Le Figaro* entitled "M. Mayeux":

> Who is this man? Is he the living satire of our century? What is the meaning of this heavy rifle carried by a dwarf, this exaggerated soul in this frail body? Why such vigorous passion only to end up with a grotesque figure? What does Mahieux represent? the Assembly, the July Monarchy, the whole of France perhaps. . . . Mahieux is a type, Mahieux is you, he is me. He is all of us with our young hearts and our aging civilization, our perpetual contrasts; victors without victories, fireside heroes.[12]

MAYEUX AS AGENT PROVOCATEUR

Sometimes the issue of a free press raised by Mayeux within lithographs was intertwined with other types of "royal" criticism. In one print, for instance, Mayeux tries to impress two women by professing freedom of the press, as suggested by the caption of the image (fig. 19). When compared with other prints, particularly with those that function as humorous restatements of rococo paintings by Boucher and Fragonard, Mayeux was often able to satirize royalty by criticizing the visual style that kings had created—the rococo festivals that entranced kings so that they paid little attention to the real issues—the people. There are a great many prints that deal with personal relationships and feature Mayeux courting, flirting, or looking up dresses.[13] Some scholars have chosen to interpret this as Mayeux exerting his political power to control women. In the context of the burgeoning women's rights movement (which had started with womens' support of the revolution of 1793, but had been stifled by restrictions of freedom imposed by the Jacobins), these prints can be read as a criticism of the treatment of women—with Mayeux assuming the place of the wrongdoers. "Despite the role of women in electing

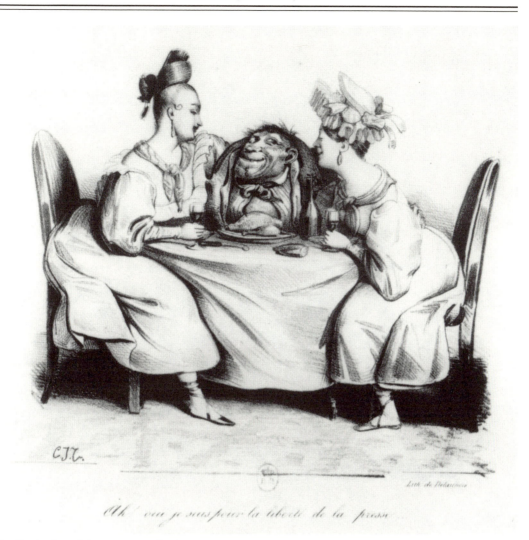

19. Charles-Joseph Traviès, *I am for the Freedom of the Press*, 1831, lithograph. Paris, Bibliothèque Nationale

the representatives of 1789, despite the preoccupation of intellectuals with natural rights and despite the proclamation of liberty and equality, each successive revolutionary government denied political rights to women."[14] Curiously, it was acceptable for the "hero" to demonstrate these wrongs, for a person of his deformity could never really be seen as a seducer of women—hence Mayeux acted as an agent to right wrongs. The emphasis is on humor in a print where the woman affectionately calls Mayeux "her little hunchback." While in another image, where along with shapes of bedclothes and pillows the dwarf becomes part of a grouping that resembles male genitals, the woman calls him "little Hercules" (fig. 20).

– *41* –

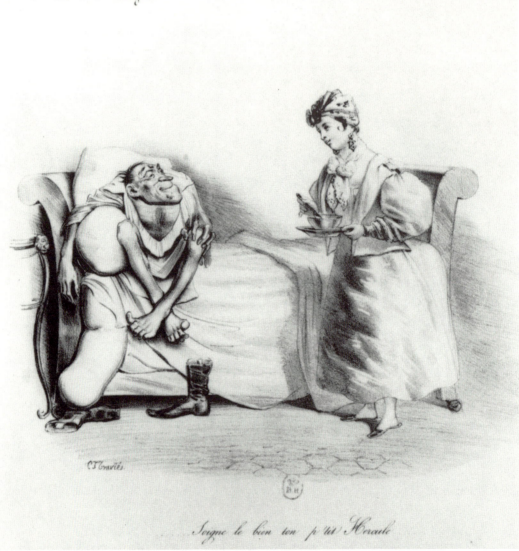

20. Charles-Joseph Traviès, *Witticisms of Mr. Mayeux,* no. 15, *Take Good Care of Your Little Hercules.* . . . 1831, lithograph. Paris, Bibliothèque Nationale

As often as Mayeux succeeds with the opposite sex, he is made the fool by the women he pursues. He is willing to go to some lengths to impress a woman; in one print he wades in ankle deep water, pulling a woman on a rolling platform to aid her across the street without getting her feet wet.[15] In at least two prints, women have the upper hand, as they torture Mayeux by pushing him—a bit too high for comfort—on a swing or tickle him with a large broom.[16] Mayeux was married and had a family during this

philandering. In one work the dwarf is caught with two women by the missus, who says "So this is how you spend your time!"[17] Ironically, it turns out, Mrs. Mayeux checks up on Mr., to make sure that he is serving the needs of the citizens. In another print the caption reads "Yes Mrs. Mayeux, I have obtained the right to vote for my citizens."[18] One very important print goes a bit further in the case of acknowledging the role of women during the revolution—here Mayeux refers to a woman serving on the barricades—even though the caption discusses her rear end.[19]

Other images of Mayeux place him in various professions. Depiction of the professions in caricatures dates to the Middle Ages and found an enthusiastic revival during the period of the July Monarchy.[20] Mayeux was part of this revival as he assumed the roles of hairdresser, bartender, shoemaker, teacher, and shopkeeper.[21] An important set of works uses the literary technique of acute visual metaphor to comment upon another kind of censorship under Louis-Philippe—the censorship of pornography. When Mayeux assumes the profession of butcher, and sells a young lady a sausage with a caption implying "Is it big enough for you?" the double meaning becomes clear (fig. 21). In a related work, Mayeux now buys the sausage because Mrs. Mayeux doesn't think his andouille is large enough.[22] If these prints are not quite graphic enough to make the point, there are a group of illustrations from a book written in 1832 called *The Secret Loves of M. Mayeux*, part of the ENFER collection of the Bibliothèque Nationale that do. This book, which intertwines Mayeux's political history with his sexual awakening, is illustrated with more realistic depictions of the dwarf. It was printed and distributed in Brussels where censorship laws were not as strict.[23] A second book, also of the ENFER collection, utilized known prints and captions by Traviès, Daumier, and others and altered them to make them pornographic illustrations for the *Douze journées érotiques de M. Mayeux* (1831). Undoubtedly, this gave another dimension to the ways in which printmakers were regarded at the time.

The Mayeux prints and literature discussed thus far have a common feature. They use Mayeux as a tool and emblem to provoke awareness of political and social issues and to poke fun. Because the figure of Mayeux was repeated visually in serial form and appeared in both periodicals and novels, he appealed to a wide audience who could follow his thoughts and adventures on an ongoing basis. Mayeux, as a hunchback dwarf, was an unlikely "hero," but he was uniquely qualified to address the critical issues of the July Monarchy—from the government policies on censorship of the press to the intimate relations between the sexes.

MAYEUX'S CHARACTER

Compared to Daumier's Robert Macaire and Monnier's Prudhomme, relatively little has been said by art historians about the figure of Mayeux. Recent scholarship has mentioned Mayeux briefly as part of the larger collection of caricatures of the July Monarchy.

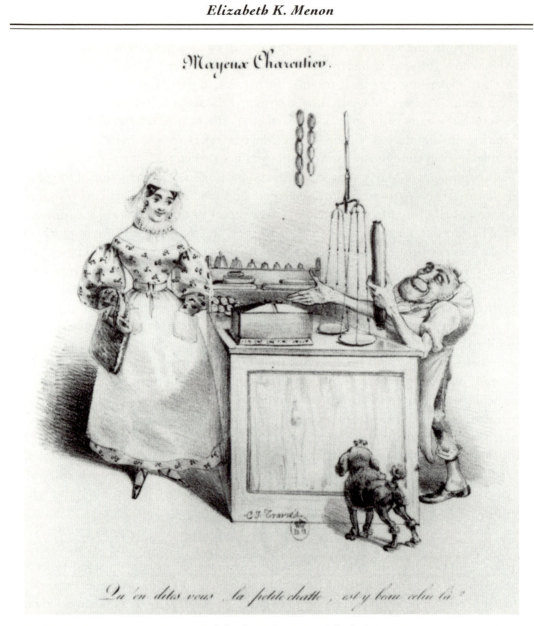

21. Charles-Joseph Traviès, *Mayeux Pork-butcher, What Do You Think of It My Little Pussy-Cat, Is This One Not Handsome?*, 1831, lithograph. Paris, Bibliothèque Nationale

In these studies Mayeux has been shown negatively. The outward appearance of Mayeux, his deformation, has led to the interpretation of him as the ultimate typification of the July Monarchy—a "monster" created by the people. Wechsler, for instance, claims that Philipon intended Mayeux as a "personification [of] a whole ominous aspect of the 1830 Revolution: the figure of a small self-seeker who had chosen the revolutionary side and

who, as a member of the National Guard, was in a position to exercise petty tyranny and exploitation, not least over women."[24] Mayeux , however, was less a self-seeker than a watchdog, if you will. In reality this deformed creature would not be in a position to exploit anyone—and this results in the humorous recognition of real problems. The people during the time seemed to understand that Mayeux was not a tyrant, not even in the petty sense. He was a hero—he identified problems, such as the treatment of women or the machinations of the National Guard—and called these issues to the public's attention.

Weisberg, on the other hand, identifies Mayeux as a figure "ridiculed in the July Monarchy . . . more odious and sinister than even Robert Macaire . . . Mayeux developed into a fantastic conception that surpassed the perverse realm of reality associated with the July Monarchy."[25] This interpretation does not seem as incorrect as it actually is (in lieu of supporting documents the images could be interpreted in this way)—but Mayeux actually predates the July Monarchy and again, the deformed dwarf was considered a hero of the people.[26]

During the years 1831–1833 Mayeux became a veritable emblem in Parisian society and culture. One print of Mayeux, by Charles Philipon, has a mirror insert that replaces the face.[27] Weisberg interprets this work as "embody[ing] Parisian fascination with itself"[28] but he has read this work apart from its original context. This print is one of a six-part series of figures with mirrors for faces, including a little girl and an Alsatian. This suggests that the viewer was meant to "try" on these different roles or types.[29] Another interpretation, supported by an extensive use of the literature of the period, is that the mirror reveals that Mayeux is someone else—the "everyman"—much like John Bull of England, in whom each citizen saw himself. Thus, this image suggests camaraderie, union in the cause of justice for France's entire population. An image showing Mayeux and John Bull engaged in a boxing match was made during the July Monarchy (fig. 22). The two individuals are seen about to come to blows over who can be the true "everyman."

But why choose the figure of a deformed dwarf as the representation of "everyman"? Why not a figure strong and imposing like England's John Bull? A note in the *Gazette de Paris* (1859) posits Mayeux "in the tradition of Thersites and Aesop, malformed outsiders and mockers of society."[30] This is interpreted by Wechsler to mean that Mayeux, "without social ties or responsibility, is in a position of arbitrary (though petty) social power."[31] But the *Gazette's* statement can be interpreted in another way. Perhaps the fact that Mayeux was an outsider gave him freedom from society's rules regarding public criticism—i.e., censorship. The figure of the dwarf allowed the public some self-criticism and political criticism, with the "distance" afforded to an outcast. Dwarfs and hunchbacks were extremely popular during the decades preceding the July Monarchy. Two series of illustrations depicting hunchbacks in various professions dated c. 1820 are kept at the Musée Carnavalet. In addition, a text titled *Bossuaniana* was published in

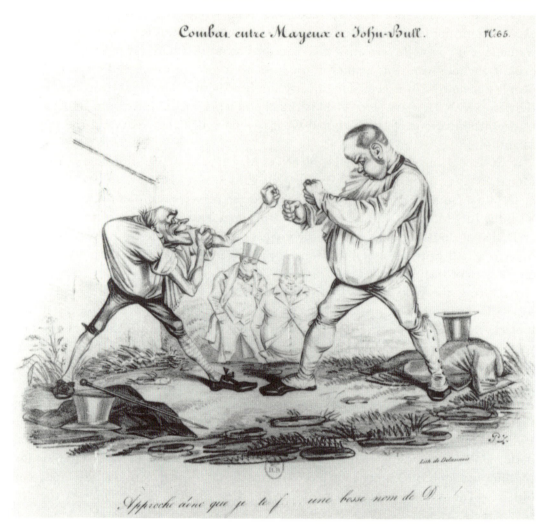

22. Anonymous, *Battle between Mayeux and John Bull, Come Closer, for God's Sake, so I Can Give You a Good Lick!,* 1831. Paris, Bibliothèque Nationale

1817, which in no less than 120 pages expounded the many virtues of hunchbacks. Philipon's *La Caricature* chose a dwarf as the personification of "Caricature" which appeared in illustrations that showed the agitations between the journal and the government.[32]

Why this particular dwarf was chosen as the "everyman" figure is a complicated question to answer. There is not one single documented explanation for the development and use of "Mayeux" during the July Monarchy. Many authors ranging from Baudelaire to the Goncourts have claimed to know his true origin, but each of these "stories" is different—partially due to the fact that at the height of Mayeux's popularity many artists and literati joined the bandwagon and developed new stories and images

with Mayeux as the central focus. Mayeux's origin is not found in one person or one source as is Robert Macaire or Joseph Prudhomme. Rather, Mayeux is unique in that he "evolved" from a conglomeration of sources. A hypothesis can be formed by examining Mayeux's origin which involves, first, a prototypical "Mayeux" caricature and, second, an actual figure by the name of "Mayeux," and, third, the prevalence during this century of the sciences of physiology, physiognomy, and phrenology. Finally, the tradition of street theatre, which included Polichinelle and different types of clowns as sources, also had an impact on the creation of Mayeux. We will examine each of these in turn.

MAYEUX'S SOURCES

Mayeux evolved from several sources—some of which are better known than others. First, Jean-Baptiste Isabey, a Romantic artist, in 1814 drew a figure that could serve as a source for the later works of Traviès.[33] This drawing bore no caption and the figure was not named, although they are early proof of the existence of a Mayeux-like figure. Isabey was best known for his portraits of another figure short in stature—Napoleon. We have no proof that Isabey had Napoleon in mind when he drew the figure that we now recognize as Mayeux—but the caricature was completed (in 1814) when Napoleon had fallen from favor as his campaign defeats became public. At the time of the revival of the memory of Napoleon (when things got very bad under Louis-Philippe), Isabey once again returned to works that glorified the emperor's memory.[34]

A second avenue to explore in the search for the origin of the character Mayeux is the possibility that there was a real person by this name who served to inspire artists. Concurrent with Isabey's creation of this image, there existed a Frank Mayeux who was speaking out for the rights of man. "Man of letters, ex-provisional Mayor, he was delegated during the invasion to put a stop to the ravages committed by the Allies in a Commune of the Department of the Seine." Frank J. Mayeux addressed the emperor himself in a speech that claimed that Napoleon's policies could not be reconciled with the independence and happiness of the people.[35] This Mayeux suggested that Napoleon's despotism was contrary to the emperor's early promises of liberty for France's citizens and specifically attacked censorship of the press.

> Yes, I repeat, you refuse the nation representatives who are worthy of her. If feudalism is reestablished, concealed under false appearances, if the hatred of the French name is revived everywhere in Europe by new foreign wars, if commerce is sacrificed to the bloody glory of conquests, if freedom of the press is violated by persecutions, you will end up with slaves and not with men of active sympathies on whom you can count. You will end up with slaves who will abandon you in adversity a second time, and with enemies who will multiply under your feet. You will fall once again.[36]

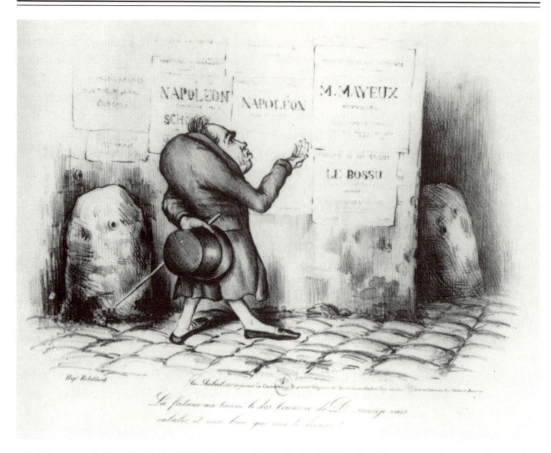

23. Hippolyte Robillard, *My Luck Has Run Out, Dammit, but I'll Hatch a Plot. He Laughs Best Who Laughs Last!,* 1831, lithograph. Paris, Bibliothèque Nationale

This position as the speaker for the rights of the people was the precise one that Mayeux—the caricature—was to occupy during the July Monarchy. The connection of the name Mayeux and the drawing by Isabey probably was not made in 1814. It is more likely that this was done by Philipon who, in June of 1829, drew what was probably the first image of a hunchback dwarf named Mayeux.[37] Despite the fact that Traviès' earliest works are dated well into the year 1830, he is the individual credited (both during the period and today) with the creation of Mayeux.[38]

There are a great number of prints showing Mayeux impersonating Napoleon, which seem to demonstrate the connection to the period c. 1814 as a source for Mayeux. In a print entitled *Métamorphose de M. Mayeux* the connection with Napoleon is evident from the caption, which notes "Think about the giant if you dare, pygmies!"[39] A second work shows Mayeux in front of signs that mention his name, "le bossu" and "Napoleon" side by side (fig. 23). In other prints, meanwhile, Napoleon is shown in a particularly

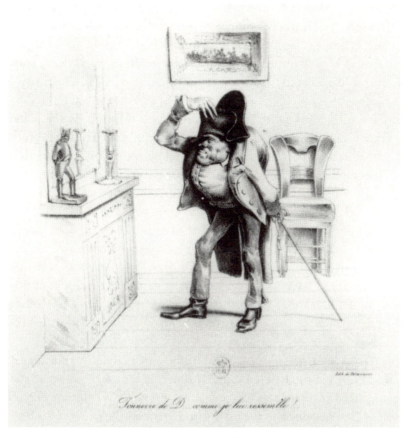

24. Anonymous, *D . . . Damn How Much Alike We Look!*, 1831, lithograph.
Paris, Bibliothèque Nationale

unkind light—as Mayeux tells the viewer about his Napoleonic hat "the hat of a great man," a dog lifts its leg on him.[40] Yet another print shows Mayeux posing in front of a statue of Napoleon and asking the rhetorical question "Who do I resemble?" (fig. 24). The use of Mayeux in prints suggestive of Napoleon can be seen as both an acknowledgment of Isabey's work and as documentation of the burgeoning "Cult of Napoleon" that formed as part of the negative response to Louis-Philippe's ministry. Significantly, these works then belong, in a way, with images by Charlet and Raffet of Napoleon.[41]

In some works, the connection to the artists involved in this revival is made clear. In one, Mayeux has assumed the guise of Napoleon and an artist simultaneously: "These . . . artists have all failed to capture my resemblance. I am only a dauber. However, I have to paint myself to show the public the difference between Mayeux and the Apollo Belvedere."[42] The humor here is that Mayeux has created an exact likeness of Napoleon while the intent was to create a self-portrait. Another work showing Mayeux atop the

Vendôme column makes the correlation among Mayeux, Napoleon, and Louis-Philippe. Napoleon had placed a statue of himself dressed like Caesar on top of the column. In succeeding governments it was removed, but Louis-Philippe decided to replace the statue of Napoleon, this time dressed in military garb. Here then is the satire as Mayeux, in his Napoleonic military garb, lays claim to his territory—now all of Paris.[43]

A third issue to investigate in the evolution of Mayeux is the scientific "atmosphere" in France during this period. Both Philipon and Traviès were interested in physiology and phrenology, related sciences that purported to draw parallels between the shape of a person's body and head to his personality and intelligence. It is not known to what extent they believed the science, but from the number of documents that they published such as *Physiologie du bourgeois*, it is clear that these sciences, then in vogue, were in their minds. So were these sciences in the minds of much of France, and had been for two centuries—certainly long enough that Isabey could have used them as well when he created his prototypical Mayeux. Le Brun's drawings were also well-known and his studies in physiognomy were used to illustrate his dissertation, which he presented to the Academy of Painters and Sculptors.[44] In the 1790s Ducreux referred to these sciences as well when he completed a number of works based on the concept of "the grimace."[45]

The primary scientific source on physiology in France was Lavater. *The Monthly Magazine* IX (1800) claimed that Lavater's *Essays of Physiognomy* was "the finest book which ever appeared in France or any other country."[46] While not entirely satisfying those in quest of "hard sciences," the text acknowledged the fields of biology, anthropology, anatomy, zoology, and physiology. "A further attraction lay in the fact that the science of physiology seemed to reconcile conflicts between science and religion."[47] During Lavater's lifetime, at least eight French versions of his text were completed and received positive press and wide distribution. Interest in these sciences was demonstrated not only by Philipon and Traviès, but also by Daumier, Cham, Dantan, and, of course, by Géricault whose portraits of the insane were conceived as "medical documents."

In many representations of Mayeux, the importance of the sciences of physiology and phrenology is implicit. Works from *Le Charivari* compare Mayeux to an orangutan. In one, the gentleman in the top-hat comments that Mayeux should be flattered to be from the same geneological origin as the ape. In another, Mayeux urges his pregnant wife to ignore the "monster" that ominously hovers in the background.[48] Included in this latter print is a second dwarf-like figure (obviously the couple has already had one child), who bears even more resemblance to the orangutan than does Mayeux.[49]

In additional works Mayeux is compared with a camel. In one print, he struggles with a monkey that has perched itself on his head, while in the background a camel kneels (fig. 25). This suggests both man's evolution from apes and the location of a

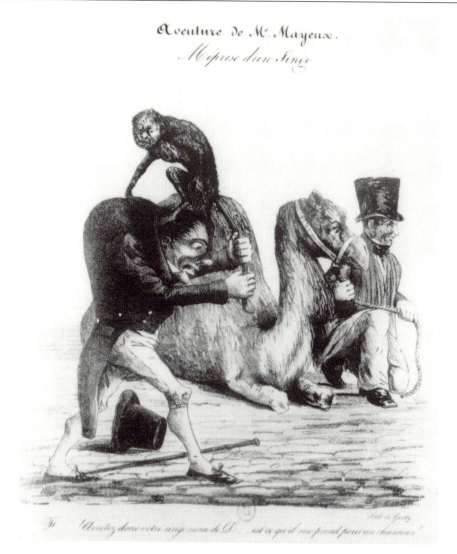

25. Anonymous, *Adventures of Mr. Mayeux. A Monkey's Misunderstanding. The Devil to You! Do Restrain Your Monkey for God's Sake, Is He Taking Me for a Camel!*, 1831. lithograph. Paris, Bibliothèque Nationale

hump like the one that Mayeux possesses. In the caption, Mayeux shouts to the man at the right, "restrain your monkey for God's sake, is he taking me for a camel!" In another print Mayeux, disguised in a beard and glasses, gestures to a number of representations of himself. In the background hangs a sign for orthopedic deformities which also has an image of Mayeux upon it and a poster of a camel underneath. In the caption, Mayeux complains again about the artists who draw him and pleads with them to stop.[50] In another, extremely explicit work, Mayeux, ever cognizant of his deformation, visits a

specialist in hopes of "straightening things out." The caption declares that he hopes that if he can become normal he will be left alone (by the artists who continually depict him).[51] This is further evidence of the special status that the figure of Mayeux was given—at once a work of art and highly critical of the producer of the work, who in his representation of Mayeux dissects him in a very scientific manner much in keeping with the times.

There is also the possibility that the very proportions of Mayeux were meant to be suggestive of a certain type of personality, a certain amount of intelligence. Many artists drew Mayeux, but only Traviès kept the dwarf's dimensions carefully proportional in each situation. It is possible that Traviès (or Isabey before him) actually used documentary drawings by Lavater and Gall to arrive at the specific character of Mayeux. Getty has documented Grandville's interest in these sciences and especially that of comparative anatomy.[52] Furthermore, a series of drawings by Grandville preserved at the Musée Carnavalet show that the artist completed skeletal studies of Mayeux's anatomy—and the specific spinal deformities that lead to the appearance of his hump. The caricature Mayeux can thus be compared to documents available during the July Monarchy, in which the proportion and shapes of body parts was purported to reveal the owner's personality. Compared to the composite faces made by Woolworth from Lavater's studies of individual features, Mayeux comes closest to the composite called "Satire." Woolworth defines "Satire" by contrasting "this sterling property of the mind from that spurious imitation of it—Sarcasm . . . Satire generally attacks the passions, and Sarcasm the person; Satire the follies, and Sarcasm the infirmities of men. As Sarcasm consists in giving pain to the world, so Satire is as commonly receiving pain from it: it is as much attacked as it is attacking, and more dreaded than disowned."[53] As we have seen, this description is consistent with Mayeux's role in the criticism of the July Monarchy, and there was no greater instance of man's folly than the election and perception of the citizen king, Louis-Philippe.

The last component to be addressed in the development of Mayeux is the tradition of street theatre. A lithograph connects the images of the monkey, the camel, and Mayeux with the image of the clown Pierrot (fig. 26). The poster is titled "Le Véritable Mayeux" and features a schematic drawing of Mayeux, a bird, and a camel. While the barker points to the poster, a monkey and the Pierrot snarl menacingly at one another. The caption reads: "See the famous Mayeux—he is not stuffed, he is alive. See him tie his shoelaces without bending over." Here the Pierrot and the monkey suggest two aspects of the development of Mayeux—the evolution from apes we have discussed and aspects of "physiognomic clowns" that, as part of the street theatre, specialized in various grimaces.

Jules Janin, a prominent theatre and art critic, "celebrate[d] the clown as a representative of the vague and vast 'people' . . . [while] Victor Hugo's *Le Roi s'amuse* presents the fool as a symbol of the lower class of society . . . a symbol of a social class of

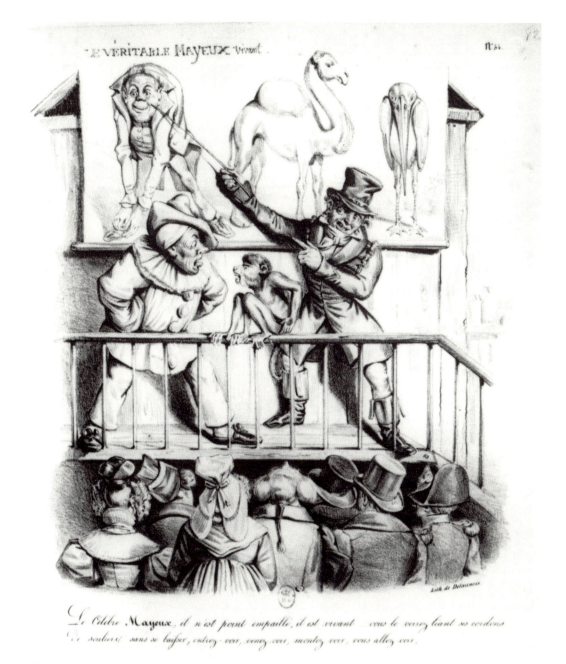

26. Anonymous, *The True Mayeux. The Famous Mayeux, He Is Not Stuffed, He Is Alive . . . You Will See Him As He Is Tying His Shoes Without Having to Bend Over, Come In and See, Come and See, Come Up and See, You Will See*, 1831, lithograph. Paris, Bibliothèque Nationale

disinherited and underprivileged individuals."[54] Louis-Philippe saw Hugo's play for what it was—open criticism of himself and his policies—and terminated the right to perform it publicly. Hugo's hero in the play was Triboulet, whom Hugo made "physically deformed and monstrously ugly. Hugo's Triboulet was mentally superior, and completely aware of his position vis-à-vis the king, but because of this positon as a jester, he was a social outcast without power, responsibility or respect. Triboulet's essentially good and simple nature had been warped by the injustices done to him by society because he was born poor and deformed."[55]

Louisa Jones has linked this literature directly to the live street performances of physiognomic clowns. She describes the milieu as being a scene similar to that in a caricature involving Mayeux (fig. 26): "a disreputable outlying boulevard became the home of small working-class theaters, cafés, vendors, hawkers, animal shows, waxworks, pantomime theaters and the first circus."[56] This was the environment in which the street-clown worked, but, after 1830, "new regulations went into effect . . . and the political satire of many famous street clowns was repressed."[57] Baudelaire claimed (in one of the many legends involving Mayeux) that the dwarf was created by Traviès as a tribute to a specific clown named Leclaire, "a puller of expressive faces . . . a very melancholy soul—a ridiculous accident more common than one supposes among the eccentric classes . . . a poor fellow [who] possessed such objective power and so great an aptitude for make-up that he could imitate to the very life the hump and the wrinkled brow of a hunch-back."[58]

According to Baudelaire, Traviès saw this clown perform "in the midst of the great patriotic fervors of July—and a radiant idea exploded in his brain. Mayeux was created."[59] Baudelaire's information regarding the clown was repeated by the writer Champfleury, who also offered no confirmation of the story. Although there were many famous clowns of this sort, there is no evidence of one named Leclaire, which strengthens the possibility that this particular story was one of a number of "made-up" or "enhanced versions of the truth" that appeared following the period in question. Another interpretation related to the street theater is that Mayeux was "the bastard son of Polichinelle," who was an accepted positive figure in the puppet theatre.[60]

The visual connection between Mayeux and Polichinelle can be seen in prints where the common elements include the pose, the expression, and the presence of the hump. Mayeux's representation as champion of the people, the whistleblower, was the same position held by Polichinelle through his long tradition. In one print, Mayeux and Polichinelle are represented simultaneously. At a costume ball, a man dressed as a woman assumes that Mayeux is wearing a costume, but of course he is not.[61] The presence of a stiff Polichinelle figure in the background both draws the connection between the two caracters and underlines Mayeux's status as a buffoon. An illustration in an 1831 issue of the periodical *L'Union Sociale* showed Mayeux receiving a medal of honor from Polichinelle—an affirmation of a relationship between the two, if not

biological at least ideological.[62] One final work in this vein shows Mayeux dressed as a jester who pokes fun at the ministry of Louis-Philippe and his censorship laws by distributing copies of images of the *poire*—the symbol used by Philipon to refer to the "First Fruit of France."[63]

MAYEUX IN RETROSPECT

We have identified four sources for the imagery of Mayeux—Isabey's prototype, the real person F.J. Mayeux, the science of physiognomy, and the clowns of the street theater. Another issue that should be briefly addressed is the literature involving Mayeux. The stories during the period explaining Mayeux's origin are as numerous as the number of authors. At least four separate authors wrote a "histoire" of Mayeux during the time period 1830–1833. His first name is, according to whom you choose to believe, either "César" or "Napoléon-Louis-Charles-Philippe." Mayeux was intended to be a marker for what was wrong with government—he played the role of the wrongdoers at a time when censorship was threatening artistic and literary freedoms. The stories written about Mayeux are complex and include his youth, education, his first loves, and of course his role in the July Revolution.[64] The images, however, only begin with his arrival in Paris—after falling off a carriage where the only expressed concern is about a small package (fig. 27). This could refer to the object to the left of Mayeux in the illustration, or could imply that Mayeux is a package—or more specifically that his hump is a package.[65]

The texts make it clear that Mayeux was a hero. In two of the texts Mayeux is continually referred to as "our hero."[66] Other documents were ascribed to Mayeux (as the everyman) during the period of the July Monarchy. A speech kept at the Bibliothèque Nationale is filed both under the actual deliverer's name and as "Mayeux before the society for rights of man."[67] It is not clear exactly when this double designation took place, but the cards identifying the document are written in nineteenth-century script. Another document entitled "Mayeux and Arlequin at the Salons" took the place of the official guide to the exhibition, which Mayeux felt was too expensive. Mayeux then proceeded to create stories about actual works that appeared at the Salon of 1831, being very kind to works that expose injustices of the Revolution while condemning works that smacked of state patronage.[68] Again this was a document written by one of several different authors that used Mayeux as a pseudonym.

Mayeux also was given his own journal during the period, called *Mayeux*, which ran from 1831–1832. The title page of this journal included the words "liberty" and "equality" and featured Mayeux's characteristic cry: "Attention, nom de Dieu!" This journal ran humorous poems and plays about the new ministry of Louis-Philippe in such a format that Mayeux was voicing his own personal opinions on these subjects. The first

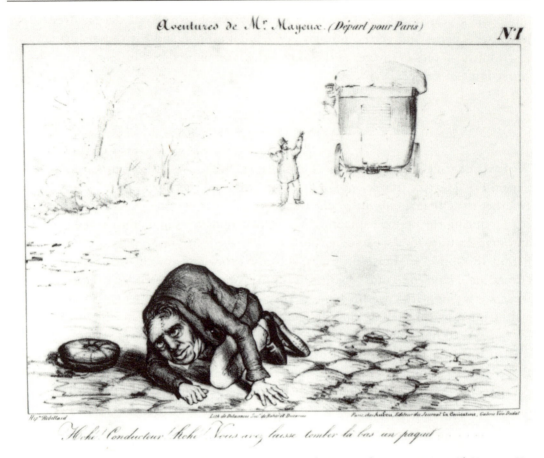

27. Hippolute Robillard, *Adventures of Mr. Mayeux (Departure for Paris). Oh Hoy! . Driver! Oh Hoy! . . You Have Dropped a Package Over There . . .*, 1831, lithograph. Paris, Bibliothèque Nationale

issue gave the following explanation of the nature of Mayeux's hump. "There has existed for a long time a man called Mayeux. This man has, like Socrates, a genie or spirit that lives in his back. This is why he is called the hunchback. The genie in his hump lets him think and lets him see, but it keeps him from speaking. It has tied his tongue." Clearly freedom of speech and freedom of the press was at issue here—an issue that was frequently dealt with in the images as well—and the prints themselves were subversive of the censorship laws. The curious point about the story of the genie in the hump, was that Mayeux could not speak. As a result, therefore, the images of Mayeux had to do the speaking for him.[69] The prints mentioned in this essay represent just a sampling of the more than three hundred prints of M. Mayeux. With increasing censorship, he was represented with less frequency, and when censorship laws were at their maximum he was "replaced" by Macaire and Prudhomme, who, while still commenting on the bourgeoisie that Louis-Philippe allowed to thrive, did not challenge the king's policies directly.

TRUE to the many-faceted nature of Mayeux in literature, there were different explanations for his disappearance. The journal by his name reported that he was dead, that he had been poisoned by Persil (Louis-Philippe's minister in charge of censorship). Other accounts claimed that rumors were started about the "petit bossu," that he had switched sides. Still another claimed that he was in prison. Yet another claimed that his death was the result of an "ingrown revolution." The *Gazette de Paris* stated in retrospect (1859) that Robert Macaire had replaced the naive Mayeux "at the hour when illusions are no longer possible." Mayeux's literary and artistic cries against censorship in particular and the ministry in general had failed to affect change but the "petit bossu" remained the most outspoken, the most blatantly truthful of the "characters" to evolve during the period of the July Monarchy.

And after all, Mayeux was not truly dead—his usefulness in political comment survived the July Monarchy and was revived under the Second Empire, when a new journal by his name was initiated as soon as Napoleon III had lifted the censorship laws. Formed from a conglomeration of ideas about outcasts of society, Napoleon, the science of phrenology, and street theater, in the end the origins of the species "Mayeux" became less important than the way in which he was used: as a tool to enlarge political imagery of the period. The creation of colorful stories under the "anonymous" name of Mayeux served to heighten the dwarf's power and significance during the reign of the July Monarchy. The fact that Louis-Philippe's censorship laws forced the disappearance of the dwarf proves that Mayeux's brand of political and social criticism was effective during the period. Attesting to his lasting influence and popularity, images of Mayeux were still being produced as late as the 1850s, and he appeared on porcelain, as statues—commemorative items such as one would expect to find in relation to an accepted hero of the people . . . the whistleblower of the July Monarchy.[70]

The Proletarian's Body: Charlet's Representations of Social Class during the July Monarchy

MICHAEL PAUL DRISKEL

IN AN UNUSUAL DISPLAY of certainty concerning the historical significance of the July Monarchy, the historian William H. Sewell has declared categorically that "class consciousness first emerged in France during the agitation that followed the Revolution of 1830."[1] Whether one holds to the Foucauldian notion that history proceeds by sudden breaks or "ruptures" such as this, or that continuity and gradual transition are the processes underlying social change, the proposition that the period from 1830 to 1848 witnessed unprecedented discourse about the concept of "social class" would be disputed by few historians of the period. Therefore, my purpose is not to recapitulate the literature on this issue, but to focus on the visual representation in one artist's work of the social constructions the "people" and the "proletariat," which accompanied this discourse. I will argue that Nicolas-Toussaint Charlet (1792–1845) invented a new image of the proletarian and created a visual equivalent for the discourse of social class that pervaded the July Monarchy.[2] But more than simply discussing this feature of Charlet's artistic production, I shall attempt to show how the theme of social class was bound up with and inseparable from a complex of other historically specific discourses and issues.

AN "HOMME DU PEUPLE"

One memorable example of Charlet's representation of the male proletarian is found in what is possibly the most famous of the *Physiologies*—a special genre of illustrated books

devoted to describing in meticulous detail the array of professions, social roles, and types constituting French society—published during the July Monarchy (fig. 28). This colored wood engraving after Charlet's drawing appeared in 1841 in a volume of the series of books entitled *Les Français peints par eux-mêmes. Encyclopédie morale du XIXe siècle*.[3] That Charlet was one of two artists selected to provide illustrations of the "Homme du peuple" for the essay devoted to this social category was probably due both to his reputation as a draftsman of the first rank and his widely publicized sympathies with the common people.[4]

Charlet's man of the people is a carpenter who wears a leather apron and calmly smokes his pipe during a respite from work. With his massive, bared forearm placed on his hip and his weight balanced on huge, columnar legs, his figure calls to mind a classical sculpture that would have been known to most of Charlet's educated contemporaries: the famous Farnese Hercules (Naples, Museo Nazionale). Of all the works in the classical repertory, this statue was the one that best expressed the concepts of physical strength and power.[5]

What is of considerable importance about this particular social type is that unlike most other categories in the book that relate to occupations or social roles, the essay by Léon Gozlan, for which Charlet provided his drawing, concerns a whole social class, in the modern sense of the term. But more than being a description of a social category, Gozlan's essay is also an entreaty for improvement of the lot of this segment of French society:

> To condemn them [the proletariat] is a sin, to forget them a crime, to accuse them of theft or rebellion is a lie. They are the martyrs of civilization: those who have neither the heart nor the means to support them, ought at least to have the justice to admire them in silence.
>
> Thus, the "homme du peuple" of the past no longer exists, because he aspired to equal rights and has obtained them. There exist only men who possess and men who do not possess. A new language has named this latter group proletarians.[6]

Gozlan proceeded to make the claim that 30,000 Parisians of this social class went hungry each day and were homeless at night, painting a bleak picture of desperation and despair. It will be noted that there is a marked discrepancy between his text and Charlet's image. While the writer is pleading for an underprivileged social group, who are at the mercy of the wealthy, Charlet has provided an image that radiates strength, self-sufficiency, and tranquility, in short a figure that displays physical and moral superiority and lays no claim to pity. Clearly, the author and the artist had divergent ideas about the nature and condition of this social class, but the reason may lie in the fact that the category itself contained two fundamentally incompatible aspects.[7] These dual depictions of the proletarian figure as both a virtuous worker and a victim of oppression, of labor as a subhuman condition and as a life-enhancing activity, were to pervade the

28. Nicolas-Toussaint Charlet, *A Man of the People* from *Les Français peints par eux-mêmes*, 1841. Providence, Brown University

discourse on the condition of the proletariat and to remain unresolved at the end of the century, when they received their most memorial expressions in sculpture, and in particular in the art of Constantin Meunier.

One might place the muscular reverie of Charlet's smoking artisan squarely within the discursive realm inhabited by the movement of "worker-poets" that developed and flourished during the July Monarchy.[8] These poets, who both lived a proletarian existence and celebrated the nobility of work in the *goguettes* of Paris and in various workers' journals that sprung up after 1830, were adopted or appropriated by bourgeois intellectuals during the period, such as George Sand and Eugène Sue, and held up as exemplars of primal virtue among the lower orders. But as Jacques Rancière has pointed out, these poets did not write verse in the speech or argot of the proletariat, but in an ambiguous, intermediary form of language existing somewhere between the atelier and the literary salon of the bourgeois cultural elite. This intermediary region is symbolized for Rancière by the imagery of a poem, "A la fumée de ma pipe," published by Charles Poncy, the best known of the worker-poets, in 1842. The smoke coming from the pipe of the worker in Poncy's poem, according to Rancière's interpretation, is made to serve as both a representation of poetic reverie and of the language of the poem itself, "in suspension between the alert refrain of work and the pomp of the alexandrine."[9] Likewise, Charlet's smoking "homme du peuple" occupies an ambiguous position within the artistic genres of the day, suspended between realistic representation of a mundane physical activity and the misty realm of myth suggested by its classical reference.

This image of the proletarian inhabiting the space of reverie is at odds with Charlet's other representations of the "homme du peuple" as a man of action. It is certainly in this later category that one must place his depictions of the fighting that took place on the barricades in 1830. One of these is a lithograph entitled *The Speech (28 July 1830) (L'Allocution (28 juillet 1830))* (fig. 29).[10] This print has a bipartite structure, with the edge of the wall dividing the foreground space into two more or less equal areas, one occupied and the other empty. On the right, in the background, the venerated Tour Saint-Jacques is visible, indicating that the site is in the Faubourg Saint-Antoine, the popular quarter of Paris where on 28 July some of the earliest and most intense fighting occurred.[11] In the vaguely rendered middleground one sees government troops attacking insurgents on a barricade. But, the emptiness of the right foreground of the picture underscores the presence of the prominent figure of the worker on the left, who stands resolutely before a motley group of individuals exhorting them to greater effort in the vernacular of the Parisian lower classes.

The following year Charlet executed a lithograph that could be considered a pendant to this image of the revolution and which has evident affinities with it (fig. 30). This scene represents a respite in the fighting, when a young boy has brought a bowl of soup to a stalwart insurgent, who wears a handkerchief on his head and has tucked his worker's blouse inside his trousers. At this moment a former soldier of the Napoleonic

29. Nicolas-Toussaint Charlet, *The Speech (28 July 1830)*, 1830, lithograph. Providence, Brown University

armies, who dominates the picture and occupies the whole right side of the image, spies a group of lancers about to attack his position and thrusts his bared arm in their direction in a dramatic gesture of warning. Although he is not the same person depicted in the previous image, he is decidedly of the same type, Charlet's conception of the real hero of the July Revolution.

More than skillfully executed records of a contemporary historical event, the real importance of these prints lies in their place in the history of representations of social types. Charlet's two workers have the solidity, ponderation, and statuesque bearing of heros from a neo-classical history painting: The reduction of details and the broad rendering of the workers' smocks and coarse trousers add to the monumentality of his paradigms for the working class. The gesture of the arm dramatically extended in space in *The Speech* is one that calls to mind a specific history painting, Jacques-Louis David's *Oath of the Horatii*. This reference is underscored by the figure of the young boy on the extreme left of the print, who assumes a profile pose with legs placed in exactly the same

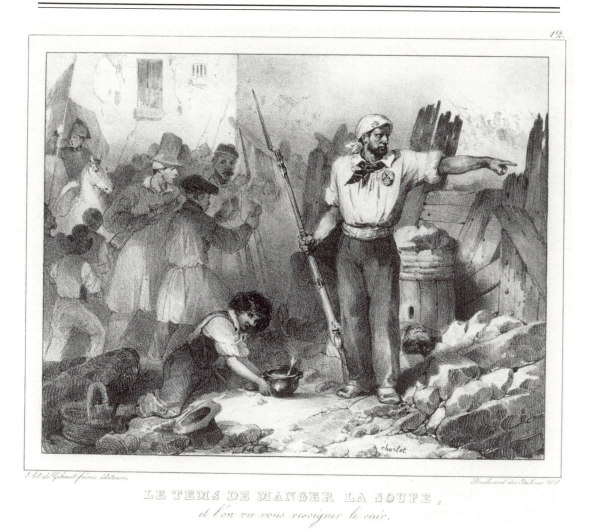

LE TEMS DE MANGER LA SOUPE,
et l'on va vous rescigner le cuir.

30. Nicolas-Toussaint Charlet, *Time To Eat Soup*, 1831, lithograph. Washington, D.C., Library of Congress

position as the Horatii brother in the foreground of David's picture. As a former student of Antoine-Jean Gros, Charlet would certainly have been well acquainted with the neo-classical language of gesture and the practice of incorporating past art into contemporary works by quotation of pose and gesture. His innovation was to employ this practice, common in the art of history painting, in a lesser graphic medium and for the depiction of members of a social class who had by and large been previously excluded from heroic representation in the fine arts. Thus, again, his figures are suspended between the immediacy of the lived moment and the memory of the classical tradition.

These prints contain not only sturdy bodies, but also a metonymy for the prole-tarian body that appears in many works by Charlet: massive forearms, bared to the

elbow. This motif appears in so many of Charlet's images that it might be considered his personal sign for both the entire body of the urban worker and his entire social class. The meaning of the bare arm is quite literally spelled out in a lithograph of Charlet, dating from 1823, which depicts a tipsy shoemaker holding his bare forearm aloft, in a pose reminiscent of the older Horatii in David's famous picture, and exclaiming "Le beau bras! C'est comme l'antique."[12] In selecting this anatomical part as a sign for an entire social class, Charlet appears to have been appropriating a trope of popular discourse, such as one finds in a *chanson* written by a tapestry worker named Mathon in 1833, lauding the strength of the proletarian:

> To arms, Proletarian!
> Make this your battle cry:
> Morality for all, for all equality!
> Victory to work! Death to sloth!
> . . . Weak is the arm of the fortunate on earth
> Sapped by laxity and repose.
> But strong is the arm of the proletarian
> Steeled by work.[13]

The strong arm of the proletarian is not simply celebrated, but is given deeper meaning by its juxtaposition with the feeble arm of the upper classes, "sapped by laxity and repose."

During the *ancien régime* the term "gens de bras" had been used to designate a particular class of workers, who were unskilled and who employed their muscles in their work more than their brains, but by the July Monarchy this designation had lost its specificity and the word "bras" was increasing associated with a whole social class. And in workers' discourses after 1830 the term "arms" [*bras*] appears with increasing frequency as a signifier for the strength of the proletariat. A pamphlet written in 1831 by Auguste Colin, a typographer by trade, offers one instance of this meaning. After complaining that the proletariat had "shaken off the yoke of the hereditary aristocracy, only to fall under the domination of a financial aristocracy," he stated where genuine social utility and the root cause of the economic recession of the period lay:

> The wealth of the States resides in the arms of laborers [*les bras laborieux*], much more than in those of the lazy rich [*les riches oisifs*] These arms now demand to be used and yet remain in a state of idleness because those who could employ them would rather leave their capital inactive than make it fruitful for the working class.[14]

In 1830 another part of the body appears as a metonymy for the proletariat in a prospectus for the short-lived worker's paper *L'Artisan; Journal de la classe ouvrière*. The author of this advertisement claimed that previously "our class counted in society as only

the arms of the social body," but that "three days have sufficed to change our economic function in society, and we are now the principal part of this society, the stomach which diffuses life among the upper classes."[15] And in another part of the prospectus the claim that the working class was the "stomach of society" was repeated. This metonymy also appears, if somewhat obliquely, in Charlet's two representations of fighting on the barricades. In *The Speech* the corporal reference lies in the caption as the working class hero delivers an address to fellow combatants in which food—a brochette of meat and grain of the fields—are invoked allegorically to describe the combat in progress.[16] In the pendant to this print, a pot of soup being delivered to the group by a young boy occupies a central place in the composition and the heroic insurgent pointing out the signs of imminent attack exclaims "time to eat soup, and they're about to take care of your hide!" Here the pot of soup seems designed to serve as an extension of the bodies of the proletarians resolutely facing their enemies.

One example of a visual artist giving the body of a worker similarly heroic proportions is a lithograph by Daumier of 1834 representing a printer, shirt-sleeves rolled up to expose his muscular forearms, standing in a pose of defiance of the July Monarchy's assault on the principle of freedom of the press. (Delteil no. 133). But monumental images of the proletariat of this kind are rare in Daumier's work and even rarer in prints by his contemporaries. One lithographer who did consecrate a major part of his output to the representation of the proletariat and had a deep empathy with this social class is Charles-Joseph Traviès. In 1831, for example, Traviès published in Philipon's *La Caricature* a bitter deconstruction of the hypocritical rhetoric of the July Revolution. This lithograph, ironically entitled *Le Peuple affranchi*, depicted a cross section of the unemployed proletariat of Paris in sunken postures of idleness.[17] Idealization, bared flesh and exposed musculature, are completely eschewed . Among his depictions of the lower classes on happier occasions is the series of lithographs Traviès published in 1839 under the title *Les Joies du pauvre peuple*. These prints represent the lower orders engaged in various forms of popular amusement, a theme often illustrated by Charlet, but unlike Charlet, Traviès refrained from romanticizing or blowing up to heroic proportions any members of this social category.[18]

Probably the best known modern study of the proletariat, or the "laboring and the dangerous classes," in France during the first half of the nineteenth century is that of Louis Chevalier. The period's preoccupation with physical characteristics as signs of social class is addressed in detail at various points in his book and he discusses the representation of the working class in the graphic art of the period, mentioning works by Daumier, Traviès, and Gavarni in particular. With the exception of Daumier's journeyman printer mentioned above, he concludes that the proletariat was simply depicted as unremittingly ugly.[19] Apparently Chevalier never looked at the work of Charlet, the most popular graphic artist of the period. While Chevalier's conclusion is wrong, part of the fault for the error lies in the secondary sources he consulted. That is, it

is due in some measure to the manner in which the history of art, focusing primarily on a handful of brand names, has been emplotted and written during our own century.

REPRESENTING THE BOURGEOIS OTHER

When social classes or groups construct signs of identity for themselves, much more is involved than isolating positive physical characteristics that will set them apart. These positive signs are endowed with negative correlates within systems of differences. Their identities are established to large degree by what they are *not*. This process has been eloquently described by E. P. Thompson in his magisterial study of the English working class: "And class happens when some men, as a result of common experiences (inherited or shared), feel and articulate the identity of their interest as between themselves, and as against other men whose interests are different from (and usually opposed to) theirs."[20] In the case of Charlet's representation of the "homme du people," this typological opposite was the image of the bourgeoisie. An example of this negative correlate for the man of the people is found in a print entitled *You Make Me Laugh (J'ris-ti!)* that Charlet published in 1840 (fig. 31).[21] In this image the worker on the left is not the heavily muscled exemplar of proletarian virtue that appears in so many of Charlet's images, but an unskilled and physically unimposing member of the lower orders holding a broom. He is juxtaposed to a seated member of the wealthy middle class whose body and face are bloated with self-indulgence, a sign for idleness and corruption.

The discourse of the laughing proletarian in this print also contains another opposition, that between the old and new aristocracies, that is repeated in different ways in Charlet's oeuvre and is a figure of difference that defines the bourgeoisie. He points to his class adversary and between guffaws exclaims "It makes me laugh to see all these slackers act like the La Tremouilles and the de Montmorencys, with their faces swollen with booze." In mentioning the names of the two illustrious French families, whose genealogies can be traced back to the Middle Ages, Charlet was making an invidious comparison between the new bourgeoisie that had been fattened by the July Revolution, or a new aristocracy of wealth, and the aristocracy of the *ancien régime*. The same idea appears in another print by Charlet, which was censored in 1840. It represents an old aristocrat visiting an artist's studio and carefully examining a painting on the easel. The caption underneath, which the censor found objectionable, read: "Aristocracy for aristocracy, I prefer that of titles. It is sophisticated and generous . . . the aristocracy of money is avaricious and has infinitely little sophistication."[22] This lithograph was a pendant to another print, *Un Mécène 1840*, that represented a member of this new aristocracy of money in an artist's studio.[23] In true philistine fashion, he is commissioning a painting that would be in accord with the decor of his home, without any consideration of the aesthetic properties of the work or the artist's vision. This compari-

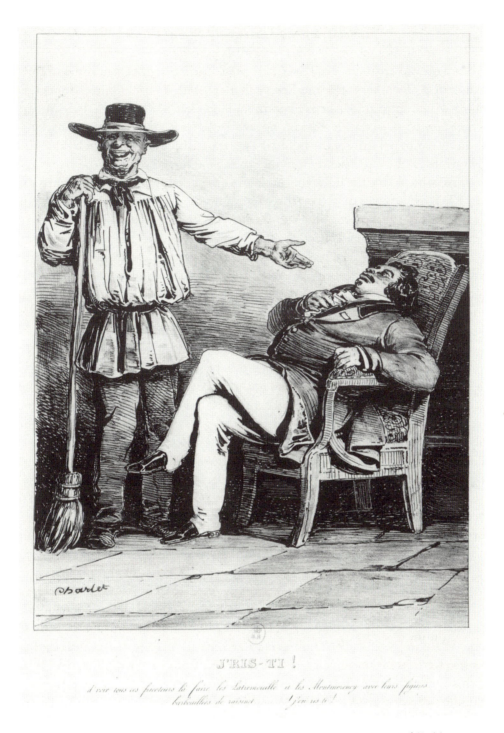

J'RIS-TI !

d'voir tous ces *fricoteurs* là faire les *Latremouille* et les *Montmorency* avec leurs *figures*
barbouillées de raisiné *j'en ris-ti !*

31. Nicolas-Toussaint Charlet, *You Make Me Laugh*, 1840, lithograph. Paris, Bibliothèque
Nationale

son between the old aristocracy of birth and the new aristocracy of wealth was a constant in the discourse of workers after the Revolution of 1830. Thus, in these prints Charlet was giving visual form to discursive commonplaces that pervaded the July Monarchy.

The bourgeoisie, considered as a negative correlate, is present in Charlet's two prints, discussed previously, of the fighting on the barricades in July, not by their bodily representations, but by another metonymy: the abandoned top-hat in the foreground of each picture, which, like the frock coat, was an unmistakable sign of class identity at the time. In *The Speech* stress is placed on this piece of headgear as a signifier of social rank by the panoply of hats on the left, all of a different type, that are placed in opposition to it. In the center of the group and on a diagonal line running across the picture through the abandoned hat stands a "voyou," or petty hoodlum, familiar from other prints by Charlet, wearing a "chapeau gris," or soft and somewhat formless stovepipe hat, that functions as a popular counterpart to the stiff top-hat of the bourgeoisie. And in the pendant picture the same message is conveyed, if somewhat less emphatically, by the abandoned top-hat in the left foreground that is partially framed by the semi-recumbent figure of the young boy delivering the pot of soup. It is further emphasized by its position as part of an implied triangle, the other two corners of which are the handkerchief covering the worker-hero's head and the *chapeau gris* of the worker in the left middleground who holds a rifle. In the context of the day, one might interpret these items as references to the absence of an entire social class from the actual struggle during the July Revolution.

If these two prints are asserting that the bourgeoisie stood aloof from the combat on the first day of the Revolution of 1830, the question that follows is how faithful is that claim to the actual historical reality of the event? An answer based on documentary evidence, rather than hearsay of the period, might be found in a study by David Pinkney that analyzes the surviving records of the Commission des récompenses nationales, a body established to provide compensation for those killed and wounded in the July Revolution. From this statistical evidence Pinkney reached the conclusion that the great majority of combatants were members of the artisan class or were *petit bourgeois* shopkeepers and merchants. From other evidence it appears that leadership in the combat was provided by veterans of the Napoleonic and Revolutionary armies. He concludes that "in the so-called 'Bourgeois Revolution' of 1830 the middle and upper bourgeoisie were either immune to bullets or absent from the firing line."[24] The latter half of this sentence might be used to describe the message in Charlet's pictures.

Pinkney's essay also addresses the historical truth of Eugène Delacroix's famous *Le 28 juillet: La liberté guidant le peuple,* which represents prominent figures from various social stations united in a struggle for liberty against a common enemy. One compelling reason why this particular work was chosen from the vast repertory of the history of art to decorate the hundred franc note today is undoubtedly that in its assemblage of personages, social divisions seem to be effaced in the pursuit of a common cause. That is, it

depicts a social consensus rallying round an abstract principle, whose value few French citizens could dispute. Yet the evidence indicates that the fighting was hardly shared equally. It follows that Delacroix's tophatted member of the bourgeoisie "scarcely deserves his conspicuous place, certainly not as a symbol of this kind in this perilous spot."[25] Thus, one can argue that Charlet's images, regardless of whether they recycled stereotypes defining social class, are nonetheless closer to historical truth than Delacroix's.

Charlet's view of the bourgeoisie is recorded in both his art and his personal correspondence and journals. An early expression of his class antagonism appears, for instance, in a journal entry written in 1832, when he accompanied French troops to the siege of Antwerp, where they defeated the army of the Netherlands. In the middle of his description of the conditions of the terrain a violent outburst reveals his animus:

> Nothing is impossible for French soldiers, and always the gaiety. . . . My guide is a good lad, and it is only among the troops that one finds this fraternity. . . . BOURGEOIS PIGS OF PARIS, I HATE YOU, I DETEST YOU! . . . [COCHONS DE BOURGEOIS DE PARIS, JE VOUS HAIS, JE VOUS EGUEXECRE! . . .] My guide led me to all the advanced posts.[26]

And in a letter written in January, 1845, shortly before the end of his life, similar contempt for the dominant social class of the July Monarchy was still present in Charlet's thought:

> Poor France! bowed over by the rod of the bourgeoisie and the agitators; this ignorant and ridiculous bourgeoisie. . . . What a regime! what a life! what shame! . . . in the middle of this rottenness, a class numerous and strong preserves the national sentiment.[27]

Here again, the "class numerous and strong" is defined against one that is "ignorant and rotten." These then are the kinds of words, sedimented in Charlet's own consciousness, that one should match with the social types in his prints.

Charlet's life was a paradox: he retained a deeply ingrained hatred of the bourgeoisie, while at the same time coveting bourgeois respectability and the honors that bourgeois culture distributed to its members. One of these honors was a seat at the Académie des Beaux-Arts, which he attempted to win in December, 1836, after the death of Carle Vernet. He was unsuccessful, but took solace in the medal of the Legion of Honor he was given in 1838 for his artistic achievements. Following this recognition he was appointed as a professor at the Ecole polytechnique in Paris, a position that provided him a secure livelihood and standard of living equal to that of most members of the middle bourgeoisie. In addition to this salary, in 1840 he received a contract for the illustrations in Count de Las Cases' famous *Mémorial de Sainte-Hélène* and was paid the enormous sum of 40,000 francs for the task.[28] To put this in perspective, one might

note that the basic living expenses for the entire household of an average skilled worker in Paris in 1840 was 950 francs per year.[29] While Charlet may have identified with the proletariat, he certainly was not a part of it at this time, if his standard of living is used as a criterion for membership.

But, one might ask whether he believed himself to be a "worker" by virtue of the profession he exercised? He certainly would not have qualified for this title in the first full-time job he performed. From 1813 to 1815 he served as registrar of recruits in Bureau du recrutement at the Hôtel de Ville in Paris and was effectively a low level bureaucrat in a position occupied generally by the *petite bourgeoisie*. It was only after he was dismissed from this position by the Bourbon Restoration that he began the serious study of the arts. Once he had chosen a profession, he appears to have never held any other type of job. Nonetheless, there was a discourse prevalent during the July Monarchy in which analogies were drawn between the production of the artist and the worker, though this only seems to have received real focus after the first Revolution of 1848.[30] And as a lithographer Charlet was much closer to the manual arts than painters or sculptors, in both the audience for whom he worked and the mechanical aspects of his chosen métier. Lithography was used for many commercial applications at the time and, along with printers, commercial lithographers enjoyed professional guild status in the world of labor. This is to say that Charlet was probably confronted with some difficulty when he tried to specify his class identity in his own mind. And his ambiguous social status may have contributed to his fascination with the representation of social class.

A STREAK OF MORAL DIDACTICISM

It should be emphasized at this point that these stern and militant images constitute only part of Charlet's social repertory. He enjoyed a reputation as a humorist because of his depictions of the foibles of the proletariat, as well as its virtues. And in addition to his heroic images of the July Revolution, he also found a comical side to the event. For instance, in one print of 1830 a female fishmonger watches another woman possessing greater financial means enter the *mairie* of one of the arrondissements of Paris to file a claim with the Commission des récompenses nationales for the death of her husband in the revolution. Speaking in the argot of the illiterate of Paris, the woman comments to a wine merchant that the highfalutin lady certainly does not need the money and laments the fact that her own husband had not had "the happy idear . . . him . . . the scoundrel . . . to had hisself killed."[31] In another humorous representation of the events of July, Charlet depicts two drunken members of the working class leaving a bar, where they have passed their time during the fighting of the *trois glorieuses*. The caption indicates that they have finally decided to go and demand bread or death. In the background the poses of the figures and the hats flung into the sky indicate that the

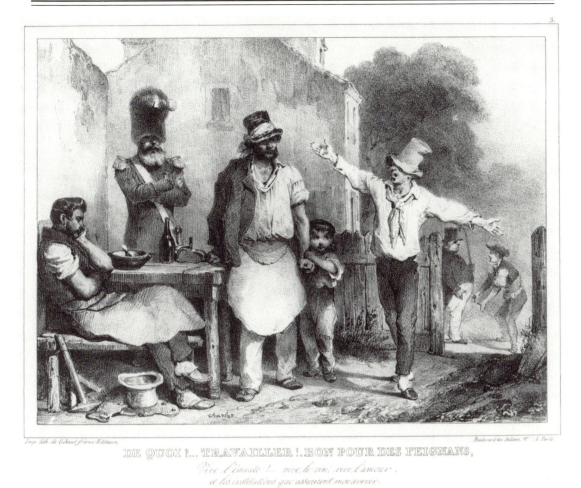

32. Nicolas-Toussaint Charlet, *What For? . . . Work! . . . Good for Slackers!* 1834, lithograph. Washington, D.C., Library of Congress

revolution is already over.[32] Like the bourgeoisie, they too have been absent from the combat. While these low-life types may form a stark contrast to Charlet's two heroic workers on the barricades, one should not infer that his attitude was all that censorious. In fact, a large part of his work consists of humorous depictions of low-life carousing and the sociability of the local cabaret or *goguette*, preferred places of amusement for the proletariat. From the number of works he executed on this theme, one can only conclude that Charlet had a genuine personal empathy with this kind of unruly behavior.

Thus, one might divide the prints of Charlet into those executed in the comic and those in the heroic or didactic modes, the latter category concerned with the presentation of a moral lesson. But in one lithograph in his album of 1834 Charlet brings these two modes into direct confrontation and moral didacticism prevails (fig. 32). On one

side of the sheet two burly workers are represented, with sleeves rolled up, at the table where they have eaten a humble luncheon repast; opposite them a tipsy *voyou*, wearing a *chapeau gris* and assuming a posture that is definitely near the "feminine" pole in Charlet's dichotomy of physical types, taunts them and denigrates the value of work, exclaiming "What for? . . . work! . . . good for slackers! . . . Long live the riot! . . . long live wine, long live love, and the institutions that will assure my future." Here, the heroic mode is clearly the one possessing moral superiority and the didactic message undercuts whatever humor one might find in the demeanor of the drunken rascal. The value of work is set against the social values of both those who wish to see continued "riots" take place during the July Monarchy and against the social order itself that fosters such conduct as is displayed here. This association of the *voyou* and the bourgeois mainstay of the social order is also implied in the print by two figures in the right background: a corpulent member of the *rentier* class and another low-life type who taunts him. Charlet implies by his composition that they belong on the same side. What is particularly interesting in this print is that the polarities "work/idleness" and "hardness/softness" override his usual "people/bourgeois" opposition.

A similar and earlier visual preachment is found in a lithograph Charlet executed around 1827.[33] This image depicts an encounter of an old worker and his son, who, while out riding with his bourgeois wife, has stopped to see his father. The son, dressed in a fashionable riding habit, stands in a pose expressing his shame, as his father urges him to give up the "galon" of servitude and "take up again the pick of independence." He has already thrown his "chapeau galonné," or hat bedecked with ribbons, on the ground on the right side of the picture, where it establishes a counterpole to a pick on the left, which has one end driven in the ground and the other hung with the stocking cap of a manual laborer. Here we see both Charlet's recurrent moral binarism and his great sensitivity to wearing apparel as a signifier of social class.

Charlet's moral vision is expressed most clearly perhaps in a series of fifty lithographs he executed from 1838 to 1842 that form a serial narrative concerning the life of a fictional Corporal Valentin during the Restoration and the July Monarchy. In one of these scenes supposedly occurring shortly before the July Revolution, the young soldier meets an archetypal charlatan, the Marquis de Las Blagueras, in a cabaret and the phony aristocrat solicits a loan, offering his bogus decorations as security. This character might be considered akin to Daumier's Robert Macaire and in his physical appearance a remarkable anticipation of his Ratapoil. A scene that follows depicts an imaginary event on 29 July 1830 when the fake aristocrat has been caught stealing and is on his knees before a firing squad directed by an old soldier. We might interpret this not simply as the artist's condemnation of thievery, but as his attempt to celebrate the positive value of "work" by focusing on "theft," an act that can be considered the antitype of the former and one that gives it greater moral force. Not only is this Charlet's stern moral lesson, but also another in the repertory of social types against which his 'homme du peuple" defined himself.[34]

THE ARMY IS THE PEOPLE

Charlet's concern with social class manifested itself obliquely in another medium in 1836, when he submitted his first oil painting to the Paris Salon. This work, which came late in his career, depicted an event, the retreat of the Napoleonic armies from Russia, that had been the subject of many previous paintings, but had never been treated in such a manner before (fig. 33).[35] Set in a vast and desolate plain in the dead of winter, the scene contains a great number of soldiers desperately attempting to make their way to safety along a route littered with the carnage and debris of war. The figures are all small in scale and treated more as an anonymous mass of humanity than as a collection of distinct personages, whose actions might be interesting in themselves. Eschewing drama and heroics, the work presents a view of the disaster from the perspective of the many common soldiers who experienced it most vividly. To put it in its context, one must remember that at the time it was exhibited a legion of artists were at work on paintings commemorating famous military events in French history for Louis-Philippe's new museum in the château at Versailles. Charlet's work could be considered a response to this official imagery or officially sanctioned version of military history.

Undoubtedly, the most laudatory review of Charlet's picture was by one of France's major poets. Alfred de Musset dwelt at some length on the picture in his discussion of the Salon, illuminating the important aspects of the work:

> The *Retreat from Russia* by Charlet is a work of the greatest significance. He has entitled it an "episode," which is much too modest; it is a poem in its entirety. Beholding it, one is first of all struck by an uneasiness and vague horror. What does this picture represent? Is it Berezina, is it the retreat of Marshal Ney? Where is the general staff? Where is the point that attracts the eyes, which we are accustomed to finding in battle paintings in our museums? . . . it is simply the *grande armée*, it is the ordinary soldier, or more particularly it is mankind. . . . He is one of the first to have painted the people [le peuple], and one must admit that his spiritual caricatures, as amusing as they are, have not predicted this first effort. . . . It is certainly a work of our time, clear, hardy and original. I seem to see a page from an epic poem written by Béranger.[36]

As de Musset correctly implies, the subject of the picture is less the horrors of war, as exemplified by the infamous retreat from Russia, than a eulogy for the anonymous masses who constituted Napoleon's army, or "le peuple." For Charlet the common soldier was a member of the proletariat or member of the class of individuals to whom the title "homme du peuple" applied. In fact, a consistent theme of Charlet's graphic work is either the elision of the distinction between workers and soldiers or assertion of their identity as members of the same social class. Representation of this primal bond

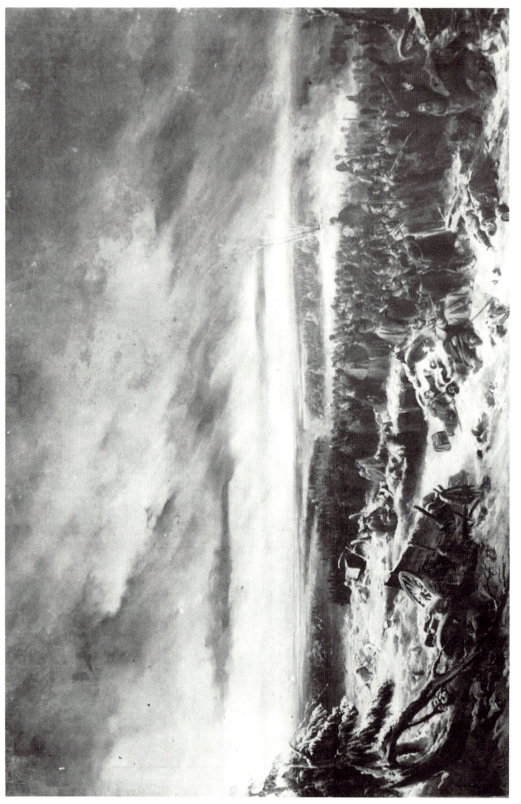

33. Nicolas-Toussaint Charlet, *The Retreat from Russia*, 1836, oil on canvas. Lyon, Musée des Beaux-Arts

appeared early in Charlet's career and continued during the July Monarchy. In a lithograph Charlet executed in 1824, for example, a peasant stands behind his plow and points to the earth, while confronting a soldier who likewise gestures toward the ground.[37] Underneath this scene the caption reads "The laborer nourishes the soldier/The soldier defends the laborer."[38] Their common link is the earth, which the one tills to provide food for the nation and the other, working in his own métier, defends. In 1835 Charlet produced a variant on this theme in an album of lithographs entitled *Alphabet moral et philosophique à l'usage des petits et des grands enfants*. In this series of prints, one corresponding to each letter of the alphabet, the letter "S," or the word "Souvenirs" which begins with it, is illustrated by an image of the legendary Nicolas Chauvin (from whence the term "chauvinism" derives), dressed in the costume of a peasant farmer and standing in front his humble cottage with his farm implements.[39] In the distance a group of soldiers are passing and Chauvin is set to daydreaming nostalgically about his own military service, thereby creating a psychological bond between farmer and soldier.

Both these prints invoke the topos of the "soldat-laboureur," a deeply resonant theme that was to pervade popular culture in France from the Restoration until the early decades of the twentieth century.[40] One of the most famous evocations of the topos was a poem "Le Soldat-laboureur" written by Emile Debraux during the Restoration.[41] In the poem an old soldier returns to his family farm after twenty years in the military and while plowing the fields uncovers the skeleton of a fallen member of the Napoleonic armies, still wearing the medal of the légion d'honneur, and pledges to build a funeral monument to him in the middle of his fields. The earth is thus the common bond between the dead soldier and the living farmer.

While in the earliest examples of this topos the "laboureur" in the equation was usually a peasant farmer behind his plow, the category soon expanded to include the skilled artisan and urban worker. Charlet evoked the urban variation of the theme in a lithograph in his album of 1829. The laborer is a stone cutter, dressed in a leather apron, who is at work on an urban construction project, when Napoleon pays a visit to the site. Upon seeing him, the laborer snaps into a military salute and recites the famous battles in which he has participated.[42] Of all the images of Charlet in which this theme is implicated, however, the one that makes the equation patently clear in both the image and the caption was executed in 1840. In the foreground a burly worker and a soldier clasp hands in a gesture of solidarity above a legend that reads "The Army? It is the People!"[43] It was this print that the worker-poet Jérôme-Pierre Gilland, a locksmith by trade, referred to specifically in an article on apprenticeship that he published in 1841 in the worker's journal *La Ruche populaire*. Written in the form of a dialogue, one party in the discourse on the nobility of work infers that this existential activity gains stature from its relationship to military prowess:

> It seems to me that I am not in my true vocation in hammering iron, although there is nothing ignoble in it. On the contrary, it is from the anvil that comes

the sword of the warrior, who defends the liberty of the people and the ploughshares that feed them. The greatest artists have understood the large, masculine poetry that stretches across our bronzed foreheads and robust limbs, and sometimes have rendered it with great happiness and energy: our illustrious Charlet especially, when he placed a leather apron near the uniform of a grenadier, saying "The Army. It is the People!"[44]

What is important here is not that Gilland was inspired by Charlet, but that both the lithographer and the worker-poet were participating in the same deep-rooted cultural discourse, but in different media.

Another noteworthy item in de Musset's paean to Charlet's *Retraite de Russie* is his comparison of it to a poem by Pierre-Jean Béranger. This equivalence was an almost obligatory homage by 1836 and had appeared in print scores of times. Béranger was universally known as the individual who in his *chansons* had celebrated the people more warmly than any other writer of the day. Another bond between the work of Charlet and Béranger was a deep sympathy for the ordinary or the quotidian. This quality was captured well by the art critic Théophile Thoré in the preface to his *Salon de 1845,* which is addressed to Béranger: "You have proven well that there are no small subjects nor small forms, that there are only small artists." But more important than their mutual reverence for the ordinary, Charlet and Béranger shared a profound reverence for Napoleon Bonaparte, one depicting him in the medium of lithography on many occasions and the other celebrating him in verse numerous times.

THE PEOPLE ARE NAPOLEON

This devotion to both the people and to Napoleon, a man who made himself an emperor and assumed absolute power in France, might at first appear to be a classic case of cognitive dissonance. However, this apparent paradox or contradiction is explained to some degree when one considers the way in which Napoleon's legend was reformulated during the Restoration and the July Monarchy. In short, during this period the democratic aspects of Napoleon's person and rule were enormously exaggerated in all manner of publications and his authoritarian acts were correspondingly diminished in their retelling. Both this paradox and the way in which the Napoleonic legend lent itself to reinterpretation were addressed in 1828 in an important book written by Auguste de Chambure and illustrated by Charlet. The author articulated the quandary and then proceeded to solve it. Of all the men who had governed great empires "none exercised more absolute power; however none enjoyed greater popularity among the people and the army."[45] To explain this popularity de Chambure recounted at length the whole repertory of anecdotes about Napoleon and his encounters with the common people or

the clever ways in which he attempted to portray himself as a member of that social class called "the people." He concluded with the observation that "one must recognize that Napoleon had a great advantage over all other sovereigns. Raised among the people, he knew what the people esteemed and admired in a ruler . . . the people did not wait until he was dead to judge him, and history counts few sovereigns whose memory has remained as popular."[46]

Whatever efforts Napoleon may have made during his rise to power to cast his persona in a democratic mould, the seminal event in the process was the publication in 1823 of the Count de Las Cases' famous *Mémorial de Sainte-Hélène* which purported to be a record of Napoleon's conversations with him while in his final exile. The voluminous text provided a picture of what might have been had not France been defeated by its enemies. This work quickly became a bestseller and passed through numerous reprintings before the appearance of the first illustrated edition in 1842.[47] The artist who provided the 1800 illustrations and vignettes for the work was, appropriately enough, Charlet. In terms of the quantity and quality of drawings involved this is undoubtedly the most important book illustrated by a single artist during the July Monarchy. Of all the illustrations in the book, that which probably struck the most resonant cord in promoting Napoleon's plebian image was one that can be placed under the sign of the "soldat-laboureur" (fig. 34). Here the great man is depicted tilling the fields on the island of Saint Helena. This vignette recounts a story in which Napoleon, during a horseback ride on the island, dismounted and took a plow from a peasant farmer. He then tilled a perfect furrow, demonstrating his closeness to both the soil and those who work it. This one story is emblematic of the main thrust of Las Cases' book and functions as a symbolic mediation between Napoleon and the people.

The dramatic announcement on 12 May 1840 by the government of Louis-Philippe that Napoleon's body was to be returned to France stimulated much debate over his place in French history, the appropriate place to lay his remains to rest, and the social message that would be encoded in his tomb. Of all the sites proposed the one with the greatest democratic associations was the Place Vendôme and it was widely promoted by many in the left opposition.[48] Because of these populist associations, Frédéric Soulié, prolific novelist, sympathizer with liberal causes and founder of the periodical *Napoléon; journal anecdotique et biographique de l'Empire et de la Grande Armée*, urged that it be selected for the burial site in a brochure he published in 1840. Soulié preferred to promote the part of the Napoleonic myth that made him the Emperor of the People, or the Father of Equality. Under this guise the hallowed Vendôme Column was the most appropriate place for his body:

> Remember also that equality was the law under his reign; it is because of this that he is our hero; it is for this reason that he has remained so great and so revered in our memories; it is for this that there is in our hearts an enthusiastic

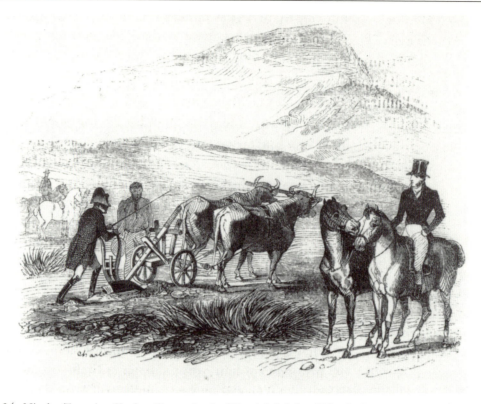

34. Nicolas-Toussaint Charlet, illustration in *Mémorial de Sainte-Hélène* by De Las Cases, 1842. Providence, Brown University

and profound cult for his memory; for this reason his tomb ought to be equally accessible to the smallest and to the largest person, to the poorest and the richest, to the last as well as to the first in our nation; it is for this reason that we men of the people, we do not wish to need a special favor to be able to go and kneel by the sepulcher of our emperor of all.[49]

Quite possibly the most remarkable discussion of the relationship between that entity known as the "people" and Napoléon published during the July Monarchy is found in Léon Gozlan's essay on the "homme du peuple," which, as we have seen, was illustrated by Charlet. Gozlan presented a schematic picture of the aftermath of the French Revolution in the following way:

It is the man of the people [homme du peuple] who saved the compromised country, put in peril by it [the Revolution]. Having conquered liberty for the nation, he wished to carry it to other nations, to show how beautiful it was. He found glory on the way; a mysterious column began to march before him to provide a light in the middle of his dark night. Napoleon appeared at the summit of this column. Italy, Egypt, Germany were successively conquered

by the people, led by Napoleon, man of the people. Serfs in 1600, subjects in 89, citizens in 93, the people were crowned emperor in 1804.[50]

In the final sentence of this paragraph mediating links between Napoleon and the people are completely abandoned; Napoleon *is* the people and the people *are* Napoleon, one and indissoluble. It is likely that Charlet shared Gozlan's mystical logic and would have seen no contradiction in his own simultaneous worship of the sovereign people and the emperor.

ANTICLERICALISM, EDUCATION, AND CLASS IDENTITY

One of Charlet's visual equivalents for this discourse is a print he executed in September 1840, when, despite the government's decision to place Napoleon's tomb in the church of the Invalides, widespread debate was still in progress over the appropriate final destination for his body (fig. 35). In this scene, which might be considered Charlet's vote for the burial site, his standard burly man of the people, wearing a leather apron, with sleeves rolled up to expose a muscular emblem of class identity, salutes the unseen statue of Napoleon on the Vendôme Column, giving the monument biblical significance by proclaiming it to be the people's "Song of Songs." Many of Charlet's prints and caricatures contain multiple and interrelated layers of meaning and this one is no exception. More than a simple homage to the emperor is inscribed in this image, for the worker's speech is directed toward the figure passing before the monument on the right, a teacher brother, or "grand frère," of the La Salle order. This order consisted of religious laymen who devoted their lives to elementary education and the propagation of the Catholic religion. In Charlet's print, the worker enjoins the brother to make the children of France sing the praises of the Vendôme Column and admonishes him to tip his hat: "chapeau bas, frère!" With its display of contempt for the teaching brother, Charlet's image encapsulates the general attitude of the male proletariat to the Catholic Church and its clergy during the July Monarchy.

Modern sociological research by Henri Boulard and Gabriel Le Bras has confirmed what was a general opinion during the period itself: the Catholic Church was for the lower classes of the urban areas of France almost a nullity. In his *Le Secret du Peuple de Paris* (1863) the locksmith, decorative sculptor, and writer Anthime Corbon described succinctly the degree of participation of the proletariat in the ceremonies of the Church: "If it were not for women, who persist more than men, the working population of Paris would abstain almost totally."[51] Corbon further noted that the common people knew nothing any longer of the symbolism of the Church and "that the ceremonies are dead letters for our people." It follows from his remarks that the liturgy and rites of the Church had become primarily a social activity for the bourgeoisie, whose education permitted participation of a kind denied the lower classes. Corbon's assessment of the

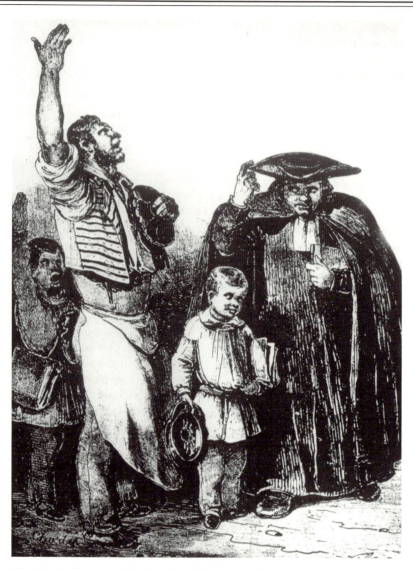

35. Nicolas-Toussaint Charlet, *Make Them Praise the Column*, 1840, lithograph. Providence, Brown University

proletariat's attitude toward religion corresponds to the message in a print Charlet executed after the pillage of the Archbishop's Residence in Paris, a building next to the Cathedral of Notre-Dame, in February 1831. In the lithograph a young worker leafs through a book that he picked up during the sack of the religious monument, and expresses his opinion of its contents: "Believe it's Latin; probably got a lotta stupidities in it, stories of 6000 years ago, time of Barrabas, that ain't true, but make ya laugh."[52] One might interpret this not as Charlet's approval of the desecration of the religious monument or of the worker's ignorance, but as his contention that the use of Latin in the

rites of the Church was a class barrier separating the bourgeoisie from the people. It can also be considered as his representation of a root cause of the event.

One of the social issues that generated the most passion during the July Monarchy is addressed in this print of 1840 as well, in the guise of the two school children in the picture. The child whose education is in the hands of the religious layman has already removed his hat, but stands in a rather indecisive pose. In contrast, the worker's son, whom one assumes is enrolled in a secular elementary school, raises his arm in a vigorous salute emulating that of his proletarian father. This image juxtaposes figures representing secular and religious education, thereby making direct reference to the struggle for control over the educational system in France between secularists and supporters of the Church.

The issue became an increasingly volatile one after ordinances were passed in 1828 that restricted the operation of parochial schools, generating a widespread demand among Catholics for "liberty of education." This call was incessant during the 1830s and generated a great debate in both the public arena and parliament in the early 1840s. As might be expected, it in turn produced a counterdemand for the complete secularization of primary education in France. Accompanying this debate over the relative rights of religious and secular schools was the movement to provide elementary education for all members of French society, including children of the proletariat. The result of this campaign was the Guizot Law of 1833, named after the minister of public education, that required every commune in France with more than 500 inhabitants to maintain an elementary school for boys. This law established the primacy of the state over the church in elementary education and further increased the hostility of Catholics for secular schools.

Another issue involved in the wide ranging discussion of education in France during the early years of the July Monarchy was the continued value and function of the so-called "école mutuelle," a system of secular schools developed around 1815 to give poor children a rudimentary education by employing older and more capable students to teach the younger ones, under the direction of a single school master. These schools had the strong support of the political opposition during the Restoration and were consequently generally opposed by legitimists. The political coloration of the advocacy for this type of schooling might be seen in a proclamation of 31 July 1830 issued by the Société pour l'instruction mutuelle, an organization formed during the Restoration to promote the mutual school. The society professed its pride in the role played in the July Revolution by its former students: "It is in our schools that they learned devotion for their country, for our sacred laws, and to preserve order in combat and moderation in victory."[53]

That Charlet strongly supported the concept of the mutual school can be inferred from several of his prints done after the July Revolution. In one executed in 1831, a teaching brother stands at the door of an "école de charité" and watches a group of school children pass his school by and enter one labeled "école mutuelle." One of the children bears a tricolor flag with the words "Vive les mutuelles" written on it. Making reference to the teaching brother the caption reads "It's all over for the owls [hibous]."[54] In another lithograph from 1830, done shortly after the July Revolution and bearing the

caption "The Revolution will make a tour of the world," a group of school children are staging a rebellion in a classroom and a teaching brother rushes toward them with a whip, while another surreptitiously pins a sign on the back of the teacher's gown bearing the epithets "âne" and "oie."[55] Finally, in another lithograph of 1830 a teaching brother pauses in front of an "école mutuelle," adopting the same frontal pose that Charlet gave him in his print of 1840 saluting the Vendôme Column, and is menaced by the children who are bearing arms and exclaiming "c'est un ennemi!" On the wall of the mutual school is scribbled "Vive Philippe 1er et l'école mutuelle."[56] Thus, Charlet's juxtaposition of the two schoolchildren and the two mature male figures in his print of 1840 might be seen as his condemnation of schools under the aegis of the Brothers of La Salle and his celebration of secular education. Although the mutual schools had been largely absorbed by the new state-supported secular schools by 1840, the print might also be considered his retrospective praise for the practice of mutual assistance solidarity by members of the same social class, as they had been fostered by the "école mutuelle."

CHARLET'S POLITICS BEFORE 1840

The outpouring of caricature directed against the person of the king and other members of the political establishment during the first five years of the July Monarchy has received considerable attention in literature on the period. Noticeably absent from the names that reappear in these discussions is that of Charlet. With one exception, at a time when it was still legal, he refrained from caricatures of Louis-Philippe or individual members of his government.[57] However, his displeasure or disappointment with the direction the government took after the balmy days of July might be inferred from a satirical print of 1831 in which two soldiers are seated before a plate of beans, ready to dive in. Looking more closely at the repast, which is dry and lacking sauce, one remarks fatalistically that "It's always the same ones who hold the butter dish. . . . That means the Revolution hasn't been introduced into the beans yet."[58] This might be rephrased as "The Revolution hasn't changed the cook."

But regardless of Charlet's dissatisfaction with the results of the Revolution of 1830, he was opposed to a repetition of it, and was a supporter, if a half-hearted one, of the constitutional monarchy of Louis-Philippe, at least until 1840. His view of the republican riots or demonstrations in the early years of the July Monarchy might be inferred from several of his prints. In a caricature of 1836 a group of school children are shown acting out a riot and a central figure in the group carries the tricolor upon which is written "A bas tout."[59] And in another work of the same year a peasant is conversing with a disheveled and apparently drunken member of the proletariat, who points to the city and exclaims: "Ah, how sad Paris is without riots."[60] And in a letter of August 1835, he made his opinion of radical republicans explicit: "I detest the red caps and the

immorality of those who wear them."[61] As a member of the National Guard, Charlet helped quell the violent demonstrations or rebellions that occurred in France during the first four years of the reign of Louis-Philippe, although we have no details about his actions during these disturbances. He had been a member of the National Guard, an organization that was largely composed of veterans of the Napoleonic campaigns, before it was suppressed during the Restoration, and was made a captain in the organization when it was restored at the beginning of the July Monarchy. In 1834, he was elected as a battalion chief and given considerably more responsibility.

Charlet's attitude toward politics and civil unrest closely mirrors that of the working class of Paris, as they have been described by Edgar Leon Newman. In his study of the "crowd" during the early years of the July Monarchy, Newman has stressed that the objectives of the artisanal workers of Paris and those of the liberal bourgeoisie after the July Revolution were widely divergent. While certain members of the liberal bourgeoisie and students imbued with republican ideals continued to push for fundamental political changes, the workers generally ignored their activities. As Newman puts it: "The workers, it seems, were irritated by the ravings of these well-dressed young radical intellectuals; far from joining the students, the tanners, hatters and other workers of the Faubourg Saint Marcel complained bitterly about the gathering of radical students around the Place du Panthéon."[62] He further recounts one incident on 14 July 1831 in which a group of workers chased away a group of students who were attempting to plant trees of liberty at the Place de la Bastille, because they believed them to be one of the causes behind the economic malaise of the country and their unemployment. Like these workers, Charlet seems to have believed that the July Monarchy had not produced significant changes for the proletariat in France, but he abstained from overt criticism because he believed the installation of a republican government would simply result in the replacement of the bourgeoisie supporting Louis-Philippe's "juste-milieu" by another group representing the same class interests, but spouting republican slogans. More importantly, like the workers of France, his real model for political leadership was Napoleon Bonaparte, and none of the politicians in France could begin to measure up to this demigod. But no political or military leader even remotely approaching the stature of Napoleon was in the offing in France, and Bonapartism, as an independent political force or organized political party in France, was of little consequence. Hence his indifference to politics.

While Charlet appears to have distrusted politicians in general, he did greatly admire one individual. The object of his admiration was Adolphe Thiers, who held several key cabinet positions during the July Monarchy, and as an ardent guardian of the the Napoleonic legend was the individual primarily responsible for bringing Napoleon's body back to France. It was to Thiers in February 1839 that Charlet wrote a long letter revealing his political beliefs. This epistle began with Charlet's declaration of his love for the people, that is "intelligent working people [le peuple travailleur intelligent]."

Acting as a self-appointed spokesperson for them, he informed the politician, who was at the moment a member of the Chamber of Deputies and engaged in a battle to bring down the cabinet of Molé, Louis-Philippe's unofficial prime minister, that Thiers views were those of the people. Of all the politicians in France: "You alone comprehend the only form of government possible after the July Revolution, you alone understand popular sympathies, you alone have the confidence of the National Guard, that is the solid party that supported you in June and saved the nation."[63] The support in the month of June that Charlet mentions was the response of the National Guard to Thiers' orders, while minister of the interior, to suppress mercilessly the rebellions that occurred in Paris on 5 and 6 June 1832. One can only assume that Charlet also approved Thiers' actions in brutally putting down the demonstration in Paris on 13 April 1834 which resulted in the infamous massacre on the rue Transnonain. In like manner, one must assume that he approved of Thiers' advocacy of the repressive September Laws of 1835, which instituted a system of prior censorship of prints. The date of the letter also indicates that he approved of Thiers' criticism of the amnesty of 1839 which permitted many political radicals to return to France. Finally, his letter seems to give at least tacit approval to Thiers' attack on the government's foreign policy, which he claimed had greatly reduced the nation's power and prestige in the international community.

THREATS OF WAR AND REVOLUTION IN 1840

In September 1840 Charlet was invited to dine with Thiers and the renowned historian Auguste Mignet. Charlet's letter recounting the conversation that took place during that encounter reveals a profound change had occurred in his view of the July Monarchy:

> What to do? One thing or the other. The "juste-milieu" is an imbecility. Let us be either monarchists or republicans. One can't straddle the two, and at this time one straddles. Inquietude fills everyone's mind, and no one has confidence in the future. . . .avarice is the order of the day . . . the servants of the king . . . perceive the coming storm.[64]

This appears to be an accurate description of the general climate in France at the time. After the ministerial crisis in February 1839 the king dissolved the chambers and the general election that followed produced no viable government. There was still no stable government in place when, on 12 May, the left wing secret Société des Saisons staged an armed insurrection in Paris. Although this uprising was put down, political discontent among radical republicans continued to grow and was greatly accelerated when the so-called "Reform Movement" was launched in early June 1840. Originally the term "reform" was intended to cover suffrage rights and the composition of parliament, but it soon came to signify radical change in the political structure as a whole.

Coinciding with this internal turmoil was the appearance of the "Eastern Question." This concerned a war that had broken out between the pasha of Egypt, whom France considered an ally, and the Sultan of the Ottoman Empire, who was supported by the allied powers, England, Austria, Prussia, and Russia. That these allied powers were France's former enemies, who had forced her to sign the humiliating treaties of 1815 ceding her territory and to pay heavy reparations, only increased the popular demand that France go to war on the side of Egypt and at the same time avenge this historical ignominy. Radical republicans immediately sensed that a foreign war had revolutionary potential and would be the key to bringing down the July Monarchy, a perception that only increased their ardor for war. Members of the *petite bourgeoisie*, with their memories of the citizens armies of 1793 and the treaties of 1815 in mind, also supported the call for war to avenge France's humiliations. While the middle bourgeoisie tended to be divided over the issue, the upper bourgeoisie or the new aristocracy of commerce, wishing to solidify the material gains it had made since 1815, were opposed to any new wars and supported a peaceful solution to the crisis. It was the peaceful alternative that Louis-Philippe ultimately chose. Thus, the war fever of 1840 was deeply entangled in class conflicts and came to be widely seen as a battle of class interests.[65]

Charlet's formal break with the July Monarchy and his informal alliance with the radical republicans demanding war occurred in July 1840, when he resigned his commission in the National Guard, a body that he had formerly considered the vanguard against the threat of revolution in the urban areas of France. He then began a campaign in support of a foreign war with a series of lithographs, the first of which was entitled *La Marseillaise*. This print represented a group of soldiers and muscular *hommes du peuple* ripping down posters that read "Traités de 1815," and pointing to graffitti on a wall proclaiming "nos vieilles frontières ou la mort." Rejected by the censor on 22 August, this lithograph was only the first of twelve promoting war and condemning the pacifism of the bourgeoisie which met with government censorship, making Charlet far and away the most heavily censored graphic artist that year, a fact that one might consider poetic justice given Charlet's apparent support for the September Laws before 1840.[66]

Not all of Charlet's prints executed in support of the demand for war were censored. One of those that escaped the blue pencil and was approved on 12 September 1840 shows clearly how he had schematized the conflict in France and reduced it to an opposition of two social classes (fig. 36).[67] A member of the "Classe forte" stands eyeball-to-eyeball, or metonymy to metonymy, with a member of the "Classe moyenne," holding a bayonet between them. Muscular forearm and powerful body are in a position of dramatic confrontation with tophat and frock coat covering a frail body. The caption that assigns the words "fil et coton" to one figure and "Fer et acier" to the other sets up the opposition "soft/hard" that is a recurrent motif in the artist's work. Signifying the proletarian blacksmith's willingness to go to war, the socket bayonet condenses the meaning of the image into one concrete object. At a deeper layer of

36. Nicolas-Toussaint Charlet, *Middle Class, Strong Class,* 1840, lithograph. Paris, Bibliothèque Nationale

implication the two sides of this binary composition should be interpreted to represent the opposition of the People of France and their foreign enemies, the bourgeoisie serving as a surrogate representation for the latter.

But this image also seems to imply that a state of warfare existed between these two opposed social classes, with the bayonet symbolizing the gauntlet that has been thrown down between them. If this interpretation is correct, it is a remarkable harbinger of the

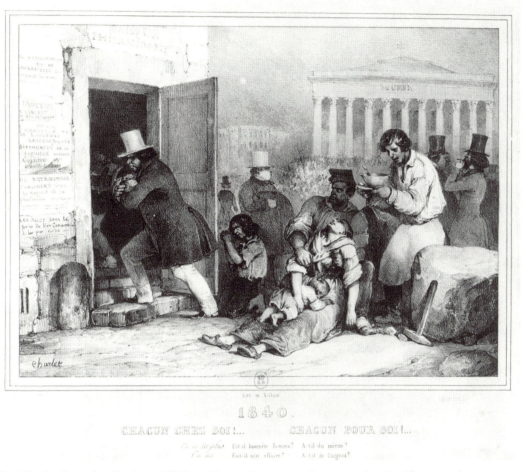

1840.

CHACUN CHEZ SOI!... CHACUN POUR SOI!...

37. Nicolas-Toussaint Charlet, *1840 Every Man at Home! . . ., Every Man for Himself!. . .*, 1840, lithograph. Paris, Bibliothèque Nationale

idea of class struggle between the proletariat and the bourgeoisie that was later to be elaborated by Marx and Engels. This is not to say, however, that the idea of "class struggle" did not exist prior to the 1840s. In fact, Thiers and Mignet both believed that conflict between the landed aristocracy and the bourgeoisie had been continuous since the Middle Ages and that it culminated in the French Revolution. What neither was willing to admit, however, was that class struggle between the proletariat and the bourgeoisie had supplanted that earlier conflict of interest. Other prominent theorists of the *juste milieu*, such as François Guizot, maintained that class struggle no longer existed because the Revolution of 1830 had made French society a unified whole.

Of the more than 1100 lithographs executed by Charlet, the image that contains the most striking condemnation of the greed of the bourgeoisie, pacific or otherwise passed the censor in August 1840 (fig. 37).[68] This scene, bearing the caption *1840,*

Every Man at Home! . . . Every Man for Himself! . . . (1840, CHACUN CHEZ SOI! . . . CHACUN POUR SOI! . . .), is set in the open space in front of the Paris stock exchange, seen in the background. Rushing past an impoverished or starving proletarian family, a member of the bourgeoisie enters a bank, clutching bags of filthy lucre in his arms. In the middleground other financial fat cats parade across the space. On the walls of the bank one finds a sign bearing the oxymoron "banque philantropique" and posted sheets of paper with comments that amplify the message of the image. One indicates that "Of the new and the old aristocracy, the superiority of the first is in greed." And another: "Of patriotism considered under its relation to [economic] production."

Greed and callous indifference to the welfare of others and the nation were the accusations leveled by the lithograph, rather than specific ridicule of the king, the government, respect due the law, or the concept of private property, all of which were forbidden by the September Laws. Almost every discussion of the graphic arts during the July Monarchy ritually condemned the system of state censorship of prints these laws instituted and the names Philipon, Daumier, Gavarni, Grandville, and Traviès are customarily recited as heroic figures engaged in a struggle for freedom of the press. What is never mentioned, however, is that Charlet had this print unofficially censored or at least ostracized by a journal that previous literature has considered a "victim" of censorship.

On October 11, 1840 the opposition satirical journal *La Caricature*, founded by Charles Philipon in 1830, but sold after the passage of the September Laws, published an article that described Charlet's lithograph in much greater detail and commented on its message. The anonymous article, evidently written by the editor Albéric Second, after likening the print to the platitudes of popular songs, the politics of the street corner, the eloquence of cheap one sou newspapers, and the morality of the tavern, addressed itself to the artist: "Oh, Charlet! do not give our enemies the pleasure of seeing us commit stupidities. Do not force your talent any more, take up the torch again, take up your crayon and make us laugh . . . As for us, we will never accept for publication caricatures of this type."[69] At the time this was written the paper continued indirectly to lampoon the politics of the government, particularly its Middle East policy, but seldom used its pages to criticize the economic system in France, of which it and many of its subscribers were direct beneficiaries. While Second probably would not have considered his refusal to publish caricatures that attacked the socio-economic system or the class system as "censorship," one could argue that the effect was the same. What we should keep in mind when discussing the role of satirical journals such as *Le Charivari* and *La Caricature* in their opposition to the July Monarchy is that political opposition was thoroughly conflated with the desire to make a profit, first of all, and, secondly, that the owners of these publishing enterprises generally belonged to the same social class as the members of the government of Louis-Philippe.[70] One can surmise that Second saw himself or his patrons in Charlet's caricature of the rotund bourgeois clutching bags of money.

It has been argued throughout this essay that the issue of social class and the idea of class struggle occupied a position of centrality in Charlet's art. I would not conclude from this, however, as classical Marxist theorists might, that in his work one discovers fundamental, essential structures or relations that conditioned all cultural production of the period. Rather, I believe that the case of Charlet's prints illustrates how the notions of class struggle and social class were intersected by and interwoven with a complex of determinate historical conditions and cultural discourses, such as nationalism, militarism, and anticlericalism. That is to say that this dense network of circumstance cannot be collapsed into class relationships alone.

Whose July Monarchy Anyway?

Having attempted to explain how Charlet's art engaged the historical conditions and discourses of its day, I might conclude with a difficult question: What is Charlet's place in the art of the July Monarchy? The answer to this is far more problematic than simply assigning him a place in a hierarchy of aesthetic value or influence, for this question poses another: What is the "art of the July Monarchy"? At first one might answer that the phrase means simply all the art produced during a certain historical period, art patronized or sponsored by the government in power, or art that most saliently represents or negotiates primary social, cultural, or economic concerns that set this particular historical period apart from others. But this sort of formulation begs the crucial question of the standpoint or class perspective of the interpreter, or: *Whose* July Monarchy are we talking about?

The art dating from the reign of Louis-Philippe that survives today in our museums, at the château of Versailles, and in various public buildings generally falls in the "high art" category and represents the culture patronized by the educational and cultural elite of the period, who represented a relatively small segment of the population. The same is true of most exhibitions of nineteenth-century art in our own era; one social class is viewing the art produced for a similar social class across a span of time. This art certainly does not represent the perspective, or world view, of the most numerous social group in France, one that became more conscious of its own identity during the July Monarchy than at any time previously. The paradox here is that though large in numbers, this social class has had relatively few artists who were concerned with representing social reality from their point of view. Charlet, as the artist who occupied himself with picturing the world from this underclass perspective more than any other of his time, regardless of his unavoidable mixture of it with traditions and practices deriving from the elite culture of the upper classes, would certainly deserve to be considered the most representative artist of the July Monarchy—if demographic numbers were used as a criterion in the selection process.

Proto-realism in the July Monarchy: The Strategies of Philippe-Auguste Jeanron and Charles-Joseph Traviès

GABRIEL P. WEISBERG

IN RECENT CRITICISM of the July Monarchy exhibition held in 1989 at the University of Missouri, and of its accompanying catalogue, considerable attention has centered on the person and work of Philippe-Auguste Jeanron.[1] Michael Marrinan, in two reviews, has preferred to see him as a painter of some ability who produced conventional seascape compositions during the 1850s. Jeanron, however, remains an artist whose best works have been hidden from public scrutiny since the mid-nineteenth century. Marrinan has had considerable difficulty in seeing him as a significant transitional painter, indeed, as a proto-realist. He doubts that proto-realism, or "prefiguration" of future images or themes, exists as a valid concept.[2] A second blind spot manifests itself in his lack of understanding of how Jeanron's staunch political ideology can be linked to the misery of the people, when his best-known canvases are seemingly devoid of political commentary.

What makes these criticisms so valuable is that they clearly demonstrate the different ways in which the same paintings are seen and regarded by art historians and interpreters of visual culture. On the one hand, writers can see a given work, as Marrinan does, as representing or possessing traits of Romanticism. On the other hand, as I have posited here, it is possible to consider Jeanron's images as containing the seeds of a nascent realism. In reading images this way, confusion often reigns, which leads to the general acceptance of the more bellicose, theoretical position at the expense of truly

examining the works of art themselves for pertinent clues. By using Jeanron as a test case, the debate between a theoretically forced position and a tendency to examine works of art in detail has been intensified. In the end, by utilizing Jeanron's works for a methodological demonstration, it is apparent that the manipulation of terms, and a failure to read images convincingly, can actually mask what artists truly accomplished. We shall address the issues raised by the recent reviews in systematic fashion.

IN THE CASE of "proto-realism," Marrinan has disparaged the very existence of the category, trying instead to vitiate both art historical publications from the past that used the term, with direct application to Jeanron, and to denigrate the presence of any sort of early realist tendency during the July Monarchy, other than what might be applied later to the sacred cow, Gustave Courbet.[3] While Marrinan has battled against ideological windmills, he has also helped to achieve (or has perhaps prefigured) something quite remarkable, although it was undoubtedly not part of his agenda to do so. In the process of making Jeanron the center of controversy, the Louvre has taken steps to publish, in toto, Madeleine Rousseau's pioneering doctoral dissertation on Jeanron, which was completed in the 1930s and has long been inaccessible to scholars.[4] This new publication, based on Rousseau's text, has been prompted by the recent discovery of a cache of early Jeanron works.[5] The appearance of these drawings has heightened the artist's visibility. They will certainly help clarify the picture of Jeanron that has been based on the relatively small number of works that has been available to substantiate Jeanron's place as a proto-realist.

Such indications of a growing interest in Jeanron undoubtedly will not resolve the debates about his relative significance in the history of art. Yet, due to this renewed attention, Jeanron's career, his often revolutionary and radical ideas, and his militant, Republican political stance during the 1830s and 1840s will continue as a theme of discussion.[6] In addition, scholars will have to assess whether it was merely his choice of theme—or, in the mundane language of a contemporary writer, his selection of subjects—that helped form Jeanron's proto-realism, or whether it was some visual quality, such as directness, naïveté, coarseness, or humble attitude, that "prefigured" works by Courbet and others. It is the goal of this essay to help establish the existence of proto-realism in general and to verify the significant contribution made by Jeanron and such artists as Charles-Joseph Traviès to the proto-realist tendency that indeed "prefigured" the work of Courbet, Edouard Manet, and others.

Jeanron's importance and his role as a proto-realist are not, as some would believe, the hypothetical fabrication of the recent July Monarchy exhibition or the product of revisionist attitudes of the past decade. In 1851, Prosper Haussard equally credited Jeanron, Courbet, and Millet as the "chiefs" of a "school of painters of the people."[7] Later, Jeanron was recognized as both a radical and a realist by Léon Rosenthal in his pioneering text *Romanticism to Realism*.[8] This book's intention was to document the

appearance of an early realism that predated or prefigured the Salon of 1851—the Realism Salon.[9] More recently, other scholars have echoed these early comments. Linda Nochlin called Jeanron a "proto-realist" and indicated that he was "allied to the spirit and achievement of Courbet's realism in both [his] socially conscious subject matter and [in his attempt] to provide this iconography with a new form."[10]

Even Michael Marrinan admitted in his book, *Painting Politics for Louis-Philippe*, that the paintings that hung in the Salons "during the twenty years prior to Courbet's first major paintings cannot be discounted."[11] Indeed, it was his goal to prove that these Salon works, which included paintings by Jeanron, were important. Yet, with specific reference to Jeanron, Marrinan denies the presence of any political significance in *The Little Patriots* (a matter that will be dealt with later) but admits that the artist usually followed a "socially critical posture."[12] Perhaps the most important point made is the admission that, in Salon paintings, "sentimental sweetness [can mask] subversive structure," a fact that Marrinan applied not to Jeanron, but to Roehn, an artist who used the same strategy in his work.[13]

From the statements of Haussard, the writings of Laviron and Théophile Thoré, and the interpretations of Rosenthal, Nochlin, Marrinan, and T.J. Clark, it is apparent that the seeing of Jeanron as a proto-realist as a recent manifestation is to misread the past. He has been considered a proto-realist by earlier scholars and theoreticians due to the powerful imagery he created during the July Monarchy, which made these eighteen years a crucial period in the organization of the tendency identified as realism. Perhaps in beginning to assess the works of Jeanron, it may be enlightening to review the precepts that were first defined by Laviron and later elaborated upon by Thoré and Castagnary long before Champfleury refocused them to fit the art of Courbet. They exist, in fact, to the extent that this artist's work can be seen not only as a "prefiguration" but also as a solid source for future art.

Laviron laid down early concepts—a foundation—that was later developed into realism. He advocated the democratization of art, demanding that art be made available to all people. Jeanron complied with this concept in both art and deed. As the director of the National Museums of France after 1848, he agitated for the very changes that would bring about this democratization of art. The Louvre was to become a "palace for the people" through projected reforms, such as holding exhibitions there and placing the national library within its walls. With the establishment of the National Museum System, Jeanron was successful in mobilizing artworks to be sent to the provinces, which again advanced the idea of an "art for the masses."[14]

A second way of democratizing art involved expanding the range of "acceptable subjects," specifically acknowledging that simple, everyday scenes and the life of lower class individuals could be worthy subjects for art. According to Laviron, this would be accomplished by recording "character" in the visible world, not merely by slavish copying. In addition to following this precept in his own art, Jeanron brought out of

storage works by certain artists, most notably Chardin and Le Nain, thus making their graphically realistic nature, both in subject and style, available for study. By doing this, Jeanron made possible the fulfillment of Laviron's third "requirement": the use of early masters and the idea of building a "tradition" for realism. [15]

In putting both Jeanron and Marrinan in their respective places, it is crucial to consider some of the former's works that demonstrate the constructed criticism of the latter. Well before the 1848 Revolution, which resulted in his elevation to the position of director of the National Museums of France, Jeanron worked diligently to unite militant politics with his art. He completed a series of drawings and oil paintings that sympathetically mirrored the life and hardships of the people. Their reactions to warfare were recorded, as was the necessary fight for survival that followed the unsuccessful revolution of 1830, which swept in the "July Monarchy." The condition of the poor who fought on the barricades is shown in Jeanron's drawing *Wounded Man* of 1831 (fig. 38). It was Jeanron's widely known and appreciated advocacy of *le peuple* that made him a popular and logical choice to oversee the Louvre's collections. [16]

Since Jeanron had been one of those fighters in 1830, and had transcribed a number of street conflagrations into works of art, he was able to remain optimistic about the revolution and the change of power in government for only a short period of time. [17] He, along with Charles Philipon (1806—1862), Charles-Joseph Traviès (1804—1859), and others, soon recognized that Louis-Philippe's regime intended to do little to alleviate the suffering of the poor. The discontent of all three artists became manifest in the radical publication *La Caricature*. An important image by Jeanron found in this journal underscored the fact that the hopes of the barricade fighters were dissipating. While this image can be read as being essentially autobiographical, the figure also represents many in similar situations.

Even *The Little Patriots* (*Les Petits Patriotes*) of 1830 (fig. 39) contains notes of Romantic sentiment and has deeper implications. Its sentimental sweetness masks a subversive structure that was missed or denied by at least some critics of the Salon of 1831. To some simplistic thinkers, represented here are "children playing on the barricades" that, in their Greuzian charm, inhibit those seen in Jeanron's works, which were deemed to be more socially conscious. The fact that the work was praised at the Salon seems to have led to its downfall in the minds of those contemporary art historians who have not thought to ask *why* Jeanron, first, painted this particular subject and, second, utilized Romantic sentimental overtones in addition to a nascent realism.

Perhaps the choice of subject can be explained by the following quote, which was published in 1833 in a two-volume study that documented the insurrection that brought Louis-Philippe to power.

Children, zealous agents of destruction, roamed the street breaking sign-
boards, coats of arms, lanterns, shields, which showed any evidence of royal

38. Philippe-Auguste Jeanron, *Wounded Man*, 1831, drawing. Paris, Private collection

39. Philippe-Auguste Jeanron, *The Little Patriots,* 1831, oil on canvas. Caen, Musée des Beaux-Arts

protection. Either by foresight or instinct, their anger was also directed against the street lamps which all ended in the gutter, broken in a thousand pieces. The result was that in the evening, the city would have remained in the dark if the moon, which was not part of the conspiracy, had been so inclined as to enter its first quarter the previous night. At the same time, especially around the Hôtel de Ville, which had been designated as the center of all events by a clever authority, barricades went up. By noon, the revolution was more than accomplished—it was proclaimed. [18]

These are, after all, only children, as much as some would like us to believe that violent acts committed by children for the "cause" during the fighting would somehow preclude their being viewed as innocents by either artists or by the Salon public at the time. Surely the fact that the Salon audience greeted the painting positively reflects an understanding on the part of those who had lived through, and had been changed by, the conflict. These children of the nation, who had fought on the barricades in 1830, had put their trust and their futures in the hands of the adults who were instigating the conflict. Far from "aping their parents," these tattered and tired children represented, in 1831, the miserable outcome of the July days. These true innocents were being badly served by those who were now in control of the government. In this context, Jeanron's use of Romantic melancholy was timely and was a strategy likely to win the painting a place in the Salon, especially when other of his works had been rejected for their more untempered and caustic realism.

The growing dissatisfaction with the government of Louis-Philippe in the months immediately following the Revolution of 1830 forms an undercurrent in the image of *The Little Patriots*, an undercurrent that the Salon public could either choose to acknowledge or to ignore. This sense of misery, which underlay the surface Romanticism of this successful Salon painting, was evident in other works by Jeanron and his fellow artists. Understandably, this tendency did not gain the approval of the Salon judges, and these works were not admitted for public display in the Salon. Such realist themes, through which the forward-looking tendencies in Jeanron's work can be isolated, were most apparent in his graphic images, and especially in his drawings. While *The Little Patriots* was accepted to the Salon of 1831, two drawings by Jeanron were rejected, ostensibly for the troubling and disconcerting imagery they presented. [19]

In one of these works, Jeanron focused on a member of the proletariat aiding a wounded comrade during the intense street fighting of 1830. Originally in the collection of Paul Huet, another artist with staunch Republican values, this drawing was known to other radical artists, such as Traviès and Daumier, at the time. [20] The companion piece to this work (fig. 40) offers a realistic scene that reveals compassion for those who were plunged into further jeopardy by the July Revolution. This drawing, showing emaciated figures huddled in a poorly furnished attic, served as the continuation, in a

40. Philippe-Auguste Jeanron, *Dying Man,* 1831, drawing. Paris, Private collection

narrative format, of the subtext of the other drawing. One intelligent critic concluded that the first drawing represented the intense street fighting of 1830, while the second stood for 1831, when the vanquished combatant was dying from his wounds and from starvation or illness. Since Jeanron, in his choice of a proto-realist theme with its emphasis on the down-and-out family living in a garret, was drawing parallels between events in 1830 and the situation in 1831, it was apparent that things were getting worse, not better, for many. It was obvious that, in addition to not being cared for, the poor were not even acknowledged for their role on the barricades.[21]

In re-examining the reasons for the rejection of Jeanron's drawings, two fundamental issues come to the fore. First is the choice of contemporary themes. These works called attention to the inadequacies of the newly formed government and thus differed from the efforts of those artists who were vying for representation in the Salon. Second is the fact that in these drawings Jeanron was working in a style that was blunt, schematic, and defied the canons of academic taste and finish. The scene within the attic contains unusual distortions of form and exaggerations in body position that increase the emo-

41. Philippe-Auguste Jeanron, *A Scene of Paris,* 1833, oil on canvas. Chartres, Musée des Beaux-Arts

tional range. Chalk and charcoal are often handled in a coarse and crude manner and are applied with energy and fervor not unlike the early works of Gustave Courbet. The different style that Jeanron launched in these works made these drawings unacceptable, for they challenged contemporary taste and the very ways in which exhibitable works were supposed to be done.

A second painting by Jeanron, the recently relocated *A Scene of Paris* (*Une Scène de Paris*) of 1833 (fig. 41), has been dismissed much in the same way as *The Little Patriots*, for allegedly containing strong doses of Romanticism, which thus would seemingly prevent the work from achieving a proto-realist status.[22] As before, this work was admitted to the Salon when more outwardly agitational drawings were refused. In seeking a pattern, it seems that suggestions of Romanticism allowed the work to be shown to a Salon audience and permitted the subversive structure to be grasped by an enlightened viewer. The theme strongly emphasizes the sense of frustration felt by street fighters who were now outcast and ignored by the ruler whom they had brought to power. Furthermore, the subject and its treatment present the misery found in different

sections of Paris. This work, which was described by contemporary critics as a dismal, haunting depiction of an outcast family, resulted in the acknowledgment that Jeanron was a leader of those who sought to redress social issues that were embarrassing and even dangerous to the government due to the class stratification that it had created.[23]

This, then, is an image of frustration. The father has surrendered his youth for the cause of liberty and has gained nothing in return. Even more harrowing is the realization that his family now lives on the streets. These once-proud individuals have had their lives torn apart by distress. The impression of destitution is reinforced by such details as the ripped clothing, a device used in *The Little Patriots*, and the daughter's assumption of the role as the family breadwinner by selling flowers to earn a few sous. Here are the roots of the outcast families and destitute flower sellers who fill popular novels and paintings throughout the nineteenth century.[24] The work's dour tonal treatment further links it to images by other proto-realists who worked in a similar manner during and after this period. When one critic chose to emphasize the "classical construction" of the group at the left and the "baroque diagonal" formed by the boulevard, he no doubt forgot that works by Courbet demonstrated these same qualities.[25] In invoking the "radical" nature of Courbet's works, some have created a blind spot. T.J. Clark himself acknowledges the importance of Jeanron to the realist movement by reprinting the words of Haussard and by suggesting that it was Jeanron who cast the single vote in the Jury des Récompenses for Courbet's *Afterdinner at Ornans* (1849–51). Clark later notes that without this initial success *Burial at Ornans* and *Stonebreakers* may never have been accepted by the Salon, which indeed places great credit with Jeanron and even relegates him to a position with "net-like power."

A Scene of Paris is also important in prefiguring later realist works for its portrayal of class distinctions. Thoré's elaboration upon the ideas of Laviron in 1857 called for figures to be observed from life, dressed appropriately for their role, and given an indication of their class in society. In this work, Jeanron fulfilled these requirements through the careful contrast of the fallen proletariat and the uninterested bourgeoisie who stroll away in the distance.[26] Even though the theme is couched in a Romantic-realist style similar to *The Little Patriots*, its social message could not have been missed. These qualities did not elude Laviron, who praised and fully described the work's obvious social implication. The gloomy, dark colors that cast a pall over the group, however, reflect none of the vibrancy of the Romantics. In fact, the choice of muted tones—a hallmark of the later realists—further indicates that Jeanron was a proto-realist artist. His unification of dour color with troubling themes to create images suffused with melancholy were quite in keeping with the proto-realist stance found in his Salon-rejected drawings of the period.

One writer has made much of the interpretation of the bourgeois couple in this image as a symbolic reference to Louis-Philippe and Queen Amélie.[27] This strolling pair

– *99* –

can be compared to *Menelaus the Victor*, a caricature by Daumier that also suggests the royal couple. Marrinan has pointed out that, although Louis-Philippe was fond of strolling around the Tuileries, by the time Jeanron painted this work, the king had been dissuaded from this practice by members of his staff who were concerned for his safety and for the ministry's increasingly negative image. This does not mean, however, that Jeanron did not include the bourgeois couple to signify the king and queen. On the contrary, to the freedom fighters, they were one and the same. This is why Daumier, Traviès, and Philipon, along with Jeanron, turned to depicting the middle classes when Louis-Philippe began to impose strict censorship.[28]

Rather than a "fabrication of a completely hypothetical account of Jeanron's intentions," the use of the bourgeoisie to represent royalty was already in place by 1833, specifically in the caricatures by Traviès. Jeanron would have been familiar with these images through his involvement with *La Caricature*.[29] Thus, it was through a well-established system of implication that Jeanron was able to comment on the policies of the king and his ministry. Placing the scene in an area known to be frequented by the royal couple strengthens this intentional implication, and whether or not Louis-Philippe had moved underground at the time that the work was exhibited remains beside the point.

In 1833–1834, when opposition to Louis-Philippe was spreading through secret groups—in which Jeanron was involved, as Rosenthal has documented—the artist emerged, by art and by deed, as a major champion of civil rights and the power of the people. In light of his Salon-rejected images that targeted Louis-Philippe's regime just when hostilities against the government were on the rise, Jeanron can be considered an officially recognized troublemaker, if not an outright candidate for political repression.

If this does not document Jeanron as a prefiguration of, or source for, later artists— if his staunch militancy, his dogmatic belief in democratic ideals, his truthful representation of society's ills, and his willingness to do what was necessary to ensure that his works were seen by a Salon audience do not sufficiently prove the designation of proto-realist to be accurate—an entirely different type of work should be studied, particularly those that endeared the artist to Linda Nochlin as a "kindred spirit" of Courbet.[30] Jeanron was among the first painters to practice "provincialism" by focusing on and dedicating his work to a region of France, in this case that of the Limousin. During the mid-1830s, as the government of Louis-Philippe moved ever farther from its promises to alleviate the conditions of the poor and disadvantaged, Jeanron spent more and more time away from Paris. His self-imposed exile in the Limousin occurred precisely when the "citizen-king" was meeting with considerable criticism and when he tried to suppress his adversaries through censorship. Among the king's restrictive measures were the September Laws, which threatened caricaturists and the literati with death should they continue to ridicule the "First Fruit of France" either directly or by implication.

It is likely that Jeanron fled to the Limousin to maintain his independence as much

as to ensure his freedom to probe proto-realist themes in the countryside. From late 1833 or early 1834, Jeanron resided near the city of Limoges.[31] He spent at least four years there, living with his wife's parents and passing considerable time in what has been called the château of Camborn in the Corrèze.[32] Although the countryside in this part of France was, and remains, quite impressive, Jeanron certainly was not a pure landscapist. Despite friendships with certain Barbizon painters, such as Charles Jacque, whose portrait he painted, and his avowed admiration for canvases by such landscapists as Jules Dupré and Paul Huet, who shared his ardent Republican viewpoints, Jeanron was not interested in following their dedication to painting the countryside per se. Rather, he sought out the people of the region that he had chosen to inhabit. To demonstrate the value of regional traditions and to underscore the native tendencies and folklore that were vital to understanding the true nature of the French, Jeanron focused on depicting the daily activities of the workers in the Limousin. He was especially attracted to those who labored in the fields, maintained native folkloric traditions, or worked at the forges (a native industry of the Corrèze as well). Jeanron explored the latter area in *Charity of the People: The Forgeworkers of the Corrèze*, an image that became a critical sensation at the Paris Salon of 1836.[33] Some would like to eliminate this work from consideration because it is now lost, and any idea of its precise subject and composition must be inferred from its title, which might prove misleading and erroneous. Fortunately, there exists a complete and accurate description of the work by a critic, none other than Théophile Thoré, who attended the 1836 Salon. His comments permit confirmation of the painting's proto-realist theme, style, and social implications.

> One remembers the powerful and resolute figures of the two blacksmiths, one of whom cuts a piece of bread for a poor woman. It is an art that is new, stylistically and in meaning, and one couldn't exist without the other because as artists became socially more aware it became necessary at the same time to renew a style that was degenerate. In other words to express all that is noble and elevated in human beings from all classes.[34]

As Thoré suggests, as Jeanron's career progressed he turned increasingly away from overtly propagandistic subjects and assumed a more simple and direct representation of the lives of common people. This strategy did not, however, indicate a loss of his proto-realist qualities. Instead, this image indicated a shift in Jeanron's work from one "location" of realism to another, that is, from the city to the country. It is in this provincial version of realism that Courbet would become accomplished and even radical in the size and treatment of his images. *The Forgeworkers* verified that strong ingredients of Jeanron's proto-realism were not only a dedication to a specific region and its people but also the maintenance of a powerful and affecting social theme. Such elements were united in creating an image that was still quite challenging for this period of the July Monarchy.[35]

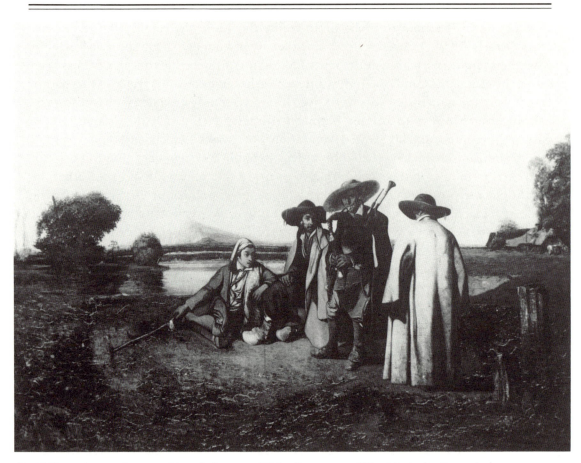

42. Philippe-Auguste Jeanron, *Limousin Peasants,* 1834, oil on canvas. Lille, Musée des Beaux-Arts

At a slightly earlier time, and with the same emphasis on Limoges, Jeanron completed *Limousin Peasants (Paysans limousins)* (fig. 42), in which he concentrated on regional types, the topicality of dress, and a rural gathering in which music is shared in the midst of nature. Produced at a time when critics were emphasizing the need for further documentation of provincial life and were calling for an artist to dedicate himself to a region in order to preserve in visual terms its dress and customs, the work made Jeanron a proto-realist in yet another distinctive way. This particular canvas, and the fact that it was exhibited in Paris while the artist was away from the city, did not go unnoticed. Jeanron was too well known for that. Those artists who were interested in the traditions of France as well as in a new style returned to his work in the 1840s to find inspiration for their own art.

Another large painting by Jeanron, entitled *Peasants at the Road Side,* further confirms the artist's interest in rustic genre. The grouping, which recalls the *Limousin Peasants*, prefigures a whole series of such peasant gatherings in the fields that would be

43. Philippe-Auguste Jeanron, *Don Quixote,* undated, watercolor.
Dijon, Musée Magnin

completed by painters later in the nineteenth century. The accurate depiction of cos-
tume, locale, and atmosphere, and the detailed treatment of the horse, attest to
Jeanron's ability to record in a highly realistic way what he saw.

Beyond his dedication to a specific region and his ability to render rural types in
large canvases, Jeanron's interests reached into the area of the graphic arts in the 1840s.
Always interested in producing illustrations to generate income, he acknowledged his
Romantic roots in images that interpret Cervantes' *Don Quixote* (fig. 43). These imagina-
tive watercolors, which captured the flamboyance of the central character and also

provided Jeanron with needed financial assistance, reveal another side or aspect to his creativity. He understood the necessity of creating popular Romantic images if the resulting commission allowed him to complete other work that was more in allegiance with his personal inclinations.

For the most part, Jeanron's illustrations of the early 1840s for such anthologies as *Stories of Past Times* did not require his astute sense of realism. Only occasionally were the stories that he illustrated based on actual scenes or involved with types observed in everyday situations. In the early 1840s, Jeanron's dedication to the Limousin was recognized in a positive way when Léon Curmer, an editor and a friend of the artist, asked him to complete a series of drawings for a section of *Les Français peints par eux-mêmes*, an encyclopedic series that recorded all aspects of French life in an effort to bring increased attention to regional types and to well-known figures from daily life whose traditional activities were about to be lost due to modernization.

Les Français became, later on, a fundamental source of information for understanding French life and for spreading popular imagery and stories. During the 1840s, and by relying on the talents of many artists and engravers, the volumes proved a rich source for the study of folklore, customs, and traditions directly related to the life of the people. There were few better ways for a proto-realist to put his images to the use of others than to be involved with this particular compendium.

Jeanron's contribution to *Les Français*, given the immensity of the project, was limited, and other artists received more commissions for illustrations. Yet, his dedication to the Limousin most likely let him use drawings that he had already made on location as the basis for a local curate, a merchant, or even a beggar. Each of the images was later engraved by others, so that ultimately Jeanron's initial representations of actuality might have been softened through reproduction and by designers who simply used his work as a starting point for the publication's illustrations. His participation in the project was nonetheless official recognition of Jeanron's status as a leading artist. That his images of the Limousin were well known indicates that he was recognized as a principal figure dedicated to a specific region. This attitude is significant for further discussion of the key aspects of the proto-realist style.

His drawings for *Les Français* were most likely based on studies that Jeanron had made in the Limousin beginning in the mid-1830s. These works, once again, emphasize the importance that the artist relegated to the medium of drawing and point up reasons why he had continually tried to exhibit these works in the public Salons. Since these drawings confirm Jeanron's newly found position as the principal recorder of the region's traditions and activities, and followed the precepts of an early realism, a further examination of the themes he selected from this period is imperative.

According to the records of the Archives du Louvre, notations of Jeanron's efforts to exhibit drawings with non-urban themes began in the early 1830s. The record book for 1834 states that his *Hunter in the Mountains* was refused by the jury.[36] Its large size,

however, suggests that this was not merely a sketch but rather a fully finished drawing capable of standing as a work of art. It is most likely that Jeanron was in the vanguard of realist artists who considered drawings to be finished works, not merely preparatory studies.[37] This change in attitude, which varied from standard academic attitudes, provides yet another reason for the drawing's rejection.

For the 1836 Salon, Jeanron submitted another drawing, entitled *Philosophe Campagnard*. Although it may have been close in spirit to a work now in the Cabinet des dessins in the Louvre, the size of the work and its unusual title suggest that it, too, has unfortunately not been located, despite the emphasis that Jeanron was giving to worker themes based on the Limousin. In the late 1830s and early 1840s, Jeanron's effort to show his drawings in the Salons ceased. He seems to have had some success in exhibiting portraits, a category in which he did not excel, and his interest in scenes of daily life went underground, only to resurface in the drawings that he sent to Curmer for use in *Les Français*.

Some exceptions to this scenario, however, are found. Drawings of figures fishing or carrying knapsacks on their backs (fig. 44) provide evidence of Jeanron's interest in either hunters—the paintings of Alexandre Decamps come to mind in the selection of this theme—or wandering types that trudged through the countryside accompanied by a faithful dog. It does remain uncertain whether Jeanron had a specific individual in mind with these works. The hunter's features often suggest both a specific person and the artist's attempt to record a regional "type." The treatment of the drawing is also significant: the coarse, blunt charcoal lines emphasize that Jeanron was working from life, and quite rapidly at that. This is not a typical, set studio piece. Instead, Jeanron has employed an awkward, crude style to underscore his directness of purpose, which further reinforces his proto-realist manner for recording an outdoor type.

The recent discovery of another drawing, on blue paper, further elucidates Jeanron's attraction to scenes of everyday life in the Limousin. The configuration of the drawing, here called *The Meeting* (fig. 45), raises serious questions about Jeanron's relationship with other painters, specifically with the dean of French realism, Gustave Courbet. While mention of this drawing does not appear in the existing literature on the artist, and no notation of any drawing with this theme is found in the Archives du Louvre's records of the annual Salon, Jeanron did exhibit a painting at the 1836 Salon entitled *Shepherds of the Midi* (*Bergers du Midi*) (unlocated).[38]

While it may be difficult to accept the figures in this work as shepherds, and no flock is in evidence, the fact that Jeanron focused on another category of regional types during the 1830s, while in the Midi, provides sufficient reason to date this drawing during, or close to, the period of time when Jeanron was living in the Limousin. In its choice of theme and setting of figures, it also prefigures Courbet's *The Meeting* or *Bonjour Monsieur Courbet* and a related work by Courbet, *The Homecoming* (1852).

Clearly, the image represents two figures of the Limousin, dressed in regional garb,

44. Philippe-Auguste Jeanron, *Hunter and Dog,* undated, drawing. Paris, Musée du Louvre

45. Philippe-Auguste Jeanron, *The Meeting,* undated, drawing. Private collection

encountering one another in the midst of an expansive plain. The figure at the left, with a knapsack draped over his shoulder, a hat bent over his head to protect himself from the sun, and a long walking stick, seems to have traveled a long way to meet the figure at the right. He has, at least, been stopped on a journey. Jeanron's treatment of the figure at the right is also worth noting. He stands back and removes his hat, engaging in conversation with the other wanderer. The man at the left possesses the air of an itinerant worker, who has approached his new patron in the open countryside.

This congenial meeting, which Jeanron emphasizes by placing his protagonists in the frontal plane, occurs in a setting in which they stand out in sharp relief from their surroundings. The sense of journey—of one friend or worker traveling to meet another—is conveyed in a study that would have strong resonance for the future by further establishing Jeanron as a proto-realist whose compositions were important for the evolution of themes and formats used by Courbet.

Undoubtedly, the temptation is strong to demonstrate that this drawing was a usual source upon which Courbet relied for his well-known *Bonjour Monsieur Courbet* of 1854. The analysis of this painting, which has often been tied to literature and to

apocryphal stances by Courbet, as well as to the visual and literary tradition of the "wandering Jew," might be more easily and readily explained if Courbet knew of other works—by a proven proto-realist—that addressed similar issues and employed an organizational scheme that was so strong as to be visionary. It lends further credence to the belief that the proto-realists were not operating in a vacuum and that their imagery influenced others in ensuing decades.[39]

A second artist who used drawing strategically was Charles-Joseph Traviès; he worked for *La Caricature* at the same time as Jeanron. Best known as a caricaturist, his drawings were well supported by none other than the art critic Charles Baudelaire. Writing at a slightly later date, Baudelaire found Traviès to be a draftsman of consummate skill, "an outstanding artist . . . and one who was not nicely appreciated in his own time."[40]

Among Traviès early drawings is his image of *Barbès in Prison*. As a professional revolutionary who was active in undermining the power of the July Monarchy, Barbès received the support of some leading members of the agitational press, particularly those who worked hard in the early 1830s to see that Louis-Philippe was ousted. Traviès completed a drawing that showed Barbès in prison, where the activist was often found due to his involvement in revolutionary plots to overthrow the government, and leaning against a wall in a mood of romantic introspection and isolation.[41] The work more than records Barbès' appearance: it can also function as an allegorical statement of what was likely to happen to insurrectionists, and it certifies that Traviès was sympathetically aligned with those who agitated for social change. This drawing also served as a preliminary step to a painting that Traviès ostensibly sent to the 1835 Salon and which was purportedly rejected by the jury because it focused on a leader of the insurrectionary movement at a time when such issues were still sensitive. Although the painting has been lost, the drawing did not go unnoticed by others at the time. It was apparently reproduced as a lithograph in *La Revue des peintres* (1835) and circulated as a reminder of Barbès' imprisonment and unjust condemnation by the government. The lithograph also promoted the cause of liberal Republicanism by providing a ready, "at hand" image of an agitational hero. Obviously, certain aspects of proto-realism were utilized to fan the flames of social change and to keep alive the memories of those who had championed liberal causes.

As with Jeanron, the majority of Traviès' drawings have disappeared. A search of the available archives and the numerous museums of France has failed to uncover the range of drawings that would have allowed Baudelaire to make his astute comments in the 1860s. While there is no dearth of prints, and many of these images have their roots in realist themes and images, the drawings per se either have been destroyed or remain, for the moment, lost to posterity, thus hampering an exacting assessment of the place Traviès occupied both in the evolution of proto-realism and of the ways in which this tendency could have influenced artists of the late 1850s and early 1860s.

At least, this seemed to be the case until several drawings were recently located. An examination of these images provides a broader context in which to consider the artist. Given Traviès' penchant for caricature and character analysis, the likelihood remains that a number of his drawings were quickly realized sketches that played upon the humorous. This certainly is true with his jailer (fig. 46), whose set of keys is subordinate to the unusual slant of his body and to the artist's trenchant ability to present this personality's vacant stare. Possibly developed from Traviès' own visits to, or stays in, prison (he was actually put in Ste. Pélagie for a time), this drawing may have been completed at approximately the same time as his portrait of Barbès—at the height of the first phases of the July Monarchy. While it is not possible to document the number of such free sketches that the artist created, the fact that this was done in pen and ink suggests that he worked quickly, basing his images on actual persons or on those social types that passed through his world. This drawing, similar to his development of a caricature, could have been one of hundreds that Traviès made in order to arrive at an image that he could utilize for a print. Others, of beggars or tramps on the road, display a compassion with the less fortunate.

Another ink drawing of a ragpicker (fig. 47) moves closer to the established host of types and themes that would emerge as part of proto-realism and would be used by artists beyond this frame of reference, such as François Bonvin. The comment at the right—what rotten luck—draws attention to the unfortunate figure who is trying to eke out an existence from the gleanings of society. Dressed in a rumpled top hat and carrying a tall, long stick and a bag for rags, there is little doubt that here is a prototypical ragpicker, a type that would appear in many other, although slightly later, realist drawings. Bonvin's drawings from the early 1850s suggest the ways in which Traviès' composition could have served as a model. While it is difficult to ascertain the exact date of Traviès' drawing, the probability is strong that it was completed early in the July Monarchy. It seems to be among the first attempts of any proto-realist artist to come to terms with a social type that would dominate realist drawings and would even be found in some crucial paintings of Manet during the 1860s.

The question remains as to the number of drawings of such ragpickers and homeless wanderers that Traviès could have produced and to which Baudelaire was attracted. While the answer is difficult to determine, the existence of other drawings of wanderers, sometimes with small children, posed against a desolate countryside, raises the possibility that the proto-realists were on to new types and categories of figures as a way to propagandize that vast numbers of people in society were ill-treated and had been forgotten by the July Monarchy. A drawing of cooks and workers further dramatizes this message.

One final drawing by Traviès needs to be examined (fig. 48). In his charcoal depiction of a drunkard (*soûlard*), Traviès transcended the July Monarchy. Although this drawing, like most of the artist's work, is undated, here again he depicted another type

47. Charles-Joseph Traviès, *A Begger*, undated drawing. Perpignan, Musée des Beaux-Arts

46. Charles-Joseph Traviès, *A Jailer*, undated, drawing. Perpignan, Musée des Beaux-Arts

48. Charles-Joseph Traviès, *A Drunkard,* undated, drawing. Perpignan, Musée des Beaux-Arts

that symbolized a deeply rooted social problem. Alcohol and its effects came under greater scrutiny as the century progressed. The pressures of city life and the sense of alienation experienced by many led to an increased concern with alcoholism. Drunkards were everywhere and, similar to the ragpicker, became an appropriate theme for proto-realists fascinated by the environment's effect on people and the prevalence of types that had to be visualized and explained. In this case, a drunkard, his hands in his coat pockets and his hat slightly askew to suggest his tipsiness, leans against a wall for support. While a sense of unsteadiness is not as pronounced as in Manet's *Absinthe Drinker* of

1859, Traviès is heading in the same direction by trying to suggest the effects of alcohol. Although this drunkard is not as exaggerated in appearance as that of Manet, Traviès was nonetheless exploring ways to depict a social problem so that none could miss his message or deny that this type of individual actually did exist in society. In effect, then, Traviès the proto-realist introduced a set of themes or types that affected the course of realist art. Since these drawings were known in 1859, when Traviès died, it is little wonder that Baudelaire was impressed by what this artist had accomplished.

With the continued discovery of drawings and early paintings by Jeanron and Traviès, their position in the creation of a viable proto-realism, both in terms of the selection of theme and the creation of strategies of selection, is assured. The fact that some of their images provide parallels to the works of far better known artists who were active at a slightly later date raises the complex issue of whether Jeanron's or Traviès' compositions were studied by more adventuresome artists and can ultimately be accepted as "true prefigurations" of future art.[42]

Since Baudelaire was at least one enthusiastic supporter of Traviès, the artist's compositions must not have been hidden away by the 1850s. Thoré's later comments on Jeanron indicate that this artist's works were accessible as well. Both men were appreciated by those who were central to the argument surrounding the definition of "modern." Renewed examination of Jeanron and Traviès directs increased attention to those artists whose early forms of realism—albeit tinged with Romantic qualities, as in the work of Courbet—made the July Monarchy a cauldron of new visual ideas. Their use of themes does not seem to be an accident of history. Instead, their configurations prefigured the slightly later efforts of artists in the evolution of socially centered realism.

V

Historical Vision and the Writing of History at Louis-Philippe's Versailles

MICHAEL MARRINAN

EVEN TODAY scholars committed to the specialized study of painting produced in France during the reign of Louis-Philippe—and especially those interested in pictures of historical events—must contend with the searing criticism leveled against such works by the veritable doyen of the field, Léon Rosenthal. Writing in 1914 about those painters he described as *juste milieu*, and after belittling their attempts to steer a "middle of the road" course between the strong poles of "romantic" and "abstract" styles, Rosenthal concluded that whether

> fully elaborated or abridged, the machines in which the juste milieu had placed its highest ambitions and by which it aspired to artistic greatness, constitute the most debatable part of its achievement. The juste milieu becomes easier to accept when it renounces the grand manner that it only knows how to simulate, for then it can devote itself to the ingenious presentation of ingeniously selected subjects. These are the usual concerns of illustrators and, in fact, the juste milieu is above all else engaged in illustration. [1]

It will not be necessary to rehearse the aesthetic bias that informs Rosenthal's assessment, for his own preferences are now fairly easy to recognize. [2] Rather, I want to begin by suggesting that Rosenthal's remark about the illustrational character of the imagery he calls *juste milieu* is actually an appropriate description of its achievement—an achievement intimately connnected to the particular situation in which most pictures of modern history were painted during the July Monarchy. Thus, my purpose is neither to

refute Rosenthal's criticism, nor to supplant it with a more sympathetic view, but simply to sketch the logic of that situation as a first step towards understanding how illustration came to supplant the received notions of what constituted ambitious history painting.[3] Indeed, a study of the visual mechanics of these pictures strikes me as historically more useful than embedding them in an amorphous ideological web of generalized cultural eclecticism,[4] or making them the inevitable product of a presumably "low brow" middle-class taste,[5] for it offers the possibility of understanding why such pictures look the way they do and how they were able to generate an enthusiasm from contemporary critics that seems irrecoverable today.

Consider two paintings that represent episodes from July 28th, the second day of the 1830 Revolution that brought Louis-Philippe to power: *The Capture of the Hôtel de Ville* by Amédée Bourgeois (fig. 49) and Eugène Delacroix's *28 July: Liberty Leading the People* (fig. 50).[6] Both of these pictures were exhibited at the Salon of 1831 and both were purchased by the government: the king's Civil List paid for the Bourgeois; the Interior Ministry for the Delacroix.[7] Yet it would be difficult to imagine two histories that diverge more sharply than the critical trajectories traced by these works after their joint appearance at the Salon. Delacroix's *Liberty* was hidden from public view during most of Louis-Philippe's reign, while the Bourgeois took its place at Versailles among pictures that recorded events of the July Revolution and the Citizen-King's accession to the throne.[8] This is the kind of history one might be inclined to mobilize if arguing that leaders of the July Monarchy were simply purveyors of bad taste who lacked aesthetic sensitivity, and I suspect that most of today's museum curators would not agree with their exhibition policy. Not surprisingly, the situation is now exactly reversed: *Liberty* hangs in a place of honor in the Louvre while the Bourgeois has disappeared into the north-wing, attic galleries of Versailles that are usually closed to the public. Nevertheless, if we believe museum curators have corrected a glaring error of judgment, we seem obliged to conclude that those in charge of Louis-Philippe's collections had fundamentally misunderstood the meaning of artistic quality.

Comparing these two works should also provoke reflection upon our contemporary standards of "greatness" and it is not too difficult to summarize why we prefer the *Liberty*. Although proceeding from an incident of the 1830 Revolution, Delacroix converted a mere *fait divers* into "Art" (with all the cultural loading implied by the capitalization) using strategies of representation—including a highly autographic technique—that participate fully in the grand tradition of European painting: he emphasized figures over place; he organized them into a compact, triangular mass; he turned them to confront the viewer directly; and, of course, he gave form to a heroine who balances allegory and physical presence with her bare-breasted and barefoot charge from a space dramatically framed by the fluttering tricolor banner and the barrel of a gun.

In contrast to the lofty visual rhetoric of the Delacroix, Bourgeois' rendering of the

people's attack on the Hôtel de Ville seems hopelessly flat-footed and prosaic. Yet it too participates in a tradition—albeit not the grand tradition—of image-making: here I mean to invoke the circulation of so-called "popular" art forms that broadly defined the parameters of the event called "the revolution of 1830."[9] It is neither mere accident nor direct "influences" that account for the striking visual similarities between Amédée Bourgeois' picture for the Salon and a characteristic print of July 28th by an unknown engraver (fig. 51).[10] The centralized presentation of the bridge where a young man died leading a fearless charge against royalist soldiers; the care to signal specific landmarks (the Hôtel de Ville, the church of Saint-Gervais); the concern to describe several types of citizens in revolt (bourgeois in top-hats, workers in shirtsleeves, women who serve as field nurses); the recourse to an elevated vantage point that affords the viewer a wealth of narrative vignettes in the foreground without relinquishing visual command of the entire locale: these are all visual tropes constantly repeated within the "low art" imagery of the revolution.[11] Indeed, any representation—visual or verbal—that claimed to "represent" the recent revolution was forced to take stock of its collective imagery.[12] Even Delacroix, despite his predilection to see the revolution through the lens of tradition, could not ignore this visual vocabulary, for doing so would be to risk the charge that his picture was simply not "true": the unspoken parameters of "appropriateness" shaped and defined by "popular" retelling compelled him to include not only a prominent tricolor flag, but also a cast of familiar characters, the rubble of a barricade, and reference to a familiar landmark—in his case the towers of Notre Dame. We might say that these elements serve less to locate the action specifically on the map of Paris (which they do not) than to locate the picture within the body of imagery that clarified the episodes and consecrated the sites of the recent revolution.

The preceding observations lead directly to a two-pronged question that strikes me as central to our understanding of history painting during the July Monarchy: why would government patronage of the arts shun the grand tradition for that of a "lesser" cultural prestige? Why would it willingly promote the visual strategies of "illustration"? I believe we can hazard some preliminary answers to such questions if we pay attention to three overlapping issues suggested by the Delacroix-Bourgeois comparison: first, the specific cultural work performed by pictures like the Bourgeois; second, the kind of viewer constructed by them; third, the type of spaces where such works were destined to appear. As we shall discover, each of these issues can be linked to the largest cultural project of Louis-Philippe's reign: the recycling of the château at Versailles into a museum dedicated "à toutes les gloires de la France."[13]

THE CENTERPIECE of the new musuem was the Gallery of Battles (fig. 52), a cavernous, sky-lighted space created by gutting the south wing of the château. Indeed, there are probably specific political motives behind Louis-Philippe's decision to destroy three floors of domestic interiors—private apartments used by those courtiers closest to

49. Amédée Bourgeois, *Capture of the Hôtel de Ville*, 1831, oil on canvas. Versailles, Musée National du Château

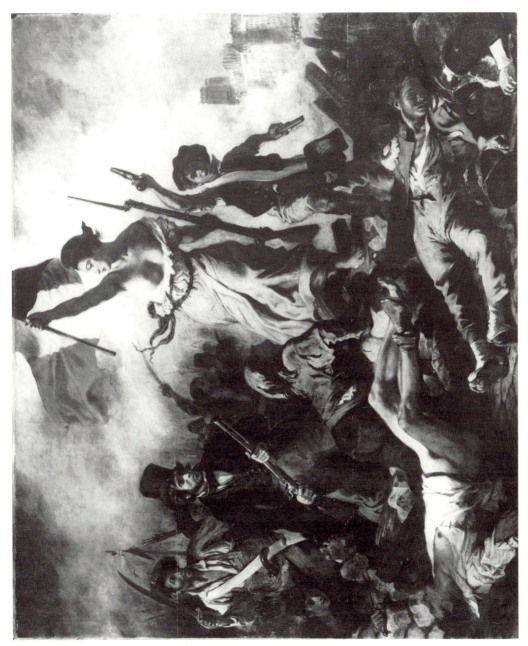

50. Eugène Delacroix, *The 28th of July: Liberty Leading the People*, 1831, oil on canvas. Paris, Musée du Louvre

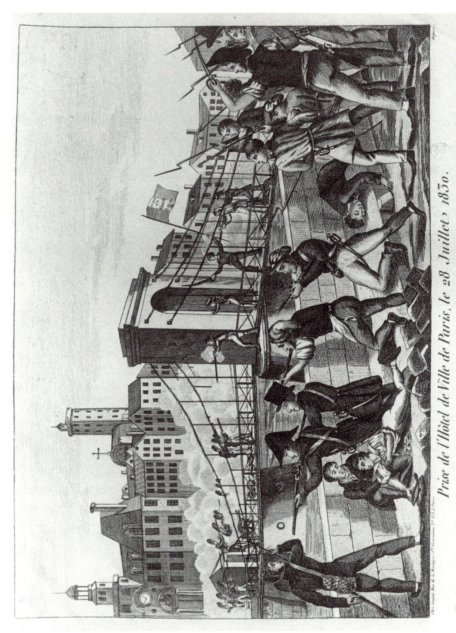

Prix de l'Hôtel de Ville de Paris, le 28 Juillet 1830.

Tandis que le peuple de Paris affrontait la mort sur la Place de l'Hôtel-de Ville les habitans de la rive gauche de la Seine se portèrent au Pont de fer qui est vis-à-vis cette Place, et malgré la mitraille, et les feux de peloton des gardes royales; ils firent une si forte résistance que jamais cette garde ne put s'en rendre maître. C'est au milieu de ce carnage qu'un jeune homme qui portait un drapeau tricolore s'avança à dix pas de la garde royale, en disant à ses camarades: "Je vais vous montrer comment on sait mourir" et je meurs, soyons; mais que je me nomme BARIOLE, il tomba à l'instant même percé de plusieurs balles. Le Pont que Napoléon passa en italie se nommait Arcole; d'où l'on dit le pont d'Arcole. Celui de l'Hôtel de Ville se nomme BARIOLE; non de celui qui s'y présenta avec le plus d'intrépidité sur le Pont.

51. Anonymous, *Capture of the Hôtel de Ville of Paris, 28 July 1830*, 1830, engraving. Paris, Musée Carnavalet

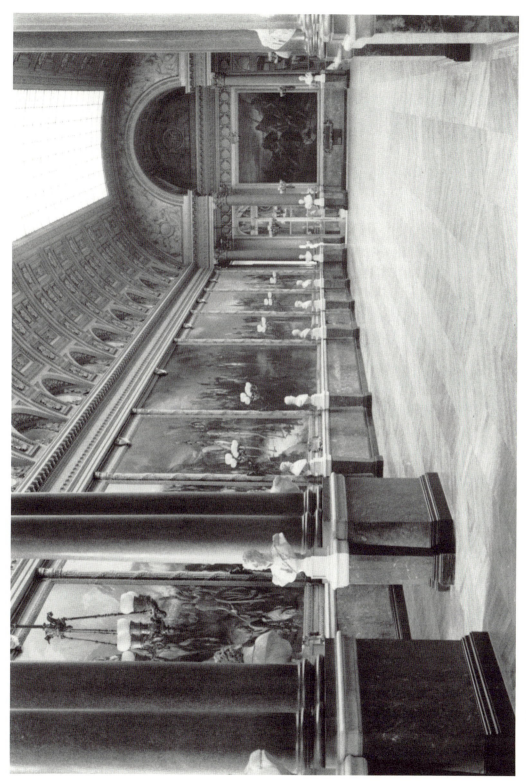

52. *View of the Gallery of Battles at Versailles*, northwest corner, with pictures of Napoléon by Gérard and Vernet

the throne under the ancien régime—to construct a single, public space designed to honor the nation's military exploits, for doing so literally replaced the château's old structure of privilege with a vision of shared national pride. [14] The gallery was designed to house thirty large paintings, some of which were "recycled" from prior duties and past regimes: for example, François Gérard's painting of Henri IV welcomed to Paris in 1594, following his conversion to Catholicism, had been commissioned by Louis XVIII in 1817 as a piece of propaganda geared to historicize the return of the Bourbon monarchy after Waterloo. [15] Within the Gallery of Battles, however, this meaning was "recontextualized" as an historic precedent for current events: if the acclaim of Paris was a sufficient mandate for Henri IV to assume political power in 1594, it could also serve to justify Louis-Philippe's accession in 1830, and it was presented as such on a grand scale in the adjacent gallery at Versailles by Charles-Philippe Larivière's picture, *The Duc d'Orléans Arrives at the Hôtel de Ville*. [16] If we limit our discussion to the selection of visual material already on hand, it does seem correct to assume that the Gallery of Battles was designed to effect a kind of political reconciliation between the newly minted Orléanist regime and the country's recent past. [17] But such a reading is complicated by the fact there there were also many new commissions awarded for pictures destined to hang in the Gallery of Battles, and Louis-Philippe apparently made a conscious effort to distribute them among as many contemporary painters as possible. [18] Indeed, the king's seeming concern to include artists of several stylistic currents within this important gallery has led some art historians to argue that the overall installation constructs a related, second-order reconciliation within French cultural life, one in which the lively critical debate between "ancients" and "moderns" (or Classicists and Romantics) was deliberately mediated and publicly cooled by a government seeking to find a "middle of the road" in art and politics. [19]

Although it seems to make fairly good sense that we interpret the Gallery of Battles as an arena of political reconciliation, I remain skeptical of the art-historical argument that describes the gallery as one attempt among many to calm the diverse aesthetic currents of mid-century France. Obviously, the elegance of an argument that posits a neat symmetry between aesthetics and practical politics is attractive, but it literally fails to see the peculiar type of decorative complexity we find in the Gallery of Battles and throughout the museum. To cite one example: the galleries dedicated to the crusades consist of pseudo-Gothic wall and ceiling mouldings carrying an encyclopedic assemblage of coats of arms that might be said to construct a synthetic political message; yet this framing system is so out of synch with the style of its pictures that the gallery could only be seen as a thoroughly botched attempt to mimic its supposed "middle of the road" political program. [20]

Nor could we say that Versailles was designed to recreate a social space in the manner of Williamsburg, for Louis-Philippe's galleries contained virtually no artifacts or references to the daily existence of ordinary citizens. All of which leads me to suggest,

or perhaps only reaffirm, that Versailles was designed to be an historical space, meaning a space where the narratives of history are told and retold. Its galleries construct a specialized viewing situation, one in which notions of artistic "schools," or an individual painter's "style" were not simply of secondary importance, but largely irrelevant. I believe the significance of this point will become clear if we turn our attention to the complex architectural settings of the galleries, settings elaborated with great care under the direct supervision of Louis-Philippe himself.[21] Spaces such as the Gallery of Battles or the Crusades Galleries provide a visitor with far more "information" than the pictures they house: portrait busts, names and dates inscribed on wall panels, mouldings decorated with coats of arms are just some of the means used to multiply severalfold the number of specific historical references mobilized by the pictorial installation. We might say that the viewing spaces at Versailles are richly nominative; that is, everywhere articulated by repeated references to specific dates, characters, and episodes that "flesh out" the chronological parameters established by the pictures on display.

This cross-cutting and articulation of the museum's viewing space by means of multiple references to what might be called historical data led me to wonder if our critical expectations for modern art museums—especially their simulation of narratively inert "formalist" spaces—were obscuring the fact that Versailles was designed above all to structure an historical narrative, and that its pictures were expected to operate in rather unconventional ways.[22] Assuming that Louis-Philippe's museum does not construct an aesthetic space, but rather an historical space designed to shape disparate incidents into the kinds of cognitive unities we usually call "events," I began to cast about for ways to frame a discussion of its unorthodox viewing situation. I soon realized that historians have long wrestled with an exactly parallel theoretical problem: namely, how it is that acts or moments from the past—known only by the archival traces they have left—can be molded into coherently unfolding "events" by narratives written in the present.[23] What I did not realize, at least at the outset, is that the issue has generated much disagreement; nevertheless, given the type of historiographic encounter structured by the galleries at Versailles, I was especially attracted to the writings of Michel de Certeau and, in particular, his analysis of the reciprocal relationship between "events" and their constituent "facts" that he sketched in *L'Écriture de l'histoire*. "The event is what carves out (*découpe*) so that there might be something distinct," he writes; "the historical fact is that which fills up (*remplit*) so that there might be meaningful statements. The former handles the organization of the discourse; the latter provides the signifiers destined to form, on the level of narrative, a series of significant elements. In short, the first articulates, the second spells out."[24] De Certeau suggests that historical narratives—precisely because they are narratives with beginnings, middles, and conclusions—pre-organize the historian's discursive field into a series of discrete "event-containers" that the writer "fills up" by generating multiple references to "facts." His special insight was to remind us that the process of writing the history of an event does

not stop when all possible "facts" have been enumerated, but actually far sooner: we stop writing when troublesome lapses in the narrative thread are sufficiently smoothed over—either by citing evidence or mobilizing other linguistic tools—so that the "event" (the narrative) makes "sense" and can be allowed to close.[25]

I want to suggest the obvious: that the "event-containers" at Versailles are quite literally architectural spaces—galleries designed to maximize the display of facts—whose narratives "make sense" when they seem to be completely "filled" by the facts they make visible. Consider, for example, the Gallery of 1792, a rectangular box whose two short ends are anchored by large paintings (figs. 53, 54) that represent battles from that year: Valmy (22 September) and Jemmapes (6 November).[26] That these two subjects figure prominently in Louis-Philippe's gallery is not surprising, for the future monarch (at that time the duc de Chartres) had fought honorably in both battles; in fact, the pictures at Versailles are large-scale replicas of originals that belonged to the king's personal collection.[27] Beneath the painting of Valmy hangs a work by Léon Cogniet (visible in fig. 53) that represents the National Guard of Paris leaving the city in September 1792 to counter the threatening advance of Brunswick's army.[28] The long walls and window casements of the gallery are everywhere covered by portraits of French generals (including the young Louis-Philippe),[29] while three pictures of skirmishes between French and Prussian forces just before and after the two principal battles complete the pictorial program.[30]

Despite the gallery's physical completeness, historians of the French Revolution will surely recognize that its choice of subjects leave large, gaping holes in the story of 1792: on the 10th of August an angry crowd invaded the Tuileries palace, forced Louis XVI and Marie-Antoinette to seek protection within the National Assembly, and prompted a vote that suspended the monarchy; on 20 September the National Convention opened its session and the most radical phase of the Revolution; Parisian crowds invaded the prisons and summarily executed thousands of inmates in early September, and so on. It is surely correct to say that in the precarious political calm of 1834 Louis-Philippe wanted very much to forget the radical, grass-roots activism of 1792 when laying out his gallery at Versailles, but that commonplace merely begs the question at hand. Rather, the selective plenitude of information organized by the Gallery of 1792 ought to remind us that it was designed to be an apparatus of historical narration—not an arena of aesthetic delight—and encourage us to ask an important art-historical question: how does the operation of this apparatus alter the function and status of the pictures on its walls?

It is fairly easy to quibble with the particular collection of facts assembled by the Gallery of 1792, but one of the peculiarities of historical narratives in general is the impossibility of proving the "truthfulness" of one over another—a difficulty created because narratives are by their nature stories told after the fact.[31] We cannot simply weigh the merits of rival stories based on the quantity of factual material they reference,

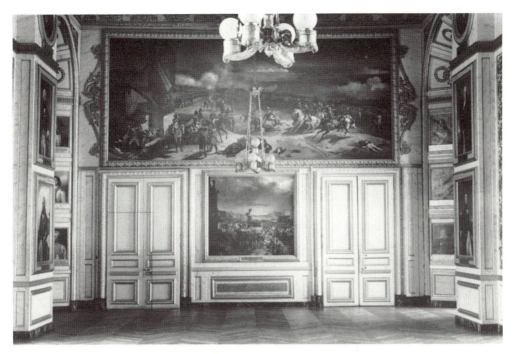

53. *View of the Gallery of 1792 at Versailles*, north wall

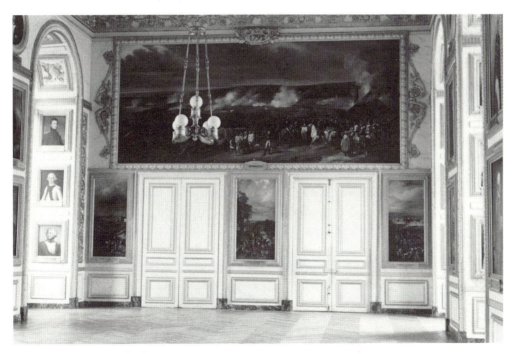

54. *View of the Gallery of 1792 at Versailles*, south wall

for that implies a collection of "more facts" might somehow be capable of bringing the past closer to us; yet few of us believe that events can be experienced more than once before they are forever lost in time past.[32] Nor is it possible to determine the relative quality of facts mobilized by competing historical narratives, because—as Roland Barthes and others have pointed out—arguments of this sort never leave the realm of language: "facts" are not real objects, but only signifiers within the linguistic order of our arguments; as such, they remain logically equivalent to one another regardless of what they signify.[33]

Although we cannot prove the "truth" of historical narratives, we regularly decide that some accounts are more compelling than others: how do they compel? What convinces us to accept the authority of their descriptions? An audience expects narrators of the past to cite documents and, in scholarly texts like the essays in this volume, such citations usually take the form of footnote references.[34] Footnotes register the narrator's familiarity with the "facts" of the event being described. They are literally gestures of "pointing out" by which the narrator successfully directs the attention of his or her audience toward a specific spot in the archive—that accumulation of material traces left by an event in the form of letters, memos, artifacts, and so on.[35] Successful direction of audience attention through this mass of detail demonstrates, above all else, the narrator's mastery of the archive. While no narrative would be so foolish as to claim that it circumscribes all the possible facts, its ability to compel depends absolutely upon demonstrating an unfaltering mastery of the archive that exceeds the expertise of its audience. This is an important point: to narrate the past while referencing the archive constructs a particular kind of audience, one that is assumed to know less than the story teller. Why is this so? Because if we know as much or more than the narrator—if, for example, we are able to pick out "mistakes" in his or her references to the archive—we no longer feel obliged to continue listening to the story; it fails to compel us, and we turn our attention elsewhere. The flip side of this situation is equally important: insofar as we continue to read or listen to an historical narrative, we demonstrate a submission to the narrator's voice. Indeed, one of the peculiarities of historical discourse is that a mastery of documents becomes a mastery of one's audience. "The internal structure of the discourse executes a chicanery," writes Michel de Certeau, "it produces a kind of reader: an addressee cited, identified, and informed by the very act of being put in the same position as the simple chronicle before knowledge. By organizing the textual space, it establishes a contract and organizes a social space. In this sense the discourse does what is says: it is performative."[36]

One might well ask how these abstract comments relate to the Gallery of 1792 at Versailles, but consider the experience of a museum visitor passing through that space: at each step the installation invites the visitor to "point out" a face or a fact and, in so doing, generates multiple and recurring shifts of attention analogous to footnote references in an historical text. The viewer's passage through the gallery is sliced into discrete

Porte d'entrée de la salle de 1792.

55. Vignette from *Versailles ancien et moderne* by Alexandre de Laborde,
1841

moments, each defined by a shift of attention and a gesture of pointing and recognition.
In short, the gallery structures the viewing encounter as a sequence of moments that
simulates the passage of days and months of the year 1792.[37] As with any simulation,
this process must be controlled if its illusion is to be effective, and we might ask: how or
what provides the control at Versailles? In an ideal world of the sort depicted in
Alexandre de La Borde's *Versailles Ancien et Moderne* of 1841 (fig. 55),[38] a veteran of
Napoleon's Grande Armée rounds out each moment of the simulation with an appropri-
ate narrative embellishment; we assume, for example, that when drawing the children's
attention to the portrait of Bonaparte he greatly extends the moment by regaling them
with a lengthy tale. In fact, this little vignette illustrates exactly my principal point

about the galleries at Versailles: viewing involved gesturing at pictures to the tempo of an historical narrative.

For the average visitor to Versailles, official guidebooks (fig. 56) offered readily available "roadmaps" to the museum's space, and they calibrated the tempo of its historical simulation.[39] Reprinted nearly every year so as to keep pace with the regular opening of new galleries, the guides were usually comprised of several sections: a general history of the château from the time of Louis XIV to its present incarnation as a museum; a review of the points of interest visible during the rail trip from Paris to Versailles; a guide to the gardens; a "short" room-by-room overview of the principal galleries; and, most important, a lengthy historical section that presents events in chronological order and makes reference to appropriate imagery wherever it might be found within the museum's galleries. In other words, the largest section of the guidebook consists of an historical narrative that serves to link visual "facts" physically dispersed among different parts of the château.

I am fairly certain that most historians would find nothing unusual in this, because historical writing generally does draw together bits and pieces of evidence stored in repositories scattered around the globe. I am also willing to admit that the peculiar bias of my training as an art historian prompts me to see the narrative situation at Versailles as worthy of note, for it produces a rather unusual set of forces upon the design and viewing of history pictures. Art historians know that since the seventeenth century the theory and practice of history painting in France emphasized the importance of a picture's *premier coup d'oeil*: it should construct a visually unified narrative so that the relationship of parts to whole—or facts to event—can be grasped by the viewer at a single glance.[40] It was also understood that a painter might be forced to introduce certain kinds of adjustments to the "facts" presented in order to mediate the complex temporal and spatial differences that separate the experience of seeing a narrative from that of reading it.[41] Indeed, we can measure something of the inevitable clash between the practice of history painting and the writing of history by paying attention to how François Gérard's famous picture of *Austerlitz* (fig. 57)—elaborated according to time-honored principles of visual narration—was inserted into the account of Austerlitz at Versailles.[42]

Napoleon's stunning victory over the combined forces of Russia and Austria in December 1805 is still studied as a model of brilliant battlefield strategy,[43] and Gérard's picture had been commissioned by the emperor in 1806 to decorate an appropriately prestigious public space—the ceiling of the Conseil d'État.[44] As we might expect, it was designed to refer directly to the planning that had brought victory to the French: the scene is set on the plateau of Pratzen, at the very point where the French cavalry had pierced the Russian lines, divided their forces, and closed the trap that Napoleon had so carefully prepared. The picture's narrative unfolds from left to right, and orchestrates the viewer's experience to culminate on the resplendent equestrian figure of Bonaparte:

VERSAILLES

ET SON

MUSÉE HISTORIQUE

DESCRIPTION COMPLÈTE

DE LA VILLE, DU PALAIS, DU MUSÉE, DES JARDINS
ET DES DEUX TRIANONS;

précédée

d'un Itinéraire de Paris à Versailles,

suivie

D'UNE NOTICE HISTORIQUE, PAR ORDRE DE NUMÉROS, DE TOUS LES
TABLEAUX, PORTRAITS, BAS-RELIEFS, STATUES ET BUSTES;

et ornée de Plans et Vignettes gravés sur acier.

Dans le Musée,

AUX GALERIES HISTORIQUES DE VERSAILLES.

56. Title page from *Versailles et son musée* by Janin, c. 1841.

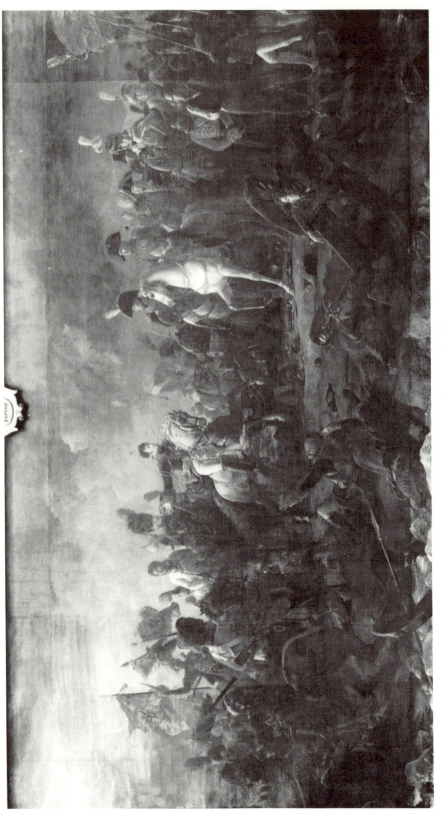

57. François Gérard, *The Battle of Austerlitz*, 1810, oil on canvas, Versailles, Musée National du Château

at the far left, vestiges of the battle (barely visible within the interstices of the screen of principal characters) alternate with the arrival of captured banners; further toward the center—and riding in the same direction as our visual scan—General Rapp announces with great excitement that the elite troops of Tsar Alexander's Imperial Guard have been routed, have fled to a frozen lake, and are drowning by hundreds as the ice cracks. Rapp's headlong gallop is met by Napoleon's reversed placement both to arrest the lateral movement and to emphasize his calm amidst the general melee. At the far right, a contingent of key advisers and a company of foot soldiers, their backs to the frame, anchor the action and close the narrative at the physical "end" of the visual field. In short, Gérard structured the picture's narrative energy so that it builds to a crescendo at the emperor's feet, and he accented the fact by bathing the principal player and his white horse in an intense, raking light against a relatively dark ground. Finally, the grisly display of cadavers strewn across the foreground space, the poignancy of wounded soldiers who struggle to respond to Rapp's announcement with joy, the striking expressions of consternation on the faces of captured Russian and Austrian officers all serve to root the viewer with a corporeal fixity: what we know of the battle is limited by the parameters of "normal" vision and the geography of where we stand.

Given the significance of Austerlitz to Bonaparte's biography and the high visibility of the picture's commission, it is not terribly surprising that Gérard adjusted the work's visual and narrative logic to aggrandize the commander-in-chief. What is surprising, however, is that the painting's visual drama counts for very little within its new viewing environment at Versailles. We might even say that it is ignored insofar as Gérard's cast of characters, and his careful visual integration of separate narrative moments, are dispersed across four pages of text that describe the event by referring visitors to several images hanging in different parts of the museum (figs. 58, 59).[45] The guidebook nowhere comments upon who or what we actually see in the picture, but offers instead a general account of the battle that Gérard had relegated to the background interstices. On the following two pages the text describes events that occurred well after the victory: an especially revealing detail concerns picture number 803 (see fig. 59), *The 1st Batallion of the 4th Regiment Presents to the Emperor Two Banners Taken from the Enemy at the Battle of Austerlitz*, which is listed in the guide without naming the artist. In fact, the picture had not yet been painted, although its "place" within the museum's narrative was already programmed.[46] More than anything else, the missing picture underscores the extent to which both the installation and the experience of pictures at Versailles were shaped by texts.

Gérard's *Austerlitz* spoke with an undeniable authenticity because it was, after all, a genuine "relic" of the Empire; yet its coherent virtual space and the spectator's physical fixity—both assumed by Gérard to be essential to the narrative integrity of history painting—were largely irrelevant in the new museum, for its project to simulate history required a dispersed textual space and a disembodied, omniscient kind of seeing. In fact,

793. Bivouac de l'armée française la veille au soir de la bataille d'Austerlitz (1805).

Par MM. ALAUX et BROCAS, d'après Bacler d'Albe.

Aile du Midi. — Rez-de-chaussée. — Salle n. 69.

Le soir de la veille de la bataille, Napoléon voulut visiter à pied et incognito tous les bivouacs; mais à peine eut-il fait quelques pas, qu'il fut reconnu. Il serait impossible de peindre l'enthousiasme des soldats en le voyant. Des fanaux de paille furent mis en un instant au bout de milliers de perches, et quatre-vingt mille hommes se présentèrent au-devant de l'empereur, en le saluant par des acclamations; les uns pour fêter l'anniversaire de son couronnement, les autres disant que l'armée donnerait le lendemain son bouquet à l'empereur. Un des vieux grenadiers s'approcha de lui et lui dit : « Sire, tu n'auras pas besoin de t'exposer; je te promets, au nom des grenadiers de l'armée, que tu n'auras à combattre que des yeux, et que nous t'amènerons demain les drapeaux et l'artillerie de l'armée russe pour célébrer l'anniversaire de ton couronnement. »

794. Napoléon donnant l'ordre avant la bataille d'Austerlitz (1805).

Par CARLE VERNET, en 1808.

Aile du Midi. — Rez-de-chaussée. — Salle n. 69.

Le jour de la bataille, l'empereur était à cheval avant le jour, entouré de tous ses généraux Murat, Bernadotte, Soult, Lannes, Davoust, Duroc et Bessières. Napoléon attendait, pour donner ses derniers ordres, que l'horizon fût bien éclairci. Au premiers rayons du jour, s'apercevant que l'armée combinée qui tirait les hauteurs de Pratzen, il donna ordre au maréchal Soult de s'en emparer.

795. Bataille d'Austerlitz (1805).

ATTAQUE DES HAUTEURS DE PRATZEN, A DIX HEURES DU MATIN, PAR LE CENTRE DE L'ARMÉE, COMPOSÉ DU QUATRIÈME CORPS. — FORMATION DE LA GAUCHE ET DÉFENSE VERS LA DROITE DU VILLAGE DE SOKOLNITZ.

Aquarelle par M. SIMON FORT, en 1835.

Partie centrale. — Premier étage. — Galerie des Aquarelles, n. 140.

Un instant après, la canonnade se fit entendre à l'extrémité de la droite, que l'avant-garde ramenait avait déjà débordée; mais la rencontre imprévue du maréchal Davoust arrêta l'ennemi tout court, et le combat s'engagea. Le maréchal Soult se porte au même instant, se dirige sur les hauteurs du village de Pratz avec les divisions des généraux Vandamme et Saint-Hilaire. Après deux heures de combat, les alliés perdent les hauteurs de Pratzen et toute

artillerie qu'ils y montèrent. Dès ce moment ils n'eurent plus d'espoir de rétablir la bataille.

796. Bataille d'Austerlitz (1805).

Aquarelle par SIMON FORT, en 1835.

Partie centrale. — Premier étage. — Galerie des Aquarelles, n. 140.

Le prince Murat s'ébranle avec sa cavalerie. La gauche, commandée par le maréchal Lannes, marche en échelons par régiments comme à l'exercice. Une canonnade épouvantable s'engage sur toute la ligne; deux cents pièces de canon et près de deux cent mille hommes faisaient un bruit affreux. Un bataillon de quatrième de ligne fut chargé par la garde impériale russe à cheval, et culbuté.

797. Bataille d'Austerlitz (1805).

Par le baron GÉRARD, en 1808.

Aile du Midi. — Premier étage. — Galerie des Batailles, n. 457.

L'empereur Napoléon, qui était à peu de distance sous Basowitz, en avant de sa réserve, impatiente de combattre, fut bientôt informé de cet évènement. Il ordonna sur-le-champ au général R pp de se mettre à la tête de ses mamelucks, de deux escadrons de chasseurs et d'un escadron de grenadiers de sa garde. Le corps de l'ennemi, qui ne tarda pas à être cerné et déposé de toutes les hauteurs, se trouvant dans un bas-fonds et acculé à un lac. L'empereur s'y porta avec vingt pièces de canon. Ce corps fit changer de position en position, et l'on vit un spectacle horrible. Tel qu'il vaut vu à Aboukir, vingt mille hommes se jetant dans l'eau et se noyant dans les lacs. Deux colonnes, chacune de quatre mille Russes, mettent bas les armes et se rendent prisonnières; tout le parc de l'armée, mis en prise, les résultats de cette journée sont quarante drapeaux russes, parmi lesquels sont les étendards de la garde impériale, et un nombre considérable de prisonniers.

798. Mort du général Valhubert (1805).

Par M. J.-F.-P. PEYRON, en 1808.

Aile du Nord. — Premier étage. — Salle n. 78.

799. Mort du général Valhubert (1805).

Par MM. ALAUX et BRISSET en 1835, d'après Peyron.

Aile du Midi. — Rez-de-chaussée. — Salle n. 69.

58. Description from the battle of Austerlitz from *Versailles et son musée* by Janin, c. 1841

800.

Bataille d'Austerlitz (1805).

Allégorie par CALLET.

Aile du Midi. — Premier étage. — Salle n. 78.

Le général français Valhubert, mortellement blessé, rappela aux grenadiers qui accouraient pour l'enlever l'ordre de l'empereur de ne pas quitter le champ de bataille pour secourir les blessés, et les renvoya à leur poste; le soir, ayant été transporté à Brünn, il écrivit à l'empereur : « Je voudrais avoir fait plus pour vous ; dans » une heure je ne serai plus ; je n'ai donc plus besoin de vous re- » commander ma femme et mes enfants. »

801.

Entrevue de Napoléon et de François II après la bataille d'Austerlitz (1805).

Par le baron GROS, en 1812.

Aile du Nord. — Rez-de-chaussée. — Salle n. 69.

Le lendemain de la bataille d'Austerlitz, l'empereur d'Autriche envoya le prince Jean de Lichtenstein au quartier-général français pour demander un armistice et proposer une entrevue afin d'en ré- gler les conditions. L'empereur Napoléon s'était rendu à ses avant- postes près de Sarutschitz, et avait fait établir son bivouac au- près d'un moulin, à côté de la grande route ; il y attendit l'empe- reur d'Autriche, alla au-devant de lui dès qu'il eut mis pied à terre, et l'invitant à s'approcher du feu de son bivouac : « Je vous » reçois, lui dit-il, dans le seul palais que j'habite depuis deux » mois. » — « Vous tirez si bon parti de cette habitation, qu'elle » doit vous plaire » répondit en souriant François II. »

802.

Entrevue de l'empereur Napoléon et de l'archiduc Charles à Stamersdorff (1805).

Par M. PONCE CAMUS, en 1812.

Aile du Nord. — Premier étage. — Salle n. 78.

Le prince Charles a demandé à voir l'empereur. S. M. aura de- main une entrevue avec ce prince à la maison de chasse de Sta- mersdorff, à trois lieues de Vienne. Napoléon, voulant laisser à S. A. R. un témoignage de son affection particulière, lui donna son épée.

803.

Le premier bataillon du quatrième régiment de li- gne remet à l'empereur deux étendards pris sur l'ennemi à la bataille d'Austerlitz (1805).

Par M.

Aile du Nord. — Premier étage. — Salle n. 78.

Mardi 3 nivôse (24 décembre 1805), S. M. a passé la revue de la

division Vandamme. L'empereur a chargé le maréchal Soult de faire connaître qu'il a été satisfait de cette division, et de revoir, après la bataille d'Austerlitz, en si bon état et si nombreux les bataillons qui ont acquis tant de gloire et qui ont tant contribué au succès de cette journée. Arrivé au premier bataillon du quatrième régiment de ligne qui avait été entamé à la bataille d'Austerlitz et y avait perdu son aigle, l'empereur lui dit : « Soldats, qu'avez-vous fait de » l'aigle que je vous ai donnée ? » Le major a répondu que le porte- drapeau ayant été tué dans une charge au moment de la plus forte mêlée, personne ne s'en était aperçu au milieu de la fumée ; que la preuve que le bataillon n'avait point été rompu, c'est qu'un mo- ment après il avait culbuté deux bataillons russes , et pris deux drapeaux dont il faisait hommage à l'empereur, espérant que cela leur mériterait qu'il leur rendît une autre aigle. L'empereur a été un peu incertain , puis il a dit : « Officiers et soldats, jurez-vous qu'au- » cun de vous ne s'est aperçu de la perte de son aigle ? » Au même moment, mille bras se sont élevés : Nous le jurons ! « En ce cas, a dit l'empereur en souriant, je vous rendrai votre aigle. »

804. **Le sénat reçoit les drapeaux pris dans la campagne d'Autriche (1806).**

Par REGNAULT, en 1808.

Aile du Nord. — Premier étage. — Salle n. 79.

Le 1er janvier, le tribunat est sorti en corps de son palais pour porter les cinquante-quatre drapeaux qu'il a été chargé de remettre au sénat de la part de S. M. l'empereur et roi.

805. **Mariage du prince Eugène de Beauharnais et de la princesse Amélie de Bavière, à Munich (1806).**

Par MÉNAGEOT, en 1807.

Aile du Nord. — Premier étage. — Salle n. 79.

L'empereur Napoléon et le roi de Bavière ayant arrêté entre eux le mariage du prince Eugène, vice-roi d'Italie, et de la princesse royale Auguste-Amélie de Bavière, les cérémonies du mariage en- rent lieu à Munich les 13 et 14 janvier, en présence de l'empereur et de l'impératrice.

806. **Combat de la frégate française la Canonnière contre le vaisseau anglais le Tremendous (1806).**

Par M. GILBERT, en 1835.

Aile du Midi.

Le 21 avril 1806, à six heures et demie du matin, la frégate de quarante canon la Canonnière, en croisière sur les côtes sud-est de

59. Description of the battle of Austerliz from *Versailles et son musée* by Janin, c. 1841

just about any image could have held the place assigned and referenced by the museum's representation of Austerlitz: by which I mean neither a specific image hanging on the wall, nor the guide in the visitor's hand, but the understanding that emerges—from within the mechanics of historical narration—when the guidebook gestures, in a particular order, to facts visible in the museum's space. Louis-Philippe's Versailles, to repeat a point made earlier, was first and foremost an historical space, a space where history was continuously re-produced by visitors who enacted, through their gestures of reading and pointing, the simulation of historical narration.

ALTHOUGH the critical esteem of Horace Vernet has risen somewhat in recent times, it would be largely correct to say that professional critics of the day treated his work with as much harshness as the general public found it admirable, a paradox compounded by the fact that the king himself was one of Vernet's most visible and steadfast admirers.[47] This essay is neither the place to reopen nor even engage the long-running debate about the aesthetic merit of Vernet's oeuvre, but I do want to suggest that he seems to have stumbled upon—we need not describe it as genius—a rather important fact about the pictures he painted for Versailles: namely, that the unities of time and place so important to painters like Gérard were basically irrelevant. A comparison between the *Austerlitz* (fig. 57) and Vernet's picture of Jena for the Gallery of Battles (fig. 60) can help us to articulate the types of pictorial adjustments effected by Vernet for the specialized viewing environment at Versailles.[48] First of all, the Vernet isolates but a fragment of the event, and makes this isolation visible by means of severe and seemingly arbitrary croppings: both physically, by the frame of the picture that truncates soldiers at the far right and horses at the left, and chronologically, insofar as Murat's horse is literally caught in mid-air, about to charge out of the canvas. Secondly, the principal action of Jena consists of what might well be the most strategically trivial episode ever sanctified by a major battle painting: Bonaparte arrests his passage at the center of our visual field to reproach an over-eager young soldier for breaking ranks.[49] Quite unlike the complete narrative thread developed by Gérard's *Austerlitz*, the Vernet focuses upon a relatively banal incident within a rigorously clipped fragment of time, space, and action. That being said, I would like to suggest that these qualities do not prove Vernet's charlatanism, but rather constitute visual choices perfectly synchronized to the requirements of the historical vision deployed at Versailles.

Vernet sent three nearly identical paintings to the Salon of 1836: the *Jena* (fig. 60), *Wagram* (fig. 61), and *Friedland* (fig. 62).[50] When named in the Salon *livret*—the official guidebook of the annual exhibition—the pictures were accompanied by texts quite unlike those used in the guidebooks at Versailles, for the *livret* actually describes the images (fig. 63).[51] The Salon was an exhibition of art, and it was held in the Louvre, an art museum: pictures shown and viewed in that space were understood to be individual, autographic objects, not "facts" in an historical narrative. This explains, I believe, why

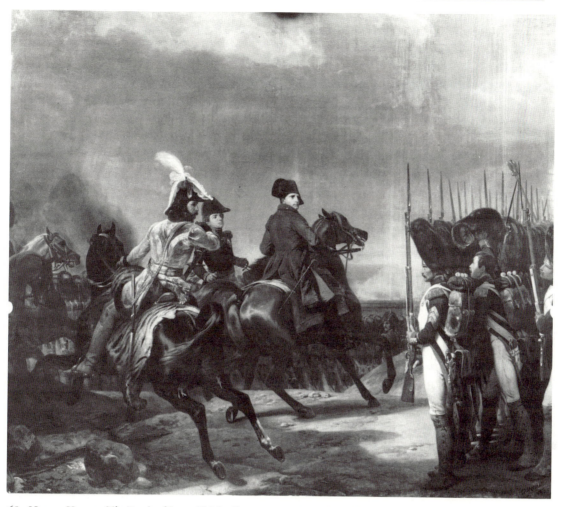

60. Horace Vernet, *The Battle of Jena*, 1836, oil on canvas. Versailles, Musée National du Château

Salon critics—equipped with categories and standards of judgment appropriate for autographic works of art—had so much trouble writing about Vernet's pictures. "These are not battles," observed Alfred de Musset, "first of all because no one battles in them; furthermore, one never could, because the emperor is there in person."[52] In the same vein, Charles Farcy complained that "the so-called battles are in the *livret*, but not at all on canvas. I see only three groups where Napoleon appears on horseback, and the rest consists of little or nothing."[53] One could cite many more comments of this sort, but I want to underscore a particularly insightful remark from the pen of Victor de Nouvion, who wrote in *La France littéraire* that "one can shift around indiscriminately the titles of Jena, Friedland, or Wagram without causing historical truth to suffer any noticeable damage."[54] In other words, some critics sensed that place-holding—not narration—

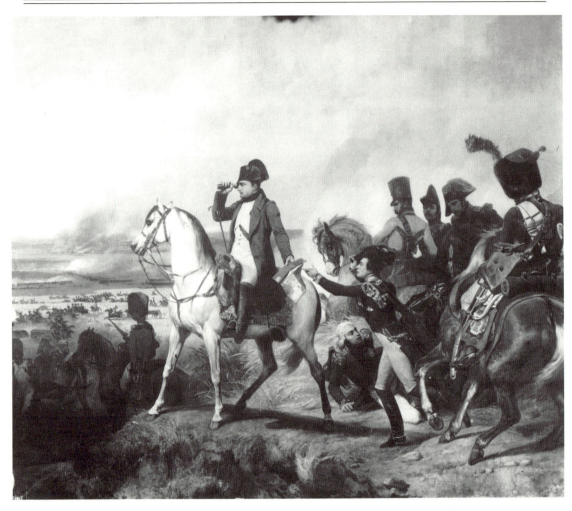

61. Horace Vernet, *The Battle of Wagram*, 1836, oil on canvas. Versailles, Musée National du Château

was the point of these pictures: their response strikes me as an inadvertent understanding of the crucial difference between "art museum" viewing and the type of historical seeing that was the norm at Versailles.

Let us take the example of the battle of Wagram, an important victory of Napoleon's campaign in Austria during the summer of 1809, to see how Vernet's picture (fig. 61) fulfills the role of "fact" in the museum's historical narrative. Like Austerlitz, Wagram's episodes were dispersed among several galleries and across several pages of guidebook text: from Bonaparte's occupation of the terrain before the battle (fig. 64), to the 6th of July—the day of the principal fighting—and its aftermath (fig. 65).[55] But even though the guide directs us right to Vernet's picture in the Gallery of Battles (number 905), we will search in vain for an "explanation" of what we see in the painting:

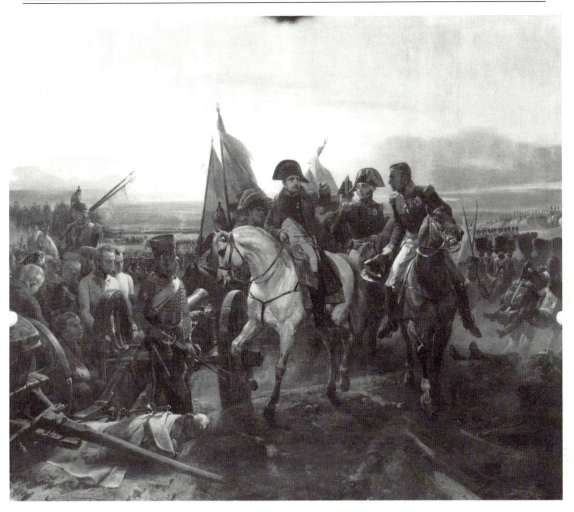

62. Horace Vernet, *The Battle of Friedland,* 1836, oil on canvas. Versailles, Musée National du Château

namely, a Napoleon so attentive to the effect of his artillery barrage that he fails to note the duc d'Istrie has been struck by a bullet only a few feet away. The museum's narrative mechanism draws our attention away from the experience of individual images so as to enmesh us in a process of reading and pointing that constitutes its simulation—its historical representation—of the event. Once again, the model involved is the writing of history: how many historians take an "aesthetic pleasure" in reading the ledgers of the July Monarchy (the series O^4) at the Archives Nationales in Paris? There are, of course, people who actually steal documents for their autographic value, but as historians we generally value them for their place within our narrative, not as objects in our private collection of old paper.

I am suggesting that the narrative system at Versailles invested pictures with the

VERNET (HORACE), 58, *r. St-Lazare.*

1803 — Bataille de Fontenoy ; 11 mai 1745.

Le maréchal de Saxe présente à Louis XIV les tro-
phées de la victoire.

<div align="right">(M. d. R.)</div>

1804 — Bataille de Iéna ; 14 octobre 1806.

L'empereur entend sortir des rangs de la garde im-
périale à pied, les mots : *En avant !* « Qu'est-ce ? dit
» l'empereur ; ce ne peut être qu'un jeune homme qui
» n'a pas de barbe, qui peut vouloir préjuger ce que je
» dois faire. Qu'il attende qu'il ait commandé trente
» batailles rangées, avant de prétendre me donner des
» avis....» C'était effectivement un des vélites, dont le
jeune courage était impatient de se signaler.

<div align="right">(Bulletin de la Grande-Armée.)</div>

<div align="right">(M. d. R.)</div>

1805 — Bataille de Friedland ; 14 juin 1807.

Napoléon, sur le champ de bataille de Friedland,
donne des ordres au général de division Oudinot pour
la poursuite de l'ennemi.

<div align="right">(M. d. R.)</div>

1806 — Bataille de Wagram ; 6 juillet 1809.

L'empereur observe l'effet que produit la batterie de
100 pièces d'artillerie commandée par le général comte
de Lauriston. Au moment où le duc d'Istrie se dispo-
sait à l'attaque de la cavalerie, un boulet tombe sur
sa selle, lui fait une légère contusion à la cuisse, et
emporte son cheval.

<div align="right">(Bulletin de la Grande-Armée.)</div>

<div align="right">(M. d. R.)</div>

1807 — Chasse dans le désert de Sahara , le 28
mai 1833.

VERNET (JULES), 9, *r. Joubert.*

1808 — Un cadre de miniatures.

63. Description of Horace Vernet's pictures at the Salon of 1836 from the official Salon catalogue

déboucher sur l'armée autrichienne et de lui livrer une bataille générale. L'empereur ayant fait jeter quatre ponts volants sur différents points, à deux heures après minuit l'armée débouchait la gauche à quinze cents toises au dessous d'Enzersdorf, protégée par les batteries et la droite sur Vittau. Une profonde obscurité, un violent orage et une pluie qui tombait par torrent rendent cette nuit aussi affreuse qu'elle était propice à l'armée française.

899. Bataille de Wagram (1809).

PREMIÈRE JOURNÉE.

Aquarelle par M. Siméon Fort, en 1835.

Partie centrale. — Premier étage. — Galerie des Aquarelles, n. 140.

Le 5, l'empereur se trouvait avec son armée en bataille, sur l'extrémité de la gauche de l'armée autrichienne; il avait tourné tous ses camps retranchés. Lorsque la première ligne commençait à se former, l'empereur ordonna d'attaquer Enzersdorf. Ce bourg était rempli d'infanterie autrichienne; des flèches en terre couvraient les portes; trois ouvrages défendaient les approches; vers le midi, Masséna envoya ses aides de camp Sainte-Croix et Pé et attaquer le bourg avec le 46e régiment. Ils enlevèrent les ouvrages, les maisons et poursuivirent l'ennemi l'épée dans les reins; ils entrèrent dans le même temps que lui dans le redan qui couvre la porte du midi.

900. Bataille de Wagram (1809).

PREMIÈRE JOURNÉE.

Aquarelle par M. Siméon Fort, en 1835.

Partie centrale. — Premier étage. — Galerie des Aquarelles, n. 140.

Le duc de Rivoli s'étant emparé d'Enzersdorf, et le comte Oudinot ayant enlevé la position du château de Sachsengang, l'empereur fit alors déployer toute l'armée dans l'immense plain d'Enzersdorf, connue aussi sous le nom de Marchfeld. Depuis midi jusqu'à neuf heures du soir on manœuvra dans cette immense plaine; on occupa tous les villages. La journée paraissait presque finie, et il fallait s'attendre à avoir le lendemain une grande bataille.

901. Bivouac de Napoléon sur le champ de bataille de Wagram (1809).

Par M. Adolphe Roehn, en 1810.

Aile du Nord. — Premier étage. — Salle n. 80.

On se prépara alors à la bataille de Wagram... L'empereur passa toute la nuit à rassembler ses forces sur son centre, où il était de sa personne à une portée de canon de Wagram.

64. Description of events before the battle of Wagram from *Versailles et son musée* by Janin, c. 1841

902. **Bataille de Wagram** (1809).

DEUXIÈME JOURNÉE.

Aquarelle par M. SIMÉON FORT, en 1856.

Partie centrale. — Premier étage. — Galerie des Aquarelles, n. 140.

L'empereur concentra son armée devant les hauteurs de Russbach pour renouveler l'attaque de la veille et prévenir la jonction du prince Jean. De son côté, l'archiduc Charles attaqua la ligne française sur les deux flancs, et la déborda dans la plaine du Danube pendant ce temps, la canonnade s'engageait sur toute la ligne, et les dispositions de l'ennemi se développaient de moment en moment. Toute sa garde se garnissait d'artillerie. L'empereur ordonna au duc d'Auerstaedt de tourner la position de Niewed 1, de pousser de là sur Wagram, et il fit former en colonne le duc de Raguse et le général Macdonald pour enlever Wagram au moment où déboucherait le duc d'Auerstaedt.

903. **Bataille de Wagram.**

DEUXIÈME JOURNÉE.

Aquarelle par M. SIMÉON FORT, en 1856.

Partie centrale. — Premier étage. — Galerie des Aquarelles, n. 140.

904. **Bataille de Wagram** (1809).

DEUXIÈME JOURNÉE.

Par M. BELLANGÉ, en 1837.

Aile du Nord. — Premier étage. — Salle n. 82.

905. **Bataille de Wagram** (1809).

DEUXIÈME JOURNÉE.

Par M. HORACE VERNET, en 1856.

Aile du Midi. — Premier étage. — Galerie des Batailles, n. 157.

sur ces entrefaites on vint prévenir que l'ennemi attaquait avec fureur le village qu'avait enlevé le duc de Rivoli, et qu'à l'intervalle de Gross-Aspern à Wagram paraissait connecté d'une immense ligne d'artillerie. L'empereur ordonna sur-le-champ au général Macdonald de disposer les divisions Broussier et Lamarque en colonne d'attaque, il les fit soutenir par la division du général Nansuty, par la garde à cheval et par une batterie de soixante pièces de la garde et de quarante pièces des différents corps. Le général comte de Lauriston, à la tête de cette batterie de cent pièces d'artillerie

marcha au trot à l'ennemi, s'avança sans tirer jusqu'à demi-portée de canon, et là commença un feu prodigieux qui éclaircit celui de l'armée autrichienne et porta la mort dans ses rangs.

906. **Bataille de Wagram** (1809).

DEUXIÈME JOURNÉE.

Aquarelle par M. SIMÉON FORT, en 1856.

Partie centrale. — Premier étage. — Galerie des Aquarelles, n. 140.

Le duc de Rivoli ayant atteint les bords du Danube, le duc de Tarente ayant formé la colonne du centre, appuyée par les réserves, le duc d'Auerstaedt ayant franchi le Russbach et enlevé Markgrafneusiedl ayant ordonné une attaque générale sur toute la ligne. A feu, l'empereur ordonna une attaque générale sur toute la ligne. A midi, le comte Oudinot marcha sur Wagram pour aider à l'attaque du duc d'Auerstaedt; il y réussit, et enleva cette importante position. Des dix heures l'armée autrichienne ne se battait plus que pour sa retraite; dès midi elle était prononcée, et se faisait en désordre, et beaucoup avant la nuit l'ennemi était hors de vue.

907. **Combat d'Hollabrunn** (1809).

Par M.

Aile du Nord. — Premier étage. — Salle n. 81.

908. **Combat d'Hollabrunn** (1809).

Aquarelle par M. SIMÉON FORT, en 1857.

Partie centrale. — Premier étage. — Galerie des Aquarelles, n. 140.

Le duc de Rivoli, poursuivant l'ennemi par Stockerau, a battu devant Hollabrunn l'arrière-garde de l'armée autrichienne, qui couvrait la marche du prince Charles en Bohême.

909. **Combat de Znaïm** (1809).

Aquarelle par M. STORELLI en 1835, d'après Bagetti.

Partie centrale. — Premier étage. — Galerie des Aquarelles, n. 140.

Le 10 juillet, le duc de Raguse était sur les hauteurs de Znaïm; il vit les bagages et l'artillerie de l'ennemi qui se dirigeaient sur la Bohême. Le 11, à midi, l'empereur arriva vis-à-vis Znaïm; le combat était engagé; le duc de Raguse avait débordé la ville, et le duc de Rivoli s'était emparé du pont et occupé la fabrique de tabac.

51*

65. Description of the battle of Wagram from *Versailles et son musée* by Janin, 1841

same functional value as the "archival documents" of an historian, despite the fact that they nominally remained products of the "high culture" practice of history painting.[56] This is not to say, however, that the image as image was rendered completely irrelevant when installed within the galleries at Versailles; rather, I would emphasize that being liberated from the responsibility to narrate independently made it possible to jettison the time-honored notions of visual narrative—the picture's *premier coup d'oeil* and unities of time and place—as guiding principles of its design. Vernet, in particular, seems to have embraced this new-found freedom, and he best exemplifies what I would describe as the creative understanding of painting as illustration—an understanding whose logic remains elusive so long as we continue to think only in terms of "art museum" viewing and experience.[57]

Nevertheless, the simulation of history at Versailles was not free of rules and protocols, and they brought to bear specific types of constraints on pictures and picture-making. Foremost among these was the imperative that images be configured as recognizable "targets" for the narratives that gesture or "point to" them. In a museum like Versailles designed expressly to attract and accommodate a very large public, to be easily recognized is an essential quality of any picture destined to play a part in the narrative system.[58] How might a painter ensure that his or her image will be recognizable to a large, heterogeneous public? Attention to the strategic formal similarities between Vernet's renderings of *Wagram* and *Friedland* (figs. 61, 62) will make it possible to draw some conclusions about how they are structured for maximum recognizability. In each picture the visual field has a strong center of interest, a center defined and anchored by the major character of Napoleon: he is large, close at hand, and silhouetted against the sky. At first glance, and from a distance of more than 150 years, we might not notice the anomaly that critics saw immediately in 1836: "we will add one more observation," remarked the *Journal des Beaux-Arts*, "concerning the prejudice of no longer representing Napoleon amidst the army except wearing a grey greatcoat over his green uniform. We saw the Emperor often enough in camp to know that in the dog days of summer, like those at Friedland and especially at Wagram, he never would have worn this double-layered outfit, which the heat would have made much more than slightly irritating."[59] Common sense suggests that Napoleon dressed for the heat just like everyone else, but the insistent appearance of his greatcoat in Vernet's pictures—coupled with the complaint that a kind of prejudice dictates that the emperor be depicted in that guise—provides an important clue as to where painters like Vernet found the means to ensure that their images generated the recognizability required at Versailles.

Napoleon's grey greatcoat and green corporal's uniform were part of a very powerful, almost mythic persona that circulated widely in prints throughout the 1820s and 1830s: Raffet's *Eye of the Master* (fig. 66) from 1833 is a charcteristic example.[60] Along with the inevitable greatcoat one rediscovers the bicorne hat, riding boots and spurs, the sword of Austerlitz, spyglass, and so on, in short, all the trappings of the *petit caporal*,

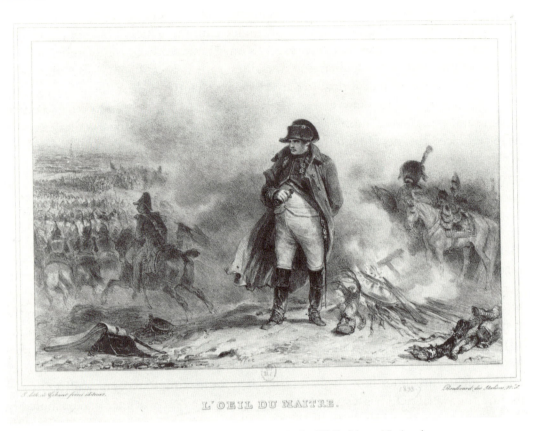

L'OEIL DU MAITRE.

66. Denis-Auguste-Marie Raffet, *Eye of the Master,* 1833, Paris, Bibliothèque Nationale

the Grande Armée's beloved object of affection and devotion whose image continued to wield great emotional power among army veterans long after the Empire's end.[61] Vernet's three pictures overlap most clearly in their manner of handling and highlighting this iconic representation of Napoleon: he is strategically placed, spatially isolated, and dramatically silhouetted in the center of the visual field, even if so doing meant neglecting the "truth" of mid-summer heat. In fact, what Vernet lost in "truth" was more than off-set by a gain in "recognizability," because repetition of the *petit caporal* virtually guaranteed that no visitor to Versailles—even those unable to read the museum's guidebook—would fail to recognize the image, respond to it, and, most important, be caught up in the museum's historical project of gesturing, pointing, and narrating within its gallery spaces. I am suggesting that Vernet renounced the history painter's usual strategies of narrative and learned references to the grand tradition in order to marshal the power of the less lofty, but infinitely more pervasive, visual culture that is often called "popular." This shift in Vernet's practice, the government's willingness to sponsor it, and the visual links discussed earlier between "popular" prints and the

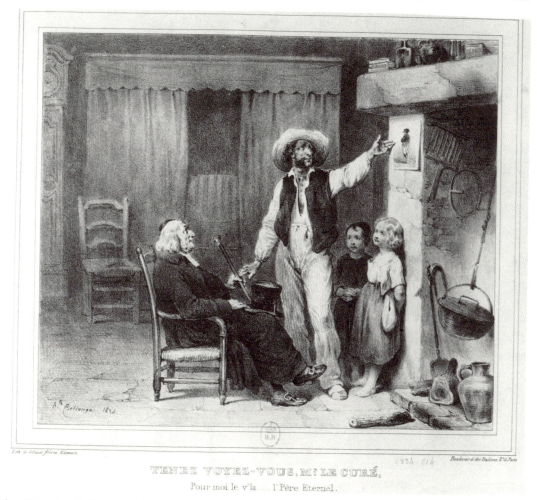

TENEZ VOYEZ-VOUS, M? LE CURÉ,

Pour moi le v'la......l'Père Eternel.

67. Hippolyte Bellangé, *Look Here Father, for Me That's Him, the Heavenly Father!*, 1835, Paris, Bibliothèque Nationale

picture of 28 July by Amédée Bourgeois (figs. 49, 51) are, I believe, related aspects of a general re-alignment of the category of "history painting" that can be at least partially attributed to a peculiarity of the viewing situation for which such pictures were commissioned and designed: the parameter of recognition required by the system of historical narration within the galleries of Versailles.

IT SHOULD BE obvious that recognition of the type I am describing is not politically inert, as the print published by Hippolyte Bellangé in 1835 makes perfectly clear (fig. 67): a Napoleonic veteran getures to an image of the *petit caporal* hanging over the fireplace while exclaiming to the village priest, "For me, *that's* him, the Heavenly

Father!"[62] His gesture is not merely a sign of recognition of the sort replicated thousands of times at Versailles, for it simultaneously registers a complicity on several levels: it signals that he understands the visual codes deployed by the image of the *petit caporal*; that he acknowledges membership in that part of the culture for which it has meaning; that his enthusiasm is rooted in experience and belief rather than reason and argument; that he would be favorably disposed towards other cultural entities who demonstrate a similar enthusiasm by displaying the icon in ways that mimic its importance above the family hearth in his own home. [63] The social dimensions of this semantic layering are not without interest, for they suggest a political dimension behind the fact that so many pictures at Versailles seem to reject "high" art forms in favor of the "popular" visual strategies of illustration.

Michel de Certeau has argued that citations are "the means of articulating the historical text across a semantic exteriority, of providing it with the appearance of taking over a part of the culture, and thereby ensuring its referential credibility."[64] I have tried to describe how citations construct narrative authority in the social sphere, and there can be no doubt that the organized system of citing established at Versailles was designed exactly to take over part of French culture—most notably its recent past—so as to re-shape a coherent narrative thread joining seamlessly the glories of the *ancien régime* to those of modern France. But the point worth stressing is the particular twist that occurs before a picture when the authority-producing mechanism of historical writing—its network of citations—coexists with gestures of recognition that signal complicity in the visual culture: united in a single act, complicity is collapsed into the process of narration, and the viewer becomes secretly, even unconsciously, an accomplice of the unfolding historical story. As we have seen, that story may describe the Revolution of 1830, the year 1792, the exploits of Napoleon, medieval crusades to free the Holy Land, or the contemporary conquest of Algeria.[65] The museum at Versailles was engineered from the start to be a great machine for writing the stories of such events, whatever the time or place; within its spaces each viewer/visitor became an essential cog of the narrative mechanism, for it was only by reading and seeing that the story would unfold in full-color simulation. Indeed, we might say that to "see pictures" at Versailles implies participation in the writing of a history with which one might not agree, but cannot physically avoid, for even the "errors" of its story remain invisible until its narrative machinery has been set in motion.

Less than three weeks after the gala inauguration of the museum at Versailles—carefully timed to coincide with the festivities surrounding the marriage of Louis-Philippe's eldest son—the king wrote with great delight to the Comte de Molé, president of his Council of Ministers: "the success of Versailles continues to be spectacular. Not just Parisians are going there, but peasants are also coming from every village. Yesterday, *Tuesday*, I am told that more than 12,000 people entered, that all of them behaved perfectly and gave no one the slightest problem. It's a chorus of praise and

satisfaction."[66] The attendance figure, if true, is astonishing even by the standards of today, but even more interesting is Louis-Philippe's comment that the large and socially mixed crowd was perfectly well-behaved. Were they merely mesmerized by the splendor of it all? Michel Foucault has reminded us that modern disciplinary societies "substitute for a power that is manifested through the brilliance of those who exercise it, a power that insidiously objectifies those on whom it is applied; to form a body of knowledge about these individuals, rather than to deploy the ostentatious signs of sovereignty."[67] It seems to me appropriate that the Citizen-King recognized his museum—his machine to write the history of France—constructed the kind of secret, modern power described by Foucault: a space where spellbound visitors, enmeshed in the mechanics of narration deployed in the galleries, were systematically tranquilized by the unfolding spectacle of their historical selves.

VI

Michaud's *History of the Crusades* and the French Crusade in Algeria under Louis-Philippe

KIM MUNHOLLAND

ALTHOUGH arguing from very different perspectives, students of the writing of history agree that the era of the French Revolution and the onset of Romanticism led to a transformation in the way history has been written and presented. In his study of *History and Historians in the Nineteenth Century*, G. P. Gooch has remarked, "The French Revolution constituted as decisive a breach with tradition in historical scholarship as in Church and State."[1] More recently Lionel Gossman has argued, "After the French Revolution the dominant ambition of historians was to make history—rather than fiction—the successor of the epic as the repository of society's values and of its understanding of the world."[2] Historians in the Romantic era turned toward history as a narrative that could present or recreate the past as if a reportage of a reality, creating what Gossman and others see as a mythic illusion. In the aftermath of the French Revolution there was also a turning to the past to find meaning that would make sense of the present. The past became organized and events stated and ordered in a way that offered lessons for contemporaries or pointed toward some purpose. History became both a kind of retrospective reportage and a "usable past"; it also became an enormously popular form of instruction and education. The way in which history was presented attempted to create an illusion of objectivity, but "the past" began to be appropriated for partisan purposes to reinforce the cultural and political myths of the moment. This may be seen in the way in which an image of France's crusading past became appropriated and used to reinforce and justify the French conquest of Algeria under Louis-Philippe.

A division of French historiography into pre- and post-Revolutionary phases in-

cludes histories and historians of the crusades, since the post-Revolutionary period brought a revival of interest in the crusades as a subject for serious historical research. A typical pre-Revolutionary attitude toward the crusades may be seen in the histories of Voltaire. In general, Voltaire regarded the crusades as the consequence of an outburst of religious fanaticism. He noted the "ferocious arrogance" of the crusaders and deplored their "excesses"; in particular, he considered the massacre of the Jews during the first crusade to illustrate the blind fanaticism of the era.[3] To further discredit the crusades as a movement, he mocked the military exploits of the crusaders, particularly in the second crusade. Voltaire's attack upon the crusades enabled him to expand his criticism to feudalism and Christianity in general, as seen in the following passage from his *History of Frederick Barbarossa* in which he discussed the military defeats of the second crusade:

> The loss of all these prodigious armies of crusaders in a country which Alexander had subjugated with 40,000 men, an empire considerably more powerful than that of the Arabs and Turks, demonstrates that in Christian undertakings there was a radical vice which necessarily destroyed them: this was the feudal government, the independence of commanders, and consequently disunion, disorder and lack of restraint.[4]

Other eighteenth-century historians, as well as Voltaire, regarded the crusades with scepticism; a crusade was hardly an enterprise in which an enlightened individual might be involved and could only take place during an age of superstition.

Against this tradition, early nineteenth-century historians began their investigations of the crusades. Their reevaluation involved a greater concern for a thorough and balanced investigation of sources, a desire to know what actually happened without preconceptions as to the motives of those involved, and, above all, a desire to avoid the largely negative judgments of the preceding generation. This new spirit of historical investigation represented a significant trend away from the attitude toward the past that had developed in the eighteenth century in which the past was to be overcome, if not overthrown, by an age of enlightenment and reason. This desire to reject the past was strengthened during the Revolutionary era. As Gooch commented, the Jacobins considered the past, "a foul dungeon from which the human spirit only just escaped."[5] He believed that this attitude was reflected in the National Assembly's order to have the records of the noble families of France destroyed. Given the revolutionary situation and a desire to build an entirely new society upon the ruins of the past, a rejection of the historical record may be understood. The rejection of the past predates the Revolutionary upheavals and may be found in the doctrines of the eighteenth-century enlightenment. Voltaire again provides an example of this spirit. His famous remark that history is after all only a pack of lies played upon the dead was made in a letter to a friend who, Voltaire knew, disliked history. Yet Voltaire's comment was more than an observation of the moment. He remarked elsewhere that at best, "Historical truths are only possi-

bilities."[6] This relativist approach to historical knowledge or understanding is even more starkly presented in Voltaire's rejection of the value of any study of the past. "Ordinary history, which is only a compilation of facts manipulated by men—and consequently crimes—has scarcely any utility," he warned, "and he who reads the gazette would have an even greater advantage than he who knows all of ancient history."[7] Both enlightenment and revolutionary traditions rejected a study of the past on the grounds that such activity was a deliberate distortion that had to be overcome in favor of an entirely new construction of the social order. If history had any utility, it was to create false myths and perpetuate superstitions. The ideals of freedom and reason called for a rejection of the past and its record of oppression.

Insofar as it represented a reaction against this present-mindedness and a corresponding hostility toward any serious study of the past for its own sake, the Romantic movement brought with it a greater admiration and respect for the past than had prevailed in the eighteenth century, and Romantics displayed a renewed interest in and sympathy for the achievements of the Middle Ages. Perhaps one of the strongest influences on French historical writing in the early nineteenth century was Chateaubriand. Gooch credits him with the entire, "efflorescence of historical studies in France under the Restoration."[8] This new enthusiasm for the Middle Ages in the first half of the nineteenth century, stimulated by Chateaubriand, undoubtedly influenced those historians who turned their interests to the crusades, but there were other influences as well, including a desire to correct Voltaire's dismissals of the crusades and a desire to find a positive lesson in them. While several historians became interested in the crusades as a topic of historical inquiry,[9] the most important of the French historians was Joseph-François Michaud, who was a friend and colleague of Chateaubriand. Gooch claims that the influence of Chauteaubriand explains Michaud's decision to write his magisterial history of the crusades: "The first effect of the forces which Chateaubriand had set in motion was seen in Michaud's 'History of the Crusades.'"[10]

Chateaubriand and Michaud shared many enthusiasms and Chateabriand's influence was considerable, but whether he served as the primary inspiration for Michaud, as Gooch implies, is open to question. Chateaubriand and Michaud were both ardent royalists: during the Restoration they served as deputies in the French Assembly, and they were well-known literary figures. Yet there is reason to believe that Michaud would have commenced his *Histoire des croisades* independently of Chateaubriand. Michaud's inspiration to write a history of the crusades resulted from a request to write an introduction for Mme. Sophie Cottin's novel, *Mathilde*. In preparing the introduction, Michaud consulted a number of writers and chroniclers who had mentioned the crusades. Further study of the crusades appealed to him and he embarked upon his famous work.[11] Furthermore, Michaud already had revealed an interest in the Orient with the publication of two volumes on the Empire of Mysore in 1801, which incidentally included a critical account and commentary upon Bonaparte's invasion of Egypt.[12] In

this account, Michaud noted the historical importance of Egypt and the Levant for trade between Europe and Asia. Even in this early work an interest in the crusades may be found in Michaud's explanation of the diversion of the fourth crusade from the Holy Land as the result of a desire of the Latins to secure Constantinople's eastern trade for themselves.[13] This early interest in the Orient, as much as Chateaubriand's influence, turned Michaud's attention toward the crusades.

Another distinction between Michaud and Chateaubriand should be noted. Chateaubriand's interest in the Middle Ages stemmed from his enthusiasm for Christianity. While devout, Michaud was much less a champion of religion than Chateaubriand. He deplored, for example, the massacre of Moslems after the capture of Jerusalem during the first crusade, remarking, "Fanaticism seconded only too well this barbarous policy. . . . Those of the crusaders whose souls were not closed to general sentiments could not halt the furor of an army which, carried away by the passions of war, believed themselves avengers of outraged religion."[14] Michaud considered himself neither a defender nor a critic of religion, seen in his comments on this massacre:

> Some writers have found in this a pretext to attack the Christian religion; others, no less blind and no less impassioned, have wished to excuse the deplorable excesses of fanaticism; the impartial historian contents himself with relating the events and laments in silence over the weaknesses of human nature.[15]

This passage suggests that Michaud was not entirely swept away by romantic zeal in his study of the crusades, since he shows himself under the influence of enlightenment standards of moderation and reasonableness. He also showed a strong scepticism toward accounts of miraculous events, such as the miracle of the holy lance at Antioch. The crusaders' victory over the Moslem leader, Kerboga, was less the result of a miraculous vision than Kerboga's tactical mistake in dividing his forces. The crusaders' claim to a vision he attributed to their extreme misery and near starvation, which made them susceptible to hallucinations. In his rejection of miracles to explain events, Michaud revealed a strain of eighteenth-century scepticism, although in his personal convictions he was a sincere Christian. His religion may have given him some sympathy for the crusaders, but he rarely allowed his religious sympathies to color his historical narrative or his judgments.

If Michaud kept his religious views within bounds, his politics intruded into his interpretation of the crusades. Michaud was a royalist of legitimist conviction, and he was fully engaged in political journalism and pamphleteering. The destruction and violence of the Revolution, whose early stages he witnessed as a young man in Lyon, shocked him, and by the time he reached Paris in 1790 he was a firm royalist and opponent of the Revolution. His pamphleteering on behalf of the throne led to eleven imprisonments, and twice he was condemned to death. He narrowly escaped death

during the Vendémiaire uprising only to continue his royalist activities under the Directory, the Consulate, and the Empire. The main vehicle for his political writing was the legitimist paper, *La Quotidienne*, which he had helped found during the Revolution. It became the major newspaper for royalists, which caused it to be closed down on several occasions, but after the Restoration in 1815 it appeared regularly and Michaud continued to write for the paper until 1828 when he sold his interest. Despite his legitimist views, he received the Legion of Honor in 1812 for his *Histoire des croisades*, which began to appear with the publication of the first of his six volumes in 1808, and he gained admission to the French Academy in 1813.[16] His loyalty to the Bourbons during the Hundred Days was demonstrated in an anti-Napoleonic pamphlet, "L'Histoire des quinze semaines," that gained Michaud a position in the king's household. He was elected a member of the Chamber of Deputies, the "Chambre introuvable," in 1816, although his timidity and difficulty in public speaking prevented his making a strong impression as a deputy. His political verve found expression in the pages of *La Quotidienne*.

Despite his active political life as a journalist and pamphleteer, the French scholar, Georges Meunier, insists that, "impartiality, absent from Michaud's polemical articles, is observed with a scrupulous fidelity in his historical work."[17] For much of Michaud's *Histoire des croisades* this remark is fair enough. There are places in Michaud's narrative, nevertheless, where Michaud's political views find expression. For instance, Michaud regarded the crusades as a revolutionary movement, "the great revolution of the holy wars."[18] He observed that the second crusade was succeeded by further "revolutions," activated by different forces and bringing different leaders to prominence, but revolutions all the same.[19] The revolutionary character of the crusades arose from the way in which this movement swept individuals out of their traditional channels, overthrew accepted institutions, and inflamed emotions. This sense of a revolutionary upheaval emerges from a passage in which Michaud claims that

> a madness for crusading was an ardent and jealous passion which called more loudly than all the others. Religion was no longer seen in any other light than as a war against the Saracens, and this religion did not permit its enthusiastic defenders any other joy, any other glory than what was presented to their heated imaginations. Love of country, family ties, the most tender affections of the heart were sacrificed to the ideas and to the opinions which then overwhelmed all of Europe. Moderation was cowardice, indifference treason, and opposition a sacrilegious endeavor. The power of laws was regarded as nothing by those who believed themselves fighting in the cause of God. Subjects scarcely recognized the authority of princes and nobles in matters concerning the holy war; master and slave had no other title than that of Christian, no other duty to fulfill than to defend religion by taking up arms.[20]

In Michaud's politically conservative mind, the parallel between these holy wars and the events of the Revolution and Napoleonic period becomes apparent. Even the behavior of the nobility in giving up its privileges during the Revolution finds a comparison to the crusades in Michaud's description of the ways in which "nobles and barons renounced domains acquired through the valor and exploits of their fathers. Lands, cities, castles for which they had not fought suddenly lost all value in the eyes of their owners and were given up."[21]

Although Michaud's history of the crusades presented a much more balanced account than had been written before, the reality was that he intended his history to provide "lessons" and instruct his readers. His history was a usable past that he turned to advantage. He did not hesitate to indicate what he believed was the overall significance of the crusades, and in this way he made his choice and interpretation. The crusades held a lesson for France in the early nineteenth century. After denying any advocacy of a favorable or critical interpretation of the crusades, Michaud provided the reader with his conclusion:

> Without believing that the holy wars have done either all the good or all the harm that is attributed to them, it must be admitted that they were a source of bitter sorrow to the generations that saw them or took part in them, but like the ills and tempests of human life, which render man better and often assist the progress of his reason, they have forwarded the experiences of nations; and it may be said that after having for a time seriously agitated and shaken society, they have, in the end, much strengthened the foundations of it. When stripped of all systematic exaggeration, this opinion will appear perhaps as the most reasonable; besides, I experience some pleasure in adopting it, since it offers consolation for the age in which we live. The present generation, which has passed through so many calamities, will not see without interest that Providence sometimes employs great revolutions to enlighten mankind, and to ensure the future prosperity of empires.[22]

Here Michaud's concern for his own time and, as a historian, relating the past to it, may be most clearly seen. For Michaud, there was a "usable past," but it was not at all the past the philosophers of the enlightenment wished to reject and escape from. Europe in the Middle Ages had its trial and purge in the crusades, while in the eighteenth and early nineteenth centuries Europe, and particularly France, experienced a similar upheaval, a new "religious war."

In Michaud's view the institution that emerged strengthened by these revolutionary times was the monarchy, and this interpretation fit with his political engagement during the Restoration. His view that France was destined for a period of peaceful consolidation was to be upset by the 1830 Revolution which brought an end to the legitimist throne and installed the Orleanist monarchy. However, to see Michaud's work as simply or solely a justification of the royalist cause under the Restoration would be an

exaggeration. At times Michaud could be critical of the leadership, or lack of it, in the crusades, particularly in the second crusade.[23] Nevertheless, for all of their excesses and popular enthusiasms Michaud judged the crusades to have had a civilizing effect on European society. The first crusade succeeded in creating a sense of unity, and it obtained one of its primary objectives by getting the belligerent and quarrelsome nobles out of Europe and drawing them together in a common cause. The Church, as advocate of the crusades and the development of a crusading spirit, took satisfaction that the first crusade produced a greater respect for the "truce of God" in western countries, and to the extent that the aftermath brought a more peaceful era, one of the primary objectives of the first crusade had been achieved. With a reduction of internal warfare and feudal anarchy, Michaud observed that the crusades gave impetus to the development of chivalry. While becoming more civilized, he concluded that the nobles also lost some of their political power to the throne, to be compensated with "the splendor and glory" of participating in the crusading movement. Michaud saw political and military power becoming more centralized during the crusades as greater resources had to be marshalled than were available to most nobles individually, and the problem of unified command also became important. The crusades also increased trade with the Levant to the profit of Europe. And, finally, the crusades represented a success of Christianity against the Moslems. Balancing gains and losses, Michaud concluded that the crusades had a civilizing effect upon western Europe and were in themselves something of a "civilizing mission" conducted against Islam.[24]

While he stressed the impact of the crusades upon Europe generally, Michaud also identified them as a distinctively "French" achievement. This identification was something of an anachronism in a history of an event in medieval Europe where such modern conceptions of the nation were not at all developed. Nevertheless, Michaud read into the crusades evidence of French glory and French accomplishments. One of his conclusions about the first crusade was that France benefited the most from it since the greatest number of participants had been French. Michaud's nationalistic enthusiasm may be seen in the following passage:

> If many scenes from this great epoch excite our indignation or our pity, how many events fill us with admiration and surprise! How many names made illustrious in this war are still today the pride of families and of the nation! What is the most positive of the results of the first crusade is the glory of our fathers, this glory which is also a real achievement for a nation, for these great memories establish the existence of peoples as well as that of families, and are, in this respect, the noblest source of patriotism.[25]

Michaud thus traced the roots of French greatness to the crusades. With the first crusade France began a process of development and progress that brought the country to the forefront of European states. Michaud claimed that "knowledge, laws, customs, power

should march forward together. This is what happened in France; so France must become the model and center of civilization in Europe." France thus became the center of European civilization, marked for a distinctive role, again a kind of civilizing mission.

Historiographers have generally praised Michaud's *Histoire des croisades* for its balance and relative objectivity. Despite the evidence of the way in which his political preferences may have influenced his interpretation of events, this is a reasonably accurate assessment, at least in comparison with other accounts available in the early nineteenth century. Yet Michaud was a fully engaged historian who did not hesitate to draw lessons. His history was at once balanced and didactic. If so, how was balance achieved? The answer lies in the contradictions within Michaud himself.

Michaud was sceptical, questioning, a believer in human progress, and an eighteenth-century rationalist, although in his revulsion at the excesses of the French Revolution he rejected some of the implications of the enlightenment heritage. At the same time, he wrote when Romanticism had eclipsed the emphasis on balance and moderation of the eighteenth-century intellectual ethos. He shared many Romanticist enthusiasms, including an appreciation and revaluation of the Middle Ages, and of course his interest in the crusades was part of a romantic fascination with orientalism and the exotic that were distinctive aspects of the Romantic movement in the arts and literature as well as in history. His writings display an emotionalism, an engagement, and one might even say a personal approach to history and commentary alongside his critical use of sources and his dismissal of "miracles" as part of historical explanation. He was partly Romantic and partly a man of the rationalistic enlightenment. Though critical of the Church and the excesses of religious zeal in the crusades, he nevertheless had a deep respect for religion. He saw in Christianity a force capable of unifying Europe, yet he was also an ardent French nationalist. He showed compassion toward certain Moslem leaders and sought a common element of humanity even when defending Christian values. He praised Saladin's humane treatment of prisoners and also deplored Christian massacres of Moslems. His royalist politics did not prevent his study of what he considered to be a "revolutionary" movement, and he was prepared to draw lessons from history. While his history sought balance and was intended as a corrective to previous misconceptions, it had its own political purpose.

Michaud's account proved to be enormously popular. It went through four editions under the Restoration; five editions, including two abridged editions for use in schools appeared under the July Monarchy; it would continue to be published throughout the nineteenth century with two printings of a nineteenth edition in 1899; and it was translated into Russian, English, German, and Italian. What gave Michaud's history its appeal was precisely a comparatively and relatively balanced tone and moderation, although, as indicated, it had a didactic, even political, agenda embedded within it. Michaud's associate and collaborator, Jean-Joseph Poujoulat, remarked that although Michaud's *Histoire des croisades* might lack verve and eloquence, its "good sense and

clarity" distinguish it.[26] While Michaud's preferences colored his outlook and are apparent in his text, his history was nevertheless an impressive achievement and became the standard account for much of the nineteenth century.

Michaud followed publication of his history with a compilation of sources, an early *Pièces justificatifs de l'histoire des croisades*, and a four-volume *Bibliothèque des croisades* which was published in 1829 and provided a guide to the materials that Michaud discovered during his research for his *Histoire des croisades*. What is impressive about this collection is the extensive compilation of Arab sources published alongside the Christian accounts. Furthermore, Michaud not only relied on previous compilations, but he made a critical evaluation of their accuracy and reliability. In this sense, Michaud anticipated the so-called "scientific" approach to historical narration of the later century by offering the reader an opportunity to check and evaluate his narrative as well as his judgments. It was not, however, intended to be an "objective" or value-free account of the past. Michaud's history was engaged and his purpose readily apparent. The documentation was presented as part of the justification for his history.

This collection of sources, set alongside his history of the crusades, established Michaud as the foremost and most accomplished historian of the crusades in a century that was devoted to history, and these publications were part of the flourishing of historical studies in France that occurred under the Restoration. In his study of historical writing in this period, Stanley Mellon has stated that history became the most popular form of written communication following the dearth of such writing during the Napoleonic era. He has cited Comte Daru's claim that the forty million pages of history published in 1825 were ten million more pages than the next category, belles-lettres.[27] Much of this history had a political purpose, with liberals out to establish the achievements and legitimacy of the Revolution and the conservatives engaged in a rediscovery of the old regime and the pre-Revolutionary past, in which they placed an emphasis on the unity and relative tranquility that France experienced under the monarchy. As Mellon noted, the attempt to build a glorious memory for the Bourbons reached back to the time of St. Louis, described by royalists as "the most perfect model that history offers" of a divine and sainted monarch who was himself a crusader.[28]

The comparison with St. Louis as a referent for contemporary events did not escape Michaud. In his preface to the 1829 *Bibliothèque des croisades* Michaud justified his work on the ground that a critical examination "by our national historians is a work which seems to us worthy of being encouraged by the descendants of St. Louis and Louis XIV." His appeal was not disinterested, since he wished to flatter the monarch, Charles X, who rather liked to be compared with St. Louis and the Sun King, in order to receive royal support for a project to travel to the Orient to visit the sites of the crusades and discover additional manuscripts. As he put it, he hoped that "this completely French undertaking may be commenced under the auspices of Charles X."[29] The flattery worked. Charles X not only identified strongly with the glories of the French monarchy, seen in

the medieval ceremony that crowned him king at Reims in 1825, but he very much appreciated the comparison with St. Louis and his expedition to Tunis at the very moment in 1830 when Charles X was preparing for his own expedition, or "crusade," to Algeria. An ability to mix his interest in history with flattery won for Michaud the magnificent sum of 25,000 francs, which Charles X granted to him for his historical research. This sum enabled Michaud to travel to Palestine and Egypt by way of Greece in his own expedition to the holy land in 1830–31. The orientalist Poujoulat accompanied Michaud on this trip and together they were able to examine the sites of the crusades, particularly the walls of Jerusalem that had been breached in the first crusade, and to obtain new sources for a corrected version of the *Histoire des croisades*.

Michaud's trip to the Orient coincided with Charles X's expedition to Algiers. Michaud was in Toulon awaiting departure for the eastern Mediterranean when the expedition assembled and then sailed for North Africa. In his *Correspondance d'Orient* he provides a vivid description of the departure of the fleet from Toulon for Algiers. He spent several evenings with General Bourmont, the commander of the expedition, and he invoked the memory of Saint Louis and reflected that they were both about to embark upon their own crusades.[30] News of the July days, the revolution and the abdication of Charles X reached him in the East. According to Poujoulat, Michaud was not particularly surprised, having expressed his concern about the course of the monarchy before his departure. In fact, he had been dismissed from his post in the king's household in 1827 when he had protested the restrictions that the monarchy had imposed on the press, and a year later he had withdrawn as editor of *La Quotidienne*. When he had taken his leave of Charles X, Michaud had been impressed with the king's familiarity with his own project, but he also observed to Poujoulat that matters would go better for the monarchy if the king understood his own affairs as well as he was informed about Michaud's plans.[31]

Michaud returned to France in August 1831. In collaboration with Poujoulat he devoted himself to the completion of his *Correspondance d'Orient*, began to edit a thirty-two volume of French history sources, *Nouvelle collection de mesures pour servir à l'histoire de la France* (1836–38), initiated an updated and corrected edition of the *Histoire*, and produced an abridged version of the *Histoire des croisades* in two volumes for the use of "young people in the schools who have neither the leisure nor the patience to read longer works, nor the means to purchase costly, multivolume sets," which appeared a year before his death in 1839.[32] This abridged version for the edification of the youth of France proved enormously popular. It appeared in a new edition in 1844, made under the watchful eye of Poujoulat, and further editions and printings continued into the Second Empire and the Third Republic for a total of no less than nineteen republications in the nineteenth century. In short, Michaud's was clearly a popular history, as he intended the abridged version to be.

As a legitimist, Michaud in his later years was in an active retirement. While

opposed to the regime, his history of the crusades became linked to the "noble enterprise" of the Algerian expedition and the conquest of a colony in North Africa. In his preface to the abridged *Histoire des croisades* of 1838, Poujoulat emphasized that a new era of struggle between light and darkness had begun on the same shores visited by St. Louis seven centuries before. "The conquest of Algiers in 1830 and our recent campaigns in Africa are nothing other than crusades."[33] They shared the same objectives, in the latter case opening trade with the Ottoman Empire and a struggle against the obscurantism of "Moslem barbarism." As we have seen, the 1838 abridged version of the *Histoire des croisades* was intended for use in the schools and to reach a younger generation to give them a sense of what had been accomplished in an earlier age as well as to impart a renewed spirit of commitment, unity, and devotion. The shortened version, Poujoulat hoped, would give young Frenchmen a sense of mission and patriotism for the purpose of regaining a sense of national renewal. Such calculations appeared at least as part of the rationale for the Algerian expedition launched by Charles X in 1830, just on the eve of the July Revolution, and, despite its legitimist origins, the image of the crusades, or at least a crusading army, would reappear under the July Monarchy, particularly as Louis-Philippe came to identify his regime with the Algerian enterprise.

The decision to send an expedition to Algiers may be interpreted in several ways, but certainly the tendency of Charles X to identify with the past glories of the monarchy, including St. Louis, played a part. The pretext for sending an expedition to Algeria stemmed from a longstanding quarrel between the French government and the Bey of Algiers over a debt that, the French claimed, had not been paid and, more immediately, from an insult that the French consul experienced when the Bey struck him with a fan during an audience. Beyond these episodes were motives of opening Mediterranean trade without the threat of piracy. Although the claims against the Bey of Algiers were economic and political, Charles X presented himself in this dispute as the defender of Christianity against the outrages of a Moslem prince. In his speech to the Chamber of Deputies justifying the enterprise Charles X invoked the blessing of the Almighty in an undertaking "for the benefit of Christianity." While his ministers calculated the economic and political benefits to be gained from the expedition, particularly the treasury of Algiers, "The old fire of the Crusades inflamed the heart of the Most Christian King."[34] Even the political motives for the Algerian expedition rested upon a calculation that would have been familiar to readers of Michaud's account: a victory in Algeria would unite the French and, as the former war minister, Clermont-Tonnerre, wrote to General Bourmont when plans for the expedition were first being prepared in October 1829, a successful overseas operation would "distract public attention from our political struggles" and provide the king with the keys to Algiers that would silence his critics in the Chamber.[35] Despite Bourmont's success in capturing Algiers on July 3, 1830, however, news of this success was not enough to save the throne from revolution three weeks later.

The call for a new crusade must have been rather astonishing to the newly installed Orleanist dynasty. Unlike his Bourbon predecessor, piety played a small part in Louis-Philippe's calculations or sentiments. Indeed, he feared that the Algerian expedition, sent in what could have been seen as a last gesture of the ultra-legitimist Charles X, might not be particularly welcome for a regime that at least initially claimed to be closer to the people and identified itself with the prudence, good sense, and pacific values of the bourgeoisie. Louis-Phillipe wished to distance himself from the intransigent, legitimist orthodoxy of his predecessor. There was some consideration of recalling the expedition, but Charles X's minister, Polignac, had portrayed the capture of Algiers as a great national success, and Louis-Phillipe hesitated to withdraw a successful expedition and risk the criticisms of nationalists. Louis-Philippe recalled General Bourmont, an ardent and intransigent legitimist, since he feared that Bourmont might refuse to fight under the tricolor banner, and replaced him with General Bertrand Clauzel, who had at one time during the Restoration been under a death sentence and whose loyalty to the new regime was firm.[36]

Uncertainty and confusion marked the first five years of the July Monarchy's attitude toward Algeria. The government, while apparently committed to remaining in Algeria, failed to produce any clear policy on further conquest or colonization. Moreover, Louis-Philippe's advocacy of a peaceful foreign policy, particularly one that would secure friendly relations with Great Britain, became complicated by the Algerian intervention, since the British were alarmed at the prospect of a French presence on the southern shore of the Mediterranean. By the beginning of 1834 the French crusade in Algeria amounted to little more than a series of military enclaves along the southern shore of the Mediterranean from which local commanders embarked upon punitive forays into the interior, only to withdraw to the safety of the coastal cities—Algiers, Oran, Bougie, Mostaganem, and Bône—where French security was assured.

A turning point in the July Monarchy's Algerian policy came in 1833–4 with the appointment of a parliamentary commission, which was given the assignment of evaluating the enterprise and recommending whether or not it should be continued. The commission travelled to Algiers where it gathered information and held hearings and concluded that French honor required that the occupation of the main coastal towns of Algiers be continued; the vote in favor of retaining a French presence in Algeria was an impressive seventeen to two, although a number of objections had emerged during the discussions and debates within the commission and subsequently in the French Assembly.[37] An ordinance of July 22, 1834, declared that the possessions in North Africa were to be French, and it created the office of governor general into that of a proconsulate with extended authority over civil and military affairs in the colony.[38]

By this time the reputation of the monarchy was becoming fully engaged and identified with the Algerian conquest. Adolphe Thiers, who had become a partisan of the Algerian conquest, claimed that the king wished to retain Algeria for two reasons.

One was that in Algeria he could "satisfy the belligerent spirits of France without raising alarms among rival powers" in Europe, meaning England, and the second reason was that Algeria would provide Louis-Philippe's sons with "a small school in military affairs and an occasion to distinguish themselves at little cost" and in a way that would bring them favorable publicity in France.[39] The glory won in Algeria would enhance the legitimacy of the throne, and it would also closely identify the House of Orléans with the army and military affairs. Just as Louis-Philippe appropriated the Napoleonic legend for his own dynastic purposes, so too would Charles X's crusade in Algeria become a means of identifying the July Monarchy with the military exploits of overseas expansion and demonstrate French prowess in "cleansing" the south shore of the Mediterranean from the threats of piracy. While not necessarily a mission for Christian civilization, this undertaking would be presented as a distinctly French achievement on behalf of civilized Europe against the Barbary coast. Five of Louis-Philippe's sons would serve in Algeria and participate in military expeditions, sometimes with considerable distinction.

The first of Louis-Philippe's sons and the heir apparent, the duc d'Orléans, arrived in Algeria in 1835 to visit the troops stationed in Algiers and Oran. His criticism of the deplorable conditions for the soldiers of the Algerian expedition won a favorable press at home.[40] The presence of the duc d'Orléans in Algeria in 1835 ended any uncertainty over the July Monarchy's commitment to a French presence in North Africa, and this first visit of the duc d'Orléans received official, artistic, and highly sympathetic commemoration in a painting by Louis-Philippe's preferred artist, preserved at the historical museum at Versailles: Horace Vernet's *Le Duc d'Orléans visite les hôpitaux*. Later that year the duc d'Orléans accompanied Marshal Clauzel on his raid against Mascara. This expedition forced Abd el-Kader, the most effective of the Algerian resistance leaders, to move his operations westward along the Moroccan frontier. After the Mascara expedition Orléans returned to France to a heroic welcome.

The following year Louis-Philippe's second son, the duc de Nemours, became involved in French efforts to capture Constantine. The first attempt failed to capture the Algerian city, but the monarchy, despite this setback, preserved its prestige when the duc de Nemours distinguished himself during the retreat with a display of bravery and cool judgment under fire. The following year the French succeeded in capturing Constantine and again the duc de Nemours assumed a leading role in the expedition.[41] With the capture of Constantine Louis-Philippe fully identified the prestige of his dynasty with the Algerian conquest and the military feats that accompanied it. The siege and capture of Constantine received official publicity with a royal commission for Horace Vernet to create three vast paintings that were installed in the historical museum at Versailles after their appearance in the salon of 1839.

The duc d'Orléans returned to Algeria again in 1839 to participate in a hazardous military expedition to the Portes de Fer, an action that caught Abd el-Kader by surprise

and broke the uneasy truce that General Thomas-Robert Bugeaud had made with the Moslem leader two years earlier. In response to this move Abd el-Kader proclaimed a holy war against the French Christians, and his supporters resumed attacks on French military outposts in the interior. By the beginning of 1840 Louis-Philippe's crusade in Algeria had become a determined struggle to break Moslem resistance to French domination, and the expedition to the Portes de Fer was a signal for a series of campaigns under Bugeaud that would eventually break Abd el-Kader's resistance. The occasion of this deliberate challenge and provocation received official artistic commemoration in Adrien Dauzats' Romantic and somewhat mysterious, *Le Passage des Portes de Fer*, preserved at the Versailles museum. Dauzats had accompanied the expedition, and he recreated its dramatic moment as a kind of "reportage" drawn from his sketches. The image is one of modern day crusaders penetrating "the unknown" in search of martial glory.

Orléans returned to France after the expedition to the Portes de Fer, having become an ardent partisan of the Algerian adventure, and the king gave a ringing endorsement of the Algerian conquest in his message to the Chamber of Deputies at the end of the year. The regime also obtained political support with the appointment of the Thiers ministry in 1840, and, despite Louis-Philippe's reservations over the general's rather rough and abrasive style, he sent General Bugeaud to Algeria as governor-general in what was to be a seven-year proconsulate with a full mandate to accomplish the pacification of the countryside by whatever means were necessary. Bugeaud proclaimed that it was "essential that the country be conquered and the power of Abd el-Kader destroyed."[42] By 1841 Louis-Philippe was explicit that the French were in Algeria to stay. Furthermore, this effort gained support from liberals such as Lamartine, who informed an audience in Mâcon that egalitarian France saw in Algeria a common battlefield that united the sons of workers with the sons of the dynasty.[43] The Algerian conquest and its sense of mission might bring unity to a divided France.

By 1848 all of the king's sons had served in Algeria and were associated with the military exploits of the conquest. The prestige of the July Monarchy through its princes had become completely identified with the progress of French expansion across the Mediterranean, and Algeria offered some distraction from the domestic criticisms of the monarchy. The Prince de Joinville, for instance, participated in the Algerian conquest as a naval officer. Although the naval role was secondary to that of the army, Joinville played a significant role in the later stages of the campaign against Abd el-Kader. His brother and the youngest son of Louis-Philippe, the duc de Montpensier, also took part in the Algerian military campaigns; he was wounded in one of the "pacification" expeditions in the southern Constantine region in 1844 and would have continued his military career in Algeria, following in the family tradition, but this avenue closed with the 1848 Revolution.

The strongest legacy of the Orleanist princes in Algeria was that of the duc

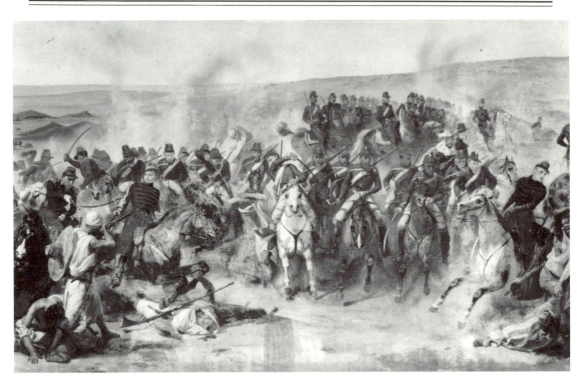

68. Horace Vernet, *Capture of the Smalah of Abd el-Kader,* Versailles, Musée National du Château

d'Aumale, who entered the army at seventeen and first saw action in Algeria in 1840 when he accompanied Marshal Valée and his brother, the duc d'Orléans, on the final expedition to Médéa, an event recorded by Hippolyte Bellangé for the Versailles museum in his *General Valée's Expedition to Médéa: The Attack on the Mouzaîa Emplacement, a High Point of the Conquest, 12 May 1840.* D'Aumale soon proved himself an able soldier and leader, despite his youth and relative inexperience. His most sensational exploit was to lead the French forces in the capture of Abd el-Kader's encampment in 1843, which provided the French with an enormous booty and forced Abd el-Kader to become a fugitive. Although critics of the regime denigrated this act of arms, the seizure of Abd el-Kader's *smalah* received considerable publicity in France, and Horace Vernet's *Capture of the Smalah of Abd el-Kader (Prise de la Smala de Abd el-Kader;* fig. 68) commemorated both an important event in the Algerian conquest and provided a propaganda statement demonstrating the superiority of "la furia francese" against the Moslems. It also revealed the violence of the war against the Moslems in Algeria.[44] Following this stunning defeat, Abd el-Kader took refuge in Morocco under the benevolent protection of Sultan Abd er-Rahman.

With the sensational capture of Abd el-Kader's *smalah,* the candidacy of the duc d'Aumale to become governor-general for Algeria began to be considered. He had

gained favor and popularity within the army, and his presence at the head of the government in Algeria would be a politically astute choice that might remove some of the criticisms of the overwhelmingly military character of the Algerian operation. Long rumored, the duc d'Aumale's appointment as head of the Algerian government came in 1847. His brief tenure gained d'Aumale considerable praise within the army. Even Bonapartists and republicans, such as General Pélissier and Jules Favre, paid hommage to his leadership.[45]

While the participation of Louis-Philippe's sons in the military campaigns gained some favor and popularity for the regime, it was not enough to save it from domestic criticism. Several journals complained of the additional costs imposed by the presence of the princes and their imposing retinue. As the journalist Faucher wrote in *Le Courier français* on the occasion of the duc d'Aumale's first voyage to Algeria in 1840, the presence of these royal princes was often, as in the first, unsuccessful siege of Constantine, an obstacle to successful military operations. Thus, the legacy of the Algerian experience, as a way of enhancing the popularity of the monarchy and as a martial school for Louis-Philippe's sons, must be considered a mixed achievement. Support for a war of conquest that ravaged the countryside in Algeria belied Louis-Philippe's claim to be a king for liberty and peace, and the hope of distracting the belligerent spirits with a crusade in Algeria proved to be an illusion.

What the July Monarchy created was a kind of legend, a commitment to an Algerian mission that would survive the regime and be continued for the next one hundred and thirty years. The Algerian legacy from the last years of the legitimist Restoration became adopted by the prudent government of the "juste milieu." Yet there was nothing restrained or moderate, at least after the first hesitant years, about an all-out commitment to a war of total conquest, marked by great brutality, to establish a French peace and bring the virtues of French civilization onto the southern shore of the Mediterranean. Although a legitimist legacy, the crusade in Algeria became a national undertaking, an expression not only of a "furia francese" but of a war on behalf of civilized Europe against the Moslems. This was the beginning of an imperialist myth that would extend beyond the July Monarchy and become the basis for a French rationale for overseas expansion in a "civilizing mission" that began as far back as the crusades and was, to borrow Michaud's interpretation of the medieval crusade, no less "revolutionary" and disruptive in its impact upon both France and the others overseas who were subjected to French domination.

The effort to identify the war in Algeria with the historical legacy of France may be found both in the popularity of Michaud's *History of the Crusades*, which was after all the work of a legitimist historian, and in Louis-Philippe's creation of the historical museum at Versailles that was devoted to "all the glories of France." Much has been written about this project recently, particularly from the point of view of the politics behind the official art that it reflected.[46] The museum has also been described as one of the "places of

memory" in which the Citizen-King created a monumental display to record the history and grandeur of the French nation in an attempt to reconcile "all the French" to their common past.[47] What is interesting to the historian is the way in which the project defined the French past and, more particularly, the prominence given to certain aspects of French history. Although a major purpose in creating the museum was to reconcile the revolutionary and Napoleonic past with the July Monarchy, the defining motto, "all the glories of France," was inclusive. During the Restoration liberal historians appropriated and rendered acceptable the revolutionary myths and legacies. As Stanley Mellon has noted, the political use of history became part of an attack upon the official history of the Restoration, which denied the recent revolutionary and Napoleonic past.[48] Both Guizot and Thiers, as liberal historians, contributed to this tradition. At the same time the legitimists appropriated other elements of the French past, most notably Joan of Arc, as a symbol of French national resurrection under the monarchy, and the crusades, as a founding moment for royalist France, for their own political purposes.

Louis-Philippe's ambitious and expensive project at Versailles tried to bring together these different and often contending visions of the French past in two ways. In a concession to the legitimist-royalist view, the origin of French history was to be found in the Middle Ages since, as Michaud had implied, the crusades consolidated the monarchy, provided France with a sense of national enterprise, and was part of an ongoing struggle on behalf of a Christian mission. At the same time Louis-Philippe incorporated selected portraits of the revolutionary and Napoleonic legacies, making an appeal to the past as a way of bringing unity and consensus to his own time. Along with the decision to return Napoleon's ashes from St. Helena in 1840, the creation of the historical museum was a major effort to reconcile the French people to their past in all its dimensions: Napoleonic, revolutionary, and old regime.

The July Monarchy's effort to embrace "all the glories of France" included, then, the conservative and legitimist vision as well as the more familiar—and more extensively portrayed—revolutionary and Napoleonic legacies, and may be seen at Versailles in the extensive coverage of these latter eras in the space consecrated to the revolutionary era, the Consulate, and First Empire. This tracing of French history through military exploit, as seen in the Gallery of Battles, provided a continuity of French history, but the July Monarchy's history of France, as seen through those rooms that focused on particular periods of the French past, such as the Revolution, Consulate, or Empire, began with the crusades. The five rooms devoted to the crusades at Versailles marked the first or defining epoch of French history, which was seen as a "national" endeavor insofar as the French kings and nobles assumed a leading role in this effort to spread the influence of Christian civilization among the peoples of the Levant. While not explicitly taken from Michaud, this emphasis on the French character of the crusading enterprise, as well as its function in bringing together diverse interests and giving opportunity for the release of military atavism abroad, connected the messages.

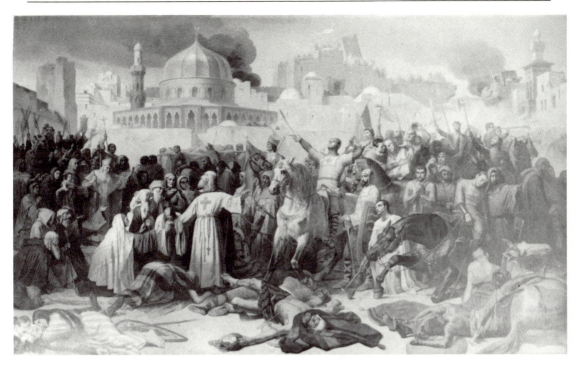

69. Emile Signol, *The Capture of Jerusalem by the Crusaders on 15 July 1099,* Versailles, Musée du Château

The purpose of the historical museum was also to appeal to a middle-class taste for history and to use history and its interest for instructive purposes, just as Michaud clearly indicated his didactic reasons for writing his *Histoire des croisades.* All history is selective, and the process of selection reveals an intention; in this sense, both Michaud's *Histoire des croisades* and the history gallery at Versailles, illustrating the crusading spirit of France in both the distant past and in the contemporary era, had propagandistic purposes, even if in both instances the creators strove to "represent" the past as realistically as possible while drawing attention to the contemporary engagement. This connection may be seen in the subjects chosen for presentation in the crusades room at Versailles and in the *Salle de Constantine* and in the *Salle de la Smalah.*

Louis-Philippe commissioned several paintings that commemorated the crusading legacy. Among the events portrayed from the history of the Crusades were Emile Signol's two paintings, *Crossing the Bosporus in 1097* and *The Capture of Jerusalem by the Crusaders on 15 July 1099* (fig. 69) from the first crusade. An event from the second crusade was noted in Merry Blondel's painting, *The Town of Ptolemais Delivered to Philippe-Auguste and Richard the Lion-Hearted, 13 July 1191*, which served to provide a crusading dimension to Louis-Philippe's search for an entente cordiale with England. Perhaps the best known of these commissioned paintings was Eugène Delacroix's *Entry of the Crusaders into Constantinople on 12 April 1204* (fig. 70), which rather heroically presented one of the

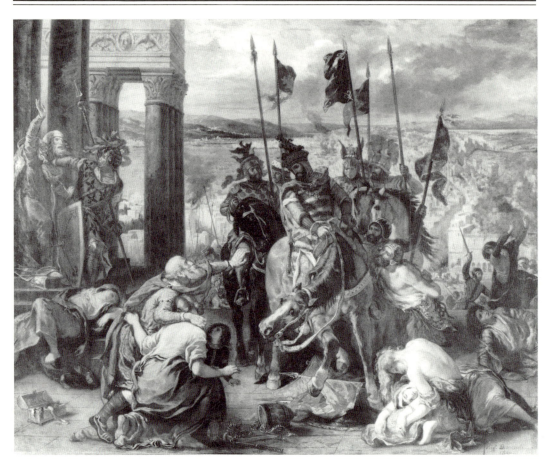

70. Eugène Delacroix, *Entry of the Crusaders into Constantinople on 12 April 1204*, Paris, Musée du Louvre

more ignoble events of the crusades, namely the fourth crusade's distraction from the holy land to seize Constantinople for the benefit of Venetian traders. Also from this fourth crusade, again presenting a sense of grandeur and domination of the Moslem East, was Louis Gallait's *Baldwin, Count of Flanders, Crowned Emperor of the Byzantine Empire at St. Sophia in Constantinople, 16 May 1204*. There was a contribution by Louis-Philippe's preferred painter, Horace Vernet, *The Battle of Las Navas de Tolosa on 12 July 1212*. Finally, linkage from St. Louis to the July Monarchy's common crusading activities in North Africa found expression in two paintings by Rouget: *Saint Louis Receives Envoys from the Old Man of the Mountain at Ptolemais in 1251* and *The Death of Saint Louis before Tunis on 25 August 1270* (fig. 71). The latter event became part of the July Monarchy's claim to continuity with France's crusading past when Louis Philippe erected a memorial to St. Louis in Tunisia.

The connection between this historical reconstruction through tableaux and the

71. Georges Rouget, *The Death of St. Louis before Tunis on 25 August 1270.*

more contemporary overseas conquest appeared at Versailles in the rooms devoted to Algeria, the *Salle de Constantine* and the *Salle de la Smalah*, both memorializing critical moments in the conquest of Algeria in the same way that the crusades room pointed to those French accomplishments of overseas enterprise from an earlier era. One author has written that the historical museum was designed to cater to "the interests of his [Louis-Philippe's] bourgeois constituency" by appealing to a "growing interest in history and popular education" as well as catering "to an insistent sense of nationalism in French culture," adding that by commissioning the paintings of the North African campaigns, "Louis-Philippe embraced the middle-class interest in French imperialism."[49] Louis-Philippe's historical museum project shared something of Michaud's rationale for a

French mission overseas, particularly against the Moslem "others" of the Mediterranean. This was recognized at the time when a contemporary account, describing the wars in Africa depicted at Versailles, referred to them as "crusades of the nineteenth century," and discovered these medieval glories in Horace Vernet's *Second Expedition to Constantine: The Assault on Constantine, 13 October 1837*, a vision that provoked the following effusive comparison in this contemporary description of the *Salle de Constantine* at the museum:

> We there find again, after an interval of five hundred years, the French nation fertilizing with its blood the burning plains studded with the tents of Islam. These are the heirs of Charles Martel, Godfrey de Bouillon, Robert Guiscard and Philip Augustus, resuming the unfinished labours of their ancestors. Missionaries and warriors, they every day extend the boundaries of christendom.[50]

Not only in the message but even in a desire to create an impression of accuracy, Michaud and Horace Vernet both travelled to sites of the French crusading expeditions in Palestine and in Algeria to give readers or viewers a sense of immediacy and verisimilitude to their descriptions of the distant and immediate pasts. Both were efforts at once to portray the distant and more recent past with a kind of realistic accuracy, but they also made political statements within an appearance of "objectivity" or detachment that fostered a kind of myth about a French crusading mission. The connection between the memory of the crusades and its impulse was recaptured by Michaud under the Restoration and continued into the July Monarchy, seen in the deliberate effort in the Versailles historical museum to associate the regime's Algerian conquest with that memory. The conquest of Algeria became an updated version of a French "civilizing mission" that would be continued beyond the end of the July Monarchy.

The "glories" of the military crusade, or the conquest of Algeria, failed to save the July Monarchy from the revolution. In this sense, the conquest of Algeria was ineffective as a distraction from domestic division and strife, just as Louis-Philippe's museum at Versailles failed to reconcile the French to a contested past and neutralize the internal dissensions of his era.[51] Ironically, the conqueror of Algeria, Marshal Bugeaud, was unable to save the monarchy in the streets of Paris during a crucial moment in the demonstrations of February 24 when his troops began fraternizing with the crowd and Louis-Philippe recoiled from taking the drastic military action that might have dispersed the demonstration. What survived from the July Monarchy was a legacy of Algerian conquest and French overseas expansion. Successor regimes continued the pursuit of the "civilizing mission" in Algeria and elsewhere in Africa and Asia; all of these efforts were accompanied by a rationale in which the notion of a crusade and France's role in the past as a crusading power continued to be evoked. This crusading myth became useful for not only the Bonapartist Second Empire but also for the Third Republic's expansionist imperialism at the end of the century. What France, Europe,

and much of the world would experience in the next hundred years was a phenomenon of imperialism that was no less disturbing and "revolutionary" in its impact than the original crusades of the medieval period had been. These overseas enterprises, given an initial push with the Algerian expedition of Charles X and carried to the length of a "total conquest" under Louis-Philippe, acquired a legitimizing myth through the invocation of the crusades of the past.

The memory of the crusades became a lesson for successive generations in the nineteenth century. The popularity of Michaud's history continued unabated throughout the nineteenth century with reprintings and new editions of both the full history and the abridged version for students. One of the most elegant of these histories was a folio edition published in 1877, just on the eve of a renewed thrust of French expansion, with one hundred engravings by Gustave Doré that again illustrated one of the "glories" of French history. No less than eighteen editions or reprintings of Michaud's abridged history of the crusades for school children appeared between 1844 and the end of the century, including a pirated "popular" history in one volume, attesting to an enduring fascination with the subject of France's crusading past. Finally, the military legend of the army as the crusading arm of French civilization that emerged from Louis-Philippe's conquest of Algeria would continue into the twentieth century when a later generation of military officers in Algeria justified their last ditch defense of "Algérie française" as a crusade against the tide of communism that they saw behind the nationalist uprisings in the French Empire, some one hundred and twenty-five years after the July Monarchy had embraced the colonial crusade in Algeria.

Pop Culture in the Making: The Romantic Craze for History

PETRA TEN-DOESSCHATE CHU

A POWERFUL SENSE of history is commonly cited among the foremost characteristics of Romanticism.[1] More often than not it is the Romantic interest in the Middle Ages that is stressed above all other historic periods. However, as Hugh Honour has pointed out,[2] medievalism probably played a more important role in "pre-Romanticism"—that complex prelude to Romanticism marked by "Gothick" novels and, what Kenneth Clark called, "Gothic Rococo" architecture—than in Romanticism proper.[3] Indeed, the Romantics were as much preoccupied with the Middle Ages, as with the sixteenth, seventeenth, and eighteenth centuries (Victor Hugo's *Cromwell,* Walter Scott's Waverley novels, Eugène Delacroix's paintings of Michelangelo and Torquato Tasso), or, for that matter, with the more recent history of the Revolution and the Napoleonic era (Charles Dickens's *Tale of Two Cities*, Hugo's *Quatrevingt-treize*, François Rude's *Awakening of Napoleon*). Only the classical past, for so long the single focus of historic interest, had little attraction for them.

While the literature on Romantic historiography and certain aspects of Romantic historicism (notably the historical novel) is substantial, the extent to which the sense of history pervaded Romantic culture, both in "breadth" and in "depth" is seldom sufficiently stressed. For not only did it have an impact on all aspects of culture, from literature to theatre, music, fine and decorative arts, architecture, interior decoration and women's fashions, but it also had much more profound repercussions within society than is usually acknowledged. Instead of merely affecting the upper crust of the educated male establishment, it likewise animated part of the lower classes and segments of society that traditionally had remained largely untouched by "high" cultural trends: women and children. This seems to have been particularly true in France, where the

political and social upheavals caused by the Revolution and the Empire appear to have prepared the ground for a cultural democratization on a scale hitherto unknown, even unthinkable.[4]

It is the purpose of this essay to demonstrate that this widespread popularity of history during the height of the Romantic movement—the later Restoration and July Monarchy periods—was symptomatic of the emergence in France of a popular culture, different from traditional folklore, and anticipating in several important ways the mass culture of the twentieth century. Indeed, that the popularity of history during this period amounted to a popular cultural phenomenon comparable (with certain reservations, to be discussed below) in intensity and breadth to, let us say, the preoccupation with ecology during the 1970s or the interest in women's issues during the 1980s. Not unlike those twentieth-century phenomena of mass culture, historicism affected both "high" and "low" culture, to the point where it became a commonly shared cultural good.

This essay consists of three parts. In the first section the broad contours of the popularity of history are sketched, in the context of literary as well as visual culture. Attention will be given to the pervasive presence of historicism rather than its complex ideological ramifications, though clearly historicism is always to a greater or lesser degree ideologically determined. In the second part, a single strand within the phenomenon of the popularization of history, namely the powerful impact in France of the historic novels of Walter Scott, is taken up and considered in greater detail. The concluding section constitutes an analysis of how and to what extent the popularity of history during the Romantic period fits modern definitions of popular culture.

THE ROMANTIC SENSE of history must be attributed first and foremost to history itself.[5] The Revolution of 1789 and its stormy aftermath, as well as the subsequent exploits of Napoleon, ripped apart the political and social fabric of France. Few Frenchmen, from the members of the royal family to the peasants in the provinces, remained unaffected by the events of the twenty-six years that spanned the storming of the Bastille and the Battle of Waterloo, and none but the mindless could fail to be aware of living through a period of historical significance.[6]

Just as the events of 1989 in Eastern Europe and China caused many to meditate on the French and Russian Revolutions,[7] so the survivors of the Revolution and the Empire saw past revolutions (the Great Rebellion of England, the Reformation in the German countries, the Dutch revolt against Hapsburg domination, etc.) in a new and different light. Most importantly, the cataclysmic events of the Revolution and the Empire brought into focus the impact on the lives of ordinary people of "living history," and fueled the realization that history, beyond an inventory of kings, wars, and peace treaties, is the sum of the cumulative experiences of a group of individuals. While the

experiences of the Revolution and the Empire set history in a new perspective, mutatis mutandis, history seemed more relevant than ever to the events of the immediate past and present.

In addition to history's new pertinence to contemporary events, there was, as Marie-Claude Chaudonneret has pointed out, a political urgency for studying history as well.[8] The defeat and humiliation of France in 1815 had made the country loose faith. Looking backward at past achievements, by studying more glorious periods of national history, was one way for France to regain its national self-esteem.

A NEW MODE of history writing was introduced during the Restoration period by a group of authors, born in the 1780s and 1790s, including, most importantly, Augustin Thierry, Auguste Mignet, Adolphe Thiers, and Prosper de Barante. Influenced by the historical novel, a literary genre recently launched in England by Walter Scott (about whom more below), they introduced a narrative style of historiography that differed from the history writing of Chateaubriand and his followers,[9] then current, which had a more epical character and was still deeply rooted in the eighteenth-century philosophical approach to history, exemplified by Voltaire and Montesquieu.[10] In his introduction to the *Histoire des Ducs de Bourgogne* (1824–26), Barante declared, "I have tried to restore to history herself the charm that the historical novel has lent her. She [history] must be above all exact and serious, but it seemed to me that she could be at once true and alive."[11] To Barante and his colleagues lending charm (*attrait*) to history was not a whim but a serious decision aimed at reaching the largest possible audience for the purpose of the political and moral education of the "people." Thierry wrote, in his *Dix ans d'études historiques* (1835), "Born a commoner, I asked that the commononers' condition be paid due tribute in our history, that the memories of plebeian integrity, of bourgois energy and liberty be collected with care and respect; in brief, that with the help of science joined to patriotism, our old chronicles are made to yield stories capable of touching popular sensibility."[12] As Thierry's remark indicates, the narrative historians made extensive use of old chronicles and documents to enliven their historic narrative with "authentic" anecdotal material and descriptive detail. By thus making history more colorful and "real" (what was called *couleur locale* at the time),[13] they hoped to attract a new popular public, far broader than the traditional readership of history books, composed largely of scholars and intellectuals.

Without exception, the new narrative historians were liberals, deeply involved in the public life of their time. Several of them were journalists and some, like Adolphe Thiers,[14] were to play important roles in politics itself. History, to these men, was a polemical instrument and historiography a political act, especially crucial during the Restoration period when censorship and oppression made explicit political commentary and outright political action all but impossible. As the narrative historians, without exception, were ardent Orléanists, their role as instigators of the opposition was played

out by the onset of the July Monarchy, but a new generation of historians, most importantly Jules Michelet, took over that task. Michelet's aim was to educate not merely the liberal middle class but the laboring masses by writing popular history books[15] that went beyond narrating the events of the past to make them come back to life.[16] To Michelet, the historian was a secular prophet whose task it was to show the people that the history of mankind was the account of its progressive march towards complete physical and spiritual freedom.

The popular historians of the Restoration and July Monarchy periods nearly all deferred to Walter Scott as a model for their new mode of history writing.[17] In his *Dix Ans d'études historiques*, Thierry praised Scott for "studying the mass of the population and revealing conflicting interests."[18] Indeed, as Georg Lukács has pointed out, Scott's characteristic plots feature ordinary "heroes" who, caught up in a momentous historical conflict, do not become fanatical partisans but take a conciliatory stance. As such they are exemplary of the mass of the population which, sandwiched between two opposing extremist camps, shows fluctuating sympathies now for one, then for the other. Scott's popularity in France may well have been related to his preference for such *juste-milieu* heroes, though no doubt it had other causes as well. His historical imagination (always rooted in thorough research),[19] which enabled him to lend (what Delacroix would call) an astonishing smell of reality to the historical narrative, and his ability to portray the totality of the historical moment in the "complex interaction between 'above' and 'below,'"[20] may well have been the most important factors in his vast international reknown.[21]

Scott's popularity in France was enormous, as was that of his American follower James Fenimore Cooper. Not surprisingly, these two authors had a substantial literary following in France, ranging from forgers and pasticheurs to more or less gifted imitators of their style. In 1832, Stendhal estimated that Scott had as many as two hundred French followers, all of whose works were read, sometimes so widely as to necessitate numerous editions.[22] In addition to those popular authors, the likes of Félix Bodin, A.-H. de Kératry, Victor du Hamel, and other now mostly forgotten writers, France produced its own brand of popular historical novel, best exemplified by the work of Victor Hugo and Alfred de Vigny. Unlike Scott, who looked upon the past as the prehistory to the present, these authors viewed history as a series of moral lessons for contemporary society.[23] Historical accuracy was less important to them than it was to Scott. As Vigny put it, it was the "truthful observation of human nature" that counted rather than the "authenticity of fact."[24]

The final flowering of the historic novel in France came in the form of the *romans de cape et d'épée*, the cloak-and-dagger novels of Alexandre Dumas and his followers. Though these authors did draw on historical sources,[25] history to them was primarily an appropriate dressing for an engaging adventure story.[26] Notwithstanding, Dumas best-selling novels, *Les Trois mousquetaires* (1844) and *Le Comte de Monte Cristo* (1844), proba-

bly did more to popularize the history of seventeenth-century France than any other work of fact or fiction.

In his thoughtful study, *Popular French Romanticism*, James Smith Allen argues that the Romantic period fostered a popular literature that, unlike the old *bibliothèque bleue*, closely resembled the elite literature of the day. Indeed, Allen goes so far as to claim that certain categories of Romantic literature clearly belonged to "literary worlds both high and low."[27] Within these categories, he includes, most importantly, narrative histories and historic novels. Using a variety of indicators, such as edition sizes, catalogues of lending libraries, and miscellaneous references, Allen demonstrates that narrative histories and historical novels were read by a considerable public comprised of readers of different gender and age, and diverse social backgrounds. In addition to providing pertinent statistical data, Allen informs us, for example, that the editions of J.A. de Norvins's narrative histories (such as his *Histoire de Napoléon* of 1827) sometimes ran into the tens of thousands; that between 1830 and 1842, Walter Scott's work appears in all twenty-six Parisian lending library catalogues he consulted; that Barante's *Histoire des Ducs de Bourgogne* was read by schoolboys, and that in 1838 copies of Hugo's *Notre Dame de Paris* were sold in the street for one franc per volume (about half of the daily wages of an unskilled laborer[28]).[29] Allen furthermore emphasizes the importance of the ephemeral press for the diffusion of such popular Romantic genres as history and historical fiction. Short articles on history, for example, appeared in the *Musée des familles,* the *Magasin Pittoresque*, and other popular periodicals which had circulations in the tens of thousands and, after 1836, when *La Presse* ran the first installment novel, a number of historical novels appeared in serial form in the newspapers.[30]

While demonstrating the increased availability of histories and historical novels, both in book and serial form, Allen also discusses the broadening of the reading public during the Restoration and, especially, the July Monarchy period.[31] It is estimated that, while in 1831 only 53 percent of men older than fourteen could read, by 1851 the figure had risen to 68 percent. During that same period, the figure for women increased from 40 percent to 52 percent.[32] This meant that reading was no longer a privileged middle-class activity but one in which the labouring classes increasingly shared as well. "The fact exists, the people (*le peuple*) know how to read," wrote Alfred Karr in 1835,[33] and in Daumier's print, *Worker and Bourgeois* (Ouvrier et bourgeois) of 1848 (fig. 72), it is the worker in his white smock who is absorbed by a newspaper while the bourgeois in black tailcoat and tophat only thinks of his belly.

The rapidly growing number of *cabinets de lecture*,[34] where books could be borrowed for the price of ten centimes, brought historic novels and history books within range of a large segment of the urban population. At the same time, technical improvements in paper making and printing made the production of printed materials (magazines, newspapers, books) ever cheaper. All these factors operated jointly to bring historical fact and fiction to a broad segment of a population that encompassed men and women,

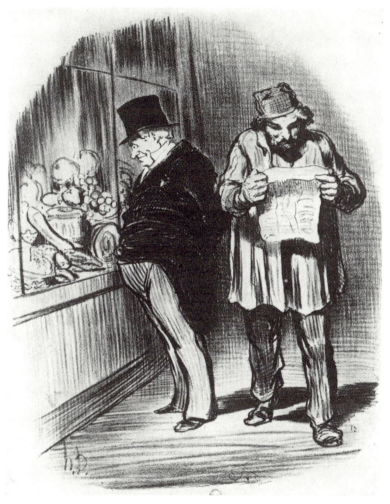

72. Honoré Daumier, *Worker and Bourgeois,* 1848, lithograph. Paris, Bibliothèque Nationale

adults and children, the well- and little-educated, the office worker, the shopkeeper, the skilled artisan, and the domestic.

WHILE NARRATIVE HISTORIES and historic novels must have reached a substantial audience, an even broader segment of the population was exposed to history through the agency of the theatre. Both the Romantic dramas of Victor Hugo, Alfred de Musset, Alfred de Vigny, and Alexandre Dumas, and the popular historic melodramas of Guilbert de Pixerécourt and his successors—Victor Anicet-Bourgeois, Joseph Bouchardy, Adolphe Dennery, and others—drew on history as a main source of inspiration.[35] Joining the visual to the verbal, the historic costume piece brought alive the very same

figures and events from the past that were common fare in narrative histories and historic novels. Indeed, since many melodramas were nothing more than dramatizations of popular historic novels, they divulged the plots of those works among a segment of the population that either could not read or read with such difficulty that a novel or history book would have been beyond its reach. "I am writing for those who cannot read," said De Pixerécourt, one of the most-performed writers of melodramas in the early nineteenth century.[36] And though his remark may well have been somewhat hyperbolic, it does suggest that the historic melodramas that were performed in the boulevard theatres of the Restoration and the July Monarchy drew crowds whose literacy level was limited. Based on a study of the relation between salaries and the price of theatre tickets during the July Monarchy, John McCormick has suggested that the typical public of the boulevard theatres was composed of skilled artisans, small shopkeepers and traders, *petits rentiers*, soldiers on half-pay, etc.[37] Contemporary cartoons, such as Daumier's *The Fifth Act at the Gaîté* (Le Cinquième acte à la Gaîté; fig. 73), with its public of petty bourgeois and working class folk, confirm this suggestion and furthermore show that the boulevard theatre attracted women and men, adults as well as children (though the latter may have attended primarily because babysitting care was not available or affordable).

Though it is customary to make a distinction between the (low) melodramas of the boulevard theatres and the (high) dramas performed in the Comédie française or the Odéon, it must be stressed that the Romantic drama did attract a popular audience as well. McCormick has shown that the least expensive seats at the Comédie française—or the Théâtre français, as it was called at the time—cost one franc, twice as much as the cheapest tickets at the Ambigu or the Gaîté, yet still within reach of the public that frequented the boulevard theatres. The least expensive seats at the Porte St. Martin (fig. 74), where many of Hugo's dramas premiered, in 1835 cost only five centimes more than at the Ambigu and the Gaîté, and by the end of the July Monarchy they were the same price. Hugo seems to have been well aware of this fact and wrote his plays with the popular component of his audiences in mind. In the introduction to Ruy Blas, first performed at the newly opened Renaissance on November 8, 1838, he wrote, "Three types of spectators make up what one commonly calls the public: firstly, women; secondly, thinkers, thirdly, the crowd (*la foule*) in the proper sense of the word."[38] Hugo went on to say that each group looks for something different in a play: the crowd wants action, women want passion, thinkers want convincing psychological characters. Unlike other forms of theatre, which only deliver one of these elements (tragedy providing passion; melodrama, action; and comedy, convincing psychological characters), the new "drame romantique" contained all three elements.[39] Hugo, by his own admission, consciously strove for a dramatic form that would appeal to a diversified public of men and women, of educated and non-educated viewers.

Like drama and melodrama, opera too drew on history for its plots. "Grand opera,"

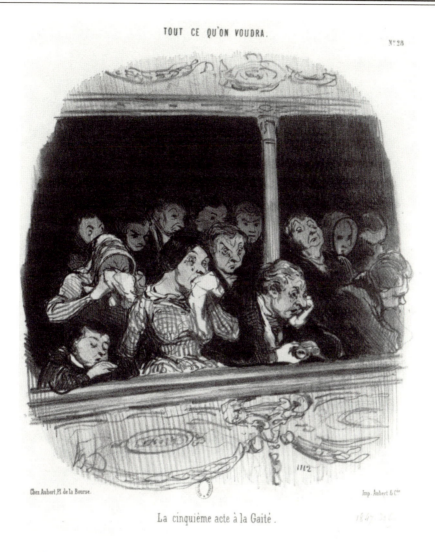

TOUT CE QU'ON VOUDRA.

N° 28

La cinquième acte à la Gaîté.

73. Honoré Daumier, *The Fifth Act at the Gaîté*, 1848, lithograph.

a July Monarchy creation much like the "drame romantique," was almost exclusively historic in inspiration—as the best-known operas performed during the July Monarchy confirm—and it was in opera that history found perhaps its most grandiose and dramatic visual representation (fig. 75). Meyerbeer's *Robert Le Diable* (first performed in 1831) and his *Huguenots* (1836), both incredibly successful grand operas were set in the past, as were Bellini's *I Capuletti e I Montecchi* (1833) and *I Puritani* (1835), Berlioz's *Benvenuto Cellini*, Donizetti's *Anna Bolena* (1831), *Marino Faliero* (1835), *Lucia de Lammermoor* (1837), *Robert Devereux, comte d'Essex* (1839), and *Lucrezia Borgia* (1840), Halévy's *La Juive* (1835) and *Charles VI* (1843), and Rossini's *Guillaume Tell* (Paris 1829)

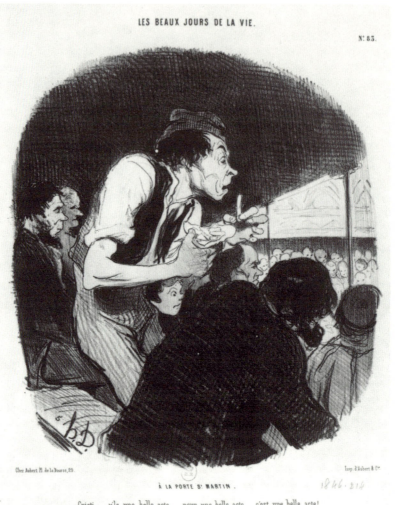

74. Honoré Daumier, *At the Porte St. Martin,* 1846, lithograph. Paris, Bibliothèque Nationale

to name only a few. Many opera libretti were, in fact, based on historic novels, dramas, or melodramas. *Lucia de Lammermoor*'s libretto, for example, was based on Scott's *The Bride of Lammermoor* and Verdi's *Ernani* (Venice, 1844) on Hugo's drama *Hernani*.

IN HIS ESSAY, "Word and Image in Pixerécourt's Melodramas," W.D. Howarth demonstrates that one of the important theatrical innovations of the melodrama was an "increasing reliance on the non-literal, and to some extant, non-verbal elements of the

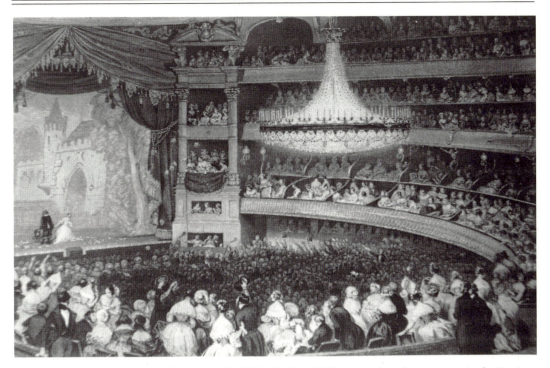

75. Charles Mottram, *Opera Performance in the Théâtre Italien*, 1842, mezzotint after a watercolor by Eugène Lami

theatre."[40] Among those non-verbal elements Howarth mentions, in particular, the frequent use of static *tableaux*, which freeze dramatic moments in the play, much like a still at the end of a sitcom.[41] Purely visual, the *tableau* (which also became a popular device in opera) interrupts dialogue and action to cause the viewer to concentrate momentarily on the stage set, the display of the figures on the stage, their gestures, body language, and costumes.

Such puncturing of the verbal by the visual has a parallel during the Romantic period in the illustrated book. A typically Romantic phenomenon, the illustrated book emerged as a function of economic and technical developments. An increased demand followed by an increased supply of books created a more competitive market and a need for aggressive marketing strategies. Book illustration constituted such a strategy, which was more effective as illustrators were better known. The invention of wood-engraving, a picture-printing technique that could be combined with traditional type (thus making it possible to print text and image at one run of the press), made the production of illustrated books less cumbersome, hence less expensive. While in earlier illustrated books the pictures (printed from etched or engraved copperplates or lithographic stones)

were printed on separate pages, often removed from the text they were meant to illustrate, the new woodblock illustrations (*vignettes*) were set within the text, generally without a border, creating a fluid relationship between the visual and the verbal.[42]

It was under the July Monarchy, particularly during the decade of 1835–1845, that Romantic book illustration reached its zenith. Many of the best-known illustrated books of the period were historic novels, histories, or newly edited classics (Dante, Shakespeare, Cervantes, Molière, La Fontaine, etc.). Illustrations, closely linked to the text, helped readers to visualize historical scenes and figures. Their authors, a Jean Gigoux, Alfred and Tony Johannot, Eugène Lami, Célestin Nanteuil, Camille Roqueplan, and others helped to promote the sale of the books they illustrated by exhibiting paintings and watercolors (sometimes the very ones that served as prototypes for their illustrations) on literary and historical subjects at the Paris Salons. Thus Tony Johannot, in 1831, exhibited a series of watercolors on subjects of Walter Scott, which were reproduced as wood-engraved illustrations in Furne's edition of Scott's *Oeuvres complètes* (1830–1832). Similarly, in 1836, he showed four watercolors underlying illustrations for Victor Hugo's *Notre-Dame de Paris* (Renduel edition, 1836), and in 1838, ten watercolors for illustrations of Goldsmith's *Vicar of Wakefield* (Bourgueleret edition, 1838).[43] At the same time, he exhibited larger oil paintings on themes by Scott (1833, 1839, 1840), as well as scenes from medieval and Renaissance history, such as the *Death of Du Guesclin* (1835), the *Battle of Rosebecque* (1839; for the Musée de Versailles), the *Battle of Fontenay-en-Auxerrois* (1840; for the Musée de Versailles); *Childhood of Du Guesclin* (Salon, 1840); and *Louis VII Forcing the Passage of the Maeander* (1842; for the Musée de Versailles).[44]

JOHANNOT'S PAINTINGS of historical subjects were by no means exceptional nor did they present a new phenomenon at the Salon. Historical subjects, other than classical (inspired by history books, historic novels, biographies of historic figures, historic dramas and melodramas, or literary classics of bygone ages), had been exhibited at the Salon since 1802, when the painters of the so-called School of Lyon (Fleury Richard, Pierre Révoil, and their followers) first began to exhibit meticulously painted anecdotal scenes from French medieval and Renaissance history. The new "genre anecdotique" or "genre troubadour" met with critical acclaim and was avidly collected by several important collectors. These included Empress Joséphine and Napoleon himself, whose artistic advisor, Dominique Vivant Denon, on several occasions drew the emperor's attention to the new genre, in which he saw combined "the detailed brushwork of the Flemish and the taste and elegance of the French."[45]

The success of the genre troubadour did not last for more than twelve years. Already by 1824 it was surpassed by other forms of history painting, commonly lumped together as "Romantic history painting." This broad category comprised large scenes from medieval or Renaissance history, painted in a tight and detailed style or with a

more loose Romantic brush, and small historic genre scenes, usually painted in a loose sketchy style.[46] The new Romantic history painting first triumphed at the Salon of 1827–28 with such monumental works as Paul Delaroche's *Death of Queen Elizabeth of England* (422 × 343 cm), Eugène Deveria's *Birth of Henri IV* (484 × 392 cm), and Eugène Delacroix's *Death of Sardanapalus* (395 × 495 cm) and his *Doge Marino Faliero*, as well as more intimate historic genre scenes like Robert-Fleury's *Tasso in the Monastery of St. Onofrio*, Bonington's *François I and the Queen of Navarra*, and the same artist's *Henri IV and the Ambassador of Spain*. It was to remain extremely popular at the Salons throughout the next twenty years.[47]

Indeed, Romantic history painting received a major shot in the arm with the advent of the July Monarchy. Louis-Philippe's own interest in history, combined with his keen awareness of the importance of history as a means of political propaganda and his sensitivity towards history's popular appeal,[48] not only caused him to conceive of the Musée historique at Versailles (see essays by Marrinan and Munholland in this volume) but also led him to buy many popular paintings on historic themes for the national collections as well as his own private one. Among his first major acquisitions for the state was Paul Delaroche's *The Children of Edward IV* (Paris, Musée du Louvre), which was bought at the Salon of 1831 for 6,000 francs. Louis-Philippe's acquisition of this painting (a bit surprising in light of its implicit criticism of usurpers of the throne) is indicative of the king's keen sensitivity to public sentiment.[49] For Delaroche's painting was the ultimate crowdpleaser, which inspired a popular play (dedicated to Delaroche), *Les Enfants d'Edouard*, written by Casimir Delavigne and first performed in the Théâtre français in 1833, and was reproduced in numerous publications, including *L'Artiste* (1831) and C.P. Landon's *Salons* (1831). Additional reproductions for separate distribution were made by H. Prudhomme (engraving), A. Béranger (two lithographs after the heads only), A.-H. Cabasson, and Delaroche himself.[50]

The enormous popularity of Delaroche's *The Children of Edward IV* was symptomatic of the broadening cultural appeal of the Salon after 1830. In the course of the July Monarchy, it changed from a biennial exhibition to an annual one (1833) and grew from an exhibition with some 1500 entries at the end of the Restoration period to a megashow with an average of 2,500 paintings, sculptures, and architectural drawings under the July Monarchy. The number of visitors also increased dramatically and this public, in growing measure, was composed of educationally and financially less-privileged members of society, causing the Salon to turn into something of a place of popular entertainment. Unfortunately, no precise statistics of the total numbers or the sociological (class, gender, age, etc.) makeup of the Salon public are available and the indicators most frequently used to describe this public are Salon critiques and documentary or satiric images of the Salon, neither of which are especially objective or precise. However, one reliable indicator of the increasing popularity of the Salon is the frequency with which Salons are critiqued in the press and the nature of the papers in which these

critiques appear. Thanks to Neil McWilliam,[51] a complete bibliography of all Salon reviews is currently available and from it we learn that during the sixteen years between the first July Monarchy Salon (1831) and the last (1847), 1,655 reviews appeared, that is nearly three hundred more than the total amount of reviews of all previous Salons, from 1699 to 1827, combined. It also means an average of a little over one hundred reviews per Salon, increasing from 78 in 1831 to 139 in 1846. McWilliam's bibliography also informs us of the nature of the papers and periodicals in which these reviews appeared. It is a motley group that includes, besides such respected established dailies as the *Journal des débats*, *Le Siècle*, and the *Moniteur universel*, and such prestigious art magazines as *L'Artiste*, numerous popular publications (*Magasin pittoresque*, *Vert-Vert*, *Le Furet de la ville et de la banlieue*, *Le Voleur*); furthermore, papers directed at specific professional groups (*Garde nationale*, *Journal de commerce*); entertainment guides (*Courrier des théâtres*, *Entr'acte*); a surprisingly large number of women's magazines (*Petit Courrier des Dames*, *La Mère de famille*, *Journal des demoiselles*); and even a number of children's magazines (*Journal des enfants*, *Le Petit poucet*).

With this knowledge in mind, it is instructive to look at Biard's *Four o'Clock at the Salon* (fig. 76), which seems to show the same crowd as the one that fills the boulevard theatre in Daumier's cartoon *The Fifth Act at the Gaîté* (fig. 73) of 1848. This leads us to conclude that the Salon public, particularly on free admission days, included the same skilled artisans, small shopkeepers and traders, *petits rentiers*, soldiers on half-pay, housewives, and children, who frequented the boulevard theatres and filled the less expensive seats at the Porte St. Martin or the Comédie française.

HISTORY was everywhere in July Monarchy France: in Louis-Philippe's Musée historique, in the Salon, the theatre, the opera, the library, the *cabinet de lecture*, the home. People's daily surroundings and the very clothes they wore were marked by the powerful historic consciousness of the time. Fashion prints of the mid-thirties show women dressed in rococo-inspired fashions, seated on Renaissance chairs in interiors filled with Gothic bookcases (fig. 77). Typical of the July Monarchy, this historical eclecticism may perhaps be related to the contemporary stage, where props and costumes were "recycled" from one historic play to another, without too much concern for historical accuracy. In a brief exposé on clothing during the July Monarchy, Henri Bouchot emphasizes the influence on women's fashions of the Romantic drama (to which we might add other histrionic events such as operas, masked balls, carnivals, etc.), which in turn were freely inspired by Renaissance and Baroque paintings.[52] In the course of the 1830s those fashions moved from a Renaissance medley that combined leg-of-mutton sleeves (*manches à gigot*) à la François I with ruffled millstone collars (fig. 78), to a clothing style derived from late seventeenth- and eighteenth-century models, with toilettes à la Pompadour, à la Montespan, or à la Lavallière.[53]

It is important to stress that history's presence was felt not only in interior spaces—

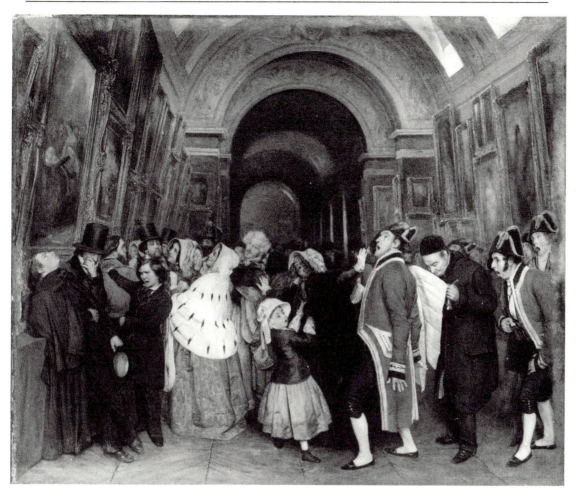

76. François-Auguste Biard, *Four o'Clock at the Salon,* 1835, oil on canvas. Paris, Musée du Louvre

museums, theatres, libraries, and private homes—but outside on the street as well. Walking through Paris during the July Monarchy, one encountered history at every corner: in the picturesque sites of *vieux Paris*, which enjoyed a new vogue thanks to their discussion and reproductions in numerous guidebooks, topographic albums (often published in inexpensive installments), and memoirs (fig. 79); in bookshop windows, where the latest illustrated histories and historic novels were on display; in theatrical affiches announcing some Romantic drama, historic melodrama, or grand opera; in the shop windows of luxury commodity dealers, where small historic genre scenes in oil, watercolor, or print mingled with furniture and bibelots in various neo-styles[54]; in the print stalls on the quais, where lithographs of historic scenes (often reproductions of Salon paintings) were for sale for modest prices; in the costumes of guests at masked balls and carnival revelers returning home at night (fig. 80), and in contemporary women's

77. Anonymous, Fashion print from *Le Voleur,* 1836

fashions that were inspired by those costumes. The street thus formed an historical continuum ranging from "real" history exemplified by historic buildings and places, to the commodified, consumable history offered to the viewer in print stalls, posters, shop windows, and fashions.

AS A MORE SPECIFIC EXAMPLE of the popularity of history during the Restoration and July Monarchy periods, we may consider the case of Walter Scott. Scott's historic novels were beginning to be known among French intellectuals as early as the second decade of the nineteenth century.[55] The first translations of his works appeared in 1816 and 1817. By 1820, practically his entire literary output to date had been translated and Scott had become a celebrity in France.[56] The following year saw the publication of the first edition of the *Oeuvres complètes.* Nineteen additional editions were to appear during the next twenty years.[57]

At the outset of the July Monarchy Scott's novels were firmly entrenched in popular

78. Achille Devéria, *9 A.M. Portrait of Mme Annette Boulanger*, 1830, handcolored lithograph.
Minneapolis, The Minneapolis Institute of Art

79. Auguste Regnier, The House of the Alchemist Nicolas
Flamel, illustration in *Charles Nodier's Promenade dans les rues
de Paris,* 1838. New York, New York Public Library,
Department of Prints and Photographs

Romantic culture. An advertisement in *Le Siècle* of May 20, 1840, claimed that up to
that date two million volumes of Defauconpret's translations of Scott had been sold.[58]
When keeping in mind that Defauconpret was only one of several translators of Scott's
novels, one realizes that the total number of sales must have been considerably higher.
Translations of Scott's novels could be found in every bookshop and *cabinet de lecture*, not
only in Paris but also in the provinces. Flaubert's Emma Bovary, during her years in the
convent at Rouen, after having clandestinely read Gothic novels and romances, "moved
on" to Walter Scott. Flaubert marvelously characterizes the popular Romantic mode as
he writes "coming later to Walter Scott, she [Emma] conceived a passion for the
historical, and dreamed about oak chests, guardrooms, minstrels. She would have liked
to live in some old manor house, like those deep-bosomed châtelaines, who spend their

80. Honoré Daumier, *Shrove Tuesday,* 1844, lithograph. Paris, Bibliothèque Nationale

days beneath pointed arches, leaning on the parapet, chin in hand, watching a cavalier with a white plume galloping up out of the distance countryside on a black charger."[59] Scott's novels were not only read in every part of France but also by all social classes from the white collar bourgeoisie represented by Emma and Charles Bovary to the blue collar working class. George Sand in *Les Compagnons du Tour de France* relates how a young workman sneaks at night into the library of his mistress to read the works of Walter Scott.[60]

Scott's popularity was diffused not only through translations of novels but also through numerous more or less successful imitations (see above, p. 169), pastiches, and even outright forgeries. The catalogue of the Bibliothèque Nationale lists six such apocryphal novels, mostly published during the early 1840s. In addition, a number of works appeared that were inspired by Scott in other ways. Among these were print albums with picturesque views of Scotland, accompanied by appropriate excerpts from Scott's novels, as well as albums with prints portraying Scott's most popular female characters, such as the *Galerie des femmes de Walter Scott* (1830) or *Beautés de Walter Scott* (1842).[61]

But perhaps Scott achieved his greatest popularity in France through the countless dramatic adaptations that were made of his work. From 1820 onwards, the boulevard theatres, banking on the success of Scott's novels, staged melodramas and comic operas with such titles as *Le Château de Loch-Leven* and *Le Château de Kenilworth*.[62] By 1822, the Waverley novels had been so often adapted to the stage that a sarcastic critic wrote "If one can squeeze another two vaudevilles and a pantomime out of them, there will probably be nothing left."[63] And the following year another critic wrote, with equal sarcasm: "Great news . . . ! The famous Walter Scott has presumably arrived in Paris with a cartload of unpublished works. Fabricators of melodramas, start sharpening your quills."[64]

From the mid-1820s to the end of the July Monarchy, scores of theatrical and musical productions of his works could be seen in Paris. In 1827 alone some ten different theatrical productions were derived from Scott's novels, causing one critic to write that perhaps Scott should claim royalties from French script writers for they borrowed so exhaustively from his work.[65]

With such a pervasive presence of Scott's works in the bookstores, the *cabinets de lecture*, the theatres and opera houses, it is not surprising that his influence should also be felt in other cultural realms. Reminiscing about the Scott fad in the 1820s and 1830s, Armand de Pontmartin wrote in his memoirs published in 1886, "One can hardly imagine this vogue [for Scott]. . . . It profoundly affected even costumes, fashions, furniture, shop-signs, and theatre hoardings."[66] Pontmartin might have added Scott's impact on painting as well. Already in 1829 an anonymous critic wrote, "Walter Scott is a godsend for the writers and artists of our time. The former imitate him, rob him and suck him dry. They live so to speak of his spoils, either by multiplying the translations of his works or by finding in them the subjects of dramatic works. The latter translate on canvas and into stone that mass of bizarre scenes, of peculiar characters . . . , and everyone finds in them what he expects for the public adores Walter Scott and favorably accepts all that calls his works to mind."[67] This was no exaggeration: more than any author's works, Scott's novels provided the narrative material for paintings of the later Restoration and early July Monarchy periods.

A number of articles, discussing this subject, have appeared in recent years.[68] Beth

Wright and Paul Joannides have, in a particularly thorough way, researched the importance of Scott's novels as a thematic source of French painting. From the catalogue of paintings and watercolors on subjects by Scott that they have compiled, it is clear that Scott's popularity among painters peaked in the early thirties, with 37 works on Scott themes in 1831 and 34 in 1833 and then gradually decreased until by the forties the average number was five. For the most part, these works were painted by artists who have long been forgotten, such as Beaujouan, Trayer, Dusaulchoy, Mme Verdé de Lisle, or Mlle L. Colin.[69] The occasional names that still ring a bell tend to belong to book illustrators, such as Tony Johannot or Camille Roqueplan. The only artists of note who consistently painted themes derived from Scott's novels were Louis Boulanger, Ary Scheffer, and Eugène Delacroix.

The case of Delacroix deserves some special attention here for it illuminates the dilemma of the artist-intellectual who thought of himself as part of a cultural elite and painted themes that, in the course of his career, moved from "high" to "low." As Martin Kemp has shown, in his article "Scott and Delacroix,"[70] Delacroix's attitude towards Scott changed quite dramatically in the course of the 1820s and '30s. While during the 1820s he frequently painted subjects derived from Scott's novels, after 1830 there was a rapid decline.

The rejection of Scott-inspired subjects for his paintings finds a parallel in Delacroix's verbally expressed opinion of the novelist. In a lengthy entry in his diary, for October 23, 1853, Delacroix sums up his ambiguous feelings towards Scott's work. Talking about the "strange pleasure," he received from his reading of the short stories of Gogol and Mérimée, he compares their work with Scott's:

> These stories have a perfume of reality that is astonishing; it is the feeling which surprised everybody when the novels of Walter Scott appeared; but good taste cannot accept them as accomplished works. Read the novels of Voltaire, Don Quichote, Gil Blas. You do not in any way imagine that you are witnessing completely real events, such as you would get from a story of an eye witness. You feel the hand of the artist and you are meant to feel it, in the same way that you see the frame of every picture. In these works, on the contrary, after the description of certain details which suprise by their apparent naïveté, like the exact name of the people in the story, unusual customs, etc., one is forced to see that what is offered is a more or less romantic fable which destroys the illusion. . . . All of Walter Scott is like that. The apparent novelty contributed to his sucess more than all his imagination, and what is making his works seem old-fashioned today and is placing them lower than the famous ones I have cited, is precisely this abuse of truth to detail.[71]

Delacroix, who in the 1820s and early 30s had probably done more paintings, drawings, and lithographs of Scott-derived subjects than any other French artist outside

the major illustrators of Scott's work (Johannot or Roqueplan), abandoned such subjects at the height of Scott's popularity in the early 1830s. This may have been the time when he first felt that Scott was not in good taste and that his works were on a "lower" plane than those of Voltaire, Cervantes, and Lesage. The fact that Scott's novels could turn "old-fashioned" so fast meant that they could never achieve the status of "classics," with all the lofty, everlasting aesthetic value that that term implies, but that they must be more like "popular literature," which enjoys a brief vogue before disappearing without a trace.

Despite his alleged disdain for Scott, Delacroix could not quite suppress his fascination with his novels, just as he couldn't deny that he spent "delightful moments" with Gogol's stories (which he found lacking in originality) or received a "strange pleasure" reading Mérimée's "mongrel" writing style. This may explain his return to Scott subjects in the late 1840s and the 1850s, when he painted at least four subjects from *Ivanhoe*, Scott's ultimately popular novel.

IN HIS *Popular French Romanticism,* James Smith Allen includes historic novels and history books among several literary genres that he characterizes as "popular Romantic literature." In this essay I suggest going one step further by calling Romantic historicism as a whole a phenomenon of popular culture, clearly distinct from the folkloristic preoccupation with history of previous periods. In folk culture, the interest in history tends to focus on single figures (in France, this might be Charlemagne, "good king" Dagobert, the Duke of Marlborough, or Napoleon), decontextualized timeless heroes, much like Christian saints, whose reknown usually rests in one or a few grand achievements which often are exaggerations, deformations, even fabulous flourishes on historic events.[72] The form into which this folk historicism is cast—legends, folk songs, *images populaires,* pantomimes, etc.—are derived from high cultural forms of the past or present, which have been adapted to a degree where they have become new and different, clearly distinguishable from elite cultural forms.[73]

Popular historicism during the Restoration and especially the July Monarchy period was of an entirely different nature. No clear dividing line can be drawn between "high" and "low." Thierry, Barante, and Michelet, while themselves belonging to the male intellectual uppercrust, aimed their writings at "le peuple." Scott's historic novels were read by members of the Parisian cultural elite (Delacroix), by farmers' daughters in provincial convent schools (Emma Bovary), and, if we are to believe George Sand, by members of the laboring class. Access to historic literature, whether factual or fictional, rapidly increased under the Restoration and July Monarchy regimes due to increased literacy rates and availability of reading materials (through growing number of *cabinets de lecture,* as well as the increased importance of the ephemeral press). Victor Hugo's *drames romantiques*, by his own account, attracted intellectuals, women, and *la foule*—a "white smock" crowd, judging by Daumier's print of the Théâtre Porte St. Martin (fig.

74), where many of Hugo's plays were performed. By the same token, historic melodramas were, not infrequently, attended by the cultural elite.[74] Paintings of historical scenes were viewed by an increasingly diversified public (at the annual Salons as well as in the Musée de Versailles (see articles by Marrinan and Munholland in this volume), which had further access to historic images through reproductions after those paintings and through book and magazine illustrations, which were often drawn by the same artists whose works were exhibited at the Salons. History, in short, was a commonly shared preoccupation of "high" and "low" society, of men and women, of children and adults.

Both in the breadth of its impact and in the fact that Romantic historicism was a phenomenon that touched both "high" and "low," it is comparable to twentieth-century phenomena of mass culture, with two important differences. Unlike twentieth-century mass culture which, due to electronic media, can be transported instantly to the most isolated locations, Romantic "pop" culture was primarily an urban phenomenon. In France, it radiated out from Paris and its repercussions in the provinces became weaker as the towns became smaller and the distances larger. Walter Scott's novels were easily available in Rouen, an important commercial center located on the Seine River, the major shipping line from Paris to Le Havre, but their availability in smaller towns on the periphery of France was, no doubt, more restricted.[75] The same may be said about newspapers, popular magazines, theatrical performances, etc.

Another important difference between Romantic popular culture and twentieth-century mass culture was the extent to which it reached the "underclass," and, equally important, the size and nature of that class itself. Adeline Daumard, in her studies of *bourgeoisie* and *peuple* in France during the Romantic period,[76] has shown that these terms do not blanket two distinct unified groups. Instead, she argues, there was something of a continuum from *bourgeoisie* via *petite bourgeoisie* or *bourgeoisie populaire* to the upper crust of *le peuple*, comprised of skilled artisans and selected salaried *ouvriers*, which could boast some savings, limited investments, and/or real estate.[77] As property owners, big or small, these groups differed from the huge impoverished underclass, the members of which, upon death, left nothing ("succession nulle")—not even the tools of their trade, or a bed and some furniture—and who consequently had to be buried in the "fosse commune." On the basis of a detailed study of death records, Daumard has found that in large towns the number of "successions nulles" for adult deaths nearly always exceeded 50 percent of the total, while in huge industrial centers like Paris, Lille, or Lyon, it could even climb to 70 percent.[78] Existing from hand to mouth, the members of this huge pauper class lived in crowded tenement houses or on the street. Though not unanimously illiterate, they no doubt included in their midst a large percentage of the total illiterate and functionally illiterate population in France. Devoid of even the barest necessities, they had no access to the theatre or the Salon. Limited in their mobility to where they could go on foot (an omnibus ride of average length cost some 30 centimes,[79]

approximately the price of 3/4 kilo of bread[80]), they largely remained confined to their socially and culturally deprived quartiers. Thus the impoverished underclass of the Romantic period differed from its counterpart in twentieth-century Europe and America both in its enormous size, out of proportion to the number of unpropertied citizens in France today, and in its quality of life. Indeed, those who live below poverty level today, including even the homeless, have at least some property (a watch, a radio, some clothes) and, more importantly for our purpose, they have access, however limited, to newspapers, magazines, books, and the electronic media. As such they share to a much larger extent in the middle-class culture of their time.

An early (perhaps the earliest) phenomenon of popular culture, Romantic historicism was both similar and different from twentieth-century pop trends: similar in that it affected a social continuum that ranged from the elite to the "people," thus eliminating the need for the separate folklore history of the past; different in that its range, both geographically and socially, was much smaller than that of mass culture phenomena today.

If historicism was the most conspicuous and pervasive aspect of Romanticism, its popularity may have been part of that movement's downfall. Indeed, it was against historicism that the new Realists who emerged in the course of the 1840s reacted most vehemently and it may well have been the popularity, the vulgarity, of historicism that they most objected to. Is there an element of elitist irony in Charles Baudelaire's exhortation to artists, in his Salon of 1846, to celebrate the "heroism" of modern life? Claiming that the artist of his time had a "vested interest in ceaselessly depicting the past" because it could be "turned to good account by the lazy," he no doubt had the popular and commercial aspects of historicism in mind.[81] Is there an element of elitism in Gustave Courbet's *Atelier*, in which a guitar, a dagger, and a plumed hat, "Romantic castoffs" as Courbet calls them, are included in the left side of the painting, among the "other world of trivial life, the people."[82] Paradoxically, we may posit that Realism, the movement that called for art and literature to focus on the ordinary life of ordinary people, was an elitist phenomenon that developed in reaction against that most popular aspect of Romanticism, historicism.[83]

VIII

The Power of Axes and the Axes of Power: L.-T.-J. Visconti, the New Louvre, and the Shape of Paris

DAVID VAN ZANTEN

THE LOUVRE dominates the center of Paris. It is huge in scale and extent, stretching a quarter mile along the Seine, then turning to display its majestic east facade, Perrault's Colonnade (figs. 81–86). It is a very old building—with a Gothic *donjon* in its foundations, with Renaissance wings that once were two different palaces, the Louvre and the Tuileries, and with a body embracing them both that was sketched in the reigns of Henri IV and Louis XIV. Nonetheless, it only achieved its final form in the 1850s as the first great project in Napoleon III's transformation of Paris. In 1871 its most important part and the ensemble's *raison d'être*, the Tuileries Palace (the actual formal residence of the sovereign), was burned and in 1878 its ruins demolished.[1]

The city came to be organized around this double monument. When in 1871 it became an institutional corpse, new functions colonized it and it became the central point of the touristic city. The Louvre and the Tuileries, although very different in shape and slightly misoriented, share a common east-west axis that already in the sixteenth century suggested projects to link them. In 1662 a north-south crossaxis was elaborated through the Louvre, traversing the Seine and terminating in the dome of Louis Le Vau's Collège des Quatre Nations, embraced in its curving wings. In the eighteenth century the east-west axis was extended, first beyond the Tuileries Garden by the Place Louis XV (now the Place de la Concorde), then up to the top of the hill with the layout of the Champs-Elysées and Ledoux's barrières (in 1806–1836 replaced by the Arc de Tri-

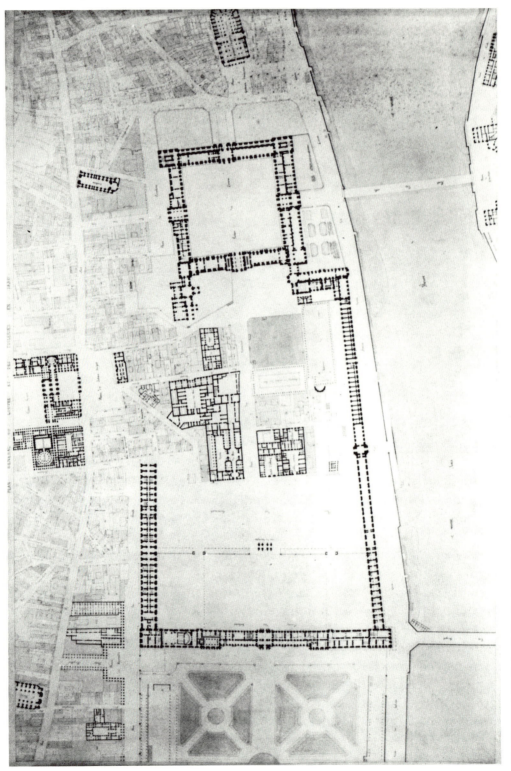

81. *Louvre and Tuileries*, Paris, Archives Nationales

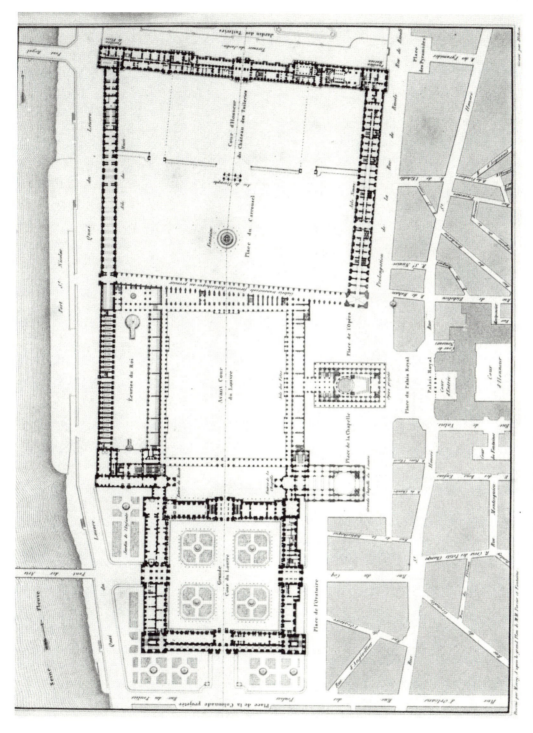

82. Pierre F.L. Fontaine with Charles Percier, *Project for the New Louvre*, 1809

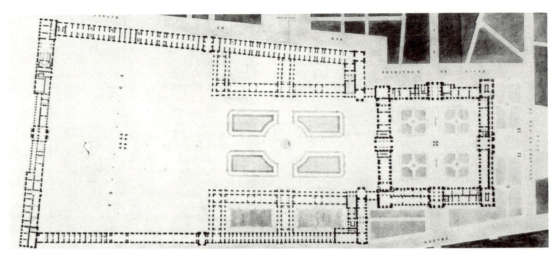

83. L.-T.-J. Visconti, *Project for the New Louvre,* 1848. Paris, Archives Nationales

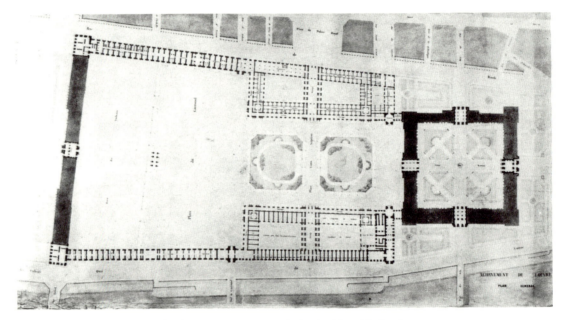

84. L.-T.-J. Visconti, *Project for the New Louvre,* 1852. Paris, Archives Nationales

omphe). In the early nineteenth century Napoleon and Louis-Philippe intended an eastward extension of that axis in the form of an avenue planned to extend from the center of Perrault's colonnade to the central door of the Hôtel de Ville. (The eastern half of this was executed during the Second Empire as the Avenue Victoria which was carried into the Hôtel de Ville with the roofing of the courtyard and the erection of a axial stairway to the ceremonial chambers.) With the completion of the Louvre during the Second Empire three more north-south axes were sketched, one linking it to the main axis of the Palais Royal across the newly opened Place du Palais Royal, a second centered on the "Guichets du Louvre" and the Pont du Carrousel meant to engender an *étoile* of avenues opening up the Faubourg Saint-Germain on the Left Bank, and a third stretching northwest to intersect the Boulevard des Capucines at its midpoint, the projected Avenue de l'Opéra.

Recent research in the government archives and in the personal papers of Napoleon III's architect, L.-T.-J. Visconti, has revealed a number of new details and peculiarities in this story.[2] It is now evident that the form that had been considered quintessential Second Empire and the symbol of the government headquartered in it (proclaimed in 1852) was already fixed by Visconti in 1848–1849 as the "Palais du Peuple" for the very different Second Republic with a distinct layout to accommodate a library and museum (fig. 83). It is also clear that Visconti did not consider his problem one of creative design at all, but of continuity. (An important, if ungrammatical, unpunctuated, and almost illegible, manuscript architectural history of the building survives among his papers.) We are made to recognize that the Louvre with its significance, its history, and its urbanistic organizing role was a sort of building that could change its function without changing its form—one with a "charge" in its stones and site that defies our "modernist" habits of functional architectural analysis. It is less a Second Republic or Second Empire building than an emanation of the city's coalescing monumental organization brought to completion in the mid-nineteenth century.

<p style="text-align:center">I</p>

It is often noted that Louis XIV's minister Colbert believed the rebuilding and extension of the Louvre to be the central monumental project of the reign and resisted the king's own attentions to Versailles; that Napoleon established his presence in Paris by employing Percier and Fontaine to fill in Louis XIV's carcass (at the cost of a million francs a year from 1805 to 1813) while adding the Arc du Carrousel, the north wing defining the Cour du Carrousel, and delimiting the Tuileries Garden by the Rue de Rivoli; that Louis-Philippe accepted that plan (revised for him by Fontaine in 1833) but failed to carry it into execution, turning instead his private attention and funds to Versailles; and finally that this thus left the Second Republic and Napoleon III to

85. *The New Louvre and the Tuileries, looking westward across the Cour du Carrousel,* c. 1860. Evanston, I.L., Northwestern University

86. *The Tuileries seen from the Place de la Concorde*, c. 1860. Evanston, I.L., Northwestern University

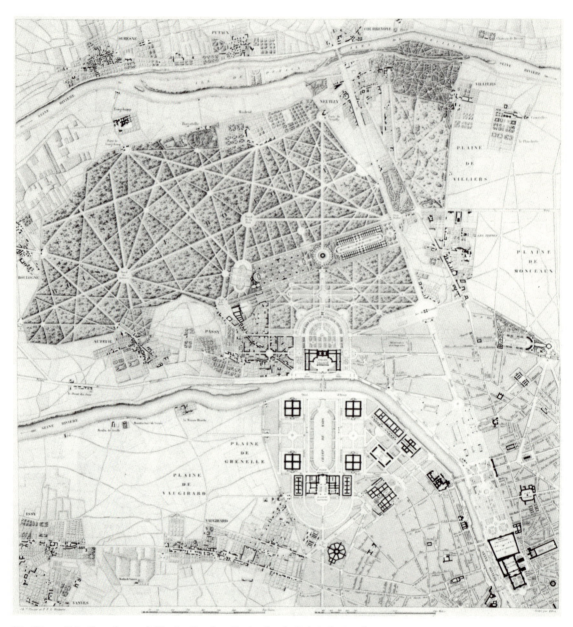

87. Pierre F.L. Fontaine and Charles Percier, *Project for the Palais du Roi de Rome*, c. 1810

proclaim their sympathy with the population of Paris by doing just that in 1848–1857, by then obliged to employ Percier's student, Visconti.[3] (After Visconti's death in December 1853, Hector Lefuel carried the project to completion.)

The sovereign's palace in his capital is a uniquely important monument. Amaury-Duval in his text on the Louvre for Louis-Pierre Baltard's *Description de Paris* (1803) points out that while in Italy "palazzo" might designate any splendid house, in France "palais" retained its exclusively royal meaning and denoted the sovereign's formal residence, as in the Louvre and the Tuileries, or the seat of some agency—usually judicial—acting in his name (the *Encyclopédie* notes "censé sa demeure").[4] It is, Blondel states in his *Cours d'architecture* (1771), "la résidence du Monarque dans la capitale de sa royaume."[5]

The palace evoked central authority. This was an absolute distinction, not one of grade: no common building could touch the walls of the palace. It was its nature to dominate its surroundings architecturally and urbanistically. The manual of police of Lemoyne des Essarts of 1786–1790 specifies that the king has urbanistic control of all construction around his palace.[6] He also notes that the king is the architect of his own palace while he might delegate that authority in the case of other, secondary government buildings.

The third plate (and the first plan type) in Durand's *Précis des leçons* (1802–1805) gives form to this, showing an ensemble that is circular in plan, embracing extensive gardens, with government ministries satellite to an axial palace defining a sunburst of *allées* (reshaping a project of 1785 by his master Boullée intended for the royal seat at Saint-Germain-en-Laye).[7] In 1810 Percier and Fontaine planned and began construction of such a palace for Napoleon on the Colline de Chaillot with state and municipal institutions enframing it down the Champs de Mars, constituting, Fontaine explained, "une ville nouvelle" (fig. 87).[8] These were the immediate, Parisian successors to a series of *Residenzstaedte* starting with Louis XIV's Versailles (proclaimed capital in 1682) and including Karlsruhe (1715) and Mannheim (1720).[9]

In a strange and interesting book of 1752 the critic La Font de Saint-Yenne pleads for a return to serious, high art in France by using the form of a dialogue between the city of Paris, the Louvre, and the ghost of Colbert in which the city recognizes the palace as its institutional heart and Colbert rearticulates his forgotten plans.[10] The frontispiece (fig. 88) shows the Louvre's colonnaded front in its contemporary state of dilapidation, the genius of the building fallen in despair before the bust of Louis XV, while the personification of the city pleads with the sovereign's representation to take cognizance of the state of his palace. The ghost of Colbert reacts in horror at the state of his creation.

To complete the Louvre was to articulate in concrete form the political shape of France. Its axes were those of power as much as of sight. The architect worked in a narrowly defined situation. We read a letter from Visconti to his cousin, Pietro Ercole Visconti, of 12 March 1853:

My job is clearly outlined: to finish the Louvre means to harmonize with what has already been built. I don't need to expend much imagination; only to display good sense in choosing[11]

He emphasized his faithfulness to the existing constructions in the short text of a pamphlet published in 1853 to accompany the display of a model of his project.

The character of the new architecture will be taken religiously from the Old Louvre: all the details are already cast and the architect will suppress all *amour propre* to preserve the monument's character as it was fixed by his predecessors.[12]

Reading this, however, one is surprised to find that a mass of very divergent projects had been prepared by different architects for the completion of the building during the decades before 1848–1852, and indeed since the Louvre and the Tuileries had first been erected in the sixteenth century.[13] If the problem were so simple to Visconti's mind, why was it so complex to everyone else's? The answer would evidently lie in the fact that first Percier and Fontaine, then Visconti, as the officially designated architects of the building and Premiers Architectes de l'Empereur, were producing projects to satisfy real needs and proprieties, while most of the mass of competing projects were unsolicited and meant to use this central problem to catch the public eye. This meant that the latter filled the space between the Louvre and the Tuileries with dexterously composed masses of building. The former, on the contrary, left most of that space open, just defining its northern and southern limits with galleries, and modulating the transition from the narrow mass of the Louvre to the broad expanse of the Tuileries. In 1815 Fontaine had won a closed competition to design the Chapelle Expiatoire by similarly conceptualizing in terms of the space enclosed rather than the architecture enclosing, proposing to build that monument as a frame for the plot of grassy earth in which aristocratic bodies had been buried helter-skelter, the king and queen's remains confused with those of the other victims.[14]

Both Louvre projects extended the facade toward the Tuileries as a courtyard between masses of building, but Percier and Fontaine closed that space with a transverse wing for the Bibliothèque Nationale (fig. 82). Visconti simply erased it and joined the courts in one great spatial composition.

Visconti's task was not to make a name for himself but to finish the organizing monument of ceremonial Paris—to do it as the sovereign's obedient hand. We might note another remark of his cited in his 1854 obituary in the official *Moniteur Universel*: "J'ai cherché toute ma vie à obliger; cela a été ma seule jouissance"—"I have sought all my life to oblige. That has been my sole pleasure."[15] His was the "inside" project, that continuing the sketch of Percier, Fontaine, and the first Napoleon. But in one funda-

D.L.F. inven. Eisen idœam expres. Le Bas ære cælav.

L'OMBRE DU GRAND COLBERT.

88. Lafont de Saint-Yenne, *L'Ombre du grand Colbert,* 1752

mental sense it was not at all as thoughtless as even Visconti made it seem: he had to make this hold together, to say something, and in terms appropriate to its unique function. Here I think he succeeded, brilliantly even.

The Tuileries, when seen from the Pavillon de l'Horloge of the Louvre, is precisely enframed by the central pavilions of the narrower eastern courtyard, then again by the north and south galleries of the broader western space. Conversely, the Louvre, when seen from the Tuileries, is enframed in the eastern courtyard and its lone pavilion strengthen by repetition along the sides. In a word, Visconti extended the great west axis from the Arc de Triomphe down the Champs Elysées across the Place de la Concorde to the central Tuileries pavilion (with its through-passage) across the once built-up space between the palaces to the Pavillon de l'Horloge of the Louvre (with its through-passage), making an axial, scenographic whole through enframement and the repetition of the orienting pavilion motif. Visconti thus did very little and yet a great deal: very little because he accepted as his "religious" duty to set off the constructions he inherited and to repeat their motifs; a great deal because by repeating, enframing and focusing their architecture around the great west axis, he extended that architecture, like a musician composing variations upon a theme, or (more pointedly) a rhetorician pro-nouncing fine platitudes.

The east-west axis focused on the Arc de Triomphe, however, is fundamentally abstract. It was only traversed from the Tuileries westward, and that infrequently. Visconti also arranged a second, very different axis in his definitive project of 1852 to actually get visitors into the building's central chamber—one completely new to the scheme that first fixed its exterior masses in 1848 as a museum and library. The central space is the Salle des Etats occupying the whole of the second level of the cross wing of the southern arm with its vault pushing into the mansard, so that it is completely unexpressed externally. This was created for the emperor's annual opening of the session of the legislature. He imposed the obligation that the body come to him, rather than he to them as had been the practice under the first Empire, the Restoration, and the Monarchy of July. As the place embodying the assertion of the emperor's absolute authority, it was politically the most significant spot in all of Second Empire Paris.

For all of the muteness of this space externally, it was very present experientially when one started down the approach to it that Visconti laid out starting in the Place du Palais Royal between that structure (once the city residence of the Orléans family) and the facade of the Nouveau Louvre's north wing. One entered at the Pavillon de la Bibliothèque erected by Visconti to dominate this new space, passed down an arcaded carriage entrance cut through the cross wing of the north arm of the Nouveau Louvre, and emerged facing the Pavillon Denon, in whose sculpted pediment Napoleon III appears for the only time on the building, conjuring peace and prosperity.[16] The pavilion enframed a vehicle entrance within which the visitor would alight, send his carriage on to the celebrated stables beneath the Salle des Etats, and ascend a monumen-

tal stair to the Vestibule Denon, which Couture had been intended to decorate. (In the end Mueller did both it and the Salle des Etats.[17]) From there one entered the chamber of convocation itself. This was new to Fontaine's project which, in other ways, set the framework for Visconti's design.

The point is that if Visconti had very little to freely design—if he didn't even have the latitude to change the massing between 1848 and 1852—he also had a great deal to arrange—things like the east-west and the north-south axes—that had to work together and be effective. He locked the building's mass and axes into the implicit monumental order of the capital, Paris—into the axes of the Champs Elysees and the Palais Royal—and thus made it embody and "represent" the power that it, in fact, contained. The most important change he made to Percier and Fontaine's scheme was to leave a wing out, and that perhaps is the point of the whole project: to do as little as possible while making effective what is already there—to let the sovereign and tradition be embodied as the "architects."

II

The Louvre is not presented as the central monument of the history of nineteenth-century Paris architecture. The conventional construction dismisses it for the unoriginality of its "style" and instead emphasizes monuments of decorative and technical innovation, especially the Opera and the Halles Centrales.[18] Why have we had to wait so many years—until an appreciation of the importance of building type, urban rhetoric, alternative systems of design, and the discovery of the Visconti family papers—to realize the nature and importance of the Louvre for an understanding of French nineteenth-century architecture?

There are two obvious answers. First, that this is our problem, not Visconti's: that we have constructed, in the twentieth century, a history of evolving architectural form that lies in an abstract sphere quite beyond what was happening in the streets and politics of Paris—one we reconstitute with photographs mapped in books. Second, that this was Visconti's problem as well because the New Louvre itself was the last gasp of absolutist monumental urbanism and that Haussmann's subsequent reshaping of Paris on new, less insistantly axial principles eroded and obscured the singleness of plan and axial image that had insinuated itself over the previous four centuries and which, for a moment in 1857, had finally been achieved.

To insist on the first point today, amid a general chorus of doubt in the so-called "modernist" vision of progress, is almost to flog a dead horse.[19] But the "modernist" reading has had a peculiar tenacity in architectural history because it gave hope that by means of "progress" a building might fulfill its reconceived social responsibility. The first liberal functionalists like the Fourierist architectural journalist César Daly could

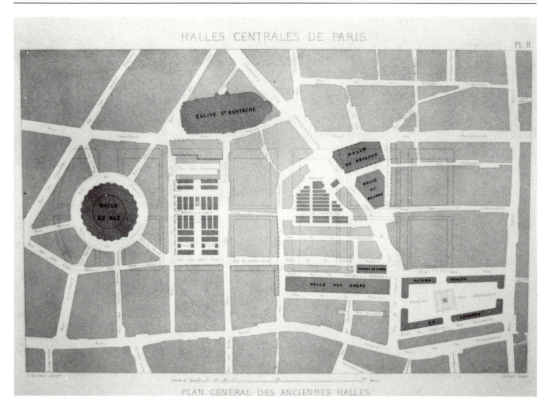

89. *Plan of the Quarter and the Halles Centrales before the construction of the Halles Centrales*

look at the buildings of a city like Paris—a texture of tremendous social and symbolic thickness—and labor to seek out hints of some sort of progressive evolution of form and efficiency in it and beyond, sometimes in small, hidden, and ephemeral things.[20] Thus the Bibliothèque Sainte-Geneviève (1838–1850) which was built and molded to shape the Place du Panthéon and set off that monumental centerpiece is extracted and treated as a monument in its own right because of its interior iron skeleton and its decorative understatement that seem incipient "modernism."[21] Here "modernism's" recent collapse leaves an extraordinary feeling of emptiness: it is hard for us to accept that architecture's social burden might simply be an illusion.

There is also a second powerful reason why the Louvre, once it was finished at the beginning of the Second Empire, might have ceased to seem a monument of central significance: the fact that the very axial, monumental organization that it concertized in central Paris just then began to be eroded and contradicted in a series of parallel urban transformations which reflected a more immediate, different vision of urban form. This was manifested most powerfully in the transformation of the Quartier des Halles and the new north-south axis of the Boulevard de Sébastopol both begun during the 1850s.

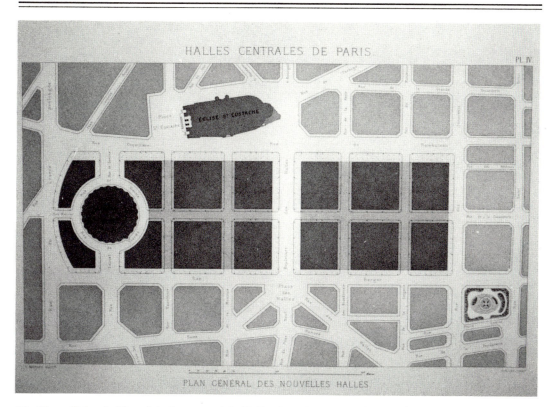

90. Victor Baltard, *Plan of the Quarter and the Halles Centrales as projected in 1854*

If we examine Victor Baltard's successive projects of 1845–1854 for the Halles Centrales we observe not only that the building itself coalesces into a tight cluster of iron pavilions connected by a grid of covered streets, but also that the whole city texture around it is projected straightening up and aligned on that grid so that the market by 1854 became only the central node of a continuous system unifying the whole quarter in an even checkerboard (figs. 89 and 90).[22] Zola in his *Ventre de Paris* (1873) depicts the Halles as a whole new city and he was closer perhaps than he knew to what is implied in Baltard's plans.

To treat the city as a grid with no axes and points of emphasis—the Halles themselves simply a momentary inflection in it as one passes up and down the through-passages—is to move attention from the monument to the city texture, to perfect that texture, to reduce the monument to its terms rather than, as in the Louvre, to make the city subserve as a background to a symbolic centerpiece. It was, of course, the Second Empire and the contemporaneous perfection of the dense, technologically efficient *immeuble Haussmannien* that transformed the flesh of the city and made that, at least for speculators and city officials, the primary constituent of the conurbation.[23] Contem-

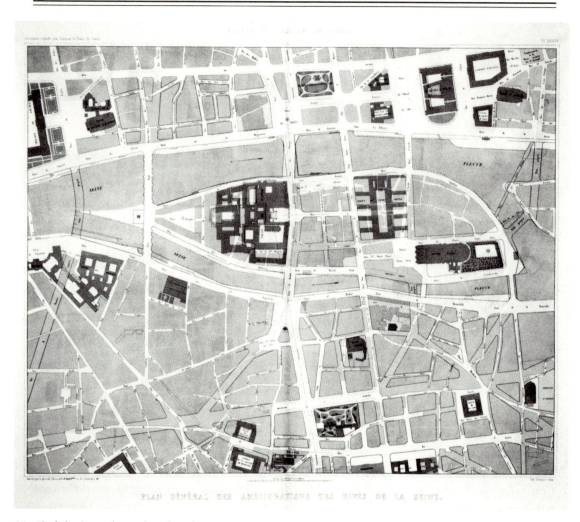

PLAN GÉNÉRAL DES AMÉLIORATIONS DES RIVES DE LA SEINE.

91. *Ile de la Cité and central Boulevards as projected by the City of Paris,* 1858

poraneously the Prefect in Lyons, Claude-Marius Vaisse, together with his city engineer, Joseph Bonnet, gridded the commercial center of the once ancient city with conscious attention to finding the most advantageous density and proportion of street-width to building-area.[24] In 1859 Ildefonso Cerdà, the city engineer in Barcelona, conceived his plan of the city extended as a grid of house block scrupulously studied to be efficient and salubrious units of an undifferentiated whole.[25]

 Back in Paris the grid never took over so completely. (Lyon and Barcelona were commercial, not capital, cities.) The Halles was a special, industrial quarter, and the gridding shown in Baltard's plans was never executed beyond one block dropped into the old Marché des Innocents, the so-called "Massif des Innocents" of 1860–1861.

Instead, the great north-south percement opening the heart of Paris, the north-central portion of which was named the Boulevard de Sébastopol, was the occasion for a whole array of inflections and adornments, executed in a different manner than the axial elaborations of the *entourage* of the Nouveau Louvre (fig. 91).[26] These were incidents along the street, openings to the right and left, some arranged as tableaux as in the cases of the Cour de Mai and the Place du Conservatoire des Arts et Métiers, some calculatedly diagonal and picturesque as in the cases of the Tour Saint-Jacques and the Hôtel de Cluny, some fabricated specially for the occasion as in the cases of the Tribunal de Commerce and the Fontaine Saint-Michel as well as the street facades of the churches of Saint-Leu and Saint-Laurent. The subject of these tableaux was an unhierarchic array of institutions of all kinds and styles—Gothic, Renaissance, modern. The boulevard itself, as Haussmann points out in his *Mémoires*, was slightly crooked and focused on several monuments along its length, the dome of the Tribunal de Commerce (failing that of the Sorbonne) and the newly reconstructed *flèche* of the Saint-Chapelle.

III

Visconti's New Louvre, then, was the last central organizing monument of the absolutist capital, its urbanistic authority—like that of the French sovereigns themselves—coming to be increasingly contested. And this contestation was not only with parallel urban systems; the once "absolutist" axes themselves were changing in character, especially during the Monarchy of July. Everywhere in Louis-Philippe's monuments and in their urbanistic entourage there had emerged a consciousness of and deference to the past.[27] The new projects of the reign were not to discipline and to replace but rather to repair, enframe, appropriate, and sentimentalize the existing monumental embodiment of authority. The four great projects of the epoch were the extension of the Luxembourg for the Senate (1836–1841, 3,000,000 francs initially committed), that of the Hôtel de Ville (1837–1841 and after, initially 12,000,000 francs), that of the Palais de Justice (1835 and after, initially 5,000,000 francs, figs. 94–95) and the restoration of Versailles (1835–1838, 4,000,000 francs).[28] Of equal scale and prominence, of course, was Fontaine's 1833 project to unite the Louvre and the Tuileries at an estimated cost of 18,000,000 francs (fig. 82). In each of these projects the original Baroque style of the older parts was reproduced in the new construction while the massing was balanced and neatened and urban spaces opened around to fix its shape in the cityscape. Visconti's 1848 project for the New Louvre was formulated according to these Louis-Philippard principles and was their most impressive demonstration—the year after that regime fell.

None of these Louis-Philippard buildings was new in their decorative vocabulary or was "rational" (in Daly's functionalist sense) in their morphology. They were, on the

92. Félix Duban, *Plan for the completion of the Ecole des Beaux-Arts,* 1832

contrary, monumental axial arrangements of accepted forms, on the analogy of formal speech, of rhetoric—the vocabulary of columns and pediments fixed like words; that of axes and cross-axes like the structure of periods. The state's obligation in its speech would seem to have been understood like that of the paternal instructor. In a fascinatingly forthright document of 1856 Henri Delaborde—gentleman painter, literatus, and government expert—set down his recipe for the Second Empire government's management of the arts (an extension of his report on the London Great Exhibition of 1851). It is entitled *Quelques idées sur la direction des arts et du maintien du goût public*[29] and covers, in a sketchy way, everything from state art manufactories to salons and public patronage to state ceremonies and organized civic gymnastics. He explains architecture thus.

> I understand an architect as an eloquent orator. He studies all the intricacies
> of language. He knows all its beauties, he is master of all its resources: what

93. Félix Duban, *Exterior courtyards of the Ecole des Beaux-arts,* 1832

subject should he address? What cause is he asked to defend? That alone occupies his mind. . . . Eloquence has become for him second nature; what concerns him is the cause. So also with an architect. He is master of his art; he carries in his head all the transformations architecture has displayed across the centuries; he also holds in the sanctuary of his mind an ideal of his own creation; then the problem: prison, palace, college, theater, stock exchange, barracks, hospital. He studies the needs, the site, the budget; this study animates his imagination . . . he composes his monument and swiftly creates, not perhaps a masterpiece . . . but a work that carries its specificity clearly on its facade. In this situation you will not have a barracks that looks like a ministry, a censor's office that looks like a barracks, a hospital that seems to be a tomb rather quietly announcing the asylum of rest and convalescence.[30]

This language that Delaborde assumes the architect to have learned perfectly and thus to mobilize effortlessly to shape expressions of the state's institutions, is spoken in a pure

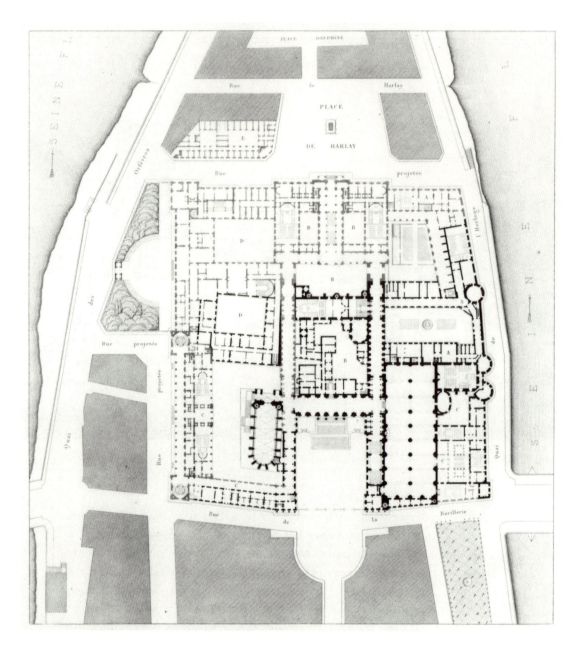

94. Jean-Nicholas Huyot, *Project for the completion of the Palais de Justice,* 1835, plan

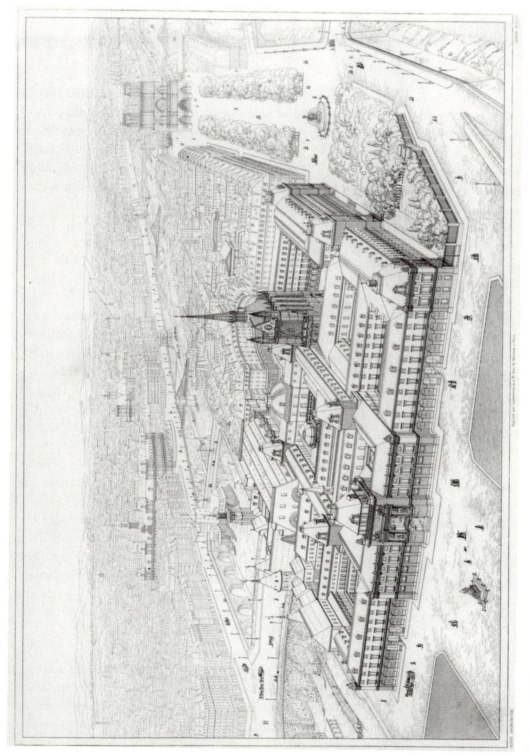

95. Jean-Nicholas Huyot, *Project for the completion of the Palais de Justice*, 1835, perspective

and formal tongue. "In all situations the State offers only proper models, it only creates things useful for study; like a *père de famille* before his children who watches his manners and his language, the State cannot permit itself some questionable stylistic fantasy, some doubtful caprice of decoration."[31]

Louis-Philippe and his designers were opening the city—as their predecessors in the eighteenth century had proposed and as their successors in the Second Empire would accomplish—but they were opening it in a peculiar way: surgically, delicately, to reveal its monumental organs in a rhetorical, clarified transformation of their original state. They were making the city into a formal declaration of its institutional contents, using the techniques of axial transparency inherited from the seventeenth century, but inflected and applied to the thick, resistant texture of Paris. And the eyes gazing down the axes were no longer those of the sovereign alone; now they were those of the middle class that had emerged from the city itself to rule (through a compliant Bourbon cousin, Louis-Philippe) in their turn. It was their history and their institutions that they arranged in these urban tableaux as well as in the proliferating guides and illustrated books like Félix Pigeory's city-sanctioned *Monuments de Paris* of 1847.[32]

There are two things that must be borne in mind about French rhetorical axiality: first, that it is merely the medium of late seventeenth- and eighteenth-century architecture, that each instance of axial design is distinct and unique and must be read for itself; second, that in the nineteenth century this medium divided into several broad sub-types, the looser Louis-Philippard arrangement to make historical texture of the city (rather than a regimented population) transparent to a multiple middle-class eye; the stricter arrangement exemplified in the panopticon to assert an even tighter absolute control over deviant members of the population in general in spatial institutional settings (and one might add the abstract transformation of axiality into the scientific theories of biological and botanical growth, which finally became the forming matrix of functionalist architecture).[33]

The Monarchy of July was the moment of dividing of these sub-types and the Louvre was the great manifestation of the first of them. I have described the precision and effectiveness of Visconti's framing of the tableaux presented along his two quite different cross-axes as well as his "religious" preservation of the architectural vocabulary of the historic monuments he was completing. His conduct follows that of the author of the foundational monument of Louis-Philippard design, Félix Duban, completing the Ecole des Beaux-Arts in 1832–1840 (figs. 92–93).[34]

In 1816 the school had been moved to the buildings of the disestablished monastery of the Petits Augustins and the architect François Debret had begun the construction of a new block of studios in the garden, intending when that was complete to flatten the whole site around it. The site, however, had been used as the Musée des Monuments Français during the Revolution and Empire and was scattered with pieces of medieval and Renaissance architecture and sculpture, especially the facades of the châteaux at

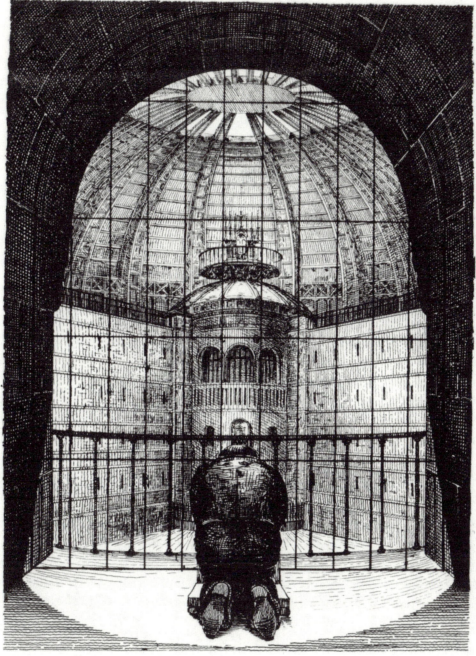

VUE, DE DEDANS UNE CELLULE, SUR LA TOUR DU CENTRE.

96. Harou Romain, *Project for a Prison,* 1840

Gaillon and Anet at the front defining a courtyard on the Rue Bonaparte. Duban took charge in 1832 and conceived a project preserving the monuments of French national architecture for student study by turning his new construction into a carefully adjusted axial sequence of spaces leading from the street through two contrasting courtyards separated by the facade from Gaillon, across Debret's old block now opened as a broad courtyard, into the semicircular ceremonial chamber. Around the curving walls of this last Delaroche painted a frieze of all the artists of modern history in attendance at the ceremonies of the Ecole, a memory theatre, like that Duban had arranged with their monuments along the path leading to it.

The Ecole, for all its importance as the seat of the Paris architectural profession, was a small, confined ensemble. The great Louis-Philippard monuments were the Luxembourg, the Hôtel de Ville, and especially the Palais de Justice, this last projected in 1835–1838 by the architect Jean-Nicholas Huyot to organize the Ile de la Cité (figs. 94–95) but not executed (in a modified form) until the Second Empire. Like Duban, Huyot had to enhance and regularize a complex of existing buildings. He did so by filling out the site in a compact mass in which the style of the historic constructions was mirrored in the decoration of the new—in places medieval, in places Renaissance or Baroque. But the overall shape was unitary, and a great tableau was created facing west, past the prow of the Ile, building off of the shapes already established by Henri IV in the houses of the Place Dauphine (with his own equestrian statue raised by his widow at the tip). Huyot completed the tableau to be seen from Henri IV's bronze eyes, looking eastward through the passage from the Pont Neuf into the Place Dauphine that spreads, then closes to a second passage that Huyot makes enframe a tall mansarded, columned pavilion that is the architect's powerful fantasy of the style of the early seventeenth century.

It is illuminating to compare this to the conceptions of the functionalist (and friend of Daly) Nicolas Harou-Romain, specifically his 1840 project for a panoptic prison (fig. 96).[35] The cells are arranged beehive-like as a five-story shell around an iron-domed void in the middle of which rises the watchtower serving as an altar platform for the daily celebration of Mass. In the frontispiece of Harou's publication we see a prisoner kneeling at the door of his cell before this tremendous tableau of authority, axiality now multiplied to become authoritarian omniscience, but its exercise cut off from the street, the city, and the world by a wall and a dome.[36]

The different ways of arranging city space that perfected themselves in mid-nineteenth-century France were less competing systems than discrete, specialized responses to segregated social situations. There came to be one kind of space for the traditional representation of governance, another for industry, another for the bourgeois touristic admiration of its own city and history—and yet another for the resocialization of the recalcitrant. The New Louvre, as it assumed its final form in the hands of Fontaine and Visconti, sank into this matrix to become an inflection in the general system.

IX

Going to Extremes over the Construction of the *Juste Milieu*

ALBERT BOIME

No one in the social sciences now takes seriously the once popular notion of the *Zeitgeist*, an amorphous concept that suggests a grand chunk of time with a distinctive beginning and a definitive ending. Indeed, from our current perspective it would seem the height of absurdity to posit an overarching explanation of an epoch that transcends the interaction of specific individuals with each other and with their environment. (Although post-modernist critics may even disagree with the contention that human agents form the individual and collective experiences of societies.) Nevertheless, I resist going to the other extreme: having just lived through the Reagan era and the "Bush(ed) milieu," no one can tell me that periodization is all emplotment. I intend to argue in this paper that there can be such a thing as a *Zeit* without a *Geist*, even though this goes against the grain of recent critical theory. If I sound a bit defensive in response to my critics, please bear with me as my aim is to demonstrate that yes, dears, there is a *juste milieu*.

Critical theorists have been working energetically during the past two decades to alert writers and scholars in the humanities and social sciences to the logocentrism of scholarly disquisition. They have substituted for causality or agency—assumed by the *Zeitgeist* explanation—the notion of an interactive intertextuality in a world where everything is immediately or potentially related. The global environment with all of its teeming life and artifacts, they argue, has become so complex and interconnected and yet so graspable through electronic communication that it is impossible to extrapolate a unique set of circumstances or phenomena that could be defined as generative. [1] There-

fore a demand for chronological priority reduces to a linear and arbitrary selection of a pair or constellation of contiguous events.

Post-modernist interpretation points out the limiting factors built into the notion of "context" that had long since replaced the notion of *Zeitgeist* for the social historians. The idea of some master formula or code explaining away the complexities of an historical epoch, the notion of a massive structure that easily accounts for all variables but in the end is too amorphous to be located in time and space has been seriously challenged by scholars such as Hayden White and others.[2] The general post-structuralist critique of monolithic, unified, discrete time periods with the suggestion of closure has made us all wary and suspicious of easy labels for epochs and periodization, and even the concepts of "epoch" and "periodization" have become prime suspects in the quest for demystification of linguistic utterances.

But although this is especially invaluable in challenging long-unquestioned assumptions and canonical formations, it does not seem empirically possible to totally disregard a process of thinking and perception that so powerfully influences social, political, and cultural behavior. The starting point of every discursive practice—even that designed to challenge such practice—may be taken as a causal link in a chain of signifiers establishing a context and organizing a discourse. Close attention to the signifying function of one's personal starting point would probably reveal his or her temporal-spatial matrix. Even the most skeptical of literary and art theorists identify themselves with specific modalities of thought bound up in collectivities and inseparable from periodization such as postmodernism or poststructuralism. It may or may not be sound humanistic practice to divide up the curriculum into fragmented areas of specialization (I personally oppose this territorial practice), but do we not still have among us social art historians, feminist art historians, semioticians, critical theorists, and postmodernists all proceeding from theoretical assumptions peculiar to their preferred methodology? We may question these assumptions from here to eternity, but in the end we still feel the overwhelming need to identify ourselves with a community of intellectual and political passions that is both generational and contemporary. For example, what does it mean for one scholar to say about another that he or she is no longer on the "cutting edge" of scholarly debate, unless there was some perception of generational change?[3] Indeed, every one who thinks and acts finds him or herself in a temporal and spatially determined situation, an objectively given milieu, Tainean, "juste," or otherwise. It is this set of subjectively experienced external conditions that ultimately provides the "context" for the development of our potentiality.

This was brought home to me most vividly by the recently published compendia of reflections entitled *The 60s Without Apology*. My project had only an ancillary cultural role to perform in this passion play, but on a personal level the stakes were high: it was during the years 1964–1968 that I began my research on the July Monarchy in France and the foundation of the modern academic curriculum in France. (Indeed, I recall

sitting with my brother—both fresh arrivals on the Paris scene in the autumn of 1964 to begin work on our dissertations—in the park across from the Bibliothèque Nationale, and reading in a French newspaper about what Jerry instantly perceived as President Johnson's ill-advised exploitation of the Gulf of Tonkin incident.) Having graduated high school in 1951, however, and pushing thirty-five by the time I completed my dissertation in the fateful year of 1968 (or is that also a mere construction?), I found myself positioned as a "transition generation." I have no doubt that this influenced my understanding of the notion of the *juste milieu* associated with the regime of Louis-Philippe. I even extrapolated the term from its original framing function to apply to what I saw as a perennial feature of "official art"—the attempt to mediate generally a compromise point between avant-garde and traditional visual practice.

Nevertheless, I stated somewhat tentatively at that time that the term *juste milieu* was first and foremost a political signifier and applied only by way of extension to the cultural realm.[4] I reaffirmed this assertion in my monograph on Thomas Couture, where I demonstrated that underlying the concept was the philosophy of eclecticism that pervaded the institutionalized educational practices of the July Monarchy.[5] My error was in seeing *juste milieu* as a kind of stage in the dialectic, in which there was a reconciliation and a settlement of antitheses. Now I understand it (more clearly I hope) as a strategizing principle for appealing to a weary and confused body of middle-class and aristocratic types who longed for a unity and healing of the divisions of social impulses, interests, and enterprises. Thus it could be exploited successfully by both the wily charlatan and the ardent idealist. Understandably, such broad applications of the concept would problematize its historical positioning and reception.

For reasons that I first only dimly perceived, my initial use of the *juste-milieu* label drove critics to exasperation and recalled its negative applications by their July Monarchy counterparts. The most recent testimony to this steady effusion of steam is Marie-Claude Chaudonneret's review of the July Monarchy literature, so staunchly conservative in its orientation that it steadfastly refuses even to include a reference to the regime in its title, which reads simply: "La peinture en France de 1830 à 1848."[6] Chaudonneret, who loves to attack my work even while doggedly retracing my footsteps, stoops to new rhetorical depths in decrying my monograph on Couture as a "monument caricatural" whose siren song of the *juste milieu* has evidently lured unsuspecting art historians to run afoul of the reefs of scholarly disquisition. She goes so far as to insist that "historically and politically, this notion of *juste milieu* does not mean very much," and then immediately follows this inanity with the astonishing assertion that "it is interesting to note that historians do not employ this term to characterize the politics or ideas of the July Monarchy."[7] Given the fact that nineteenth-century historians persistently used the term expressly for this purpose, we might ask why she engages in such strenuous denial of this particular aspect of her nation's past.

But critical dread of the *juste milieu* has haunted the commentaries on my book

since its appearance in 1980. The Americans Charles Rosen and Henri Zerner, who reviewed my Couture monograph in *The New York Review of Books*, wished that I would have stayed within the narrow art historical perimeters previously set out for the *juste milieu* by Léon Rosenthal (more about him later) in 1914, while the English Jon Whiteley, reviewing Michael Marrinan's book, *Painting Politics for Louis-Philippe*, sighed with relief: "A book on art in the July Monarchy which does not mention the 'juste milieu' until page 206 is a welcome novelty."[8] It is no coincidence that Marrinan launches his discussion of the term with reference to my views, that he then hastens to attack as imprecise and identical with the notion of *Zeitgeist*.[9]

All scholars of the period, myself included, are indebted to Marrinan for refining and amplifying the historical links between Louis-Philippe's political program and official painting, but Marrinan's interest was much more narrowly focused than mine. Although rejecting "an overly simple linkage between the July Monarchy's official art and a zeitgeist (sic) of Eclecticism," Marrinan contradicts his own stated intent on the first page of his book where he attributes civil disorder during Louis-Philippe's reign to "rapid industrialization and urbanization of France's traditionally agricultural society"—as if the king's policies treating these issues and aimed at repressing the disadvantaged sectors of French society were not directly responsible.[10] Marrinan subsequently tries to set up the prototypical expression of the eclectic ideal in the form of strawman Jean-Baptiste Mauzaisse's *Allegory of the History of Louis-Philippe*, and proceeds to show how its shabby treatment by the administration contradicts the assertion that the king's passion was to establish an eclectic official art (fig. 97).[11] But the fact that Louis-Philippe and his ministers were indifferent to the picture does not negate its particular formal and thematic structure. Other factors, including startling allusions to the barricade, the dead, and the wounded of 1830, may have been equally crucial to the official neglect (fig. 98). As stated earlier, the *juste milieu* was a strategizing concept (and no more "slippery"—to use Robert Bezucha's adjective[12]—than any other political category) formulated as a response to the compromise between the conservatives and republicans that the king had to make at the outset of his regime, and proved flexible enough to undergo gradual change in its pragmatic application to actual conditions. As the choice of both a conservative and revolutionary segment alike, Louis-Philippe could hardly have been consistent in his position. For example, Louis-Philippe's government at first reacted with measured reserve to the great liberal Catholic, La Mennais, who formulated the religious parallel to the *juste milieu* in the motto of his newspaper "God and Liberty," but gradually adopted a more positive attitude towards him in the late 1830s and early 1840s.[13] Marrinan writes as if comfortably at home within the container of the July Monarchy rather than escaping to a more distanced and nuanced perspective.

His view of the *juste milieu*, like that of many writers put off by the term, was conditioned by the reading of Léon Rosenthal's *Du romantisme au réalisme* that devotes a

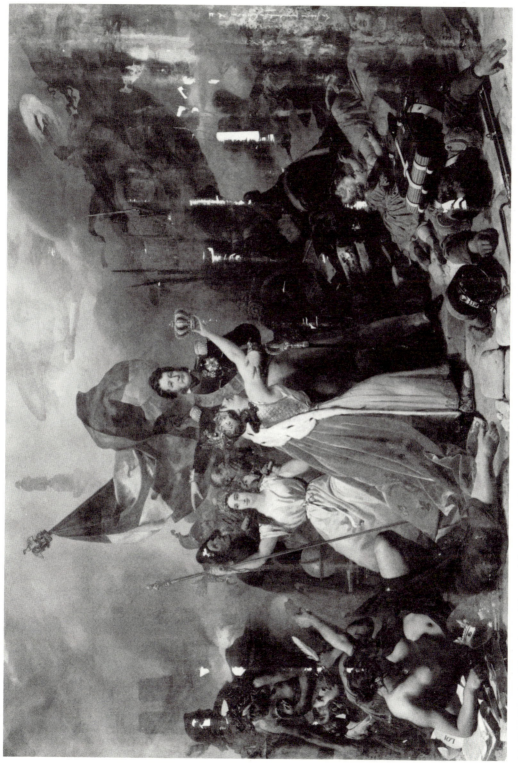

97 · Jean-Baptiste Mauzaisse, *Allegory of the History of King Louis-Philippe*, 1839, oil on canvas. Versailles, Musée National du Château

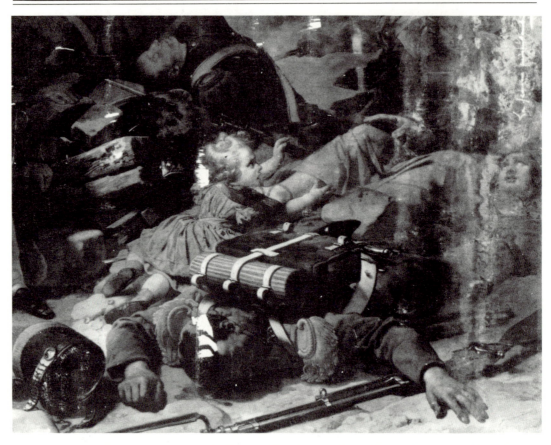

98. Jean-Baptiste Mauzaisse, *Allegory of the History of King Louis-Philippe,* 1839, oil on canvas. Versailles, Musée National du Château, detail

major chapter to the notion of the *juste milieu* as a particular category of painting in the period.[14] By Marrinan's own confession, the book—for which Marrinan wrote an insightful introduction in a recent republication—confronted him as an "intimidating predecessor."[15] Rosenthal's chapter on the subject, however, never breathes a word of politics and it was precisely my aim to ground the style in the concreteness of historical and material events. It was in the process of digging into the specificity of *juste-milieu* politics that I came upon the pervasive influence of Victor Cousin's eclectic philosophy on the culture of Louis-Philippe's monarchy. Writers like Chaudonneret, Rosen, Zerner, and Marrinan, perhaps frightened of history and of the class struggle—or of a class-based history in which culture is embedded—were reluctant to grant me credit for politicizing the term *juste-milieu* and thus wanted to turn the clock back to Rosenthal.

The *Zeitgeist*, when used, is an artificial construct imposed by an author such as a Toynbee or Spengler seizing and marshalling vast epochs like a cosmic Pied Piper. But I

did not impose the notion of *juste milieu* on the era of the July Monarchy: French people living in those years constructed their geographical, political, and social identity in relation to this term. They baptized the era themselves with the historical title, and while it is ridden with irony and contradiction neither I nor any other scholar can take credit for it. Is it mere coincidence that there are within this structure of compromise a number of subcategories of cultural and social practices bearing the same label? That there is a *juste-milieu* school of painting, a *juste-milieu* philosophy, and even *juste-milieu* economics? This is not just a term freefloating in the hole in the ozone layer, but an authentic historical label accepted by both partisans and opponents of the regime. Evidently, an adversary of the July Monarchy recognized a *juste milieu* when they saw one, even at a hundred paces. The regime of Louis-Philippe and its most ardent propagandists identified both its domestic and foreign policies as "*juste-milieu*," and they meant something quite specific in using this term. At home, it was a codeword for containing the Revolution of 1830 by implying a course midway between the dangerous shoals of absolutism and republicanism—the king defined the poles as "the abuses of royal power and the excesses of popular power"—while abroad it signified a policy of non-intervention in the struggles for liberty beyond the borders of France. In this sense, the *juste milieu* was no autonomous territory but a spatial concept that bridged the boundaries between domestic and international politics.

Certainly foreign observers understood its construction as the expression of a concrete foreign policy.[16] The historical specificity of the *juste milieu* reveals itself somewhat unexpectedly in its influence on the Italian statesman, Camillo di Cavour. He was the architect of the Italian version of constitutional monarchy, and consciously applied the term *juste milieu* to his parliamentary program designed to isolate both the extreme right wing of clericals and monarchists and the extreme left wing of radical democrats. What he had going for him was the nationalism generated by the movement known as the Risorgimento, which gave the regime a progressive veneer lacking in France. Cavour managed to gain the support of the radicals whose first priority from the start had been expulsion of foreign rulers and unification.

Not surprisingly, Cavour profoundly admired Cousin who in turn encouraged Cavour's literary talents. Cavour also read and critiqued the writings of Cousin's disciple, Théodore Jouffroy. When in France, he participated in the circles of Cousin and the French *juste-milieu* painter Paul Delaroche. When he learned of the death of Mme Delaroche, Cavour wrote: "I grieve bitterly for her unhappy husband whose inspiring genius she was."[17] On 14 January 1835 he wrote to his friend the abbé Giovanni Frézet: "The more I observe the course of events, and the conduct of men, the more I am persuaded that the *juste milieu* is the only political policy adapted to circumstances, capable of saving society from the two shoals that menace it: anarchy and despotism."[18] Although mesmerized by French intellectuals like Guizot and Cousin, Cavour did not see the *juste milieu* as inhering in any particular regime and even thought he saw it

practiced in Geneva and England as well as as in France. He saw all of Europe gravitating in the direction of the *juste milieu*, and as for Italy "it's our only hope for salvation."

Years later as Prime Minister steering the country's middle course, he could write at a difficult moment:

> Italy is in a very critical position. On the one side diplomacy, on the other, Garibaldi—that is not exactly comfortable. I still hope that we shall pull through, and succeed in establishing our country on solid principles of order and liberty, in spite of the suspicions of the Absolutists and the insanities of the Republicans.[19]

Cavour had clearly internalized the ideology of the *juste milieu* and made it the launching pad for modern Italy.

It is this historical specificity of the *juste milieu* that I tried to work through in my book on Couture. Marrinan's attempt to reduce my analysis to the vague notion of *Zeitgeist* typifies his misguided attempt to discredit my forging of the real connections between the concrete political policies of the July Monarchy and their impact on the contemporary culture. He drastically oversimplifies my arguments by grasping hold of the coattails of my observation that Versailles represented an "eclectic fantasy" and then asserts his own formulation which he thinks contradicts what I wrote:

> This evaluation necessarily minimizes the museum's cultural function: our steps through the galleries have shown that Louis-Philippe's propagandistic concerns at Versailles were not merely expressions of a culturally informed synthetic vision but were, on the contrary, politically self-serving programs manipulating a precisely focused, astutely selective historicism.[20]

If Marrinan is saying that I set forward a theory of *juste milieu* and eclecticism as the "spirit of the times," he simply failed to read my discussion; indeed, I argue repeatedly that the *juste-milieu* and eclectic position is one of extreme self-consciousness and that Louis-Philippe's program could not be otherwise than a "politically self-serving program manipulating a precisely focused, astutely selective historicism." Indeed, a recent specialist on the period writing in English similarly described the *juste milieu* as a novel conception of government, that based "a regime upon a party programme."[21] Marrinan's primary departure from my text is to give the formulation a slightly more conspiratorial twist. Indeed, eclecticism is synonymous with "selective historicism" and is based on a critical philosophy of history that sets up a program that essentially reads out of the past that which contradicts the position of the reader.

Marrinan then trots out two examples of early July Monarchy versions of *The Voluntary Enlistments of 1792* to contrast with my example of Couture's later semi-allegorical representation of the same theme to show that eclecticism had nothing to do with July Monarchy historical policy (fig. 99). He claims that "neither of these images

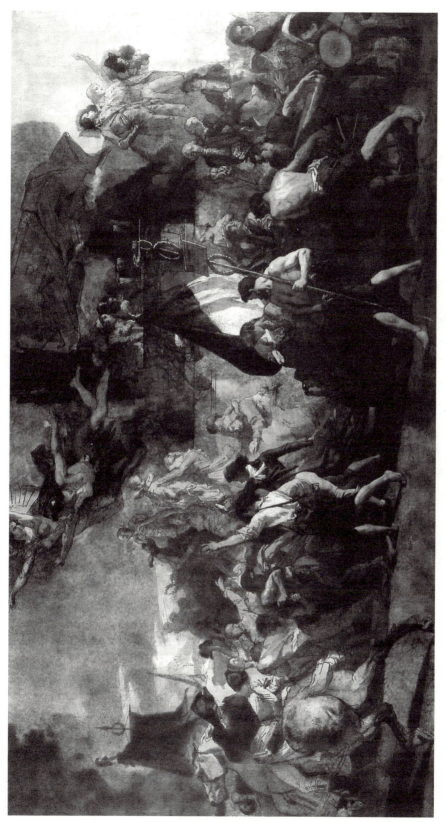

99. Thomas Couture, *The Enrollment of the Volunteers of 1792*, Salon of 1850–51, oil on canvas. Beauvais, Musée départemental de l'Oise

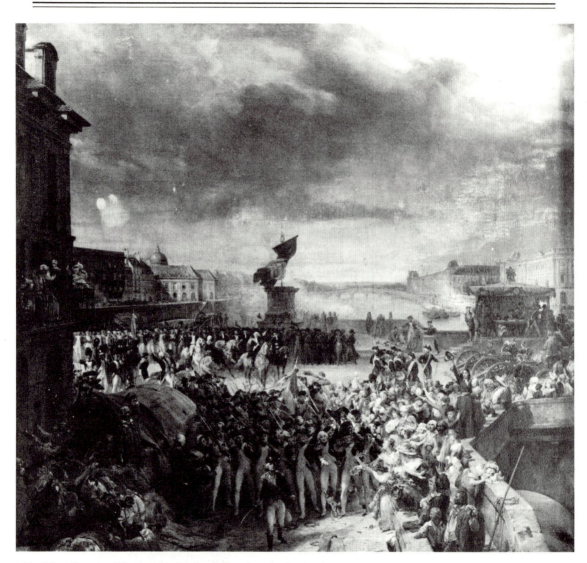

100. Léon Cogniet, *The Parisian National Guard Leaves for the Front in September 1792,* Salon of 1836, oil on canvas. Versailles, Musée National du Château

incorporates broad allegorical meanings into the historical narrative although both, as we discovered, relate versions of the event especially attuned to the contemporary political situation."[22] Yet in Cogniet's *The Parisian National Guard Leaves for the Front in September 1792* nothing could be more striking than the solitary monumental tricolor flag hung above a massive pedestal on the Pont Neuf in the heart of the composition (fig. 100). It organizes the design exactly like Delacroix's *Liberty*, but it calculatedly eliminates the allegorical personification in favor of the flag symbolism and diminishes the

power of individuals (fig. 101). Here the crowd of guardsmen and bystanders swarm in densely packed units below the horizon that neutralizes their individuality and dwarfs their potential as expressed in the Delacroix and leaves the field to a bit of bunting flying overhead. Young women distribute laurels to the passing guardsmen and mothers raise their children to expose the next generation to the highest of examples. An epic event is reduced to genre, exactly what Laffitte, the July Monarchy's first prime minister, had in mind when he said that the *juste-milieu* policy meant keeping the revolution in check. Finally, the pedestal now surmounted by the gigantic fluttering banner was formerly occupied by the statue of Henri IV, the founder of the Bourbon dynasty, toppled in August 1792 by the sans-culottes to signify the collapse of the monarchy and the establishment of the First Republic. Fittingly, the tricolor espoused by Louis-Philippe replaces the toppled Bourbon monarch and at the same time forecloses on the republican implications of the event by emphasizing the celebration of the emblematic banner as a transcendental sign of civic order.

On the surface DeBay's *The Nation in Danger, or the Voluntary Enlistments of 1792* seems to differ markedly from the Cogniet (fig. 102). The composition is now organized around a vertical axis and piles up its figures one on top of the other, building a kind of human pyramid. Yet the crowded composition culminates at the upper left-hand corner with the plaque of the slogan, "Citoyens La Patrie est en danger"—the signal for the voluntary enlistments—resembling nothing less than an altar in a chapel. DeBray makes use of a religious convention of the believers at the foot of an altar, only now a revolutionary slogan has replaced the holy effigy. Here DeBray intersects with Cogniet in building an image that emphasizes reverence for the symbols of Louis-Philippe's regime with the barest indication of sans-culottism.

Marrinan's historical readings of the texts do not essentially differ from mine, but as a self-confessed neutral observer he aims to depoliticize the concept of the *juste milieu*. In the end, he would prefer an historical analysis that cannot be comprehended in aesthetic terms but rather reduced to a form of socialist realism carrying out a specific iconographic program. Ironically, Rosenthal himself, although a committed socialist and politically astute historian,[23] seems to have deliberately retreated from drawing political conclusions about the tendency, perhaps because of the heated political situation of his own time. The book came out the year World War I began, and his conception of the book coincided with an eclectic period in culture in which the old elites were enjoying their last gasp.

At the same time, Rosenthal, born in 1870, actually represented the first generation of art historians to have grown up with the myth of the avant-garde and advocate its supremacy. His views of the nineteenth century are profoundly shaded with this modernist bias, especially as they touch on academic art and the *juste milieu*.[24] Yet Rosenthal was not historically unconscious, and it would seem that the reservoir of goodwill for Rosenthal predisposes his successors to overlook his conspicuous application of the

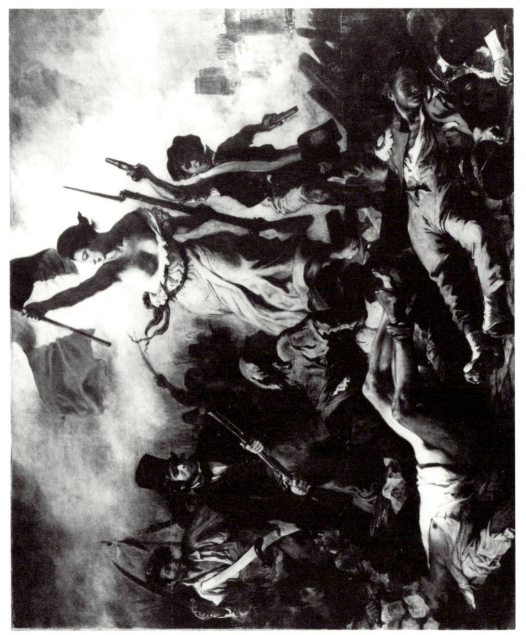

101. Eugène Delacroix, *Liberty Leading the People*, Salon of 1831, oil on canvas. Paris, Musée du Louvre

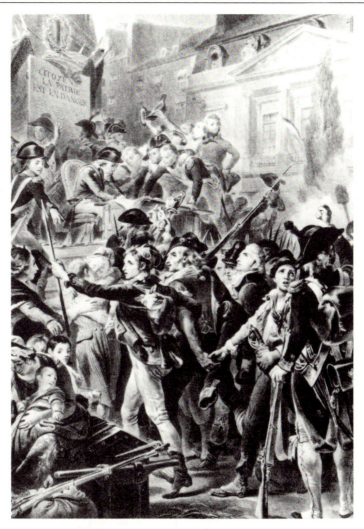

102. Auguste DeBay, *The Nation in Danger, or the Voluntary Enlist-ments of 1792*, 1834, lithograph

Zeitgeist articulated in his neglected introduction to *Du romantisme*. There he establishes the perimeters of his discussion framed by the two revolutions of 1830 and 1848. He notes that the Restoration witnessed the birth of Romanticism and the Second Republic the birth of Realism. The period in between, he claims, was one of confusion and indecision:

> Divided between the partisans and adversaries of Romanticism, incapable of satisfying either, guided by confused aspirations towards realism whose fu-ture it cannot foresee, the period of eighteen years that I am examining had

been an era of intense production, but also of research, incertitude, gestation; it imprinted on this fecundity and on this inquietude its physiognomy and unity.[25]

Rosenthal notes that the period was bracketed by revolution, showing with what power and occasionally with brutality public events can influence the evolution of painting. Indeed, he claimed that there is never a moment when painting may be considered isolated from life generally. He declared that the more he pursued the study of history, the more "the mysterious correspondences" uniting the seemingly most remote and disparate facts disclose themselves to him. These included political and social passions, philosophical or religious beliefs, and the different forms of intellectual activity that exercised an undeniable influence on painting. Science itself was not exempt from these influences, and he brought together Delacroix's color experiments with those of Chevreul. Rosenthal also displayed a lack of patience with those critics who upheld the genius of the individual artist as against his insight into "the unity of design of the human spirit." He insisted that the fascination and admiration for works of art will never in the least bit be diminished by the attempt to gain insight into the "complexity of forces" that have determined them. On the contrary, our appreciation of them can only grow through such an approach. He tells us that he has suppressed his own feelings and/or the estimation expressed in his own time towards July Monarchy works, depending rather on contemporary eyewitness testimony to give to the works their original signification.[26] Although this might seem dated now, at the time he wrote such a declaration would have had a novel ring.

Rosenthal's model for his approach was Hippolyte Taine, whose authority he invokes in the introduction. The notion of the unilateral genetic explanation of creative practice is seen most strikingly in the prototypical concept of "milieu" developed by Taine. Taine tended towards philosophical monism, inevitably expecting a one-to-one relationship between the society and the product, the cause and the effect. Born two years before the advent of the July Monarchy and educated in the thought of Victor Cousin, Taine found his happy medium between the extreme positions of idealism and materialism. Taine became a political conservative who welcomed the unprogressive character of the National Assembly after the Franco-Prussian War, and hoped that this would lead to a revival of an Orleanist constitutional monarchy. The Commune consumed him with bitter spite for the insurgents, and he cooperated on several official projects during the Third Republic to help guarantee that the "enlightened and rich classes lead the ignorant and those who work and live from day to day."[27] Taine's conservatism predisposed him to posit the notion of "milieu" as a direct causal factor in the production of a works of art. Ideas mediated by individual psychologies determined behavior but were conditioned by external forces of race, environment, and time, and

history constituted the attempt to map causal sequences in the evolution of these ideas through time.

Taine stressed the homologous character of historical epochs, thereby seemingly sacrificing individuality, nuance, and the disorderly components of everyday life. He used as his conceptual model of epochal totality a painting whose every part conduced to a necessary harmony. The historian able to identify the unifying features in a society's makeup and establish its underlying structural factors does not deny individuality, but rather positions the unique within the collective psychological and historical experience of the whole society.

I do not believe it coincidental that the Francophilic John Stuart Mill associated Taine with a *juste milieu* between positivism and idealism. Taine's own notion of the milieu—whose original meaning implies "the middle place" or a "natural place"—derived from eighteenth-century natural philosophers via Balzac's comparison of society with the "milieux" of animals in the introduction to his *Human Comedy* (1842),[28] the quintessential literary equivalent of *juste milieu* form and content. Balzac's use of the term was inspired by the biological writings of Geoffroy Saint-Hilaire, but its philosophical elaboration owes something to the philosophy of Victor Cousin whose lectures at the Sorbonne Balzac ardently followed. Balzac states boldly in his introduction that he wants a monarchy responsive to "imposing minorities" but not run by the masses, which would be tantamount to tyranny without limits. This is a restatement of the responsibilities of a constitutional monarchy proclaimed by Louis-Philippe's crowd. Balzac concludes his introduction by emphasizing that the scope of his project includes both a history and a critique of society, which authorizes him to give his work the all-encompassing title of *La comédie humaine*. And he leaves it up to the public to decide whether the work deserves the title or not. This confidence in his capacity to grasp a society in its entirety, to admit that he merely plays "secretary" to the actual "historian"—French society—is only thinkable in the context of that society's capacity to denominate itself as a *juste milieu*. The *juste milieu* invented itself through the manipulation of history and social criticism. Hence, I would argue that, *La comédie humaine*, and the social space it designates, is synonymous with the *juste milieu*, and this is the starting point for Taine's formulation. Despite the split that occurred in the nineteenth century between the Aristotelian notion of a "natural place" or "golden mean," rendered as "le juste milieu," and that of the neutral environment or simply "milieu, " both connotations reunite in Taine's thought and work. Hence the very notion of milieu may have come to him because of his coming of age during the *juste milieu*.

One piece of concrete evidence indicating his involvement in this cultural process is his unqualified enthusiasm for Thomas Couture's painting *Love of Gold*, published in his popular travel book, *Voyages aux Pyrénées*. (fig. 103) Describing the work of 1844 as the painter's "premier coup d'éclat," Taine followed with a personal explanation of his

103. Thomas Couture, *The Love of Gold,* Salon of 1844, oil on canvas. Toulouse, Musée des Augustins

praise. He classified Couture among the "moderns" who are "poets . . . determined to be painters." And he continued:

> One has sought our dramas in history, another in scenes of manners; one translates religions, another a philosophy. This one imitates Raphael, another the early Italian masters; the landscapist employs trees and clouds to compose odes or elegies. No one is simply a painter; they are all archaeologists, psychologists, giving setting to some memory or theory. They appeal to our learning, our philosophy. Like ourselves, they are full and overflowing with general ideas, Parisians uneasy and questing. They live too much by the brain, and too little by the senses; they have too much wit and too little innocence. They do not love a form for its own sake, but for what it expresses; and if they chance to love it, it is willful, with an acquired taste, akin to an antiquary's superstition. They are children of a wise generation, harassed and thoughtful, in which men who have won equality and the freedom of thought, and the right to invent for themselves their religion, rank, and

fortune, wish to find in the arts the expression of their anxieties and meditations.[29]

Here is a succinct definition of *juste-milieu* culture by a member of the newly emerging generation, torn by its utopian promise and its sordid reality. Taine concludes with a confession of his love for moderns like Couture: "I feel like them because I am of their century. Sympathy is the best source of admiration and pleasure."

It was in his introduction to the *Histoire de la littérature anglaise* (1863) that Taine first presented his celebrated notion that three primordial forces determined the form and spirit of a society: race, milieu, and the moment. Taine's discussion in his *Lectures on Art* on the interaction of artist and society touches on a number of critical points: the experience and ideas shared by the artist with his or her contemporaries; the special aptitude for going to the heart of the character of things; the manner in which the age comes to the artist's aid through the efforts of other creative minds; and finally, the encouragement given by the public to works that suit its taste and its rejection of others deemed inappropriate. Here as elsewhere the social and intellectual milieu of each period is treated as the fundamental condition for understanding the character of art. But invariably, as strikingly illustrated in his *The Philosophy of Art in Greece*, Taine's monistic attitudes toward race and milieu are rather vaguely spelled out and ideologically prejudged—for example, seeking in the physical environment an explanation of the persistence of certain biological traits—and prove him to be a victim of the *Zeitgeist* mentality.

Rosenthal, while accepting Taine's definition of the *juste milieu*, manages to evade the strictures of those who loudly denounce the notion by distancing himself from his hero's taste. Rosenthal's Tainism was moderated by his avant-gardism. Yet if Rosenthal sets out in the first chapter "Les conditions sociales," he imposes severe limitations on the category of *juste milieu* by refusing to analyze it in similar socio-political terms. Worse, in his chapter on the *juste milieu* he abandons his previously stated intentions to suppress his own opinions and begins immediately to disparage the art that he locates in this category. Marrinan makes the same mistake as Rosenthal in examining *juste milieu* as a predominantly aesthetic term, especially as applied to July Monarchy history painting or "genre historique." Such an exclusive use of the construction, although intended to bind it "to a set of historical conditions," nevertheless distorts the intimate association of the term with pragmatic applications in July Monarchy politics and culture.

What is crucial is that the primarily political term was transferred to the aesthetic domain. *Juste milieu* passed in fact as a synecdoche for Louis-Philippe's regime and culture. As a strategy to win over the public, the idea of the *juste milieu* was to use the charter as a guide to steer a middle course between legitimacy and republicanism—the two parties that threatened the favorable position of the moderate bourgeoisie and their noble allies in the wake of the July Ordinances.[30] What happened, however, was a

betrayal of this promise and the use of the *juste milieu* slogan as a mask for repression of the poor and disadvantaged and the gradual ascendancy of the haute bourgeoisie and their aristocratic allies. This actual imbalance in the two sides of the equation is illustrated in the answer Lafayette reputedly gave to the question "What is the juste milieu?" The general answered: "One person says $4 + 4 = 8$; another says $4 + 4 = 10$; a third person enters the debate and tells the others they are wrong in taking the extreme positions, and settles the argument by concluding that $4 + 4 = 9$. Voilà le juste-milieu."[31] This ingenious allusion to the erroneous arithmetic of the regime's "golden mean" is seen in the revised charter's rejection of Judaism as one of the French cults meriting recognition by the state. Thus the *juste milieu* in the religious domain was operable only within the limits established by the "Christian cults." The reporter of this sly dig at the regime's self-styled centrism, the radical Etienne Cabet, concluded that it was a system supported by partisans of the Restoration, legitimacy, and aristocracy who constitute the majority in the chambers and in public functions generally. His sarcasm was echoed in the sharp visual attacks on *juste-milieu* inconsistencies and contradictions during the early years of the regime.[32]

Throughout his critique of the July Monarchy Cabet employs the term *juste milieu* as a synonym for the government of Louis-Philippe. When discussing the government's attempt to impede and control the demonstration organized for the funeral procession of the liberal deputy Lamarque, Cabet claims that "the juste-milieu did everything possible . . . to impede or paralyze Lamarque's convoy." But when it came to the funeral of the conservative minister Casimir Périer, "Louis-Philippe and the juste-milieu employed all the government resources at their disposal to make [it] a public manifestation in support of their system." Louis-Philippe could not have permitted the demonstration to go its own way under the supervision of the organizers, because such a full-blown assembly in support of an opposition stalwart would have meant a massive protestation "against a counterrevolutionary, liberticidal, and dishonorable system." This would have added up to the death knell "of the juste milieu, and the juste milieu wished, at all costs, to prevent it."[33]

At times, Cabet writes as if the *juste milieu* comprised the majority of French society during the July Monarchy, including those taken in by the concept through the deceptive promises of the regime. He distinguished between the leaders of the *juste milieu*, the enemies of the Revolution of 1830 whom he classified as *carlistes* or those who still subscribed to legitimacy, and "the immense majority of the *juste milieu* who have strayed as the result of false promises, false hopes, and slanderous fears."[34]

Cabet refers to a spurious book, *Deux ans de règne*, ostensibly written by a single author—the lawyer Alphonse Pépin—but in fact a collaborative project edited by the inner circle of Louis-Philippe aimed at answering hostile criticism from the king's opponents and justifying *juste-milieu* policy.[35] Pépin, who was also the librarian for Mme. Adélaïde, Louis-Philippe's sister, especially directed his barbs to Bernard Sarrans,

a radical journalist and former aide-de-camp to Lafayette whose study of the hero and his treatment by the July Monarchy constituted an implicit attack on the ingratitude of the king and the regime's failure to fulfill the promises of the July Revolution. Pépin's book so outraged Sarrans with its mistaken assumptions and outright fabrications that Sarrans came back with a voluminous response entitled *Louis-Philippe et la contre-révolution de 1830*, an all-out attack on the regime stigmatizing it with the label of counter-revolution that had formerly been attached to the Bourbon Restoration.

Although the vituperative exchange between Pépin and Sarrans has largely gone unnoticed in the literature, it is especially instructive for my paper since both the ardent defender and hostile opponent of the July Monarchy employ the term *juste milieu* to describe the regime. When Pépin argues that the policies of the Laffitte ministry were essentially no different from those of Périer in wishing to guard against excesses from both the legitimist and republican sides, he italicizes his term for underscoring Laffitte's adherence to Louis-Philippe's regime: "in other words, isn't this the *juste-milieu?*" He repeats this thought quoting Laffitte's speech to the Chamber of Deputies on 27 December 1830 to the effect that liberty imposed by the foreigner is a gift as deadly as despotism, and rhetorically concludes: "Isn't this the authentic doctrine of the *juste milieu*, amplified and expanded by the president of the council of 3 November?"[36] Here the apologist for Louis-Philippe actually refers to the *juste milieu* as a "doctrine," that is, a system of thought or principle of operating procedure. Hence it is not merely a "nickname" or term of derision used by opponents of the regime, but a conscious tenet of political response to actual events. Indeed, Pépin continues to deploy the term as a synonym for the regime, as in the case where he writes of the attacks sustained by the *juste milieu* for its alleged weakness and indifference to "our national glory." The principle of the *juste milieu*, articulated by Louis-Philippe's first cabinet under Laffitte, implied that the Revolution of 1830 "had to be contained to a certain degree," that it be continually monitored by a sustained moderation, and that Europe had to be conciliated. This system of the *juste milieu* dated from 7 August [1830], the inaugural day of the monarchy of 1830.[37]

For those who insist that all of us are *juste milieu* but that it is necessary to "tilt more to the left," Pépin rejoined that such a shift would not mean that the *juste milieu* had moved leftwards but that it had abdicated its position in favor of the Left.[38] And he emphasized that it should never be forgotten

> that the condition of existence of this monarchy will always be to hold to a *juste milieu*, that it must remain *equally distant from the abuse of royal power or absolutism*, at risk of perishing like the Restoration, and *the excess of popular power* or the abuse of excessive liberty, at risk of being submerged by the democratic element; that is to say, that this government must always be moderate.[39]

Actually, Pépin's subsequent discussion of *juste-milieu* society attests to a profound conservatism; fearful of the proletariat that he stamps with the stereotypical attributes of irrationality, stupidity, idleness, and praiseworthy of the haute bourgeoisie described in generous terms, he reiterates that the system of the *juste milieu* was in perfect harmony with "the ideas and beliefs of contemporary society."[40]

Pépin's opponent, Sarrans, likewise used the term as a synonym for the regime, but a regime he asserted embodied the "counterrevolutionary" principle. He refers to the *juste milieu* as separate from himself, as the group of government hacks ready to manipulate history. He and those he admires—Lafayette, Laffitte, Dupont de l'Eure, and Odilon Barrot—are objects of hatred on the part of the *juste milieu*. Sarrans confessed that at the outset of the new government he too had desired the convergence of monarchical and republican principles in the person of the Duc d'Orléans, and even defended Louis-Philippe after 7 August against the assertions of patriots more "clairvoyant" than himself. But Louis-Philippe had no intention of surrounding his throne with republican institutions, but relegated republicanism to one extreme of his binary categories to avoid. Rather than use republicanism outright, however, he encoded it for his narrow constituency in terms such as "anarchy," "excessive liberty," and "popular power." In the end, Louis-Philippe marched straight back to absolutism.[41]

These references to the use of the *juste milieu* suggest its importance as the official label of the regime somewhat comparable to slogans like the New Deal, a New Frontier, and perhaps—if ex-President Bush can ever explain it—the New Order. But it is more than those in its standing for a principle that supposedly ran through the woof and warp of the July Monarchy's political process. Thus culture during this period was irremediably stamped with this label, and given the widespread government intervention in the arts no one could have been fully immune to its influence.

One critical feature of the "new" system is its implication that the notion of "absolutism" is relative. Despite the intrinsic conservatism of Louis-Philippe's *juste milieu*, it posited the relative merits and demerits of extreme points of view, thus relativizing ideologies—theological, economic, political—that heretofore had invoked some inviolable and incontestable ground of debate. The tendency to reconceptualize notions that had been considered absolute is inseparable from modernist thought and was succinctly expressed in the lectures of August Comte's *Cours de philosophie positive,* a work that coincides with the emergence and consolidation of Louis-Philippe's regime. There he boldly asserts that this shift constitutes one of the most important results of the intellectual revolution advancing modern society to the scientific or positive state. He further declared in contrasting the earlier theological and metaphysical stages with the positive:

> Every study of the inner nature of beings, of their primary and final causes,
> etc. must obviously be absolute, while every investigation of the laws of

phenomena is eminently relative, since it presupposes that the progress of thought is dependent on the gradual improvement of observation, exact reality being never, in any subject, perfectly disclosed: so that the relative nature of scientific conceptions is inseparable from the true notion of natural laws, just as the chimerical attachment to absolute knowledge accompanies the use of theological fictions or metaphysical entities.[42]

In this sense, I do not hesitate to suggest that the *Communist Manifesto* itself—with its Hegelian critique and perception of the dynamic of ideology—owes a major debt to the *juste milieu*. Marx and Engels announced: "The modern bourgeois society that has sprouted from the ruins of feudal society, has not done away with class antagonisms. It has but established new classes, new conditions of oppression, new forms of struggle in place of the old ones." Although the defenders of the *juste milieu* viewed their synthesis as a perpetual "happy medium," their critique of a retrograde system that had previously pretended to absolutist perfection only served to "unfix" all ideologies including its own. Analogously, all cultural cliques pretending to absolutism could now be perceived as tentative without one predominating. Classical ideals of beauty, for example, had to give way to a more dynamic approach to style and form.

Naturally, it is no easy task to isolate those precise features of style and content in that period that could be definitively labeled as *juste milieu*, consciously integrated or not. The nearest I have come to this was my case study of Thomas Couture who reached maturation in the mid-1830s. He consciously adopted a program that embraced the classical-Romantic polarities and a subject matter that corresponds to Rosenthal's defini-tion of the category as legible and easily understandable. Couture, for example, loved the proverbial and didactic theme that enabled him to fuse the formal traits of the dominant stylistic trends of his time. Rosenthal, however, did not include Couture in his chapter on the *juste milieu*, but rather relegated him to the all-purpose category of "Ephemeral or Out of Date Tendencies."[43] Still, when you read between Rosenthal's lines it becomes clear that the definitions set out in this and other chapters such as "Abstract Painting" and "Monumental Painting" overlap to considerable extent with those of the *juste milieu*.[44]

What I am trying to argue is that any attempt to define the art of this period will eventually have to come around to the characteristics of July Monarchy society, culture, and politics and this means the *juste milieu*. And here I want to return to the question of "context." While I agree that we have to question the assumptions on which the idea of a particular context rests, it must also be stressed that context is written into the very fabric of our reasoning faculties much like Kant's *a priori* categories. Relating contempo-rary art in this country to historical developments means talking about the Reagan-Bush era, as well as the assimilation of categories derived from French critical theory. One may argue that here I am dragging in the issue of "source" rather than context, but it would

be difficult, I believe, to make hard and fast distinctions between the context as a ground of stylistic development and source as the fount of an imaginative or narrative idea. The particular nature of the relationship consists not only in the reciprocity but also in the simultaneity of influences. No matter how problematical the concept of causality may be in itself, it would seem that the process in which two phenomena are connected with each other is in innumerable cases revealed to large extent from one side only. In the case of melting snow, do we need to question the assumptions about the sun as source and "context"?

True, in the social realm the conspicuous interaction or exchange between two phenomena—art and society—militates against the idea of one-sided causality. But if we once admit the influence of society upon works of art and the reciprocal participation of works of art in transforming society then it follows that what we may call the "initial conditions" flow from the former at the point of departure. Study of the social conditions that determine the forms of patronage, trade, artistic pedagogy, professional unions, and organization of work do not merely contextualize art production but ground it in ordinary life experience. While I was not as rigorous in this approach as I might have been in my previous writings, I tried to show that class situation and *juste-milieu* culture intersected. Marrinan's own position is predicated on a classless history that essentially views Louis-Philippe's society as a homogeneous and monolithic entity. Pretending to greater historical specificity in the analysis of individual works, he nevertheless reduces his study to a single unit by dealing centrally with the products favoring the regime and winds up with the very *Zeitgeist* with which he would stigmatize my work. It is understandable that he would attack my use of the *juste milieu* in the same terms, since it goes outside the boundaries of Louis-Philippe's direct sphere of control. The *juste-milieu* category then opens up to embrace the divided sympathies and changing interests within the bourgeoisie for whom the *juste milieu* was designed. Nothing expresses the new situation and the artist's new role in society more clearly than the link between political and artistic careers during the July Monarchy. People who choose politics or literature or art as a career are for the most part members of the same social stratum, and in many cases embody both functions as in the case of Louis-Philippe's ministers Guizot and Thiers. Both Guizot and Thiers wrote art criticism, histories of France, and preached in their writings the advantages of the *juste milieu*.

My purpose in writing this paper was designed to justify my previous research on the subject. I have invoked my critics to show how the concept of the *juste milieu* still operates in modern consciousness, while at the same time attempting to clarify its specific applications during the time of its incorporation into an objective political, social, and cultural program. The "golden mean" is in fact a "mean" notion in the double sense of the term, ultimately appealing to all in the name of a gospel that satisfies the urge to reconcile the painful binary oppositions of freedom and authority, anarchy and despotism, liberty and order—or now new order. But in the end it turns out to be

another illusion manipulated on behalf of those who would protect privileged interests, that is, the counterrevolutionaries. The radical Proudhon noted that the term *juste milieu*, which goes under the rubric of eclecticism in the lingo of the philosophers, is applied by preference "to the bourgeoisie, hostile to nobility and clergy, whose immobility it reproaches and whose prerogatives it covets, but who repudiates radical tendencies and rails against the egalitarian conclusions drawn from the notion of progress."[45]

Notes

VIOLENCE, SATIRE, AND SOCIAL TYPES

1. In this respect, July Monarchy Paris was akin to London in the age of Hogarth. See George 1935, George 1959, and Plumb 1973.

2. On the rise of the reading public and the business of book publishing and reading rooms, see Allen 1981 and Parent 1982. On the suggestion of an "excess of educated men," see Spitzer 1987, especially 225—59.

3. On the print explosion in Paris during the July Monarchy, see Santa Barbara 1977, Farwell 1981-, and Wechsler 1982. On the social effects of the invention of lithography, see Melot 1981. Elsewhere, Melot has described lithography as representing a real revolution, allowing "for the growth of a small industry that could provide a livelihood for entrepreneurial craftsmen in an area that had previously been of benefit to only a small group of talented individuals." See Melot 1983, 206—21.

4. Cuno 1985a and Cuno 1985b. My book-length study of Philipon and the development of French caricature from 1789 to 1848 is forthcoming from Princeton University Press. On the Passage Véro-Dodat and the commercial culture of early Parisian arcades, see Geist 1983, especially 59—73. Contemporary descriptions of it can be found in Pain 1828, 1:36, and Thiollet 1837, 4.

5. The primary source of information on Philipon's early years is a letter of 1854 written by Philipon to Nadar in response to Nadar's request for biographical information to be published in the popular journal *Le Musée français*; Fonds Nadar, B.N., Nouv. Acq. Fr. 2481, ff. 370—71.

6. The prints of l'Association Mensuelle were Philipon's greatest achievements to date and were clearly intended for a clientele of print collectors. When the stamp tax laws of 1834 required all political caricatures to be stamped within their image, Philipon complained that this deprived the association's prints of their aesthetic integrity. See Cuno 1985a, 107—8.

7. For a study of *les physiologies* and the place of la Maison Aubert in their market, see Cuno 1983a.

8. Balzac 1966. A comparison of statistics for the rise of print shops, book shops, and *cabinets de lecture* (public reading rooms) shows print shops increasing from 61 in 1820 to 88 in 1840, book shops from 351 to 479, and *cabinets de lecture* from 32 to 194. During the same period, the number of lithographic prints (of all kinds, not just of fine art prints) increased from fewer than 30 to 98. Figures were taken from the Bottin for the appropriate years.

9. For a study of the rise of the Parisian bourgeoisie, see Daumard 1963, and for a study of this generation, see Spitzer 1987. Identifying Philipon's public with any degree of accuracy is at best a difficult task. Some are identified in the pages of *La Caricature* and were listed there to attract additional subscribers who might identify with them and their kind. But there were relatively few such names and professions listed. We can determine more from a consideration of the venue of the shop, and I do this in the body of the text. But we ought also to consider the cost of Philipon's journals. A subscription to *La Caricature*, for example, cost thirteen francs for three months and single copies could not be purchased, while an annual subscription to *Le Charivari* cost sixty francs. This should be compared to the wages of seamstresses in Paris in 1853, who earned from fifty centimes to two francs a day, *corsetières* from one to five francs a day, and *culottières* from one to three francs a day. At the same time a chicken of medium size cost 2.39 francs and a kilo of bread, 28 centimes. See Statistique de la France 1864 [209]. Chevalier noted that the

economic condition of Parisian workers at the end of the Restoration was so fragile that police reports agreed that when the price of a four-pound loaf of bread rose above twelve or thirteen sous, most of the Parisian working class went hungry; Chevalier 1958, 314–16. Clearly Philipon's journals were not going to be purchased by workers. At the same time, many of the lithographs of *La Caricature* and *Le Charivari* were exhibited in the windows of la Maison Aubert, and the two journals were probably available in *cabinets de lecture*. The people who saw or read Philipon's prints and journals in this way, however, would have represented only an extension of Philipon's primary public. He would have appealed to the latter for financial support by means of subscriptions and the type of advertising allowed in his journals. See Cuno 1985a.

10. Statistics were taken from Bottin 1830.

11. Montigny 1828, 1:29. "Tout ce qu'on a inventé des arts et la civilisation, toutes les commodités du luxe, toutes les recherches du goût et de la mode, on peut se les procurer sans sortir de ce rayon: ailleurs, tout est imitation; là, tout est modèle."

12. Geist 1983.

13. For a contemporary description of the Palais Royal, see *Galignani's New Paris Guide* for 1830.

14. Balzac 1977, 355–61.

15. See Eliel 1984.

16. Parent-Duchâtelet 1836. In her study of the policing of prostitution, Harsin points to the same, when she writes that "Parent-Duchâtelet's second and most important achievement was his proletarianization of prostitutes, his transformation of them from the picturesque characters found in the works of Mercier and Restif de la Bretonne into the drab working-class figures of the nineteenth century"; Harsin 1985, 103. For a clear and cogent discussion of Parent-Duchâtelet and the implications of his proposals for controlling prostitution in Paris, see Harsin 1985, 96–130. For a more skeptical view see Corbin 1982, 13–53.

17. The character is the haberdasher in a play by Victorien Sardou, titled *Maison neuve*, 1866, quoted in Clark 1985, 42.

18. A circular of June 12, 1822, from M. de Peyronnet, le Garde des Sceaux, to MM. les Procureurs Generaux, warned that France was being inundated by *marchands colporteurs*, many of whom were not really merchants but actually vagabonds. One could not, he concluded, even be certain that they were citizens and thus ought to be kept under the closest scrutiny. Similar reports were filed from the Ministry of the Interior to the Préfecture de Police frequently during the 1820s. And when these "fraudulent" *marchands ambulants* entered Paris, they gathered about the *bouquinistes* along the bridges and quais to spread rumors and fuel political dissension. See A.N., series F7 6729, dr. 2 and dr. 74, as well as Cobb 1970 and Cobb 1975.

19. Fournel 1887, 5. "Le vieux Paris, d'un bout à l'autre de son enceinte, n'était qu'une symphonie incessante, où se mariaient sur tous les tons les voix provocatrices des marchands ambulants."

20. Fournel 1887, 66–67 and 70.

21. See Pouthas 1956 and Chevalier 1950.

22. In 1828, an ordinance was much discussed that called for rounding up the city's beggars and returning them to their place of origin outside Paris. The ordinance also called for the creation of a *Maison de refuge et de travail*, which was intended as a kind of half-way house for the integration into Parisian society of those individuals whose place of origin could not be determined but who were definitely from outside Paris. Overall, the ordinance was evidence of increased activity by police seeking to control the large, floating population of beggars and unemployed workers. Indeed, between 1827 and 1829, the number of convictions for vagabondage rose from 491 to 661, and for begging from 147 to 698; see de Sauvigny 1977, 263–65. Chevalier cites a report on the public temper of June 1828 as calling for the expulsion of five-sixths of Paris's beggars, clearing the city of a crowd of

vagrants who did nothing but spread theft and crime and stopping the dangerous proliferation of common prostitutes. See Chevalier 1958, 322.

23. See Wechsler 1982, 20–39. For a thorough discussion of the role of physiognomic description in the development of the nineteenth-century novel, see Tytler 1982.

24. Chevalier discussed the period's preoccupation with the description of physical characteristics. Indeed, he argues that "il est impossible de comprendre la violence des luttes sociales à Paris pendant ces années, si l'on ne reconnaît leurs fondements physiques et plus précisément encore morphologiques." Chevalier 1958, 519.

25. See Ferment 1982, 66–67.

26. Frégier 1840, 1:104–10.

27. Frégier 1840, 11:139–140.

28. Bédollière 1842, 170.

29. Quoted in Chevalier 1958, 452–53.

30. I have already mentioned plans proposed at the end of the Restoration calling for the expulsion of vagrants from Paris (see n. 22). In 1830, a similar bill was proposed by Dupin that called for "le gouvernement devrait chercher le moyen de faire refluer voluntairement dans les départements la classe surabondante des ouvriers qui se trouvent à Paris." Dupin's proposal failed in part because it could not be determined how one would accurately differentiate the Parisian-born from the provincial-born worker. But the bill's intention was similar to the effect of Traviès' image. It was to banish the dangerous worker or non-worker from the city's center. See Chevalier 1958, 455 n. 2.

31. Archives nationales, séries F7 3884, August 23, 1830. A police report of four years later described a troubling confrontation between a group of soldiers and their superior in front of Philipon's shop over some profane remarks made by the soldiers in response to a humorous and rude caricature of the king. See A.N., séries F7 6783, dr. 4.

32. Quoted in Chevalier 1958, 539–40. "Un genre de combat crapuleux où seul pouvait s'exercer "le pâle voyou, au corps chétif, au teint jaune comme un vieux sou." En effet, on n'avait guère vu que d'affreux bandits en bourgeron troué, en casquette arrachée, en chaussures éculées, faire avec les mains ces gestes mystérieux et sinistres, effroi du citadin paisible, ces mouvements du pied, qui forçaient la patrouille surprise à s'asseoir au milieu des ruisseaux."

33. Chevalier 1958, 527. Champfleury décrit le caractère culturel et géographique de another of Philipon's artists, Gavarni, in similar class terms: "Gavarni travaille spécialement en vue du Parisien de boulevard, et particulièrement d'un certain boulevard. Ses légères conceptions s'addressent—aux désoeuvrés qui vont et viennent de la Maison d'Or à la rue Chaussée-d'Antin et s'il est agréable aux abonnées—de l'opéra en leur offrant l'étalage de son *article-Paris*, ses fleurs sont fanées quand on les transporte dans des régions plus saines." Champfleury 1879, 258.

The Image that Speaks

A portion of this paper was presented at a symposium on the Art and Culture of the July Monarchy at the University of Minnesota on October 11 and 12, 1991. I am grateful to the department of Art History and the Center for Western European Studies for allowing me to present early aspects of my research on Mayeux. Additional research under a Mellon Grant from the Center for Western European Studies was conducted in France in 1992.

1. The July Revolution was crucial for a major reorientation of Romantic sensibility. Victor Hugo's evolution during this period both exemplified and furthered a broad effort to make effective political action a central part of the Romantic project. Hugo in *Notre-Dame de Paris* (1831) concentrates on the poor and the hungry; their grotesque and picturesque traits as well as their economic problems.

2. For example, "Galerie physiologique; L'Epicier" appeared in the fifth issue of *La Silhouette* during the year 1830 (vol. II, 36–38).

3. See Champfleury 1865.

4. Chevalier (1958) specifically links Balzac's production of "physiologies" for *La Silhouette* and his later *Comédie humaine*. Cuno 1985b, 259–79, extends these ideas to the caricatural "types" produced by Philipon, Traviès, Grandville, Daumier, and others.

5. Guizot's response was to the poor who had not received the promised right to vote. He suggested that the way to obtain the vote was to move themselves into the classes that had this right. See Collingham 1988, 291.

6. A statistical survey of both the written and visual representations of Mayeux has revealed that nearly 75 percent of the works involving this character were completed in the year 1831. This is, significantly, the year in which Louis-Phillipe assumed office. Collingham 1988, 18, 171, Cuno 1985b, 94–96, and others have suggested that Philipon and his staff at his three magazines were supporters of "the Citizen King" for about six months, then, realizing that Louis-Phillipe was not fulfilling his promises, turned against him with vitriolic caricatures. It is important, therefore, to associate the use of the ambiguous figure Mayeux with the changed attitudes of the artists/writers who made him popular.

7. Both Robert Macaire and Joseph Prudhomme appeared as characters in the theater (which was also subject to censorship) before they appeared in print. Mayeux was found first in texts, then in prints, and only after the July Monarchy was his character utilized in the theater.

8. "Riez, riez à votre aise, monsieur l'auteur; vous ne serez pas le premier qui m'ayez poursuivi par un rire insolent, depuis le jour où deux ou trois flandrins de peintres ont livré mon individu à la risée du public." *Histoire véritable de M. Mayeux* 1831, 3. This document is signed F*C*B*. I believe it was written by Philipon because these initials appear in *Physiologie du Floueur* and other texts by Philipon. In addition, this text is very flattering towards C.J. Traviès, who was a good friend of Philipon.

9. Meunié 1915, no. 230. "Ah! tu te permets de me chanter; grand Savoyard? moi je vais te

faire danser! Je vais t'en f. . . . des ogres de barbarie! je vais t'en f. . . . des Mayeux!!!" Both Wechsler 1982 and Cuno 1985b incorrectly identify Meunié as Meurie and report the text as undated. Meunié's *Les Mayeux* is significant as a bibliography of the majority of images, texts, chansons, plays, and decorative art pieces that feature Mayeux. While Meunié, the grandson of Napoleon's architect Fontaine, did not provide an analytical text on the significance of M. Mayeux, he did provide an important reference book with which it was possible to locate most of the original documents. Meunié's bibliographic entries for the prints include the complete captions which are sometimes impossible to read on the existing exemplars. Meunié also formed a society that was interested in Mayeux and held meetings at which the "petit bossu" was discussed. (Interview with Mme. M. Blatin, great-granddaughter of Félix Meunié, July 21, 1992, in Paris.)

10. Meunié 1915, no. 134. "Il n'y a qu'une bonne École madame, c'est l'École de la bosse . . . !"

11. This "majority" was not reflected in the electorate which under Louis-Philippe only increased from two to five percent of France's total population.

12. "Quel est cet homme? est-ce la satire vivante de notre siècle? que veut dire ce lourd fusil porté par un nain, cette âme exagérée dans ce corps frêle? pourquoi cette vigueur de passion, pour n'aboutir qu'au grotesque? que représente Mahieux? la chambre, la révolution de juillet, la France toute entière peut-être. . . . Mayeux est un type; Mayeux, c'est vous, c'est moi. C'est nous tous, avec nos coeurs jeunes et notre civilisation vieillie, nos perpétuels contrastes; vainqueurs sans victoires, héros du coin du feu." The article appeared on February 24, 1831. It was later partially reprinted as the introduction to *Exploits et aventures de Mahieux. A ceux qui aiment à rire comme des bossus* 1831, 5. This latter document was a collection of writings on Mayeux, including early articles from Philipon's *La Silhouette*. Like many of the texts on Mayeux, it seems to have been quite popular, for it was published in Lyon in

1831 and reprinted for release in Paris in 1832. Other texts on Mayeux went through as many as four editions. At this juncture it is necessary to address the different spellings of "Mayeux"; Mahieux, Mayeu, and Mayeux are all pronounced the same in French. Specific authors/artists did not seem concerned about the use of multiple spellings. The various spellings, for instance, are alternated within single documents and in series of lithographs by the same artist. In the case of the *Figaro* article, "Mayeux" was used, but when it was reprinted in book form the spelling was changed to "Mahieux."

13. Meunié 1915, no. 233, titled *La Revue*, features Mayeux peeping through cracks on a platform where women stand. The caption is "!!!!!!" Meunié 1915, no. 149 features Mayeux holding a ladder for a female apple picker—and looking up her dress. "Ne craignez rien, charmante Amélie! je tiens l'échelle!"

14. Hause 1984, 4.

15. Meunié 1915, no. 111. "Je suis français, bobonne, je suis français, nom de d . . . !"

16. Meunié 1915, no. 181. "Assez, assez! bon dieu! Assez!"

17. Meunié 1915, no. 43. "Ah! scélérat! . . . c'est donc ici que tu passes ta vie."

18. Meunié 1915, no. 66. "Oui Madame Mayeux, j'ai obtenu les suffrages de mes concitoyens, je suis nommé . . . ça m'était dû nom de D. . . .!"

19. Meunié 1915, no. 185. The title of this work is "Historique." The caption reads "Mais nom de D . . . jeune homme, prenez donc garde, votre derrière me sert de lunette, je n'ai f.pas besoin de ça pour voir."

20. For an account of the history of professions in caricature see Thomas Wright 1968.

21. Meunié 1915, nos. 122–134.

22. Meunié 1915, no. 213. "Tonnerre de D . . . ! Si Mme. Mahieu n'est pas contente de mon Andouille. . . .il faudra qu'elle y renonce."

23. *Amours secrets* 1832.

24. Wechsler 1982, 84.

25. Weisberg 1990, 186.

26. The earliest written documents bearing the name "Mayeu le bossu" appeared in 1829 and 1830. Traviès, usually credited with the "invention" of Mayeux, actually followed Grandville and Philipon, who drew a hunchback named Mayeux as early as 1829.

27. This work is not listed by Meunié. The series in which it appears is called *Mascarade improvisée*.

28. Weisberg 1990a, 186.

29. "The Marquise," one in the series *Mascarade improvisée*, appeared in *La Silhouette* (no. 2, June 1829) but without the mirror insert. The mirror inserts were approximately the size of a fingernail—which suggests that they were more of a novelty than a real attempt to comment on the alleged fickleness of the French people.

30. Quoted in Champfleury 1865, 202. Wechsler 1982, 82, incorrectly gives the date as 1833 (the *Gazette de Paris* had not yet been founded in this year). Given that the bulk of documents on Mayeux were written in 1831, this quote is a late one, and one that was undoubtedly influenced by Baudelaire's contemporary musings, such as those published in the October 1857 edition of *La Revue Européenne* titled "Quelques caricaturistes français."

31. Wechsler 1982, 84.

32. An example appears in the November 14, 1833, issue of *La Caricature* in an illustration called "Le Char de l'Etat" by Traviès. The personification of "Caricature" in this instance resembles Mayeux quite clearly (including the hump). Other illustrations, however, use a more generalized dwarf—who is usually not a hunchback. See for instance Grandville's drawing entitled "Grande revue passée par La Caricature le 30 Octobre 1832." *La Caricature*, November 1, 1832.

33. This caricature is included in Isabey's series *l'Album comique* (an undated collection of works). Meunié 1915, no. 1, dates the work in question around 1814.

34. The significance of Isabey and Napoleon was discussed in *La Silhouette* just a few months before the appearance of the character "Mayeux." See "Napoleon et Isabey," *La Silhouette*, vol. II, no. 1 of the collected issues, pp. 86–87.

35. F. J. Mayeux, *A l'Empereur sur l'impossibilité de concilier L'ACTE ADDITIONNEL AUX CONSTITUTIONS, avec LA MAJESTÉ, L'INDÉPENDENCE ET LE BONHEUR DU PEUPLE* (Paris, 1815). Among F.J. Mayeux's other publications are *Le Tombeau des Braves* 1818 and *Les Bédouins* 1816.

36. Mayeux 1815, 23. "Si, je le répète, vous refusez à la nation des représentans dignes d'elle, si la féodalité est rétablie sous des formes déguisées, si de nouvelles guerres étrangères raniment aux confins de l'Europe la haine du nom Français, si le commerce est immolé à la gloire sanglante des conquêtes, si la liberté de la presse est violée par des persécutions, vous aurez des esclaves et point de coeurs sur qui vous puissiez compter; vous aurez des esclaves qui vous abandonneront une seconde fois dans l'infortune, et des ennemis qui pulluleront sous vos pas: vous tomberez de nouveau."

37. This was in the series *Mascarade improvisée* (see note 29). Although there are several Grandville drawings that are dated 1829 (see those reproduced in Nancy 1986, 187–193), it is still difficult to establish definitively which artist was the first to develop Mayeux as a named character in a series of prints.

38. Most accounts credit Philipon with the ideas, which were then translated into images by Grandville and Traviès. See Getty 1984, 197–201. See also Cuno 1985b.

39. Meunié 1915, no. 100.

40. Meunié 1915, no. 30. "J'vous dis qu'tout l'monde s'en méle nom de D . . . ! . . . on prostitue le chapeau du grand homme."

41. See Marrinan 1988, 142–146, for a discussion of the formation of the cult of Napoleon.

42. Meunié 1915, no. 253. "D'artistes ont tous raté ma ressemblance, je ne suis qu'un rapin, mais il faut que je me peigne moi-même pour faire voir au public la différence qu'il y a entre Mayeux et l'Apollon du Belvédère."

43. Meunié 1915, no. 165. "Tonnerre de D . . . ! j'peux bien rester ici, je vois tant de gens qui ne sont pas à leur place."

44. Sorel 1980, 1. Significantly, one of the artists to reproduce Le Brun's drawings during the period of the July Monarchy, Michel Delaporte, also produced lithographs that featured Mayeux.

45. Armingeat 1960.

46. Graham 1979, 45.

47. Ibid.

48. Meunié 1915, no. 309. No. 1: "Voyez M. Mayeux, cet animal tient le milieu entre l'homme et le singe.—D . . . de D . . . ! Il peut se flatter d'être b.ent laid!" No. 2: "Bobonne, Bobonne! tu me ferais un monstre comme ça, ne le regarde pas tant!"

49. Other works in this series suggest that the orangutan may actually be the father of this child—that Mayeux has been cuckolded by an ape.

50. Meunié 1915, no. 21. "Faites-moi ressemblant. . . . ces farceurs me font toujours en Caricature. . . . ça me vexe nom de D . . . !"

51. Meunié 1915, no. 159. The title of this work is *M. Mahieu, sur le lit Orthopédique.* "—Ah! Tonnerre de D . . . , Docteur, Ces b . . . là me f . . . peut-être la paix! quand vous aurez corrigé mon infirmité."

52. Getty 1981, 107–121.

53. Woolworth 1852, 147. While Woolworth's text postdates the appearance of Mayeux and appeared in London, it is based on Lavater's drawings which were well-known in France. The artists of the July Monarchy could come to the same conclusions about the configuration of "satire" by looking directly at Lavater's texts and assembling the individual features (which is precisely what Woolworth did).

54. Harper 1981, 69. This interpretation of Hugo's work was given during the period in the periodical *La Charge*, which also published in November 1832 an important work by Michel Delaporte entitled "Le Poiricide" which featured Mayeux about to stab Louis-Philippe in the back. The anonymously authored article on Hugo was titled "The King is not Amused" and also appeared in *La Charge* in 1832.

55. Harper 1981, 66.

56. Jones 1988, 31.

57. Ibid., 32.

58. Baudelaire 1956, 176.

59. Ibid., 177.

60. Speaight 1988.

61. Meunié 1915, no. 106. "Non, Mayeux. . . .tu es un monstre, tu veux me séduire."

62. Meunié 1915, no. 310. "Polichinelle Victorieux" appeared in *L'Union Sociale* of June 23, 1849.

63. Titled "Le Char de l'Etat," mentioned above.

64. The longest and most complete account is found in a four-volume, nearly 800-page work by Auguste Ricard (a popular novelist of the period) titled M. Mayeux (1831). Ricard's other novels seemed to focus on "types" as well. At the time of M. Mayeux's publication his *Le Portier* and *La Grisette* (also multiple-volume works) were each in their second edition. He was also in the midst of writing *La Soeur de charité*. Publications ghostwritten for Mayeux include *Histoire véritable de M. Mayeux* (Paris, 1831), *Mayeux à la société des droits de l'homme* (Paris, 1833), *Histoire complète et seule véritable du petit bossu Mayeux* (Paris, 1831), and *Relation historique, véritable et remarquable des derniers momens de la mort et des funérailles de M. Mayeux* (Paris, 1831).

65. This implication is present in other works where, for instance, Mayeux is not admitted into the palace because the guard thinks that he is concealing a package, on account of the bulge in the rear of his jacket. The bulge, of course, is Mayeux's hump.

66. See for example F*C*B* 1831 and *Exploits et aventures* 1831. It is certainly possible that part of Mayeux's purpose was to satirize the very notion of "héros," especially when revered examples like Napoleon were more public figment than actual fact.

67. The two titles for the one document are (1) *Mayeux à la société des droits de l'homme* and (2) *Adresse à la société des droits de l'homme par citoyen Verneuil*.

68. *Mayeux et Arlequin aux salons* 1831.

69. While the visual and literary allusions to M. Mayeux largely disappeared at the same time that censorship laws were tightened, there is no evidence to date to suggest that the government had singled out artistic representations of the hunchback as offenses against the king or his policies. The journal *Mayeux* succumbed to censorship and its editor A. Mugney was sentenced to six months in Ste. Pélagie. A play that featured M. Mayeux as a member of the National Guard, *Le Fossé des Tuileries* (December 1831), was allowed to be performed only after the scene with Mayeux was removed. It is possible that the government did not fully understand the significance of the prints with Mayeux as the central character, or that they did not appear as vituperative as the many works by Philipon's artists that were either censored or prosecuted after the fact. Another possibility is that Mayeux disappeared not as a result of censorship per se, but as a result of the change from a hopeful perception of society to one where the government was seen as negative. Baudelaire's claim that M. Mayeux represented "our hopes and fears" and the statement in the *Gazette de Paris* that "Macaire replaced the naive Mayeux at the hour when illusions were no longer possible" seem to bear this out.

70. Meunié 1915 lists statues, figurines, and a service of plates. Jules Janin in *Histoire de la littérature dramatique* made a similar observation about the popularity of the figure who "gave his name to clothes, handkerchiefs, hats, stores, vaudevilles" (quoted in Wechsler 1982, 195).

THE PROLETARIAN'S BODY

1. Sewell 1980, 281.

2. The foundation for any work on Charlet is the catalogue of his prints, published in 1856 by La Combe. The only recent scholarship on the artist is Driskel 1987, but it deals primarily with his censored prints for one year only. The present essay can be considered an amplification of and complement to that article.

3. La Combe's invaluable catalogue does not mention this illustration or deal with the many books illustrated by Charlet.

4. One typical example of a writer stressing Charlet's identification with the people is found in an early issue of *L'Artiste*, the most important art periodical of the period. Speaking of a contest that had been held for the decoration of the Chamber of Deputies, the anonymous critic expressed his regret at the absence of Charlet: "But while the contest was still open . . . we would have wished to see Charlet enter into competition with Delacroix. There is between Charlet and the people a sympathy so profound that he certainly would have drawn from the subject a work both original and new." *L'Artiste*, 1831, 123.

5. Gavarni provided the other illustration of the "homme du peuple" for the publication. Unlike many of Gavarni's images of individuals at the bottom of the social ladder, his figure was given a classical gravitas and bearing, but the model for his figure was Praxitelean, rather than Herculean.

6. Gozlan 1841, 383.

7. Sewell 1980, 242, finds the same to hold true for the period as a whole: "In the complex and variegated discourse of the 1840s, labor was both lowered to the subhuman and raised to the sublime."

8. On this movement see Newman 1976.

9. Rancière 1983, 38–39.

10. This print is discussed by Marrinan 1988, 73, who in a far-fetched attempt to find a new source for Delacroix's *Le 28 juillet: La liberté guidant le peuple* argues that Charlet's print provided an inspiration for the painting. In his effort to twist the visual evidence to fit this argument the author even asserts that the building in the background of Charlet's lithograph is the Cathedral of Notre Dame, which is manifestly false.

11. Further evidence that this is the locale of the scene is provided by a lithograph, more documentary in nature, entitled *Combat de la rue Saint-Antoine (28 Juillet 1830)*, which is signed "Charlet et Jaime." A copy is found in the collection of the Musée Carnavalet, but is not listed in La Combe's catalogue. See Paris 1980, 36, no. 67.

12. La Combe 1856, no. 283. In another lithograph of the same year, La Combe 1856, no. 520, the cobbler once again raises his bared arm, while making a reference to a cardinal principle of neo-classical art: "La Forme avant la couleur."

13. Quoted by Sewell 1980, 214.

Aux armes, Prolétaire.
Prends pour ton cri de guerre:
Moralité pour tous, pour tous égalité
La victoire au travail! Mort à l'oisiveté!
. . . Faible est le bras de l'heureux de la terre
Qui s'énerva dans un lâche repos.
Mais il est fort le bras du prolétaire,
Qui s'endurcit dans les travaux.

14. Auguste Colin, *Le Cri du Peuple*, 1831. Quoted in Faure 1976, 51.

15. Reprinted in Faure 1976, 215.

16. The complete caption reads: "Polignac a mis la broche, y n'mangera pas le rôti! Enfants! veillez au grain, soignez les pénitents! Du bon coin! tel et roide d'hauteur! Et quand nous aurons secoué le panier aux ordures, si la France nous doit plus qu'elle ne peut payer, nous lui ferons crédit."

17. This print is discussed and reproduced by Weisberg 1990a, 157, fig. 7-7.

18. On Traviès see Santa Barbara 1989, 149–168. Also see Weisberg, 1993.

19. Chevalier 1981, 413–16.

20. Thompson 1963, 9.

21. La Combe 1856, no. 969.

22. La Combe 1856, 974. The original caption is listed in register the "Dépot des estampes et gravures presentées et non-autorisées" in the Archives Nationale, F.18.VI.48, no. 53, 17 November, 1840: "Aristocracie pour aristocracie, je préfère celle de titres. Elle est polie et généreuse . . . l'aristocracie d'argent est avare et infiniment peu poli." This print was approved on 24 November when the caption was changed to read simply "La vieille aristocratie. Elle était polie et généreuse." See Driskel 1987, 614–15.

23. La Combe 1856, no. 974.

24. Pinkney 1964, 5.

25. Ibid.

26. From an entry in Charlet's unpublished

papers, dated 6 December 1832. La Combe 1856, 64.

27. Ibid., 188, Letter of Charlet to La Combe dated 7 January 1845.

28. Burty 1860, 275.

29. Louis 1927, 68.

30. On this discourse see McWilliam 1988. For an example of the problem it posed for a contemporary of Charlet, see Driskel 1990.

31. La Combe 1856, no. 772. The legend, a good example of Charlet's attempts to capture the idiom of the lower classes, reads: "L'eau va-z-à la rivière . . . c'te pas grand'chose de Duché, la v'là qui va toucher la pension de c'que son pauvre homme s'est fait tuer le vingt-huit Juyet; . . . ça n'en a aucunement d'besoin . . . Mon guerdin n'a pas eu c'te bonne idée-là . . ., lui; . . . l'scélérat, . . . d'se faire tuer."

32. Ibid., no. 338.

33. Ibid., no. 583. The date of this in La Combe's catalogue is only approximate. A copy of this print is found in the Library of Congress.

34. Ibid., no. 936. Marrinan 1988, 44, discusses and reproduces this print, without any indication that it is part of Charlet's Valentin series, and dates it as reportage circa 1830, rather than more than eight years after the July Revolution, as was the actual case.

35. See, for example, Joseph-Ferdinand Boissard de Boisdenier, *Episode in the Retreat from Russia*, Salon of 1835, Musée des Beaux-Arts Rouen, and Edouard-Alexandre Odier, *Episode in Moscow*, Salon of 1833. Both of these depicted large-scale single figures encountering the horrors of this campaign.

36. de Musset 1836, 132–33.

37. La Combe 1856, 298.

38. Ibid., no. 298. In another lithograph of the same year, Ibid., no. 536, Charlet depicted the encounter of a humble sign painter and a prosperous Salon painter, both of whom had formerly studied with the same teacher. The bourgeois painter pretends not to recognize his former fellow student. Their class allegiances are underscored by the fact that the sign painter has just completed an image on a shop wall of a soldat-laboureur.

39. Ibid., no. 861. Nicolas Chauvin was a soldier of the armies of the Revolution and the Empire, who became a legend in the nineteenth century for his fanatical patriotism and his devotion to the memory of Napoleon. He was the subject of numerous popular plays and caricatures.

40. On the cultural significance of this theme see de Puymège 1984 and Athanassoglou-Kallmyer 1986.

41. Paul-Emile Debraux, "Le Soldat-laboureur," in *Receuil de chansons*, Paris, 1840. This was published in an anthology of four undated poems written during the Restoration.

42. La Combe 1856, no. 734.

43. Ibid., no. 968.

44. Quoted in Rancière 1981, 16 (my translation). In the actual print the leather apron of a carpenter is slung over the shoulder of his outstretched arm, which grasps the hand of the soldier next to him. Thus, it is visually juxtaposed to the chevrons of rank on the soldiers uniform, or his badge of office.

45. de Chambure 1828, 37.

46. Ibid., 151–52.

47. While the complete work was made available in 1842, it was released in fascicules prior to that date, the first installment appearing on 15 December 1840, the date of the return of Napoleon's body to Paris. On the publication see Burty 1860.

48. This debate concerning the location and the social values implicated in the proposed sites is analyzed in considerable detail in Driskel 1993.

49. Soulié 1840, 21.

50. Gozlan 1841, 279.

51. Corbon 1863, 302.

52. La Combe 1856, 461.

53. Quoted by Tronchot 1973, III: 177. This is the authoritative study of the educational experiment.

54. La Combe 1856, no. 762.

55. Ibid., no. 776.

56. Ibid., no. 777.

57. Ibid., no. 344. This caricature of 1831 was intended for an album designed to help pay the fines of *La Caricature*.

58. Ibid., no. 778. "C'est toujours les mêmes qui tient l'assiette au beurre . . . ça fait que la Révolution n' s'a pas encore introduit dans les z'haricots."

59. Ibid., no. 871.

60. Ibid., no. 882.

61. Ibid., 85. Letter of 13 August 1835 to Feuillet de Conches.

62. Newman 1975, 27.

63. The letter dated 16 February 1839 is reproduced in its entirety in Halévy 1921, 115–18. It was written in response to Thiers' "Lettre aux électeurs d'Aix 1830," published in *Le Constitutionnel* on 14 February, in which he outlined his ideas on domestic and foreign policy.

64. La Combe 1856, 129. Letter dated 12 September 1840.

65. On the positions of the different social classes during this crisis, see Daumard 1970. 341–45. These prints and their implications are discussed in detail in Driskel 1987.

67. La Combe 1856, no. 967.

68. Ibid., no. 353.

69. *La Caricature*, 1840, 4.

70. On Philipon's shift away from political content in his publications and his increasing interest in their commercial success, see Cuno 1983.

PROTO-REALISM IN
THE JULY MONARCHY

A portion of this paper was originally presented at the July Monarchy conference held at the University of Minnesota in October 1991. At that time, the author received considerable support from Professor Robert Bezucha concerning aspects of Jeanron's role as a proto-realist and in particular in interpreting one drawing crucial to the argument outlined in this paper.

1. Jeanron was discussed in *The Realist Tradition* (Cleveland, 1980). His role was more precisely defined in Weisberg 1990c, 101–5. Jeanron's inclusion in the 1989 July Monarchy exhibition engendered considerable debate in critical reviews published by Michael Marrinan, who had great difficulty seeing the artist either as a proto-realist or as a painter/draftsman around whom an "art for man" could have originally emerged. For further reference see Marrinan 1990, 301–5, and Marrinan 1989–90, 42–63. Recently, Jeanron has stirred considerable interest among curators in the national museums of France, and a number of his drawings have been secured by the Musée des Beaux-Arts in Calais. Also see McWilliam, 1993, 277–79.

2. Marrinan 1989–90, 50–51. The author raised the same issues in his *Art Journal* review (Marrinan 1990), providing further evidence of his own stridency in trying to establish the artist's position.

3. Marrinan 1990, 305, in which he cites that Jeanron and Antigna, another painter used in his argument, fail to "destabilize our expectations, nor complicate our relationship to their subjects in the manner of Gustave Courbet's *Casseurs de pierre* of (1850)." Seeing Jeanron (or Antigna) solely against Courbet reveals Marrinan as an upholder of the most conservative view of the traditional canon on early realism and distinguishes him as being unwilling, despite claims to the contrary, to enlarge his scope of pictorial reference.

4. For further reference see Rousseau 1935. This dissertation is difficult to consult and exists only in a typescript copy that is available on written approval from the Louvre. The author originally obtained permission from Madeleine Rousseau to read her dissertation.

5. These drawings were secured by Patrick Le Nouène, the current director of the Calais Museum. The author was unable to consult them at the time this article was completed.

6. Rousseau 1935, vol. 1.

7. Cited in Clark 1973, 130. For further reference see Grew 1988, 203–31.

8. Rosenthal 1987.

9. For a discussion of the origins of early realism see Cleveland, 1980 and Weisberg 1981, 128–30.

10. Nochlin 1976, 120. Jeanron's significance to the formation of Courbet's art is discussed on pages 120–24. Nochlin's perceptive comments have provided one of the starting points for the assessment of Jeanron in this paper.

11. For reference see Marrinan 1988.

12. Ibid.

13. Ibid.

14. For further reference see Rousseau 1935, vol. 1.

15. For reference to Laviron see Cleveland, 1980, 1–2.

16. Rousseau 1935, vol. 1.

17. Weisberg 1990c, 101–2.

18. Bazin 1833, 17. "Des enfans, agens zélés de tout ce qui est destruction, couraient les rues en brisant les enseignes, les armoiries, les lanternes, les écussons qui avaient quelque signe de protection royale. Soit prévoyance, soit instinct, leur colère s'en prenait aussi aux réverbères qui tombèrent tous en éclats dans le ruisseau, de sorte que, le soir, la ville n'aurait rien eu pour s'éclairer si la lune, qui n'était pas du complot, ne s'était avisée d'entrer la veille dans son premier quartier. En même temps, des barricades se formaient, surtout autour de l'Hôtel-de-Ville, qu'une direction habile avait désigné comme le centre des mouvemens. A midi, la révolution était plus que faite; elle était proclamée."

19. Weisberg 1990c, 103 n. 6. These drawings were found in a collection of watercolors by Paul Huet, an artist with very strong Republican sentiments who was well established during the July Monarchy. Huet remained closely linked to both Jeanron and the painter/lithographer Daumier.

20. Ibid., 103–4.

21. Ibid., 104.

22. Marrinan 1990, 304. This writer continued to center his argument against Jeanron on this painting, dismissing evidence derived from the drawings in establishing a proto-realist tone in Jeanron's work. See Marrinan 1989–90, 50–

51. Curiously, Marrinan goes no further in his negative reasoning here than to recite earlier beliefs published in the *Art Journal*. Also see McWilliam, 1993, 277–79 for further discussion on the tone of this painting.

23. Weisberg 1990c, 105–6. The author notes that Jeanron postulated "a veritable *art social*, one that focused on the lives and mores of the lower classes."

24. For reference to wandering types see Brown 1985.

25. Marrinan 1989–90, 50–53.

26. Nochlin 1976, 121. Nochlin cites the following as documentation: "M. Jeanron a demandé ses sujets aux scènes de la vie du peuple et aux angoisses de sa misère. Mais on aperçoit chez lui un sentiment de peinture plus large, et une appréciation plus profonde du malaise de la classe laborieuse. Sa *Scène de Paris*, par exemple, est un tableau bien pensé, dont le sujet principal est relevé par des contrastes heureusement choisis." The misery of the lower classes, a burgeoning problem for Louis-Philippe, is underscored in this work by Jeanron.

27. Marrinan 1989–90, 52.

28. For a discussion of the issues of censorship see Goldstein 1989.

29. On Traviès see Weisberg 1990a, 148–91.

30. Nochlin 1976, and especially her discussion of artists considered to be proto-realists. Nochlin was among the first to use the term proto-realist in any discussion of Jeanron.

31. Rousseau 1935, 50–55.

32. Ibid., 53–54. It was in this region that Jeanron focused on the theme of forge workers. A painting with this theme was shown at the Salon of 1834. The author spent considerable effort, without success, searching the Camborn region for further documentation on the Jeanron family.

33. Rousseau 1935, 53.

34. "On se rapelle la tournure puissante et délibérée des deux forgerons, dont l'un coupe du pain à une pauvre femme. C'est de l'art nouveau par la forme et par le fond et l'un ne pouvait aller sans l'autre; car en entrant dans cette sympathie populaire, il fallait aussi renouveler en même

temps la forme abâtardie, c'est-à-dire exprimer tout ce qu'il y a de noblesse et de grandeur dans la nature humaine de toutes les classes." Nochlin 1976, 122. This quote about Jeanron led Nochlin to call him a "significant forerunner of realism."

35. Rousseau 1935, 50–55, 251–58.

36. See "Tableaux présentés au Salon," 1834, listed as *Chasseur dans la montagne* (refusé) in the Archives du Louvre.

37. See Chu 1980, 21–36.

38. See "Tableaux présentés au Salon par Philippe-Auguste Jeanron," Salon of 1836, in the Archives du Louvre. The painting's measurements are given in a notation in the Louvre records.

39. For reference to this theme see Nochlin 1967, 209–22.

40. For reference see Baudelaire 1964, 166–68.

41. Weisberg 1990c, 108–9, for a reproduction.

42. Marrinan, in his reviews of the July Monarchy catalogue and exhibition, maintains the belief that "prefiguration" is an incorrect way to see these works. This strategy goes against the grain of what others have established previously and continue to do.

HISTORICAL VISION

Unless otherwise stated, translations from the original language are the author's own. I would like to thank Professors Chu and Weisberg for their invitation to participate in this volume. Research funds at Stanford University—provided by the Dean of Humanities and Sciences and the Ruth Halperin Fund—were used to prepare the manuscript, and are gratefully acknowledged.

1. Rosenthal 1914; rpt. 1987, citations from 204 and 216–17.

2. For an extended analysis of Rosenthal's "modernist" bias refer to my "Présentation" comments for the reprint edition: Rosenthal 1914; rpt. 1987, i–xix.

3. The phrase "logic of the situation" is meant to recall the work of Sir Karl Popper and its importance to much of my own thinking: Popper 1957, 149.

4. The principal proponent of this view in modern scholarship is Albert Boime: Boime 1971, 15–21, and Boime 1980, 3–35. The reader is also directed to Professor Boime's essay in the present volume.

5. The neat logical symmetry of this argument —where rising middle-class and middle-brow tastes meet declining artistic values in a muddled middle ground—has a long history in the history of art. It was regularly used by legitimist critics opposed to the Orléans dynasty, as discussed in Marrinan 1988, 20–21. Modern scholars still find it attractive; witness the recent commentaries: Condon 1990, 93; Chu 1990, 116; and Weisberg 1990b, 131. For a critique of the ideological difficulties associated with this kind of argumentation see Marrinan 1989–90, 47.

6. Figure 49: Salon of 1831, no. 3053. Versailles, Musée National du Château, inv. no. MV5186 (145 × 195 cm). Figure 50: Signed and dated "Eug. Delacroix 1830." Salon of 1831, no. 511. Paris, Musée du Louvre, inv. no. RF129 (259 × 325 cm).

7. Purchase of the Bourgeois for 1,000 FF was decided by the Civil List (that is, the Crown) on 27 September 1831 (*Archives du Louvre*, 2DD/4, fol. 24; *Archives Nationales* O^4 2821), and payment to the artist was made on 29 October 1831 (O^4 372, no. 1732). Delacroix's picture was bought by the Interior Ministry for 3,000 FF in September 1832 (*Archives Nationales* F^{4*} 504, no. 2214, 8 September 1831).

8. For a summary of the often murky history of Delacroix's picture in and out of French public collections consult Paris, 1982, 60–62.

9. On the visual culture of the 1830 Revolution, including a discussion of Delacroix's transformation of it, see Marrinan 1988, 27–76, and Marrinan 1989–90, 55–60. I use the rather awkward phrase "so-called popular" to signify a kind of visual production that circulates outside of the

professional artist/museum/art gallery merchandising loop, but without meaning to suggest that it is to be taken less seriously by the historian.

10. Figure 51: *Capture of the Hôtel de Ville of Paris, 28 July 1830*. Paris, Musée Carnavalet, série P.C. Hist. 43F (19.3 × 27.3 cm). Engraving published "Chez Caisse, Rue de la Montagne Ste Geneviève N°25, à Paris."

11. Many of these images are available for study in the Collection de Vinck at the Bibliothèque Nationale, Cabinet des Estampes; they are catalogued in Villa 1979, nos. 11.024–11.343. Also consult the exhibition catalogue Paris, Carnavalet 1980, nos. 42–142.

12. The remarkable overlap between visual and verbal accounts of the 1830 Revolution becomes immediately apparent when the imagery cited in the previous note is compared to the many short histories that appeared in late 1830 and early 1831. For an extensive bibliography of these texts, refer to Tavernier 1967, 193–283.

13. The definitive, archive-based account of Louis-Philippe's transformation of the château from royal residence to historical museum remains Francastel 1930, whose research has been refreshed and lavishly illustrated by Gaehtgens 1984. A succinct summary of the political and cultural importance of the renovation and its program is provided by Gaehtgens 1986.

14. For the Gallery of Battles building history see Francastel 1930, 64–65, and Gaehtgens 1984, 92–111, the latter with good reproductions of several architectural renderings. Creation of the large gallery had been planned from the outset of the renovation, for it was mentioned in the first public announcement of Louis-Philippe's plans for Versailles: Montalivet 1833, 2043.

15. *Henri IV Welcomed by the City of Paris in 1594*, Salon of 1817, no. 372. Versailles, Musée National du Château, inv. no. MV2715 (510 × 958 cm). On the original commission and political implications of Gérard's picture, consult Kaufmann 1975 and Gaehtgens 1984, 181–83.

16. Salon of 1836, no. 1126. Versailles, Musée National du Château, inv. no. MV2785

(550 × 1205 cm). On the political significance of Louis-Philippe's trip to the Hôtel de Ville on 31 July 1830 and Larivière's picture of it, refer to the discussions in Marrinan 1988, 32–33 and 58–60, and Gaehtgens 1984, 288–93.

17. This reading of the Gallery of Battles as an historical bridge across the chasm of radical revolution and authoritarian militarism is developed in detail by Gaehtgens 1984, 247–55.

18. The point was often underscored by contemporary critics, for example, Jal 1845, 98: "What the King wanted was that everyone who calls himself a painter would participate in setting up the monument he was raising to the glory of France. He generously wished that the largest number of artists would associate their names with this patriotic project. He also wanted to help, by means of honorable encouragement, a great many people without personal fortunes who were usually overlooked by government commissions, since they tend to be concentrated among a certain number of those reputed to be the most talented."

19. For example Boime 1980, 30–31, and Condon 1990, 82.

20. Generally closed to the public and very little discussed in the literature, the suite of galleries dedicated to the history of the crusades merits a systematic study. For a color photograph, see Gaehtgens 1984, 111.

21. Between 1833 and 1848 Louis-Philippe made 398 personal visits to Versailles in the company of his advisers and the château's resident architect, Frédéric Nepveu. After each visit Nepveu diligently prepared a summary of the visit and outlined in detail the items discussed; a complete copy of his remarks exists in the archives of the Musée Condé at Chantilly (côte 91G I–IV). More than any other document, Nepveu's summaries underscore the king's direct and personal intervention in the smallest details of the museum's installation: from the sequence of pictures to be installed in the Gallery of 1830 (31 October 1834) to the "richness" of the decorative mouldings in the Gallery of 1792 (4 February 1835);

from the height at which to hang pictures in the Gallery of the Estates-General (12 July 1835) to the addition of his initials "LP" in the coats of arms built into the mouldings of the Gallery of Battles (25 November 1838), and so on.

22. For a recent and powerful de-bunking of the seemingly "inert" space of the modern musuem, see Preziosi 1992, 379–86.

23. For a useful gloss on the general problem of "the event" in theories of history consult Ricoeur 1984a and White 1987, 26–57. More technical discussions that have greatly influenced my thinking about the issue include: Barthes 1967, 65–75; de Certeau 1975, 103–9; Foucault 1969, 44–54; Genette 1969, 49–69; Miguelez 1971, 20–36; Ricoeur 1984b, 92–149; and Veyne 1971, 45–52.

24. De Certeau 1975, 114. In this context, the important critique of "normal" history sketched by Foucault 1969, 9–20, must be emphasized, for it greatly affected de Certeau's own thinking.

25. De Certeau 1975, 102. Hayden White, in particular, has published a number of provocative discussions concerned with the dynamic relationship between a narrative's chaining of discrete events and the practical limits of actually doing so: see White 1973, 5–29; "The Historical Text as Literary Artifact" in White 1978, 81–100; and White 1987, 17–25; also consult Veyne 1971, 13–24.

26. The copy of *Valmy* was painted by Jean-Baptiste Mauzaisse: Versailles, Musée National du Château, inv. no. MV2335 (296 × 678 cm). Mauzaisse received 8,000 FF for the work (*Archives du Louvre*, 2DD/23, fol. 102, 10 May 1834). Henri Scheffer painted the copy of *Jemmapes* for the same fee: Versailles, Musée National du Château, inv. no. MV2336 (296 × 678 cm). About the importance of these battles to Louis-Philippe's personal biography see Marrinan 1988, 77–79; Gaehtgens 1984, 266–80; and Mellon 1958, 25–27.

27. The original compositions by Horace Vernet are now in London: *The Battle of Valmy*, signed and dated "H. Vernet 1826." London, The National Gallery, inv. no. 2964 (175 × 287 cm); *The Battle of Jemmapes*, signed and dated "H. Vernet 1821." London, The National Gallery, inv. no. 2963 (177 × 288 cm).

28. *The Parisian National Guard Leaves for the Front in September 1792*, Salon of 1836, no. 364. Versailles, Musée National du Château, inv. no. MV2333 (189 × 204 cm). The picture was commissioned on 10 May 1834 for 7,000 FF (*Archives du Louvre*, 2DD/4, fol. 55), shortly after the king had personally specified the subject and its emplacement in the gallery: see Nepveu's account of Louis-Philippe's fourth visit to Versailles on 6 March 1834 (*Archives Condé*, 91G-I, no. 153).

29. The portrait is visible at the far right of figure 53 between the window casements: *Louis-Philippe d'Orléans, duc de Chartres*, painted by Léon Cogniet in 1834. Versailles, Musée National du Château, inv. no. MV2344 (135 × 95 cm). For a reproduction see Marrinan 1988, fig. 142, or Gaehtgens 1984, 274.

30. From left to right as visible in figure 54 the three pictures are: *The French Army Enters Mons 7 November 1792* by Hippolyte Bellangé, Salon of 1836, no. 103. Versailles, Musée National du Château, inv. no. MV2337 (188x 83 cm); *Combat in the Gorges of the Argonne* by Eugène Lami, Salon of 1835, no. 1221. Versailles, Musée National du Château, inv. no. MV2334 (190 × 93 cm); *The Combat of Anderlecht 13 November 1792* by Hippolyte Bellangé, Salon of 1835, no. 101. Versailles, Musée National du Château, inv. no. MV2338 (189 × 82 cm).

31. About the theoretical peculiarities of the time shifts presented by the writing of history see Barthes 1967, 66–69; de Certeau 1975, 46–62; and Foucault 1969, 44–54.

32. On the theoretical differences between a compilation of facts and historical explanation consult the brisk exchange between Danto 1953, and Walsh 1958 and also the discussion in "Historicism, History, and the Imagination" reprinted in White 1978, 106–18.

33. This is a topic much discussed by writers

working within a linguistic or semiological frame of reference. The principal texts used to formulate my comments are: Barthes 1967, 69–72; Barthes 1968, 87–88; de Certeau 1975, 63–67; Genette 1969, 55–56; Miguelez 1971, 27–30; and the essay "Historical Text as Literary Artifact" in White 1978, 92–96.

34. On the role of citing and references as the basis of historical authority see Barthes 1967, 74, and de Certeau 1975, 111–16.

35. The most provocative discussion of the archive remains, at least to my mind, Foucault 1969, 166–73.

36. De Certeau 1975, 113.

37. My thinking about the reader's role in the simulacrum of historical representation has been shaped in large part by Marin 1981, 78–81. Naturally, any appeal to the concept of simulation requires citing the archetypical essays on the topic by Baudrillard 1983, trans. 1988 and Eco 1975, trans. 1986.

38. Figure 55: de Laborde 1841, 283; the vignette illustrates the story of an old veteran who repeatedly spends his extra money on admission tickets to Versailles so that he might tell and retell to museum visitors his tales of life in the army under Napoleon's command.

39. For purposes of this essay I have used the guidebook titled *Versailles et son Musée Historique*, originally published in 1837 with wood-cut vignettes and re-published in several expanded editions with steel-plate engravings. The title page (fig. 56) indicates neither author nor publisher, but specifies that the work is available "Dans le Musée, aux Galleries Historiques de Versailles." In fact, the author was Jules Janin, and the work was published at Paris by E. Bourdin. The edition used here is not dated—it contains steel-plate engravings—although the evidence of paintings cited in its text but not yet completed (see below, note 46) suggests that it dates from about 1840. The guidebook is cited hereafter as Janin 1840?.

40. On the concept of the *premier coup d'oeil* in early Academic theory, principally in the writings of André Félibien, see Puttfarken 1985, 1–37, and Lee 1940, 255–60. Concerning its transformation in the later writings of Roger de Piles consult Puttfarken 1985, 96–105.

41. The prototypical intervention on the topic is Charles Le Brun's defense of Poussin's picture *The Gathering of Manna*, read before the Academy on 5 November 1667 and recorded in Félibien 1725, rpt. 1967, 5:400–28.

42. Figure 57: *The Battle of Austerlitz*, Salon of 1810, no. 347. Versailles, Musée National du Château, inv. no. MV2765 (510 × 958 cm). The present analysis of this picture proceeds from the comments in Marrinan 1988, 165–68.

43. For a modern appreciation of Napoleon's strategy at Austerlitz, see Dupuy 1968. The standard nineteenth-century view of its importance is the account in Thiers 1845–62, 6:304–22.

44. On the commission see the documents in *Archives Nationales* O^2 307, dossier 8 and the account in Gérard 1867, 15. Louis-Philippe briefly entertained the idea of a scheme to install the *Austerlitz* in the Salle des Sept Cheminées at the Louvre along with three other pictures by Gérard: see Aulanier 1947–64, 7:95–96.

45. Figure 58: Janin 1840?, 370–71; figure 59: Idem, 372–73. In total, the guide refers to twelve different pictures within the general timeframe and set of circumstances around the principal battle of Austerlitz.

46. Item number 803 in the guide was eventually painted by Francisque Grenier de Saint-Martin. Signed "F. Grenier," Salon of 1840, no. 759. Versailles, Musée National du Château, inv. no. MV1714 (116 × 154 cm). The commission was awarded to Grenier on 1 May 1835 for 2,400 FF (*Archives du Louvre*, 2DD/4, fol. 178) and he was paid for the completed canvas on 16 October 1840 (*Archives Nationales*, O^4 1834, no. 11301). It seems logical to me, insofar as the picture is listed without an artist's name in the guidebook and because it was ready to hang in late 1840, that the edition of the guide to Versailles dates from about that time, that is, about 1840.

47. The tradition of critical writing against Vernet stems largely from the scathing commentary published by Charles Baudelaire in his "Salon of 1846": for the original text see Baudelaire 1986, 157–63. Baudelaire's criticisms were broadened and sharpened by Silvestre 1857, 1–52, whose account provoked Vernet to file (and win) a lawsuit against the author. Rosenthal's assessment of Vernet must be located directly within this framework (1914, rpt. 1987), 216–20. In contrast, Robert Rosenblum sounded the new tenor of appreciation in his introduction to the Vernet exhibition catalogue: Rome, 1980, 13–19. The recent work of Driskel 1990a and Beetem 1984 have tried to revalorize Vernet by contextualizing his work (ususally its thematic content) within the artist's social and political milieu, but there has been little commentary about Vernet's characteristic narrative and visual structure. There can be no doubt that Louis-Philippe admired Vernet, for he showered the painter with commissions worth hundreds of thousands of francs: in September 1845, for example, he was promised 220,000 FF for ten pictures of the French conquests in Morocco (*Archives Nationales*, O^4 2240, no. 3969). Earlier, in July 1835, the king saw to it that Vernet was given a large studio space in a former stagecoach office on the Avenue de Sceaux near Versailles, and he regularly stopped in to follow the progress of Vernet's work (*Archives Condé*, 91G-I, 12 July 1835 and following).

48. Figure 60: *The Battle of Jena*, signed and dated "H. Vernet 1836." Salon of 1836, no. 1804. Versailles, Musée National du Château, inv. no. MV2768 (465 × 543 cm). For a discussion germane to my present comments see Marrinan 1988, 166–72, and Gaehtgens 1984, 236–38.

49. The Salon *livret* cites an extract from the *Bulletins de la Grande Armée*:

L'Empereur entend sortir des rangs de la garde impériale à pied, les mots: *En avant!* Qu'est-ce? dit l'empereur; ce ne peut être qu'un jeune homme qui n'a pas de barbe, qui peut vouloir me préjuger ce que je dois faire. Qu'il attende qu'il ait commandé trente batailles rangées, avant de prétendre me donner des avis. . . . C'était effectivement un des vélites, dont le jeune courage était impatient de se signaler.

50. Figure 61: *The Battle of Wagram*, Salon of 1836, no. 1806. Versailles, Musée National du Château, inv. no. MV2776 (465 × 543 cm). Figure 62: *The Battle of Friedland*, Salon of 1836, no. 1805. Versailles, Musée National du Château, inv. no. MV2772 (465 × 543 cm). About the picture of Jena, see note 48.

51. *Explication des Ouvrages de Peinture, Sculpture, Architecture, Gravure, et Lithographie des Artistes Vivans exposés au Musée Royal, le 1er mars 1836* (Paris: Vinchon, 1836), 192.

52. Musset 1836, 158.

53. Farcy 1836, 165–66.

54. De Nouvion 1836, 296. Similarly, the critic for *Le Voleur* remarked: "I can, without any scruples, mix up Jena, Friedland, and Wagram by changing around the titles and crossing out the livret's explanation; I see nothing in the compositions which might differentiate them" ("Salon de 1836," *Le Voleur*, IXe année, 2e série, V, no. 16 [20 March 1836], 282).

55. Figure 64: Janin 1840?, 399; Figure 65: Idem, 400–01.

56. I thus return to the relationship between "high" and "low" visual forms introduced at the start of this essay when discussing the pictures of 28 July 1830 by Bourgeois and Delacroix (figs. 49, 50). I would hope, however, that the ensuing analysis has made it possible to see some of the specific choices involved in each of those pictures, and that the reader will not be content to say simply that one lacks "quality" while the other everywhere exemplifies it.

57. Writing about Vernet's battle pictures, including the three I have focused on in this essay, Rosenthal 1914, rpt. 1987, 218, seems to have been mystified by just such an "art museum" bias: "in the canvases dedicated to the battles of Revo-

lution and Empire—*Valmy* and *Jemmapes* (1831), *Jena*, *Friedland*, and *Wagram* (1836)—where the years of hindsight and scale of the victories should have incited him to greatness, he [Vernet] seems to have been at a loss and only saved himself by means of anecdotes."

58. My thinking about the role and importance of recognition in the operation of discursive practice has been shaped in large part by Foucault 1969, 139–54, and sharpened by the comments in Bryson 1983, 38–43 and 150–53.

59. "Salon of 1836: Deuxième Article," *Journal des Beaux-Arts*, IIIe année, I, no. 9 (15 March 1836), 130.

60. Figure 66: *Eye of the Master*, signed in the plate "Raffet." Paris, Bibliothèque Nationale, Cabinet des Estampes, série Dc189, t. VI (20.3 × 28.1 cm). The print appeared as plate 8 of the album of Raffet's lithographs published in 1833 by Gihaut frères: see Giacomelli 1862, no. 372.

61. See Lucas-Dubreton 1959 and the discussions in Bluche 1980, 167–204, and Marrinan 1988, 141–64. Barbara Day is preparing a book-length study of how Napoleonic imagery was spread through rural France during the 1820s and 1830s by colporteurs of cheap prints.

62. Figure 67: Signed and dated in the plate "Bellangé 1834." Paris, Bibliothèque Nationale, Cabinet des Estampes, série Dc175, t. IV (17.3 × 20.4 cm). A print from the album of Bellangé's lithographs published in 1835 by Gihaut frères.

63. My argument obviously depends upon the types of cultural analyses made possible by semiology. Barthes 1964, 49, emphasized the essential point: "if the connotation has signifiers typified by the media employed (image, word, objects, habits), it shares in all of its signifieds at once: one will find the same signifieds in published form, in visual imagery, or in the gestures of an actor (this is why semiology is only conceivable within a network we might call holistic). This shared domain of the signifieds of connotation is the domain of *ideology*, of which there can be only one for a given society and a given history, whatever might be the signifers of connotation to which that ideology has recourse." Barthes's anal-

ysis is imported usefully to an understanding of the power behind stereotypic imagery in Bryson 1983, 150–61. See too the discussion of hagiography and the hero in de Certeau 1975, 274–88.

64. De Certeau 1975, 112.

65. On French military intervention in Algeria, see the essay by Professor Kim Munholland in the present volume.

66. Letter from Louis-Philippe to Molé dated 28 June 1837 (*Archives Nationales*, 300 APIII 35). The duc d'Orléans was married to Hélène de Mecklembourg-Schwerin on 30 May at Fountainebleau; festivities continued as the bridal pair made their way to Paris and then on to Versailles, where they culminated in the gala opening of the museum on 10 June.

67. Foucault 1975, trans. 1979, 220.

MICHAUD'S HISTORY OF THE CRUSADES

1. Gooch 1949, 156.
2. Gossman 1990, 252.
3. Voltaire 1879, vol. 11, 442–444.
4. Voltaire 1879, vol. 13, 314.
5. Gooch 1949, 156.
6. Voltaire 1879, 20:560.
7. Voltaire 1879, 32:502.
8. Gooch 1949, 161.
9. Two of these historians, Maxime de Choiseul-d'Aillecourt, writing in 1809, and Henri Prat, writing in 1840, both set themselves the task of ameliorating Voltaire's condemnation while admitting that many of the excesses of the crusades could not be condoned: Choiseul-d'Aillecourt 1809, i–ii; Prat 1840, 1–2.
10. Gooch 1949, 161.
11. Michaud's inspiration from the time of his introduction to *Mathilde* is mentioned by his collaborator, M. Jean-Joseph Poujoulat, in the introduction to the sixth edition of the *Histoire des croisades*; see Michaud 1841, 1:i–vi, and Meunier 1894, 1; see also Bordeaux 1926, 69–70.
12. Michaud 1801.
13. Michaud 1801, 1:158.

14. Michaud 1825, 1:448–9.

15. Michaud 1825, 1:446–7.

16. Napoleon is reputed to have signed the decree of admission on the eve of the battle at Leipzig.

17. Meunier 1894, 2.

18. Michaud 1825, 1:514.

19. Michaud 1825, 2:248.

20. Michaud 1825, 1:121–2.

21. Michaud 1825, 1:123.

22. Michaud 1825, 6:171–80.

23. Michaud 1825, 2:231.

24. Michaud 1825, 1:516–23.

25. Michaud 1825, 1:510, 522–24.

26. Bordeaux 1926, 70.

27. Mellon 1958, 1. A mild challenge to Mellon's assertion of the poverty of historical writing during the Empire may be found in Burton 1979, 117, in which the author argues that historians of the imperial era endeavored to make history more "scientific" and showed a greater sophistication and maturity than in eighteenth-century chronicles and narratives.

28. Cited in Mellon 1958, 64.

29. Michaud 1829, 1:xv.

30. Michaud and Poujoulat 1833–35, vol. 1, 3.

31. Poujoulat, pref. to Michaud 1841, xxxvii–xxxix.

32. Michaud and Poujoulat 1838, ix.

33. Michaud and Poujoulat 1838, xvi.

34. Montagnon 1986, 67.

35. Clermont-Tonnerre to Bourmont, 17/10/1829, quoted in Serval 1980, 21.

36. Schefer 1928, 47–48, 53–54.

37. Vâlet 1924, 108–9.

38. Montagnon 1986, 146.

39. Cited in Guiral 1956, 58.

40. Guiral 1992, 202–3.

41. Vâlet 1924, 142.

42. Cited in Guiral 1956, 58.

43. Cited in Montagnon 1986, 258.

44. Nochlin 1989, 53.

45. Guiral 1992, 212–14.

46. Marrinan 1988.

47. Gaehtgens 1986.

48. Mellon 1958, 3–4.

49. Meister 1982, 21.

50. "Hall of Constantine" in *Versailles: Palace, Museum, Gardens*, cited in Meister 1982, 23.

51. Gaehtgens 1986, 166–7.

POP CULTURE IN THE MAKING

1. See, for example, Vaughan 1978, ch. 4; Honour 1979, chs. 4 and 5; See also the essay by Kim Munholland in this volume (pp. 144–165).

2. Honour 1979, 192.

3. Clark 1962, 39. Pre-Romantic paintings on medieval subjects were primarily produced in England (Fuseli) and Germany (Nazarenes), but a number were also executed in France under Louis XVI. See Detroit 1975, 168, 337–38, 408–9, and 660–61.

4. To an extent, this cultural democratization was a function of dramatic improvements in primary education. Between the first years of the Restoration (1817–20) and the later part of the July Monarchy, the mean number of primary schools in France more than doubled, rising from 24,520 to 59,697. See Allen 1991, table A.5. The July Monarchy regime played an important part in this development, particularly through Guizot's education bill of 1833 (see introduction, p. 4). It is important to realize, however, that this trend towards the improvement of primary education had its roots in the Englightenment. On this subject, see Gontard 1959.

5. See Honour 1979, 193: "it is seldom sufficiently stressed how great, perhaps crucial a part in the development of the Western historical sense was played not so much by historians and historical novelists as by history itself."

6. Lukács 1962, 23–25, links this mass awareness of contemporary events to the new phenomenon of the *levée en masse* and the necessity, on the part of recruiters, to explain the purpose of war through popular propaganda. Hobsbawm 1962, 119, causes us to consider Lukács' thesis in the proper perspective by pointing out that the "mass army" of the Revolution and the Empire

was small by twentieth-century standards. Napoleon's *Grande Armée*, at the outset of the Russian campaign comprised 700,000 men, of which 300,000 were non-French. Between 1800 and 1815 only 7 percent of the total population of France were called up, compared with 21 percent in the much shorter period of World War I.

7. The more so, of course, as they coincided with the much-publicized bicentenary celebration of the French Revolution.

8. Chaudonneret 1991, 73.

9. Including Joseph-François Michaud, whose work is discussed in chapter 6.

10. The difference between the narrative historians and Chateaubriand and his followers should not be exaggerated. It is important to realize that Chateaubriand himself already had introduced an unprecedented measure of narration into historiography and it is not surprising, therefore, that Augustin Thierry, the leading narrative historian, was inspired to history writing by reading Chateaubriand's *Les Martyrs* as a schoolboy. See Lagarde and Michard 1960, 357.

11. "J'ai tenté de restituer à l'histoire elle-même l'attrait que le roman historique lui a emprunté. Elle doit être avant tout exacte et sérieuse; mais il m'a semblé qu'elle pouvait être en même temps vraie et vivante." Barante (1824–26) 1842, XXVII.

12. "Né roturier, je demandais qu'on rendît à la roture sa part de gloire dans nos annales, qu'on recueuillit, avec un soin respectueux, les souvenirs d'honneur plébéien, d'énergie et de liberté bourgeoises; en un mot, qu'à l'aide de la science unie au patriotisme, on fit sortir de nos vieilles chroniques des récits capables d'émouvoir la fibre populaire."

13. On the subject of *couleur locale*, see the essay by Patrick Noon in Paris 1992, 67.

14. Thiers' political activity began in 1830 when he became a member of Louis-Philippe's council of state, was elected to the Chamber of Deputies (deputy of Aix), and became under-secretary of state (November). He remained active in politics throughout the July Monarchy and (intermittently) during subsequent regimes

until, in 1871, his political career culminated in the presidency of the Third Republic.

15. As Lionel Gossman (1990, 167) has pointed out, the idea of the popular book, the *livre populaire* haunted Michelet all his life. As early as 1820, he wrote in his journal "If I had the talent I would like to write, for the people, books that could be sold for very low prices" ("Si j'en avais le talent j'aimerais à écrire pour le peuple des livres qu'on vendrait à vien bas prix"); Michelet 1959, 88.

16. Michelet spoke of his historiographic effort as *résurrection*. In the preface to the 1869 edition of his *Histoire de France*, he wrote, "Even more complicated, more frightening was the problem I posed for myself in history, namely the resurrection of life in its integrity, not only in its surface aspects but in its profound interior organisms" ("Plus compliqué encore, plus effrayant était mon problème historique posé comme résurrection de la vie intégrale, non pas dans les surfaces, mais dans ses organismes intérieurs et profonds.") Michelet 1971-, 4:12. Comparing his historiographic effort with the works of the narrative historians on the one hand, and with those who had recently renewed the eighteenth-century philosophical approach to history (men like François Guizot and Edgar Quinet) on the other, he wrote, "May I be credited, in the future, with having set rather than attained the goal of historiography . . . Thierry saw it as narration and M. Guizot as analysis. I have called it resurrection and that term will stay" ("Que ce soit là ma part dans l'avenir d'avoir non pas atteint, mais marqué le but de l'histoire . . . Thierry y voyait une narration et M. Guizot une analyse. Je l'ai nommée résurrection et ce nom lui restera.") Quoted in Lagarde and Michard 1960, 362.

17. As Gossmann 1990, 227–56, has pointed out, the distinction between history and literature was less clear in the eighteenth and nineteenth centuries than it is today.

18. Gossman 1990, 91. Thierry's own work is characterized by his view of modern European history as a function of racial conflict, whereby race must be interpreted not in its modern, nar-

rowly biological sense, but in its original meaning as a group of individuals with common interests, characteristics, appearance, habits, or the like.

19. On this subject, see Brown 1979.

20. Lukács 1962, 49.

21. On the popularity of Scott, see Lukács 1962, 48ff. See also the essays by Paul Ochojski (on Scott's German reputation), Anna Katona (on the impact of Scott in Hungary), and R.D.S. Jack (on Scott and Italy) in Bell 1973.

22. Partridge [1924] 1968, 259.

23. Vigny, in the introduction to his best-known historical novel *Cinq-Mars*, stated that he intended to "paint the three kinds of ambitions that can stir us, and besides the beauty of sacrificing oneself to a generous thought" ("peindre les trois sortes d'ambition qui nous peuvent remuer et à côté d'elles la beauté du scrifice de soi-même à une généreuse pensée"). See Vigny 1948, 2:19.

24. Vigny 1948, 2:25, "la vérité d'observation sur la nature humaine, et non l'authenticité du fait."

25. Material for *Les trois Mousquetaires*, for example, was derived from the *Mémoires de M. D'Artagnan* (1700–1701) by Giles de Courtilz.

26. See Dumas, "History is a pawn shop where theatrical tableaux are dressed." Cited in Rahill 1967, 75.

27. Allen 1981, 9.

28. Sée 1951, *passim*.

29. Allen 1981, 4, 11, 143, 147.

30. Most importantly, perhaps, the historic novels of Alexandre Dumas, who, in 1845, sold the exclusive publication rights of his novels to *Le Constitutionnel* and *La Presse* for a period of five years at an annual retainer fee of 63,000 francs. See Pinkney 1986, 125.

31. On this fascinating subject, see also Allen's later book, *In the Public Eye* (1991).

32. Allen 1991, table A.7. On the difficulties of assessing literacy, see ibid., ch. 2.

33. Quoted in Allen 1981, 151.

34. Bottin's *Almanach de Commerce* lists 32 cabinets in 1820, 150 in 1830, 189 in 1840, and 226 in 1850. After that date their number declines rapidly. See Allen 1981, 140.

35. For the early history of the genre in France, Rahill 1967, 46–52, distinguishes two types of melodrama, domestic and historic. During the later Restoration and early July Monarchy periods, the historic melodrama appears to have been most common.

36. Quoted in Bradby, James, and Sharrat 1980, 17. De Pixerécourt (1773–1844) is associated primarily with the Empire and the Restoration although he lived nearly to the end of the July Monarchy. A total of thirty thousand performances of his plays were recorded in Paris and the provinces between 1797 and 1834 (Rahill 1967, 40). The next generation of melodrama authors was equally succesful. Bouchardy's *Sonneur de Saint-Paul*, which opened at the Gaîté on October 2, 1838, is recorded to have brought ticket revenues of more than 200,000 francs (Bradby, James, and Sharrat 1980, 33).

37. John McCormick, "Joseph Bouchardy: A Melodramatist and his Public," in Bradby, James, and Sharratt 1980, 33–48.

38. "Trois espèces de spectateurs composent ce qu'on est convenue d'appeler le public: premièrement, les femmes; deuxièmement, les penseurs; troisièmement, la foule proprement dite."

39. Hugo clearly made a virtue of what critics of the *drame romantique* saw as a vice: its dependance on melodramatic effects. "Romantic drama is nothing but melodrama dressed up in the artificial pomp of lyricism," Charles Nodier wrote, suggesting that all that was different about the Romantic drama and the melodrama was the presence or absence of rhyme in the dialogue. Quoted in Rahill 1967, 69.

40. See Bradby, James, and Sharratt 1980, 29

41. As Howarth points out, the *tableau* was an eighteenth-century invention, much used in the *drames bourgeois* of Diderot, who recommended the *tableau* as a static alternative to the *coup de théâtre*. See Bradby, James, and Sharratt 1980, 27.

42. On the Romantic vignette, see Zerner and Rosen 1984, 71–96.

43. Color reproductions of the *Vicar of Wakefield* watercolors, now in the Musée des Beaux-Arts in Rouen, are found in Columbia 1990, pls. 5–14.

44. Marie 1925, 91–93.

45. Chaudonneret 1980, 15.

46. Marrinan 1988, 24, warns us that the term "genre historique" was not commonly used until 1835.

47. Following are some of the more popular works that were exhibited between 1827 and 1848: Delaroche's *Children of Edward IV* and the same artist's *Cromwell Discovering the Corpse of Charles I* (Salon 1831), Robert-Fleury's *Scene from St. Bartholomew's Day* (1833), Delaroche's *Execution of Jane Gray* (1834), Gigoux's *Death of Leonardo da Vinci*, Delaroche's *Murder of the Duc de Guise*, and Scheffer's *Dante and Virgil Meeting the Shades of Paolo and Francesca* (1835), Winterhalter's *Decamerone* (1837), Devéria's *Clotilde Mourning Her Grandsons* (1838), Robert-Fleury's *Charles V Picking up Titian's Paintbrush* and Cogniet's *Tintoretto Tracing the Image of His Dead Daughter* (1843), Robert-Fleury's *Reception of Columbus by the Spanish Court* and Isabey's *Ceremony in the Church of Delft* (1847).

48. Marrinan 1988, 25.

49. Louis-Philippe set great store by public opinion. In his memoirs he mentions the necessity for a monarch to completely understand the country's mood, or, what he called the "gathering together of views shaped by luminaries, education, readings, conversations, sometimes even by the fashions of the time." Quoted in Marrinan 1988, 215–16.

50. Detroit 1975, 389–390.

51. McWilliam 1991.

52. Quoted in Simond 1900, 2:334–337.

53. For an interesting collection of fashion prints of this period, see Fischel and Von Boehn 1927, vol. 2.

54. On this subject, see Green 1989.

55. Partridge [1924] 1968, 188–89.

56. On the reception of Scott's novels in France, see Massmann 1972, which contains an index of critical reviews in French periodicals, and Partridge 1968.

57. For this information, see the printed catalogue of the Bibliothèque Nationale in Paris.

58. Partridge [1924] 1968, 123.

59. Flaubert [1856–57] 1950, 50.

60. Partridge [1924] 1968, 125.

61. See the printed catalogue of the Bibliothèque Nationale.

62. Partridge [1924] 1968, 224–225.

63. Ibid., 225.

64. Ibid., 225.

65. Ibid., 226.

66. Ibid., 121.

67. Ibid., 122.

68. Kemp 1973; Wright 1981; Wright and Joannides 1982.

69. Wright and Joannides's list contains a surprising number of women painters, suggesting that there was a substantial audience among women for Scott and the historic novel in general.

70. In Bell 1973, 213–227.

71. Delacroix 1972, 342.

72. See Bollème 1971, 183: "Mais l'histoire se déforme, se transforme, et sur elle se brode un autre récit."

73. In their article, "Die Folklore as eine besondere Form des Schaffens," Pyotr Bogatyrev and Roman Jacobson (1929) posit that folk and high culture are two distinct, but communicating systems. Either system borrows from the other and adapts materials from the other system to its own by creatively transforming them.

74. Théophile Gautier, visiting one of the melodrama theatres, found the audience "pittoresque," indicating that he felt a bit out of place. Descotes 1964, 243. Delacroix went to the Ambigu in 1824, together with Raymond Soulier and Thales Fielding to see *Les Aventuriers*, which he found "very interesting and done in a new style. Natural." See Delacroix 1972, 67.

75. As Allen 1991, 59–60, points out, literacy rates were also considerably lower in the country, particularly in the southern part of France, below the line extending from Le Havre in the west to Besançon in the east.

76. See Daumard 1963 and Daumard 1975.

77. Daumard 1975, 24.

78. Ibid.

79. Simon 1900, 2:112. In 1825 there were 378 omnibuses, which served 100,000 passengers a day. Income from tickets was 30,000 francs.

80. Sée 1951, vol. 1, 182.

81. Baudelaire (Mayne) 1956, 126.

82. Courbet (Chu) 1992, 132.

83. This thesis is borne out by the fact that Realism in its time never won approval while Romantic history painting remained popular throughout the Second Empire period. At the Salon of 1852, for example, one of the greatest crowd pleasers was Louis Gallait's *Last Honors Paid to the Counts of Egmont and of Hoorne by the Great Oath of Brussels* and not Courbet's *Demoiselles du village*, which was widely criticized and caricatured in its time. See Holt 1982, 79.

The Power of Axes

1. De Clarac 1826–53, I:237–669; Fontaine 1833, 53–60; Hautecoeur 1924; Aulanier 1947–1968; Babelon 1987; Jacquin 1988, 1991; Daufresne 1989; Van Zanten 1991.

2. See Babelon, Jacquin, Daufresne and Van Zanten all cited above.

3. See Damisch 1969; Fontaine 1987, numerous references; Marrinan 1988.

4. Baltard and Duval 1803–5, I:2–3; *Encyclopédie ou dictionnaire raisonnée des sciences, des arts et des métiers* 1751–1765, "Palais," vol. 11 (1765).

5. Blondel 1771–77, II:233.

6. Lemoyne des Essarts 1786–1790, II:535.

7. Szambien 1982.

8. Fontaine 1833, 12–13; Lavedan 1951a, 1951b; Haasengier 1983. The drawings: Archives Nationales, N III Seine 1089–1090.

9. Keim 1990.

10. Lafont de Saint-Yenne 1752.

11. "Ma mission désormais est toute tracée[:] finir le Louvre veut dire le raccorder avec ce qui est fait[.] [J]e n'ai pas donc de grands frais d'imagination à faire[;] seulement du bon sens a avoir pour bien choisir." Biblioteca apostolica Vaticana, Autografi Ferrajoli Visconti, #7392: letter of 12 March 1853. I owe this reference to Professor Daniela Gallo of the Scuola Normale Superiore, Pisa.

12. "Le caractère de la nouvelle architecture sera emprunté religieusement au Vieux Louvre; tous les details sont déjà moulés, et l'architecte fera abnégation de tout amour-propre pour conserver à ce monument le caractère que ses devanciers lui ont imprimé." *Description du modèle représentant l'achèvement du Louvre par M. Visconti, Architecte de l'Empereur*, Paris: Vinchon, 1853.

13. These are published systematically in Daufresne 1989.

14. Fontaine 1987, II:197–99.

15. *Moniteur universel* 4 January 1854.

16. The subject is given in a document: "L'Empereur, fort de ses destinées et l'appui qui lui donne la reconnaisance des Français pour les bienfaits de Napoléon Ier, clôture des révolutions et des discordes civiles, rapelle la concorde et l'union, invoque la paix, source des prospérités, fait fleurir la commerce, les arts et l'industrie, honore la religion et convie la France à l'exécution des vastes entreprises qui doivent illustrer son règne." Archives Nationales, 64 Aj 63. The sculptor was Simart.

17. Boime 1980, 189–229, 283–91; Vaisse 1977; Davenport 1986, 145–63.

18. For example, Giedion 1941; Hitchcock 1958; Loyer 1983.

19. What portion of that large and increasing literature to cite here? Rorty 1979; Smith 1988; Toulmin 1990; Fisher 1991.

20. On Daly: Saboya 1991. Examples can be found in Pevsner 1936 (especially his treatment of August Endell) or Kaufmann 1955.

21. The shape of the Place du Panthéon was fixed simultaneously with the promulgation of Labrouste's design: *Recueil des actes administratifs de la préfecture de la Seine*, 1875, I: 126–128 (2 July 1884). Daly 1852.

22. Baltard 1863; Boudon, Chastel, Couzy, and Hamon 1977; Broussel n.d.

23. Castex 1977; Loyer 1987.

24. Leonard 1961; Gardes 1988; Bruston 1975; Arland and Bertin 1992. Also: Bailleux de Marisy 1865.

25. Cerdà 1867. Also: Choaye and Lopez de Aberasturi 1979.

26. Pinon and des Cars 1991, 126–41.

27. Marrinan 1988; McWilliam 1982; Driskel 1989, 1991.

28. De Gisors 1847; Calliat 1844 and 1856; Vachon 1882; Taylor 1989; Gaehtgens 1988.

29. Laborde 1856.

30. "Je comprends un architecte comme un orateur éloquent. Il a étudié toutes les difficultés de la langue, il en connait toutes les beautés, il est maître de toutes ses ressources: quel sujet doit-il traiter? Quelle cause le charge-t-on de défendre? Cela seul désormais le préoccupe. . . . L'éloquence est devenue en lui une seconde nature; ce qui l'occupe, c'est sa cause. Ainsi de l'architecte. Il est maître de son art, il a dans sa tête toutes les transformations que l'architecture a subies à travers les siècles; il a aussi dans le sanctuaire de son âme l'idéal qui s'est formé lui-même; vient le programme: prison, palais, collège, théâtre, bourse, caserne ou hôpital. Il étudie les besoins, l'emplacement, le chiffre des allocations; et, ce travail d'ensemble animant son imagination . . . il compose son monument et produit à coup sûr, non pas peut-être un chef d'oeuvre, . . . mais un oeuvre qui porte écrite au front son originalité. Dans ces conditions vous n'aurez pas une caserne qui ressemble à un hôtel de Ministre, un timbre qui fasse l'effet d'une caserne fortifiée, un hôtel-dieu dont le portique semble l'entrée d'un tombeau, au lieu d'annoncer avec calme l'asile du repos et de la convalescence" (70–71).

31. "En toutes choses, l'Etat n'offre que des modèles exquises, il ne fait que des acquisitions utiles a l'étude; comme un père de famille qui devant ses enfants observe son maintien et son langage, l'État ne doit pas se permettre une fantaisie de style contestable, une caprice de décoration douteuse" (68).

32. Choaye 1992.

33. Axiality has been treated only tangentially. See Alewyn 1959; Habermas 1989; Elias 1969; Foucault 1975; Marin 1981; Paul-Lévy 1984.

34. Van Zanten 1987, 71–83; Marmoz 1982.

35. Published as a book, Harou-Romain 1840.

36. See Foucault's famous *Surveiller et punir* 1975 (1979); also see Miller 1987.

GOING TO EXTREMES

1. Rosenau 1992, 112–114.

2. White 1978.

3. Bezucha 1991, 479.

4. Boime 1971, 10.

5. Boime 1980, 9–11.

6. Chaudonneret 1991, 71–80.

7. Ibid., 74.

8. Rosen and Zerner 1982; Boime, 1982; Whiteley 1989, 57.

9. Marrinan 1988, 206 and 281, note 28.

10. Ibid., 1, 208.

11. Ibid., 208–209.

12. Bezucha 1990, 20.

13. Allison 1916, 18, 22, 31–34, 100. A letter from La Mennais just shortly after the July Revolution shows how close he was to the king's declared position: "Among us there exists already a group of liberals who are weary of anarchy and despotism and who understand that the oppression of one party by another is not liberty but tyranny." Ibid., 27.

14. Rosenthal 1914, 202–231.

15. Marrinan 1987, I–XXIV; Marrinan 1988, 2.

16. Metternich-Winnenburg 1881–1886, VII, 471.

17. Count Cavour 1894, 64–66.

18. Cavour 1962 et seq., I, 174.

19. Count Cavour 1894, 88–89.

20. Ibid., 206.

21. Collingham 1988, 108.

22. Ibid., 207.

23. Marrinan 1987, IV–VI.

24. Ibid., XII. This is betrayed in part by the inordinate importance he attached to *facture* as a measure of quality. Marrinan makes a convincing case for the influence of Signac and the Post-impressionists generally on Rosenthal's aesthetic criteria.

25. Rosenthal 1914, i.

26. Ibid., ii–iii.
27. Taine 1907, III, 173.
28. Kahn 1953, 103–104.
29. Taine 1867, 345–346.
30. For an excellent semiotic approach to July Monarchy politics, see Petrey 1991, 52–77.
31. Cabet 1833, I, 202.
32. Weisberg 1990, 152, cat. nos. 95–97.
33. Columbia 1990, 258–259.
34. Ibid., II, 184–185, 192–193.
35. Ibid., 222.
36. Pépin 1833, 210, 215.
37. Ibid., 216–217, 228.
38. Ibid., 235–237.
39. Ibid., 239.
40. Ibid., 416.

41. Sarrans 1834, I:xi–xii, 2:212note; II, 7, 113.
42. Comte 1974, 140.
43. Rosenthal 1914, 248–256. Marrinan suggests that Rosenthal was perplexed over how to deal with a painter displaying a "rich facture" but with whose proverbial themes and sentiment he was wholly unsympathetic. Marrinan 1987, XII.
44. See, for examples, Rosenthal 1914, 207, 209, 251, 255, 301. Couture's teacher, Delaroche, one of Rosenthal's chief protagonists of the *juste-milieu* style, also did monumental painting.
45. Proudhon 1851, 25–27. Proudhon consistently uses eclecticism and *juste milieu* as synonymous terms: see for example Proudhon 1923a *et seq.*, I, part 1, 301; Proudhon 1923b 2, 255.

Notes on Contributors

ALBERT BOIME, Professor of Art History at the University of California at Los Angeles, has published extensively in all areas of nineteenth-century art. His most important study focusing on French art under the July Monarchy is *Thomas Couture and the Eclectic Vision*. Also important for the period are *The Academy and French Painting in the Nineteenth Century* and the forthcoming third volume of his *Social History of Art*.

PETRA TEN-DOESSCHATE CHU is Professor of Art History at Seton Hall University. Her publications on French nineteenth-century realism include *French Realism and the Dutch Masters* and *The Letters of Gustave Courbet*. She has also written several essays on the art of the Barbizon School. A recent recipient of a research grant from the National Endowment for the Humanities, she is currently preparing a monograph on Courbet.

JAMES CUNO is Elizabeth and John Moors Cabot Director of the Harvard University Art Museums. An expert on graphic art under the July Monarchy, he has published several articles on the print publisher Charles Philipon and on French popular prints of the French Revolution and the Romantic period. He is currently preparing a book on French caricature from David to Daumier.

MICHAEL PAUL DRISKEL, author of *Representing Belief: Religion, Art, and Society in Nineteenth-Century France* and *As Befits a Legend: Building a Tomb for Napoleon, 1840–1861*, has published numerous scholarly essays on the social history of art during the July Monarchy. He is currently a Program Officer with the National Endowment for the Humanities.

MICHAEL MARRINAN is Associate Professor of Art History at Stanford University. His book *Painting Politics for Louis-Philippe: Art and Ideology in Orléanist France, 1830–1848* was published in 1988 by Yale University Press. He was a Guggenheim Fellow during 1989–90, and is presently completing work on a monographic study of the painter Gustave Caillebotte.

ELIZABETH K. MENON is a doctoral candidate in art history at the University of Minnesota. She has published articles in the *Gazette des beaux-arts* and *Art Journal*. Her dissertation, "The Cultural History of M. Mayeux in Nineteenth-Century French Art and Literature," provides the foundation for the article in this publication.

KIM MUNHOLLAND is Professor of History at the University of Minnesota. A specialist in nineteenth- and twentieth-century French history, he has published several articles on French imperialism. He is currently preparing a book on "Politics, Art, and Growing Old in France, 1880–1930."

GABRIEL P. WEISBERG is Professor of Art History at the University of Minnesota. He has developed an extensive interest in the July Monarchy having served as Consulting Curator on *The Art of the July Monarchy* exhibition (1989–90) and having written a number of articles in the exhibition catalogue funded by the National Endowment for the Humanities. A recent article, "In Deep Shit: The Coded Images of Traviès in the July Monarchy," appeared in the Scatological Art issue of the *Art Journal* (fall 1993).

DAVID VAN ZANTEN, Professor of Architectural History at Northwestern University, has published widely in the history of French nineteenth-century architecture. His doctoral dissertation on *The Architectural Polychromy of the 1830s*, published in 1977, was followed by *Designing Paris: The Architecture of Duban, Labrouste, Duc, and Vaudoyer* (1987) and numerous articles on both avant-garde and conservative architecture in France.

Bibliography

ANYONE INTERESTED in examining the visual culture under the July Monarchy has to contend with some commonly held prejudices about the art of this period. One is that the period of the "Citizen King" is dull, artistically speaking, and, with the possible exception of the work of Daumier, not really worth exploring. Another holds that, though the July Monarchy witnessed the activity of such major artists as Jean-Auguste-Dominique Ingres, Eugène Delacroix, and Camille Corot, they really were the products of the preceding Restoration period. Indeed, perhaps the only artistic movement that by common agreement is considered "vintage" July Monarchy is the Barbizon School, but the acknowledged leaders of that school, Jean-François Millet and Théodore Rousseau, did not gain a solid reputation until the Second Empire. This diminished view of July Monarchy art accounts for the limited number of important studies of the subject, notably cohesive investigations of the interconnections between different artists, art forms (painting, sculpture, graphic arts), and "classes" of art ("high" and "low")—a fact that was duly noted by Marie-Claude Chaudonneret in her critical overview of recent literature on July Monarchy painting (1991).

Léon Rosenthal, the first to attempt a comprehensive study of the art of the July Monarchy, in his seminal *Du Romantisme au Réalisme* (1914) saw the 1830s and 1840s as essentially a transitional period. He found Romantic qualities in the works of some artists, classical elements in those of others. At the same time he detected a nascent realism in the works of several younger painters who came to maturity in the late 1830s and 1840s.

More recently, two scholars have looked at the July Monarchy in a different way. Both Thomas Gaehtgens and Michael Marrinan, recognizing the significance of history painting during the period in question, have explored the intrinsic meaning of officially commissioned history paintings in the context of the ideology of Louis-Philippe's regime. While on the one hand their publications called for an enlargement of the canon, on the other they were limited in their exclusive emphasis on official art. Thus they left a broad range of art works—in all media—still to be examined.

The limited knowledge of July Monarchy art that resulted from the paucity of publications on the subject was perhaps the principal reason why the exhibition of *The Art of the July Monarchy* (organized by the Museum of Art and Archaeology at the University of Missouri-Columbia in 1989) and its accompanying catalogue were so compelling to both scholars and the general public. The organizers of the exhibition and the authors of the catalogue made a firm attempt to give "a face" to the July Monarchy by bringing out some important characteristics of the period as they manifest themselves in its art. While not contradicting Rosenthal's assessment of the July Monarchy as an eclectic era, in which many conflicting attitudes competed for attention, they did identify a number of cultural and art historical phenomena that were new and unique to this period (such as the flowering of caricature and book illustration or the rise of landscape painting) and firmly linked these to their social and cultural-historical context. Most importantly, they demonstrated that the July Monarchy can no longer be seen as a period when "nothing" happened in the arts or as merely a transitional period.

Two aspects of July Monarchy art have escaped the general neglect, landscape painting and graphic arts. Since landscape painting is not discussed in this volume we will pass over the litera-

ture devoted to the subject. Instead, more attention will be given to recent publications in the field of media art. Prior to the 1980s, Honoré Daumier was considered the only "master" on this terrain and other graphic artists received little serious assessment. In the past decade, however, there has been a trend to look closer at caricature and other forms of visual satire found in the popular press. As a result, artists other than Daumier—Nicolas Charlet, Paul Gavarni, J.J. Grandville, Charles Traviès—are given renewed attention. Moreover, there is a growing awareness and interest in the social, political, commercial, and legal contexts in which their graphic imagery must be understood.

As early as the 1950s, Edwin Bechtel, in his *Freedom of the Press and L'Association Mensuelle: Philipon versus Louis Philippe,* drew attention to the crucial role of Charles Philipon in the production and distribution of popular prints. By focusing attention on Philipon's numerous conflicts with the censor, Bechtel caused a new awareness of the political climate in which these prints were created. By 1980, the contribution of Philipon as a promoter and radical instigator of popular graphics absorbed several German art historians. In the exhibition catalogue, *La Caricature: Bildsatire in Frankreich, 1830–1835 aus der Sammlung von Kritter,* lithographs that appeared in *La Caricature* are discussed and interpreted in a systematic and coherent fashion. This is one of the earliest publications to move beyond mere description towards a full consideration of the social implication of the prints in question. In 1982, Judith Wechsler, in *A Human Comedy: Physiognomy and Caricature in 19th-Century Paris* further refined the study of nineteenth-century prints—especially from the July Monarchy—by centering on social caricature and the importance of specific types. Wechsler points out that such types were used—even invented—by artists of the period as a means of criticizing specific modes of social behavior. Some of the types were presented as characters that had to be avoided at all cost. Most of these came from the "unsafe" world of the destitute and were meant to convey a sense of uneasiness about classes of society that were considered dangerous and undesirable.

With the completion of James Cuno's doctoral dissertation on "Charles Philipon and La Maison Aubert: The Business, Politics, and Public of Caricature in Paris, 1820–1840" (1985), a new dimension of the popular print industry was introduced. Cuno tried to identify the types of audiences that bought and saw the prints that Philipon and those who worked for him completed. He presented Philipon as an example of an early nineteenth-century media entrepreneur who was both a promoter and prodder of artists and an ever-present figure behind the scene, as an "idea man," who was instrumental in the creation of a series of images that satirically and caustically demolished the persona and eventually the regime of Louis-Philippe, Philipon constantly ran the risk of confrontation with the censor and even political imprisonment. Cuno successfully demonstrated that the prints of the period must be read in a complex context of commercial entrepreneurship, audiences, and political censorship.

Coinciding with Cuno's examination of Philipon's multifarious activities, other writers were studying the secondary figures in the graphic arts. In the exhibition catalogue, *Grandville, Dessins originaux* (Nancy, 1986), Clive F. Getty centered on Grandville's working method, showing the numerous ways in which he heightened or modified images and providing critical information on the role of physiognomical science in the creation of caricatures. Moreover, by carefully reconstructing the societal context of the early July Monarchy, he laid the groundwork for a more accurate reading of images by an artist who had previously received little attention from art or cultural historians.

On the heels of Getty's political reading of Grandville's work, the historian Robert Goldstein published his *Censorship of Political Caricature* (1989). While Goldstein examined more than the July Monarchy, his book was crucial for an understanding of the period since it enlarged our understanding of the moral implications and political arguments centered around caricature.

Goldstein's study, an outgrowth of his earlier work, carefully monitors the ebb and flow of censorship showing how certain artists and major images fell victim to sudden unexpected strictures. Likewise in 1989, Elizabeth Childs completed her doctoral dissertation on "Honoré Daumier and the Exotic Vision: Studies in French Culture and Caricature." Childs tries to enlarge the awareness and understanding of some little-studied lithographs by Daumier that show images of non-Western cultures. While exploring, through these prints, French attitudes to the Middle East, Africa, and China, she also shows that Daumier used exotic images to comment on contemporary issues in Paris, thus demonstrating that his prints have several levels of potential interpretation. The July Monarchy exhibition of the same year provided another opportunity to assess the contribution of popular prints to social agitation. Beyond a summary of earlier publications, Weisberg's catalogue essay on caricature is an attempt to provide a comprehensive, synthetic overview of graphic imagery under the July Monarchy and to define the main thematic issues. It also links popular prints to other aspects of the visual culture of the July Monarchy, demonstrating that they did not exist in a vacuum as earlier publications have tacitly suggested.

Recent publications have not moved far beyond the parameters established by the close of the 1980s. Sandy Petry's "Pears in History" (*Representations,* 1990) presents Philipon as a type of semiotic insider who used the emblem of the pear to make his satiric points—hardly a startling observation in 1990. Similarly, Elise Kenney and John Merriman, in their catalogue *The Pear: French Graphic Arts in the Golden Age of Caricature* (Mount Holyoke College Art Museum, 1992) break little new ground but they provide a solid introductory text in which they stress the significance of reading prints within the context of freedom of the press (or lack thereof). Elizabeth Childs' "Big Trouble, Daumier, Gargantua, and the Censorship of Political Caricature" (*Art Journal,* 1992) builds on earlier interpretations, although the author provides a more careful, inter-

pretive reading of Daumier's visual "text." None of these articles, however, contribute new viewpoints or modes of interpretation. Hence, while popular prints of the July Monarchy have seen considerable attention in recent years, the commitment to move forward into new uncharted territories needs to be maintained. Without it, the achievements of the past few years will falter.

Allen, James Smith. *Popular French Romanticism: Authors, Readers, and Books in the 19th Century.* Syracuse, N.Y., 1981.

———. *In the Public Eye: A History of Reading in Modern France, 1800–1940.* Princeton, 1991.

Alewyn, Richard, and Karl Sälzle. *Das grosse Welttheater: Die Epoche der höfischen Feste in Dokument und Deutung.* Hamburg, 1959.

Allison, John M.S. *Church and State in the Reign of Louis-Philippe.* Princeton, 1916.

Amours secrets de M. Mayeux. Brussels, 1832.

Arland, Catherine, and Dominique Bertin. *De la rue Impériale à la rue de la République.* Lyon, 1992.

Armingeat, Jacqueline. "Ducreux et la grimace." *Gazette des Beaux-Arts* 55 (May-June 1960): 357–59.

L'Artiste. "Boissy-d'Anglas; Concours." 1 (1831): 122–23.

Athanassoglou-Kallmyer, Nina. "Sad Cincinnatus: 'Le soldat laboureur' as an Image of the Napoleonic Veteran after the Empire." *Arts Magazine* 60 (May 1986): 65–75.

Aulanier, Christine. *Histoire du Palais et du Musée du Louvre.* 10 vols. Paris, 1947–68.

Babelon, Pierre. "L.T. J. Visconti et le Louvre." In *Etudes offertes à André Chastel,* 617–32. Paris, 1987.

Bailleux de Marisy. "La transformation des grandes villes de France." *Revue des Deux Mondes* 57 (1865): 357–86.

Baltard, Louis-Pierre, and Amaury Duval. *Monuments de Paris.* 2 vols. Paris, 1803–5.

Baltard, Victor. *Monographie des halles centrales de Paris.* Paris, 1863.

Balzac, Honoré. *Correspondance.* Edited by Roger Pierrot. Paris, 1966.

———. *La Comédie humaine.* Edited by Pierre-Georges Castex. 10 vols. Vol. 5: *Illusions perdues.* Paris, 1977.

Barante, Prosper de. *Histoire des ducs de Bourgogne.* 12 vols. 1824–26. Paris, 1842.

Barthes, Roland. "Rhétorique de l'image." *Communications* 4 (1964): 40–51.

———. "Le discours de l'histoire." *Information sur les Sciences Sociales* 6, no. 4 (1967): 65–75.

———. "L'effet du réel." *Communications* 11 (1968): 84–90.

Baudelaire, Charles. *The Mirror of Art.* Translated and edited by Jonathan Mayne. New York, 1956.

———. "Some French Caricaturists." In *The Painter of Modern Life and Other Essays.* Translated and edited by Jonathan Mayne, 166–68. London, 1964.

———. *Ecrits esthétiques.* Collection 10/18. Paris, 1986.

Baudrillard, Jean. "Simulacra and Simulations." 1983. In *Selected Writings*, translated by Paul Foss, Paul Patton, and Philip Beitchman, 166–84. Stanford, 1988.

Bazin, A. [Anais de Raucour]. *L'Epoque sans nom, esquisses de Paris 1830–1833.* Paris, 1833.

Bechtel, Edwin T. *Freedom of the Press and L'Association Mensuelle: Philipon versus Louis Philippe.* New York, 1952.

Bédollière, Emile Gigault de la. *Les Industriels, métiers et professions en France.* Paris, 1842.

Beetem, Robert N. "Horace Vernet's Mural in the Palais Bourbon: Contemporary Imagery, Modern Technology, and Classical Allegory during the July Monarchy." *Art Bulletin* 66 (June 1984): 254–69.

Bell, Alan., ed. *Scott Bicentenary Essays.* London, 1973.

Bezucha, Robert. "An Introduction to the History." In *The Art of the July Monarchy: France 1830 to 1848*, 17–48. Exh. cat. Columbia, M.O., & London, 1990.

———. Review of *Art in the Age of Revolution, 1750–1800*, by Albert Boime. *American Historical Review* 96 (April 1991): 479.

Blondel, Jacques-François. *Cours d'architecture.* Completed by Pierre Patte. 6 vols. Paris, 1771–77.

Bluche, Frédéric. *Le Bonapartisme.* Paris, 1980.

Bogatyrev, Pyotr, and Roman Jacobson. "Die Folklore as eine besondere Form des Schaffens." In *Donum Natalicum Schrijnen.* Nijmegen/Utrecht, 1929.

Boime, Albert. *The Academy and French Painting in the Nineteenth Century.* London, 1971.

———. *Thomas Couture and the Eclectic Vision.* New Haven & London, 1980.

———. "'The Unhappy Medium': An Exchange," *The New York Review of Books*, 21 October 1982.

Bollème, Geneviève. *La Bibliothèque bleue: Littérature populaire en France du XVII au XIXe siècle.* Paris, 1971.

Bordeaux, Henri. "Joseph Michaud, historien des croisades." *Revue des Deux Mondes* 35 (1926): 59–90.

Bottin, Sébastien. *Almanach du commerce de Paris.* Paris, printed annually.

Boudon, Françoise, André Chastel, Hélène Couzy, and Françoise Hamon. *Système de l'architecture urbaine: Le quartier des halles à Paris.* Paris, 1977.

Bradby, David, Louis James, and Bernard Sharrat, eds. *Performance and Politics in Popular Drama.* Cambridge, 1980.

Broussel, Patrick. *Victor Baltard: Projets inédits pour les halles centrales.* Paris, n.d.

Brown, David. *Walter Scott and the Historical Imagination.* London, 1979.

Brown, Marilyn. *Gypsies and Other Bohemians: The Myth of the Artist in Nineteenth-Century France.* Ann Arbor, 1985.

Bruston, André. "La régénération de Lyon, 1853–1865." *Espaces et Sociétés* (1975): 81–103.

Bryson, Norman. *Vision and Painting: The Logic of the Gaze.* New Haven and London, 1983.

Burton, June K. *Napoleon and Clio: Historical*

Writing, Teaching and Thinking during the First Empire. Durham, N.C., 1979.

Burty, Philippe. "Les dessins de Charlet pour le mémorial de Sainte Hélène."*Gazette des Beaux-Arts* 1 (1 March 1860): 275–82.

Cabet, Etienne. *Révolution de 1830 et situation présente (Novembre1833); expliquées et éclairées par les Révolutions de 1789, 1792, 1799 et 1804 et par la Restauration*. 2 vols. Paris, 1833.

Calliat, Victor. *Hôtel de Ville de Paris, mesuré, dessiné, gravé et publié par Victor Calliat*. 2 vols. Paris, 1844 &1856.

La Caricature. "Caricatures." 41 (1840): 4.

Castex, Jean. *Formes urbaines: De l'îlot à la barre*. Paris, 1977.

Castille, Hippolyte. *Les Hommes et les moeurs en France sous le règne de Louis-Philippe*. Paris, 1853.

Cavour, Camillo. *Epistolario*. 12 vols. Milan, 1962.

Cerdà, Ildefonso. *Teoría general de la urbanización*. 2 vols. Madrid, 1867.

Certeau, Michel de. *L'Ecriture de l'histoire*. Paris, 1975.

Chambure, Auguste de. *Napoléon et ses contemporains*. Paris, 1828.

Champfleury [Jules-François-Félix Husson]. *Histoire de la caricature moderne*. Paris, 1865.

———. *Henry Monnier, sa vie et son oeuvre*. Paris, 1879.

Chaudonneret, Marie-Claude. *Fleury Richard and Pierre Révoil: La peinture troubadour*. Paris, 1980.

———. "La peinture en France de 1830 à 1848: Chronique bibliographique et critique." *Revue de l'Art* 91 (1991): 71–80.

Chevalier, Louis. *La Formation de la population parisienne au XIXe siècle*. Paris, 1950.

———. *Classes dangereuses et classes laborieuses*. Paris, 1958.

———. *Laboring Classes in Paris during the First Half of the Nineteenth Century*. Translated by F. Jellinek. Princeton, 1981.

Childs, Elizabeth C. "Honoré Daumier and the Exotic Vision: Studies in French Culture and Caricature." Ph. D. diss., Columbia University, 1989.

———. "Big Trouble. Daumier, *Gargantua*, and the Censorship of Political Caricature." *Art Journal* 51 (Spring 1992): 26–37.

Choaye, Françoise. *L'Allégorie du patrimoine*. Paris, 1992.

Choaye, Françoise, and Antonio Lopez de Aberasturi. *Ildefonso Cerdà: La théorie générale de l'urbanisme*. Paris, 1979.

Choiseul-d'Aillecourt, Maxime. *De l'influence des croisades sur l'état des peuples de l'Europe*. Paris, 1809.

Chu, Petra ten-Doesschate. "Into the Modern Era: The Evolution of Realist and Naturalist Drawing." In *The Realist Tradition: French Painting and Drawing, 1830–1900*, 21–36. Exh. cat. Cleveland, 1980.

———. "At Home and Abroad: Landscape Representation." In *The Art of the July Monarchy: France 1830 to 1848*, 116–30. Exh. cat. Columbia, M.O., & London, 1990.

Clarac, Charles O.F. comte de. *Musée de sculpture antique et moderne ou description historique et graphique du Louvre*. 8 vols. Paris, 1826–53.

Clark, Kenneth. *The Gothic Revival*. 1928. Harmondsworth, 1962.

Clark, Timothy J. *Image of the People*. Greenwich, C.T., 1973.

———. *The Painting of Modern Life*. New York, 1985.

Cleveland, The Cleveland Museum of Art. *The Realist Tradition: French Painting and Drawing, 1830–1900*. 1980.

Cobb, Richard. *The Police and the People: French Popular Protest, 1789–1820*. Oxford 1970.

———. *Paris and Its Provinces, 1792–1802*. London, 1975.

Collingham, Hugh A.C. *The July Monarchy: A Political History of France, 1830–1848*. London & New York, 1988.

Columbia, University of Missouri. *The Art of the July Monarchy: France 1830 to 1848*. 1990. (also shown in Rochester and Santa Barbara)

Comte. Auguste. *The Essential Comte.* Edited by S. Andreski. London, 1974.

Condon, Patricia. "Historical Subjects." In *The Art of the July Monarchy: France 1830 to 1848*, 80–100. Exh. cat. Columbia, M.O., & London, 1990.

Corbin, Alain. *Les Filles de noce: Misère sexuelle et prostitution (19e siècle).* Paris, 1982.

Corbon, Anthime. *Le Secret du peuple de Paris.* Paris, 1863.

Count Cavour and Madame de Circourt. Some Unpublished Correspondence. Edited by Count Nigra. London & Paris, 1894.

Courbet, Gustave. *The Letters of Gustave Courbet.* Translated and edited by Petra ten-Doesschate Chu. Chicago, 1992.

Cuno, James.(a) "Charles Philipon, La Maison Aubert, and the Business of Caricature in Paris, 1829–41." *Art Journal* 43 (Winter 1983): 347–54.

———.(b) "Philipon et Desloges: Editeurs des 'physiologies' (1841–1842)." *Cahiers de l'Institut d'Histoire de la Presse et de l'Opinion* 7 (1983): 137–60.

———.(a) "Charles Philipon, La Maison Aubert, and the Business of Caricature in Paris, 1829–1841." *Gazette des Beaux-Arts* 106 (October 1985): 95- 112.

———.(b) "Charles Philipon and La Maison Aubert: The Business, Politics and Public of Caricature in Paris, 1820–1840." Ph. D. diss., Harvard University, 1985.

Daly, César. "Bibliothèque Sainte-Geneviève." *Revue Générale de l'Architecture* 10 (1852) cols.: 379–84.

Damisch, Hubert. "La colonnade de Perrault et les fonctions de l'ordre classique." In *L'Urbanisme de Paris et de l'Europe, 1600–1660.* Edited by Pierre Francastel, 85–94. Paris, 1969.

Danto, Arthur C. "Mere Chronicle and Philosophy Proper." *The Journal of Philosophy* 50 (March 1953): 173–82.

Daufresne, Jean-Claude. *Le Louvre et les Tuileries: Architecture de papier.* Liège, 1989.

Daumard, Adeline. *La Bourgeoisie parisienne de 1815 à 1848.* Paris, 1963.

———. *Les Bourgeois de Paris au XIXe siècle.* Paris, 1970.

———. "Le peuple dans la société française à l'époque romantique." *Romantisme* 13 (1975): 21–28.

Davenport, Nancy. "Charles-Louis Mueller et ses décorations peintes au Louvre." *Bulletin de la Société de l'Histoire de l'Art Français* (1986): 145–63.

Debraux, Paul-Emile. "Le soldat-laboureur." In *Recueil de chansons.* Paris, 1840.

Delacroix, Eugène. *The Journal of Eugène Delacroix.* Translated by Walter Pach. 1937. New York, 1972.

Descotes, Maurice. *Le Public de théâtre et son histoire.* Paris, 1964.

Description du modèle représentant l'achèvement du Louvre par M. Visconti, architecte de l'Empereur. Paris, 1853.

Detroit, The Detroit Institute of Art. *French Painting 1774–1830: The Age of Revolution.* 1975. (also shown in Paris and New York)

Driskel, Michael P. "Singing the "Marseillaise" in 1840: The Case of Charlet's Censored Prints." *Art Bulletin* 69 (December 1987): 604–25.

———. "By Competition or Administrative Decree? The Contest for the Tomb of Napoleon in 1841." *Art Journal* 48 (Spring 1989): 46–52.

———.(a) "An Introduction to the Art." In *The Art of the July Monarchy: France 1830 to 1848*, 49–79. Exh. cat. Columbia, M.O., & London, 1990.

———.(b) "The 'Gothic', the Revolution and the Abyss: Jean-Philippe Schmit's Aesthetic of Authority." *Art History* 13, no. 2 (1990): 193–211.

———. "Le Tombeau de Napoleon." In *L.T.J. Visconti architecte, 1791–1853.* 168–180. Paris, 1991.

———. *As Befits a Legend: Building a Tomb for Napoleon, 1840–1861.* Kent, O.H., 1993

Dupuy, Trevor N. *The Battle of Austerlitz: Napoleon's Greatest Victory.* New York, 1968.

Eco, Umberto. *Travels in Hyper-Reality*. 1975. Translated by William Weaver. New York, 1986.

Elias, Norbert. *Hoefische Gesellschaft*. Darmstadt, 1969.

Eliel, Carol. *Louis Boilly, 1761–1845*. Paris, 1984.

Encyclopédie ou dictionnaire raisonné des sciences, des arts et des métiers. 17 vols. Paris, 1751–65.

Exploits et aventures de Mahieux. A ceux qui aiment à rire comme des bossus. Lyon, 1831.

[F.C.B.?]. *Histoire véritable de M. Mayeux*. Paris, 1831.

Farcy, Charles. "Salon de 1836." *Journal des Artistes et Amateurs* 1, no. 11 (13 March 1836): 165–66.

Farwell, Beatrice. *French Popular Lithographic Imagery, 1815–1870*. 12 vols. Chicago, 1981.

Faure, Alain, and Jacques Rancière, eds. *La Parole ouvrière*. Paris, 1976.

Félibien, André. *Entretiens sur les vies et sur les ouvrages des plus excellens peintres anciens et modernes*. 6 vols. (1725). Reprint. Farnborough, 1967.

Ferment, Claude. "Le caricaturiste Traviès. La vie et l'oeuvre d'un 'Prince du Guignon (1804–1859)." *Gazette des Beaux-Arts* 99 (February 1982): 63–78.

Fischel, Oskar, and Max von Boehn. *Modes and Manners of the Nineteenth Century, as Represented in the Pictures and Engravings of the Time*. 4 vols. London & New York, 1927.

Fisher, Philip. *Making and Effacing Art: Modern American Art in a Culture of Museums*. Oxford, 1991.

Flaubert, Gustave. *Madame Bovary*. Translated by Alan Russell. First published in the *Revue de Paris*, 1856–57. Harmondsworth, 1950.

Fontaine, Pierre F.L. *Résidences des souverains*. Paris, 1833.

———. *Journal*. 2 vols. Paris, 1987.

Foucault, Michel. *L'Archéologie du savoir*. Paris, 1969.

———. *Surveiller et punir: Naissance de la prison*. Paris, 1975.

———. *Discipline and Punish: The Birth of the Prison*. 1975. Translated by Alan Sheridan. New York, 1979.

———. *Machines à guérir*. Liège, 1979.

Fournel, Victor. *Les Cris de Paris, types et physionomies d'autrefois*. Paris, 1887.

Fowler, L.N. *The Illustrated Phrenological Almanac*. New York, 1850.

Francastel, Pierre. *La Création du musée historique de Versailles et la transformation du Palais, 1832–1848*. Paris, 1930.

Frégier, Honoré-Antoine. *Des classes dangereuses de la population dans les grandes villes*. 2 vols. Paris, 1840.

Gaehtgens, Thomas W. *Versailles: De la résidence royale au musée historique. La galerie des batailles dans le musée historique de Louis-Philippe*. Translated by Patrick Poirot. Antwerp, 1984.

———. *Versailles als Nationaldenkmal: die Galerie des Batailles im Musée Historique von Louis-Philippe*. Berlin, 1988.

———. "Le musée historique de Versailles." In *Les Lieux de mémoire*, edited by Pierre Nora, vol. 2, part 3, 143–67. Paris, 1986.

Gardes, Gilbert. *Lyon: L'art et la ville*. 2 vols. Paris, 1988.

Geist, Johann F. *Arcades: The History of a Building Type*. Translated by Jane O. Newman and John H. Smith. Cambridge, M.A., 1983.

Genette, Gérard. "Frontières du récit." In *Figures II*, 49–69. Paris, 1969.

George, Mary D. *Catalogue of Political and Personal Satires*. Vol. 5: *1771–1783*. London, 1935.

———. *English Political Caricature to 1792: A Study of Opinion and Propaganda*. Oxford, 1959.

Gérard, François. *Correspondance de François Gérard, peintre d'histoire*. Paris, 1867.

Getty, Clive. "The Drawings of J.J. Grandville until 1830: The Development of His Style during His Formative Years." Ph. D. diss., Stanford University, 1981.

———. "Opposition Caricature and Political

Harassment." *Print Collector's Newsletter* 14, no. 6 (January-February 1984):197–201.

Giacomelli, Hector. *Raffet: Son oeuvre lithographique et ses eaux-fortes*. Paris, 1862.

Giedion, Sigfried. *Space, Time and Architecture*. Cambridge, M.A., 1941.

Gisors, Alphonse de. *Le Palais du Luxembourg*. Paris, 1847.

Goldstein, Robert J. *Censorship of Political Caricature*. Kent, OH, 1989.

Gontard, Maurice. *L'Enseignement primaire en France de la Révolution à la loi de Guizot (1789–1833): Des petites écoles de la monarchie de l'ancien régime aux écoles primaires de la monarchie bourgeoise*. Paris, 1959.

Gooch, George Peabody. *History and Historians in the Nineteenth Century*. New York, 1949.

Gossman, Lionel. *Between History and Literature*. Cambridge, MA, and London, 1990.

Gozlan, Léon. "L'homme du peuple." In *Les Français peints par eux-mêmes*, vol. 3, 272–83. Paris, 1841.

Graham, John. *Lavater's Essays on Physiognomy*. Bern, 1979.

Green, Nicholas. "Circuits of Production, Circuits of Consumption: The Case of Mid-Nineteenth-Century French Art Dealing." *Art Journal* 48 (Spring 1989): 29–34.

Grew, Raymond. "Picturing the People: Images of the Lower Orders in Nineteenth-Century French Art." In *Art and History: Images and Their Meaning*, edited by Robert I. Rotberg and Theodore K. Rabb, 203–31. Cambridge, 1988.

Guiral, Pierre. *Marseille et l'Algérie (1830–1941)*. Gap, 1956.

———. *Les Militaires à la conquête de l'Algérie*. Paris, 1992.

Haasengier, Hans-Joachim. *Der Palais du Roi de Rome auf dem Hügel von Chaillot*. Frankfurt, 1983.

Habermas, Juergen. *The Structural Transformation of Public Space*. Translated by Thomas Burger. Cambridge, M.A., 1989.

Halévy, Daniel. *Le Courrier de M. Thiers*. Paris, 1921.

Harou-Romain, Nicolas. *Projet de pénitencier*. Caen, 1840.

Harper, Paula H. *Daumier's Clowns: Les Saltimbanques et les Parades*. New York, 1981.

Harsin, Jill. *Policing Prostitution in Nineteenth-Century Paris*. Princeton, 1985.

Hause, Steven, and Anne R. Kenney. *Women's Suffrage and Social Politics in the French Third Republic*. Princeton, 1984.

Hautecoeur, Louis. *Histoire du Louvre*. Paris, 1924.

Hitchcock, Henry-Russell. *Architecture: Nineteenth and Twentieth Centuries*. Harmondsworth & Baltimore, 1958.

Hobsbawm, Eric J. *The Age of Revolution, 1789–1848*. New York, 1962.

Holt, Elizabeth Gilmore. *The Art of All Nations, 1850–73: The Emerging Role of Exhibitions and Critics*. Princeton, 1982.

Holub, Robert C. *Reception Theory: A Critical Introduction*. London, 1984.

Honour, Hugh. *Romanticism*. New York, 1979.

Jacquin, Emmanuel. "La seconde république et l'achèvement du Louvre." *Bulletin de la Société de l'Histoire de Paris et de l'Ile de France* (1988): 375–401.

———. "La Réunion du Louvre aux Tuileries." In *L.T.J. Visconti, architecte, 1791–1853*. Paris, 1991.

Jal, Augustin. "Musée historique de Versailles." *Moniteur des Arts* 2 (1845): 89–91, 97–99, 105–07, 113–15.

Janin [Jules Janin]. *Versailles et son musée historique: Description complète de la Ville, du Palais, du Musée, des Jardins et des Deux Trianons . . . suivie d'une notice historique, par ordre de numéros, de tous les tableaux, portraits, bas-reliefs, statues et bustes et ornée de plans et de vignettes gravés sur acier*. Paris, n.d. [1840?]

Jones, Louisa. *Sad Clowns and Pale Pierrots*. Lexington, K.Y., 1988.

Kahn, Sholom J. *Science and Aesthetic Judgement*. London, 1953.

Kaufmann, Emil. *Architecture in the Age of Reason*. Cambridge, M.A., 1955.

Kaufmann, Ruth. "François Gérard's *Entry of Henry IV into Paris*: The Iconography of Constitutional Monarchy." *Burlington Magazine* 117 (December 1975): 790–802.

Keim, Christiane. *Staedtebau in dem Kreise des Absolutismus*. Marburg, 1990.

Kemp, Martin. "Scott and Delacroix, with Some Assistance from Hugo and Bonington." In *Scott Bicentenary Essays*, edited by Alan Bell, 213–27. Edinburgh, 1973.

Laborde, Alexandre comte de. *Versailles ancien et moderne*. 1839. Paris, 1841.

Laborde, Henri de. Quelques idées sur la direction des arts et du maintien du goût public. Paris, 1856.

La Combe, Joseph-Félix Leblanc de. *Charlet, sa vie, ses lettres*. Paris, 1856.

Lafont de Saint-Yenne. *L'Ombre du grand Colbert: Le Louvre et la ville de Paris*. Paris, 1752.

Lagarde, André, and Laurent Michard. *XIXe siècle*. Paris, 1960.

Lavedan, Pierre.(a) "Projets d'aménagement de la rive gauche de la Seine entre les Invalides et le Champs de Mars." *Bulletin de la Société de l'Histoire de l'Art Français* (1951): 83–85.

———.(b) "Projets de Napoléon pour l'Est de Paris." *La Vie Urbaine* 59 (1951): 1–10.

Lee, Rensselaer W. "*Ut Pictura Poesis*: The Humanistic Theory of Painting." *Art Bulletin* 22 (December 1940): 197–269.

Lemoyne des Essarts, Nicolas-Toussaint. *Dictionnaire universel de police*. 8 vols. Paris, 1786–90.

Leonard, Charlene. *Lyon Transformed: Public Works of the Second Empire*. Berkeley, 1961.

Louis, Paul. *Histoire de la classe ouvrière en France de la Révolution à nos jours: La condition matérielle des travailleurs, les salaires et le coût de la vie*. Paris, 1927.

Loyer, François. *Architecture of the Industrial Age, 1789–1914*. Translated by F.M. Dexter. Geneva, 1983.

Loyer, François. *Paris dix-neuvième siècle: L'immeuble et la rue*. Paris, 1987.

Lucas-Dubreton, Jean. *Le Culte de Napoléon, 1815–1848*. Paris, 1959.

Lukács, Gyorgy. *The Historical Novel*. Boston, 1962.

McWilliam, Neil. "David d'Angers and the Panthéon Commission: Politics and Public Works under the July Monarchy." *Art History* 5, no. 4 (December 1982): 426–46.

———. "Art, Labour and Mass Democracy: Debates on the Status of the Artist in France around 1848." *Art History* 11, no. 1 (1988): 64–87.

———. *A Bibliography of Salon Criticism in Paris from the July Monarchy to the Second Republic, 1831–1851*. Cambridge & New York, 1991.

———. *Dreams of Happiness. Social Art and the French Left, 1830–1850*. Princeton, 1993.

Marie, Aristide. *Alfred et Tony Johannot*. Paris, 1925.

Marin, Louis. *Le Portrait du Roi*. Paris, 1981.

Marmoz, Catherine. "The Buildings of the Ecole des Beaux-Arts." In *The Beaux-Arts and Nineteenth-Century French Architecture*, edited by Robin Middleton, 124–37. Cambridge, M.A., 1982

Marrinan, Michael. "Presentation." In *Du Romantisme au Réalisme: Essai sur l'évolution de la peinture en France de 1830 à 1848* by Léon Rosenthal, i–xxiv. Paris, 1987.

———. *Painting Politics for Louis Philippe: Art and Ideology in Orléanist France, 1830–1848*. New Haven & London, 1988.

———. "The Modernity of Middleness: Rethinking the Juste Milieu." Review of *The Art of the July Monarchy: France 1830–1848. Porticus* 12–13 (1989–90): 42–63.

———. "Exhibition Reviews, The July Monarchy." Review of *The Art of the July Monarchy: France 1830–1848. Art Journal* 49 (Fall 1990): 301–05.

Massmann, K. "Die Rezeption der historischen Romans Sir Walter Scotts in Frankreich (1816–1832)." *Studia Romantica* 24. Heidelberg, 1972.

Mayeux, F.J. *A l'empereur sur l'impossibilité de concilier l'acte additionnel aux constitutions, avec la majesté, l'indépendance et le bonheur du peuple*. Paris, 1815.

Mayeux. A. Mugney, ed. Paris (12 July, 1831–May 30, 1832).

Mayeux. P. Dufour, ed. Paris (17 June–July 10, 1848).

Mayeux et Arlequin aux salons. Paris, 1831.

Mayeux à la société des droits de l'homme. Paris, 1833.

Meister, Maureen. "To All the Glories of France: The Versailles of Louis-Philippe." In *All the Banners Wave: Art and War in the Romantic Era, 1792–1851*, 21–26. Exh. cat. Providence, R.I., 1982.

Mellon, Stanley. *The Political Uses of History: A Study of Historians in the French Restoration*. Stanford, 1958.

Melot, Michel. "The Nature and Role of the Print." In *Prints: History of an Art*, translated by Helga Harrison and Dennis Corbyn, 8–131. Geneva & New York, 1981.

———. "Social Comment and Criticism." In *Lithography: 200 Years of Art, History, and Technique*, edited by Domenico Porzio, and translated by Geoffrey Culverwel, 206–21. New York, 1983.

Metternich-Winneburg, Richard Clemens Lothar Fürst von. *Mémoires, documents et écrits divers laissés par le prince de Metternich*. 8 vols. Paris, 1881–86.

Meunié, Félix J. *Les Mayeux*. Paris, 1915.

Meunier, Georges. *Les Grands historiens du dix-neuvième siècle*. Paris, 1894.

Michaud, Joseph-François. *Histoire des progrès et de la chute de l'empire de Mysore*. Paris, 1801.

———. *Histoire des croisades*. 4th ed. 6 vols. Paris, 1825–29.

———. *Bibliothèque des croisades*. 4 vols. Paris, 1829.

———. *Histoire des croisades faite d'après les derniers travaux et les dernières intentions de l'auteur, précédée d'une vie de Michaud par M. Poujoulat*. 6th ed. 6 vols. Paris, 1841.

Michaud, Joseph-François, and Jean-Joseph Poujoulat. *Correspondance d'Orient*. 7 vols. Paris, 1833–35.

Michaud, Joseph-François, and Jean-Joseph Poujoulat. *Abrégé de l'histoire des croisades à l'usage de la jeunesse*. Paris, 1838.

Michelet, Jules. *Nos fils*. Paris, 1869.

———. *Ecrits de jeunesse*. Edited by Paul Viallaneix. Paris, 1959.

———. *Oeuvres complètes*. Edited by Paul Viallaneix. Paris, 1971–.

Miguelez, Roberto. "Le récit historique: Légalité et signification." *Semiotica* 3, no. 1 (1971): 20–36.

Miller, Jacques-Alain. "Jeremy Bentham's Panoptic Device." *October* 41 (Summer 1987): 3–29.

Moniteur Universel (4 January 1854).

Montagnon, Pierre. *La Conquête de l'Algérie*. Paris, 1986.

Montalivet, Marthe-Camille comte de. "Rapport au Roi." *Le Moniteur Universel*, no. 248 (5 September 1833): 2043.

Montigny, L. *Le Provincial à Paris*. 2 vols. Paris, 1828.

Musset, Alfred de. "Salon de 1836." *Revue des Deux Mondes* 6 (1836): 144–76.

Nancy, Musée des Beaux-Arts. *Grandville: Dessins originaux*. 1986.

Newman, Edgar L. "The Blouse and the Frock Coat: The Alliance of the Common People of Paris with the Liberal Leadership and the Middle Class during the Last Years of the Bourbon Restoration." *Journal of Modern History* 46, no. 1 (1974): 26–59.

———. "What the Crowd Wanted in the French Revolution of 1830." In *1830 in France*, edited by John M. Merriman, 17–40. New York, 1975.

———. "Sounds in the Desert: The Socialist Worker Poets of the Bourgeois Monarchy, 1830–1848." In *Proceedings of the Third Annual Meeting of the Western Society for French History*, 260–99. 1976.

Nochlin, Linda. "Gustave Courbet's Meeting: A Portrait of the Artist as a Wandering Jew." *Art Bulletin* 49 (September 1967): 209–22.

———. *Gustave Courbet: A Study of Style and Society*. New York, 1976.

———. "The Imaginary Orient." In *The Politics of Vision: Essays on Nineteenth Century Art and Society*, 33–59. New York, 1989.

Nodier, Charles. *Paris historique. Promenade dans les rues de Paris*. 3 vols. Paris, 1838–39.

Nouvion, Victor de. "Salon de 1836." *La France Littéraire* 24 (March-April 1836): 277–320.

Pain, Joseph. *Nouveaux tableaux de Paris*. 2 vols. Paris, 1828.

Parent, Françoise. *Les Cabinets de lecture: La Lecture à Paris sous la Restauration*. Paris, 1982.

Parent-Duchâtelet, Alexandre-Jean-Baptiste. *De la prostitution dans la ville de Paris*. 2 vols. Paris, 1836.

Paris, Musée Carnavalet. *Il y a cent cinquante ans . . . Juillet 1830*. 1980.

———, Musée du Louvre. *La Liberté guidant le peuple de Delacroix*. 1982.

———, Musée du Petit Palais. *Richard Parkes Bonington "Du plaisir de peindre."* 1992 (also shown in New Haven)

Partridge, Eric. *The French Romantics' Knowledge of English Literature*. 1924. New York, 1968.

Paul-Lévy, Françoise. *La Ville en croix: De la révolution de 1848 à la rénovation haussmannienne*. Paris, 1984.

Pépin, Alpnonse. *Deux ans de règne, 1830–1832*. Paris, 1833.

Petrey, Sandy. "Pears in History." *Representations* 35 (Summer 1991): 52–71.

Pevsner, Nikolaus. *Pioneers of Modern Design*. London, 1936.

Pinkney, David H. "The Crowd in the French Revolution of 1830." *The American Historical Review* 70, no. 1 (1964): 1–17.

———. *Decisive Years in France: 1840–1847*. Princeton, 1986.

Pinon, Pierre, and Jean des Cars. *Paris. Haussmann*. Paris, 1991.

Plumb, John Harold. *The Commercialisation of Leisure in Eighteenth-Century England*. The Strenton Lecture, 1972. Reading, 1973.

Popper, Sir Karl. *The Poverty of Historicism*. Boston, 1957.

Pouthas, Charles H. *La Population française pendant la première moitié du XIXe siècle*. Paris, 1956.

Prat, Henri. *Pierre l'Ermite et la première croisade*. Paris, 1840.

Preziosi, Donald. "The Question of Art History." *Critical Inquiry* 18, (Winter 1992): 363–86.

Proudhon, P.J. *Les Confessions d'un révolutionnaire pour servir à l'histoire de la révolution de février*. Paris, 1851.

———.(a) *De la création de l'ordre dans l'humanité*. In *Oeuvres complètes*. Edited by C. Bouglé and H. Moysset. Paris, 1923.

———.(b) *Système des contradictions économiques ou Philosophie de la misère*. In *Oeuvres complètes*. Edited by C. Bouglé and H. Moysset. Paris, 1923.

Puttfarken, Thomas. *Roger de Piles' Theory of Art*. New Haven & London, 1985.

Puymège, Guy de. "Aux origines du chauvinisme: Le soldat laboureur." *Le Vieux Papier* 291 (1984): 133–44.

Quélen, Louis Hyacinthe de. *Oraison funèbre . . . {du} duc de Berry*. Paris, 1820.

Rahill, Frank. *The World of Melodrama*. University Park & London, 1967.

Rancière, Jacques. *La Nuit des prolétaires*. Paris, 1981.

———. "Ronds de fumée (Les poètes ouvriers dans la France de Louis-Philippe." *Revue des Sciences Humaines* 190 (1983): 31–47.

Recueil des actes administratifs de la préfecture de la Seine. 9 vols. Paris, 1875.

Les Révolutions du XIXe siècle. 12 vols. Paris, 1974.

Ricoeur, Paul.(a) *The Reality of the Historical Past*. Milwaukee, 1984.

———.(b) *Temps et récit II: La configuration dans le récit de fiction*. Paris, 1984.

Romain, Harou. *Projet de pénitencier*. Caen, 1840.

Rome, Académie de France. *Horace Vernet*. 1980. (also shown in Paris)

Rorty, Richard. *Philosophy and the Mirror of Nature*. Princeton, 1979.

Rosen, Charles, and Henri Zerner.(a) "The Unhappy Medium." *The New York Review of Books*, 27 May 1982.

Rosen, Charles, and Henri. Zerner.(b) "'The Unhappy Medium': An Exchange." *The New York Review of Books*, 21 October 1982.

Rosenau, Pauline-Marie. *Post-Modernism and the Social Sciences: Insights, Inroads and Intrusions.* Princeton, 1992.

Rosenthal, Léon. *Du Romantisme au Réalisme: Essai sur l'évolution de la peinture en France de 1830 à 1848.* 1914. Paris, 1987.

Rousseau, Madeleine. "La vie et l'oeuvre de Philippe-Auguste Jeanron, peintre, écrivain, directeur des musées nationaux, 1808–1877." Thesis, Ecole du Louvre, 1935.

Saboya, Marc. *Presse et architecture au XIXe siècle: César Daly et la Revue Générale de l'Architecture et des Travaux Publics.* Paris, 1991.

Santa Barbara, Santa Barbara Museum of Art. *The Charged Image: French Lithographic Caricature 1816–1848.* 1989.

———, University of California. *The Cult of Images: Baudelaire and the Nineteenth-Century Media Explosion.* 1977.

Sarrans, Jean-Bernard. *Louis-Philippe et la contre-révolution de 1830.* 2 vols. Paris, 1834.

Sauvigny, Guillaume Bertier de. *Nouvelle histoire de Paris: La Restauration, 1815–1830.* Paris, 1977.

Schefer, Christian. *L'Algérie et l'évolution de la colonisation française.* Paris, 1928.

Sée, Henri. *Histoire économique de la France.* 2 vols. Paris, 1939–51.

Serval, Pierre. *La Ténébreuse histoire de la prise d'Alger.* Paris, 1980.

Sewell, William H., Jr. *Work and Revolution in France.* Cambridge, 1980.

Silvestre, Théophile. "Horace Vernet." *Histoire des artistes vivants.* 2d series, vol. 1, 1–52. Paris, 1857.

Simond, Charles, ed. *Paris de 1800 à 1900.* 3 vols. Paris, 1900.

Smith, Barbara Herrnstein. *Contingencies of Value: Alternative Perspectives for Critical Theory.* Cambridge, M.A., 1988.

Sorel, Edward. *Resemblances.* New York, 1980.

Soulié, Frédéric. *Le Tombeau de Napoléon.* Paris, 1840.

South Hadley, Mount Holyoke College Art Museum. *The Pear: French Graphic Arts in the Golden Age of Caricature.* 1991. (also shown in New Haven and Ann Arbor)

Speaight, George. *The History of the English Puppet Theater.* London, 1988.

Spitzer, Alan B. *The French Generation of 1820.* Princeton, 1987.

Statistique de la France: Prix et salaires à diverses époques. Strasbourg, 1864.

Szambien, Werner. "Durand and the Continuity of Tradition." In *The Beaux-Arts and Nineteenth-Century French Architecture.* Edited by Robin Middleton, 18–33. London, 1982.

Taine, Hippolyte, *Voyages aux Pyrénées.* Paris, 1867.

———. *Sa vie et sa correspondance.* 4 vols. Paris, 1907.

Tavernier, Bruno. "Iconographie des Trois Glorieuses." *Arts et Traditions Populaires* 15 (July-December 1967): 193–283.

Taylor, Katherine. "The Palais de Justice of Paris: Modernization, Historical Consciousness and Their Pre-History in French Institutional Architecture, 1835–1869." Ph. D. diss., Harvard, 1989.

Thierry, Augustin. *Dix ans d'études historiques.* 1834. Brussels, 1835.

Thiers, Adolphe. *Histoire du Consulat et de l'Empire.* 20 vols. Paris, 1845–62.

Thiollet, François. *Nouveau recueil de la menuiserie et de la décoration intérieure et extérieure.* Paris, 1837.

Thompson, Edward Palmer. *The Making of the English Working Class.* New York, 1963.

Thureau-Dangin, Paul. *Histoire de la Monarchie de Juillet.* 7 vols. Paris, 1884–1904.

Toulmin, Stephen. *Cosmopolis: The Hidden Agenda of Modernity.* Chicago, 1990.

Tronchot, Raymond. *L'Enseignement mutuel en France de 1815 à 1833: Les luttes politiques et religieuses autour de la question scolaire.* 3 vols. Lille, 1973.

Tytler, Graeme. *Physiognomy and the European Novel.* Princeton, 1982.

Vachon, Marius. *L'Ancien hôtel de ville de Paris.* Paris, 1882.

Vaisse, Pierre. "Couture et le Second Empire." *Revue de l'Art* 37 (1977): 43–68.

Vâlet, René. *L'Afrique du Nord devant le parlement aux XIXe siècle*. Paris, 1924.

Van Zanten, David. *Designing Paris: The Architecture of Duban, Labrouste, Duc and Vaudoyer*. Cambridge, M.A., 1987.

———. "Visconti et le nouveau Louvre." In *L.T.J. Visconti, architecte, 1791–1853*, 220–53. Paris, 1991.

Vaughan, William. *Romantic Art*. New York & Toronto, 1978.

Veyne, Paul. *Comment on écrit l'histoire*. Paris, 1971.

Vigier, Philippe. *Nouvelle histoire de Paris-Paris pendant la Monarchie de Juillet*. Paris, 1991.

Vigny, Alfred de. *Oeuvres complètes*. Edited by F. Baldensperger. 2 vols. Paris, 1948.

Villa, Nicole. *Collection de Vinck—Inventaire analytique: La Révolution de 1830 et la Monarchie de Juillet*. Paris, 1979.

Voltaire, François-Marie-Arouet. *Oeuvres de Voltaire*. Paris, 1879.

Walsh, William Henry. "'Plain' and 'Significant' Narrative in History." *Journal of Philosophy* 55 (22 May 1958): 479–84.

Wechsler, Judith. *A Human Comedy: Physiognomy and Caricature in 19th-Century Paris*. Chicago, 1982.

Weisberg, Gabriel P. "The Leleux: Apostles of Proto-Realism." *Arts Magazine* 56 (September 1981): 128–30.

———.(a) "The Coded Image: Agitation in Aspects of Political and Social Caricature." In *The Art of the July Monarchy: France 1830 to 1848*, 148–191. Exh. cat. Columbia, M.O., & London, 1990.

———.(b) "The Cult of Personal Portraiture." In *The Art of the July Monarchy: France 1830 to 1848*, 131–47. Exh. cat. Columbia, M.O.,& London, 1990.

———.(c) "Early Realism." In *The Art of the July Monarchy: France 1830 to 1848*, 101–15. Exh. cat. Columbia, M.O. & London, 1990.

———.(d) "Antoine Vivenel, The Private Museum and the Entrepreneur under the July Monarchy." *Journal of the History of Collections* 2, no. 1 (1990): 21–39.

———. "In Deep Shit: The Coded Images of Traviès in the July Monarchy." *Art Journal* 54 (Fall 1993).

White, Hayden. *Metahistory: The Historical Imagination in Nineteenth-Century Europe*. Baltimore & London, 1973.

———. *Tropics of Discourse: Essays in Cultural Criticism*. Baltimore & London, 1978.

———. *The Content of the Form*. Baltimore & London, 1987.

Whiteley, J. "The King's Pictures." *Oxford Art Journal* 12 (1989): 57.

Woolworth, Thomas. *Facts and Faces*. London, 1852.

Wright, Beth S. "Scott's Historical Novels and French History Painting, 1815–1855." *Art Bulletin* 73 (June1981): 268–87.

Wright, Beth S., and Paul Joannides. "Les romans historiques de Sir Walter Scott et la peinture française, 1822–1863." *Bulletin de la Société de l'Histoire de l'Art Français* (1982):119–146; (1983): 95–115.

Wright, Thomas. *A History of Caricature and Grotesque in Literature and Art*. 1865. New York, 1968.

Zerner, Henri, and Charles Rosen. *Romanticism and Realism: The Mythology of Nineteenth-Century Art*. New York, 1984.

Index